Reorienting Ozu

REORIENTING OZU

A Master and His Influence

Edited by Jinhee Choi

OXFORD
UNIVERSITY PRESS

OXFORD
UNIVERSITY PRESS

Oxford University Press is a department of the University of Oxford. It furthers
the University's objective of excellence in research, scholarship, and education
by publishing worldwide. Oxford is a registered trade mark of Oxford University
Press in the UK and certain other countries.

Published in the United States of America by Oxford University Press
198 Madison Avenue, New York, NY 10016, United States of America.

© Oxford University Press 2018

Library of Congress Cataloging-in-Publication Data
Names: Choi, Jinhee editor.
Title: Reorienting Ozu : a master and his influence / edited by Jinhee Choi.
Description: New York : Oxford University Press, 2018. |
Includes bibliographical references and index.
Identifiers: LCCN 2017021094 | ISBN 9780190254971 (cloth : alk. paper) |
ISBN 9780190254988 (pbk. : alk. paper) | ISBN 9780190255008 (oxford scholarship online)
Subjects: LCSH: Ozu, Yasujirō, 1903-1963—Criticism and interpretation.
Classification: LCC PN1998.3.O98 C57 2017 | DDC 791.4302/33092—dc23
LC record available at https://lccn.loc.gov/2017021094

9 8 7 6 5 4 3 2 1

Paperback printed by Webcom, Inc., Canada
Hardback printed by Bridgeport National Bindery, Inc., United States of America

CONTENTS

FIGURES

LIST OF CONTRIBUTORS

Mark Betz is Reader in film studies at King's College London, UK. He is the author of *Beyond the Subtitle: Remapping European Art Cinema* (2009), as well as several articles and book chapters on postwar art cinema and film culture, the reception of foreign films in North America, the history of film studies, and contemporary manifestations of art film aesthetics with an emphasis on Asia. His work has been published in *Screen, Cinema Journal, The Moving Image,* and *Camera Obscura,* and in the collections *Defining Cult Movies, Inventing Film Studies,* and *Global Art Cinema,* among others.

Adam Bingham is Lecturer in film and television at Nottingham Trent University and the author of *Japanese Cinema Since Hana-Bi* (2015). He writes regularly for *Cineaste* and has contributed to recent books on female filmmakers, neo-noir in Hong Kong cinema, and on representations of prostitution.

David Bordwell is Jacques Ledoux Professor Emeritus of Film Studies at the University of Wisconsin-Madison. He has written several books on film history and aesthetics, including *Ozu and the Poetics of Cinema* (1988; 1994), *Poetics of Cinema* (2007), and *Planet Hong Kong: Popular Cinema and the Art of Entertainment* (2000; 2nd ed., 2011). With Kristin Thompson he has written *Film Art: An Introduction* (2013) and *Film History: An Introduction* (McGraw-Hill, 2009). They write about cinema at www.davidbordwell.net/blog.

William Brown is Senior Lecturer in film at the University of Roehampton, London. He is the author of *Non-Cinema: Global Digital Filmmaking and the Multitude* (forthcoming), *Supercinema: Film-Philosophy for the Digital Age* (2013), and *Moving People, Moving Images: Cinema and Trafficking in the New Europe* (with Dina Iordanova and Leshu Torchin, 2010). He also the coeditor of *Deleuze and Film* (with David Martin-Jones, 2012). He has published numerous essays in journals and edited collections, and has directed various films, including *En Attendant Godard* (2009), *Circle/Line* (2016), *Letters to Ariadne* (2016), and *The Benefit of Doubt* (2017).

Jinhee Choi is Reader in film studies at King's College London, UK. She is the author of *The South Korean Film Renaissance: Local Hitmakers Global Provocateurs* (2010) and has coedited three volumes, *Cine-Ethics: Ethical Dimensions of Film Theory, Practice and Spectatorship* (2014), *Horror to the Extreme: Changing Boundaries in Asian Cinema* (2009), and *Philosophy of Film and Motion Pictures* (Blackwell Publishing, 2006).

Darrell W. Davis is a recognized expert on East Asian cinema, with books and articles on Japanese, Taiwanese, Hong Kong, and pan-Asian film and media industries. His latest project is an analysis, evaluation, and prognosis of Chinese connected viewing, conducted with UC Santa Barbara and Warner Bros. He lives and teaches in Hong Kong.

David Deamer is the author of *Deleuze, Japanese Cinema and the Atom Bomb: The Spectre of Impossibility* (2014) and *Deleuze's Cinema Books: Three Introductions to the Taxonomy of Images* (2016); he has also published a few journal articles and book chapters here and there. Deamer's interests lie at the intersection of cinema and culture with history, politics, and the philosophy of Deleuze and Nietzsche. Deamer is a semi-independent scholar affiliated with the English, Art, and Philosophy departments of Manchester Metropolitan University, UK; he blogs online at www.david-deamer.com.

Albert Elduque is postdoctoral researcher in the University of Reading (UK), where he is part of the project "Towards an Intermedial History of Brazilian Cinema: Exploring Intermediality as a Historiographic Method" ('IntermIdia'). His PhD thesis (Universitat Pompeu Fabra, Barcelona, 2014) dealt with the notions of hunger, consumption, and vomit in the cinema of the '60s and '70s, taking into account European and Brazilian filmmakers such as Pier Paolo Pasolini, Marco Ferreri, and Glauber Rocha. His main research interests are Brazilian cinema (particularly its relation with music traditions), Latin American cinema overall, and the aesthetics of political film. He is the coeditor of the film journal *Cinema Comparat/ive Cinema*, published by Universitat Pompeu Fabra.

Manuel Garin is Senior Lecturer in film studies at Universitat Pompeu Fabra, Barcelona. He has been a visiting scholar at the Tokyo University of The Arts and the University of Southern California, where he developed the comparative media project *Gameplaygag. Between Silent Film and New Media*. He is the author of *El gag visual. De Buster Keaton a Super Mario* (2014) and has published in peer-reviewed journals such as *Feminist Media Studies*, *International Journal of Cultural Studies*, *L'Atalante*, and *Communication & Society*. Trained as a musician, he holds an MA in Film Scoring from ESMUC Music School.

Aaron Gerow is Professor in Japanese and East Asian cinema at Yale University and has published widely on variety of topics in Japanese cinema and popular culture. His publications include *Visions of Japanese Modernity: Articulations of Cinema, Nation, and Spectatorship, 1895–1925* (2010), *A Page of Madness: Cinema and Modernity in 1920s Japan* (2008), and *Kitano Takeshi* (2007). With Markus Nornes he also wrote *Research Guide to Japanese Film Studies* (2009), a revised edition of which recently appeared in Japanese. He is currently writing about the history of Japanese film theory.

Daisuke Miyao is Professor and the Hajime Mori Chair in Japanese Language and Literature at the University of California, San Diego. Miyao is the author of *The Aesthetics of Shadow: Lighting and Japanese Cinema* (2013), *Eiga wa neko dearu: Hajimete no cinema sutadīzu* (Cinema is a cat: Introduction to cinema studies) (2011), and *Sessue Hayakawa: Silent Cinema and Transnational Stardom* (2007). He also edited *Oxford Handbook of Japanese Cinema* (2014) and coedited *Transnational Cinematography Studies* (2017) with Lindsay Coleman and Roberto Schaefer, ASC.

Michael Raine is Assistant Professor of film studies at Western University, Canada. His most recent publications are an introduction to Matsumoto Toshio in *Cinema Journal* 51, no. 4 (2012), "Adaptation as Transcultural Mimesis," in *The Oxford Handbook of Japanese Cinema* (2014), and "From Hybridity to Dispersion: Film Subtitling as an Adaptive Practice," in *Media and Translation* (2014). He is also coediting a book of essays, *The Culture of the Sound Image in Prewar Japan* (forthcoming).

Yuki Takinami is Associate Professor of media studies at Josai International University. He completed his dissertation, "Reflecting Hollywood: Mobility and Lightness in the Early Silent Films of Ozu Yasujiro, 1927–1933," at the University of Chicago and published articles in Japanese on silent films directed by Ozu. He also translated into Japanese essays written by Miriam Hansen, Katherine Hayles, and others, and published articles on television and music video.

Kate Taylor-Jones is Senior Lecturer in East Asian studies at the University of Sheffield. She is the coeditor of *International Cinema and the Girl* (2015) and has published widely in a variety of fields, including a forthcoming edited collection entitled *Prostitution and Sex Work in Global Visual Media: New Takes on Fallen Women*. Her latest monograph study, *Divine Work: Japanese Colonial Cinema and Its Legacy*, has recently been published with Bloomsbury Press. Kate is editor-in-chief of the *East Asian Journal of Popular Culture*.

Mitsuyo Wada-Marciano is Professor of film studies at Carleton University (Canada). Her research interests include Japanese cinema and East Asian cinema in global culture. She is the author of *Nippon Modern: Japanese Cinema of the 1920s and 1930s* (2008) and the coeditor of *Horror to the Extreme: Changing Boundaries in Asian Cinema* (2009). She recently published *Japanese Cinema in the Digital Age* (2012) and edited *Viewing "Postwar" in the 1950s Japanese Cinema* (in Japanese, 2012). She is currently finalizing a book manuscript on the cinema in post-Fukushima Japan.

Junji Yoshida is an independent scholar of modern Japanese literature and film. His Ph.D. thesis entitled "Origins of Japanese Film Comedy and Questions of Colonial Modernity" reconsiders mainstream Japanese film comedies by Inagaki Hiroshi and Ozu Yasujiro as creative responses to the regime of colonial imagination and the crisis of representation. He is currently preparing a book manuscript on the complicity of laughter with restructuring of social relations against tradition.

Reorienting Ozu

Introduction

JINHEE CHOI

Japanese director Ozu Yasujiro has become a cultural icon, whose far-reaching influence is evident both in and beyond the medium of film. Directors such as Wim Wenders, Claire Denis, and Hou Hsiao-hsien have paid homage to Ozu through their work, while Abbas Kiarostami dedicated his film *Five* (*Panj*, 2003) to Ozu. The serialized comic *Mystery of Ozu Yasujiro* (*Ozu Yasujiro no nazo*, 1998–1999) features an American director named Stan, who tries to locate the meaning of *mu*, a kanji character inscribed on Ozu's gravestone.[1] Concierge Renée, one of the two principal characters of the French novel *The Elegance of the Hedgehog* (*L'élégance du hérrison*, Muriel Barbery, 2006), watches Ozu's *The Munekata Sisters* (*Munekata kyodai*, 1950) during her spare time. To her great delight, she finds out that a new resident of her building has the same last name as the great director.[2] With an increasing presence as a major figure in cinema as well as appearing in other cultural milieus, Ozu needs to be revisited in a broader context—including moving beyond Japan.

Western scholarship on Ozu has primarily focused on his film style, with various attempts to identify the origin(s) of his aesthetic—including to what extent Ozu's distinctive and unique film style may reside in his "Japaneseness." From culturalists such as Donald Richie and Paul Schrader, to Marxist Noël Burch, to neoformalists David Bordwell and Kristin Thompson, and historians such as Daisuke Miyao and Mitsuyo Wada-Marciano, the diverse methodologies employed in characterizing Ozu's films not only indicate Ozu's enigmatic aesthetic but further, as Mitsuhiro Yoshimoto insightfully points out, reflect the changing position of Ozu in the establishment and development of film studies as an academic discipline.[3] Ozu still figures in contemporary critical discourses on directors such as Hou Hsiao-hsien, Kitano Takeshi, and Kore-eda

Hirokazu and on a global canon of contemporary slow cinema. Why does Ozu still matter in contemporary global film scenes and scholarship? This volume aims to consider the formation of Ozu's aesthetic within the various cultural and historical contexts and examines Ozu's influence on both Japanese directors and those from all around the globe, revisiting the limits and benefits in considering their relationship under the notion of influence.

THE OZU SYSTEMATICS, THE EVERYDAY, AND NEW THEORETICAL PARADIGMS

Ozu's poignant film style is now widely known among film aesthetes and scholars: his oblique, sparse storytelling, the pictorial quality of shots and carefully arranged props, spatiotemporally ambiguous inserts (pillow shots), his use of 360-degree space and low-height camera, repeated visual motifs (trains, smokestacks, beer bottles, clothes lines), and tonal stillness/stasis, to list just a few. Noël Burch has characterized Ozu's film style as "systematics"—"an association of inter-related but semi-autonomous systems,"[4] while Bordwell explores it under the rubric of a "parametric" style that consists of identifiable formal parameters governed by a system of its own logic.[5] Japanese film scholar Hasumi Shigehiko and Japanese New Waver-turned-critic Yoshida Kiju also identify an "Ozuesque" (and "Ozu-like") character in the master's signature style, despite the contrasting values attributed to it. Ozu's aesthetic, nonetheless, neither emerged nor exists in a vacuum; his aesthetic is very much embedded in the sociopolitical, cultural, and industrial context of Japan, interweaving through the various planes of Japanese everyday life.

For many scholars and viewers, everydayness is the principal subject of Ozu's work. Yoshida definitively claims,

[Ozu] decided to depict only incidents from everyday life He was not allured by the optimistic idea that art is grand and eternal. Limiting his cinematic expression, Ozu-san allowed his viewers to use their own imagination limitlessly. Consequently, his films, apparently plain and simple, become mysterious and constantly invoke new meanings.[6]

The everydayness in Ozu's films also constitutes what Richie calls the "*texture of life.*"[7] Richie states, "[O]ne object of Ozu's criticism throughout his career, beginning with such early pictures as *The Life of an Office Worker* and *Tokyo Chorus* (*Tokyo no korasu*, 1931), has been the texture of Japanese urban life, traditional in that it has been unthinkingly passed on from generation to generation for over a century."[8] For Schrader, the relationship between human being and its "unfeeling environment" is the key to creating a disparity between the two, which is then to be transcended.[9] Seemingly insignificant everyday objects are seen to

embody subtle nuances for Yoshida and Hasumi. The air pillows in Ozu's *Tokyo Story* (*Tokyo monogatari*, 1953), according to Yoshida, provide a "gaze" on an elderly couple; the forgetful husband, Shukichi, who falsely accuses his wife, Tomi, of being unable to find them in her bag, and the generous wife who foregoes sowing tension from the situation. Hasumi notes how a banal object such as a towel placed around the daughter Michiko's neck in *An Autumn Afternoon* (*Sanma no aji*, 1962) is there for her to remove it as she silently expresses anger toward her drunken, guilt-ridden father—a father who, having witnessed the unwelcome prospect of an unmarried daughter at his former teacher's house, bluntly brings up the question of his daughter's marriage.[10]

The everydayness manifest in Ozu's films is not merely part of his systematic, cyclical vignettes that constitute a core for his aesthetic. His everydayness is historical as well as aesthetic. It is under the sway of historical conditions, a space that registers social and familial changes. Whether it is Japanese modernity, or the disintegration of Japanese traditional family and values, or the loss of parental authority even in a nuclear family, these conditions are both resisted and accepted through the changes experienced in everyday life. Historically inclined scholars of Ozu reveal the complex negotiation taking place between Japanese modernity and Ozu's work. The domesticity in Ozu's films is not ahistorical. Ozu's films are *gendai geki*—drama set in contemporary Japan. Wada-Marciano observes that Ozu's early, lower-middle-class salarymen films (*shoshimin geki*) such as *Tokyo Chorus* and *I Was Born, But . . .* (*Otona no miru ehon—Umarete wa mita keredo*, 1932) cannot properly be examined without taking into consideration the geopolitics of Tokyo at the time; they were created in the very context of urban planning and suburbanization of Tokyo in the 1920s and 1930s, with an increasing awareness of a new sense of home and family.[11] Kristin Thompson challenges the perception of Ozu's films as being conservative; the evident "traditional" father in *Late Spring* (*Banshun*, 1949) helps his daughter Noriko come to terms with a new sense of marriage and the family based on happiness, not duty.[12] Alastair Phillips also considers the prominence of female characters in Ozu's postwar films, especially the representation of the female protagonist Noriko in the Noriko trilogy, in relation to the postwar mass female audience, and the stardom of Hara Setsuko in Japan.[13] Changing perceptions of the role of class and gender, in fact, is very much ingrained in Ozu's representation of the everyday.

The dense texture of Ozu's everydayness further provides a useful framework for a cross-cultural analysis of domestic space in which objects are in perfect order. Consider an experimental film directed by Chantal Akerman: *Jeanne Dielman, 23 Commerce Quay, 1080 Brussels* (*Jeanne Dielman, 23, quai du Commerce, 1080 Bruxelles*, 1975), depicting three days of Jeanne's everyday life. A widow working as a prostitute, Jeanne brings her customers in her home. In the film, one can find the protagonist Jeanne's obsessive compulsive ordering of everyday objects comparable to the meticulous placement and

arrangement of props in Ozu's films. In the first two days, her daily routines are established with an immaculate visual ordering of the domestic space. By the third day, the film slowly sets into a "disaster mode,"[14] in which we see domestic objects begin to be dropped, misplaced, and forgotten, signaling the deleterious disruption of Jeanne's daily routines.

The minimal aesthetic, broadly construed, of Ozu, and that of Akerman, belong to different traditions of filmmaking. If Ozu's oeuvre constituted a major strand of home drama in the Japanese film industry during the studio era, Akerman's films were influenced by American minimalist artists' filmmaking such as Andy Warhol's and French leftist filmmaking such as Jean-Luc Godard's.[15] Yet the two share a similar aesthetic sensibility—formal density. In their films, the human being comprises part of the everyday texture rather than vice versa. For both filmmakers, their way of constructing "dramatic" human actions through a rigid play with on- and off-screen space could result in the subversion of a usual hierarchy between character and environment. Noriko's unseen wedding in *Late Spring*, for instance, is less important than Shukichi's peeling of an apple in the empty home upon his return from the wedding. The murder taking place toward the end of *Jeanne Dielman* can be read, as Ivone Margulies suggests, as an equivalent to Jeanne's peeling of potatoes or preparing veal for a meal, "one more element in the unending series of 'and, and, and.'"[16] What links Akerman's film, *Jeanne Dielman*, to Ozu's aesthetic sensibility, despite their unbridgeable formal differences, is the density of film's surface texture to the effect that human beings and events become part of "the transfiguration of the everyday."[17] In Ozu, Gilles Deleuze claims, "everything is ordinary or banal, even the death and the dead who are the object of a natural forgetting."[18]

The still life and contemplative outlook of Ozu's films further attract the attention of the proponents and advocates of "slow" cinema. Compared to contemporary filmmakers such as Tsai Ming-liang, Apichatpong Weerasethakul, and Béla Tarr, who are often associated with excessively long duration of shot (and film) and slowly paced narrative, Ozu is not that "slow," as Jonathan Rosenbaum observes.[19] Nonetheless, one is often tempted to compare the tone and stillness of Ozu's films with that of slow cinema and further intrigued by Studio Shochiku's invitation of a long-take director such as Hou to pay homage to the Japanese master.[20] For those who make recourse to the philosophy of Deleuze and pay a particular attention to the temporality of slow cinema, Ozu can occupy a special place. According to Deleuze, in the time-image, time is not subservient to the construction of the movement-image that provides an illusion of the continuity of an action. It becomes the subject of cinema itself. Deleuze identifies Ozu as "the first to develop pure optical and sound situations."[21] In the shot of a vase in Ozu's *Late Spring*, inserted between two shots of Noriko with two different facial expressions, from a smile to sadness, Deleuze finds an instance of direct representation

of time—"that which endures."[22] It is the presentation of time as "becoming, change, passage."[23]

Not only Deleuze but also other Japanese scholars and critics such as Hasumi and Yoshida foster a cross-cultural study of Ozu that has been desperately needed in the field. While Yoshida's *Ozu's Anti-Cinema* (*Ozu Yasujiro no han eiga*, 1998) was published in English in 2003, Hasumi's book *Director Ozu Yasujiro* (*Kantoku Ozu Yasujiro*, 1983) has not yet been translated into English, although it is available in other languages, including French (1998) and Korean (2000). In *Manifesto of Surface Criticism* (*Hyoso hihyo sengen*, 1979), Hasumi is critical of the cinematic narration system. What Ozu offers us, according to Hasumi, is to expose such an apparent "systemicity" and reveal its impossibilities.[24] Although the focus is different, Yoshida's approach, Miyao notes, foregrounds both "the capabilities and limits of motion picture as a medium," of which Ozu was acutely aware.[25] Two chapters in this volume engage with these alternative theoretical frameworks. Darrell Davis examines Yoshida's theoretical underpinnings and assumptions in comparison with previous English-language scholarship on Ozu—in particular, Schrader and Bordwell—and attempts to translate their ideas, opening up a conversation among the three. Aaron Gerow delineates Hasumi's scholarship on Ozu as a response to the Anglophone scholarship on Ozu advanced in the 1970s and 1980s, and examines the significance of Hasumi's intervention in both Japanese film theory and culture.

Although Hasumi's work was contemporaneous with the Western scholarship on Ozu advanced in the 1970s and 1980s, the theoretical frameworks mentioned above were introduced into the English-language scholarship after the publication of the last major monograph on Ozu in English—Bordwell's *Ozu and the Poetics of Cinema* (1988). Instead of postulating a binary opposition between Japanese "indigenous" versus English or French "foreign" scholarship, or Japanese-speaking scholars versus those without a commanding competence in Japanese, this volume presents them in a manner of conversation. Hasumi was indebted to French philosophy, such as the philosophy of Deleuze, in the development of his film theory and criticism,[26] while Yoshida shares a methodological inclination with Bordwell and Thompson, in his emphasis on the "repetition and difference" as the major trait of Ozu's both life and aesthetic, who once compared himself to a tofu maker.[27] Deleuze further provides a theoretical hook for David Deamer, who in this volume offers a close reading of Kiarostami's *Five, Dedicated to Ozu*.

HE KNEW WHAT THEY MEANT; HE KNEW WHY HE WAS DOING

There might be an epistemic risk in lumping together internationally acknowledged directors under the rubric of Ozu. The cultural essentialism still prevails

when *Ozuesque* has become an umbrella term to denote *any* minimalist film style that generalizes the varying aesthetics of internationally acclaimed East Asian directors, despite the specificity of the individual directors and their own cultural orientations. Hou Hsiao-hsien, for instance, was not familiar with Ozu's work until the 1990s, despite the fact the critical discourses paired the two prior to the point of his encounter with Ozu's films. Kore-eda Hirokazu, as mentioned, denies Ozu's influence on every occasion when asked who influenced him. Is the notion of "influence" still a viable concept in discussing Ozu and the subsequent generations of directors in both Japan and abroad? Is "Ozuesque" purely a construct of critical discourses, projected onto any "new" terrain of East Asian cinema? This section, in lieu of sketching the Western key texts on Ozu—those of Richie, Schrader, Burch, and Bordwell—will examine how the notion of influence is construed in their texts. A careful rereading of the various approaches to Ozu will show that their approaches—the humanist, the culturalist, and the neoformalist—cannot and should not be as neatly mapped onto the matrix of a methodological framework.[28]

Humanist critics such as Richie and Schrader, according to Yoshimoto, locate the particularity of Ozu in his cultural heritage—Japanese culture, art, and spirituality.[29] Richie's monograph on Ozu, the first book-length scholarship on Ozu in English, was published in 1974, and it provided indispensable insights into Ozu's work. Yet his approach to Ozu is considered prominently humanist as well as culturalist, foregrounding the national character in Ozu's aesthetic. Indeed, Richie often finds in the Japanese cultural traditions an indispensible heuristic value in articulating Ozu's aesthetic sensibility. For instance, Zen Buddhism and the notion of *mono no aware*, the connotation of the latter extending its literal meaning of "pathos of things" to refer to sympathetic sadness, provides Richie with a handy analytic concept to characterize the poignancy and bittersweet sentiment detected across many of Ozu's films.[30]

Richie, nonetheless, was fully aware of the tenuous relationship existing between Japanese culture and Ozu's films. In Richie's words,

For him [Ozu] as for all good film directors, the experience of the film was the most important thing. He himself never spoke of *mu*, or *mono no aware*, though he knew what they meant, and I doubt he would ever have seriously discussed them. Indeed there is a question (a not very important one, to be sure) whether Ozu "knew" what he was doing. One possible answer is that the kind of mentality that framed the concept of *mu* had much in common with the one that created *Late Spring* (just as the kind of mentality that created Kabuki resembles the one that created the sword-fight film, which allows innocent critics to speak of the Kabuki's influence on the Japanese cinema, when in fact, none exists).[31]

It is interesting to note here that Richie describes as "innocent" those who find the influence of Kabuki on Japanese period (*jidaigeki*) films, when "none

exists." Many have claimed that Richie in fact fell into a similar kind of pit-fall in his pigeonholing of the poetics of *Late Spring* into a "Japanese" men-tality and sentimentality. Nonetheless, Richie does not offer a reductionist, essentialist account, as many assume; he sees the Japanese culture such as *mu* and *mono no aware* as providing a causal basis ("he knew what they meant") broadly construed, rather than a causal explanation for how Ozu's distinctive style came about ("whether he 'knew' what he was doing").

Contemporary Japanese film scholars map Richie's rather heterogeneous, if not eclectic, approach to Ozu too neatly onto the humanist tradition rooted in the reductionist, essentialist assumptions. Despite his "humanist" bent, Richie's approach is certainly comparative; Ozu's sense of irony, he claims, is comparable to that of Anton Chekhov or Jane Austen in that despite the estimable detachment manifest in his films, they nevertheless pull the viewer closer to characters.[32] Or the function of Ozu's low camera position, which he used persistently from the beginning of his career, is similar to the one that Gregg Toland employed over a decade later in *Citizen Kane* (Orson Wells, 1941): "the low angle made it possible to sharply delineate the various sur-faces of the image and to accentuate the one occupied by the actors."[33] Richie is amused by the fact that such an aesthetic choice—adopted by both Ozu and Toland, although independently—created a similar difficulty for the studio heads at Shochiku and RKO: namely, to build ceilings on the sets.

Richie's analysis of Ozu's films certainly was guided by his knowledge of and familiarity with Japanese culture and traditions; however, he repeatedly grants Ozu his aesthetic peculiarity and sensibility—that is, his personal predilection to sustain pictorial balance. In his description of "unaccounta-ble lapses" in Ozu's films, Richie states that "in the later films continuity is continuously broken because Ozu rearranged his props constantly for differ-ent camera set-ups. In these cases, however, he knew what he was doing, or at least why he was doing it (for compositional reasons), and if the effect is scrambled on the screen, it is at least the way he wanted it."[34] After having introduced the anecdotes of actors and actresses, including Ryu Chishu, Hara Setsuko, and Tsukasa Yoko, working on the set under Ozu's meticulous direc-tion and control, Richie claims, "the end to which all these pains were taken was, of course, composition. Ozu had various ways of creating it, but all were necessarily based on his ideas of balance and geometry."[35]

Schrader's approach to Ozu could be reassessed in a similar way. Schrader's work on Ozu operates within the tripartite relationship he sets up in his dis-cussion of the transcendental style—individuality (personality), culture (Zen), and universality (the transcendent). Schrader's rhetoric is more forceful in his assertion of the cultural influence of Japan, and Zen in particular, on Ozu's work: "Zen is not an organized religion with physical and political concerns like Shintoism or Christianity, but a way of living which has permeated the fabric of Japanese culture Zen is the quintessence of traditional Japanese

art, an art which Ozu sought to introduce into cinema."[36] Although Richie's *Ozu* was published in 1974 two years after Schrader's *Transcendental Style in Film* (originally published in 1972 [1988]) appeared, Schrader's transcendental Ozu resonates with the observations made by Richie. Schrader was very much in conversation with Richie's earlier work, *The Japanese Film* (1959), coauthored with Joseph L. Anderson and further with Richie's appreciation of Ozu, which appeared in the journal *Film Quarterly* in the 1960s.[37] Unlike Richie, who recognizes the tentative nature of the relationship between the specificity of Ozu's films and his cultural heritage, Schrader posits a stronger relationship between Zen and Ozu:

But taken as a whole Ozu's techniques are so similar to traditional Zen methods that *the influence is unmistakable*, and one must consequently assume that Ozu's personality, like that of the traditional artist, is only valuable to the extent that it expresses his thesis. His personality, like those of his characters, merges with an enveloping sense of *mono no aware*, and—the ultimate achievement of Zen art—finally becomes undistinguishable from it.[38]

But to what extent do we need to take Schrader's rhetoric here at face value, when Schrader also attributes Ozu's aesthetic to various sources, including production circumstances and Ozu's individuality?

Other precedents can be found for Ozu's techniques: the rote repetition of movement was a gag in Japanese silent comedy and became incorporated into Ozu's technique; and his stationary camera shots, Ozu once half-facetiously stated, were due to the fact that a dolly could not operate at such a low angle. And, of course, his "personality" also influenced his approach to filmmaking.[39]

Schrader, like Richie, acknowledges the various origins of Ozu's aesthetic. But more importantly, one must also pay attention to a more moderate claim when reflecting on the cultural aspects of Ozu's work: "Zen art and culture is [sic] an accurate *metaphor* for Ozu's films."[40] The metaphor is considered a figurative speech that forges a relationship between two disparate things for rhetorical effect. Ozu ultimately interests Schrader because of the capacity of Ozu's films to achieve transcendental stasis, and because of how his films could liberate the viewer from everydayness and transcend a fissure existing between environment and human being. "Zen," for Schrader, is like *mono no aware* for Richie, embodying the heuristic value that would help one to make sense of some of the "functions" that he believes Ozu's aesthetic to achieve, rather than providing a causal explanation.

Ozu's film style is ideologically significant for Burch, as he sees it as opposing or contrasting with what he calls "the institutional mode of representation" (IMR). However, Burch faces a similar kind of criticism leveled against the

culturalist; Yoshimoto claims that "Burch falls prey to the Orientalist trap."[41] Burch finds a close parallel between Ozu's aesthetic and Japanese poetry, in particular that which exists between transitional shots (or a cut-away within a scene) and pillow words in Japanese poetry. Burch sees the ambiguity of a pillow shot in relation to the shots that precede and/or follow it, similar to that of a pillow word, which appears in a poem that modifies the first word of the next line.[42] Burch's characterization of Ozu's cinema (or Japanese cinema in general) is underpinned by his own theoretical agenda to advance a critique of the IMR and its diegetic effects: that is, how the IMR that has developed along with the establishment of feature films in the West fosters the viewer's illusion of and immersion in the diegesis.[43] To Burch, Ozu's systemics, including his false eyeline match and pillow shot, challenges the "Western" conception of the fictional world as a self-enclosed entity, yielding a "decentering" effect.[44] Despite Burch's emphasis on Japanese art (such as poetry) that finds its ways in Ozu's work, he also acknowledges the irreducibility of such aesthetics to either the cultural or the collective, stating, "[T]hough it would be absurd to reduce the pillow shot to any 'ultimate' function, the pictorial quality which it almost inevitably displays may be regarded as the epitome of Ozu's surface imagery."[45] Ozu's pictorial sensibility, in the end, guides his choices in composition and editing; it is irreducible to either national or cultural origins.

A rereading of these scholars whose works provided salient turning points in the English-language scholarship on Ozu, in fact, shows their methodological ambivalence in explaining Ozu's film style: markedly in their struggles to find an adequate way to offer a view on the relationship between the individual, the cultural, and the transnational (or the universal). Ozu's aesthetic is an outcome of diverse cultural and cinematic sources, influences, and inspirations. From the methodological certainty ("the influence is unmistakable"[46]) to heuristics ("metaphor"[47]), and to analogy ("an unexpected similarity," "a parallel"[48]), the varying degrees of Japanese cultural elements that may have contributed to the establishment of Ozu's aesthetic in fact point to the need to consider both the causal basis ("he knew what they meant") of, and the causal explanation ("he knew what he was doing"[49]) for his film style and sensibility.

It is not my intention to deny that foregrounding the "Japanese" character in Ozu's film style carries an epistemic risk of losing both the historical and aesthetic complexity of Ozu's work, associating his aesthetic with a handful of "Japanese" concepts. Nonetheless, instead of generalizing some of these approaches as the culturalist, orientalist, essentialist, or reductionist, and neatly summing up the methodological paradigms and "limitations," what I hope to have indicated—by briefly surveying the moments of reservations in these scholars' attribution of the cultural influences to Ozu's world—is the conceptual difficulties they encountered in advancing an adequate framework for explaining the relationship between the individual and the collective (be it cultural, political, or national). As Schrader puts it, "[E]ach artist must use

the raw materials of his personality and culture . . . but it is not possible to extrapolate the transcendental style from within a totally Japanese perspective; one needs *several* cultural perspectives."[50] Regardless of whether they were indeed able to encompass "several" perspectives, Richie, Schrader, and Burch all acknowledge the conceptual risks in reducing Ozu's style to just cultural and historical factors. A question remains as to how to conceptualize the notion of influence, either cultural or filmic.

In his critique of the above-mentioned positions that posit strong affiliations between Ozu's film style and Japanese culture, David Bordwell points out that it is hasty for critics and scholars to presuppose the Japanese tradition as uncontested, as if it maintained its original forms stable and fixed.[51] For instance, in Japan, *mono no aware*, the idea of which dates back to the Heian period of the eighth to eleventh centuries, changed its cultural status from the object of nostalgia toward moral simplicity and purity, to a literary device, and to an inherent "Japanese" quality, subject to historical conditions.[52] In order to provide a causal explanation for the establishment of Ozu's aesthetic and style, Bordwell claims, one should seek "proximate historical practices" within which Ozu's own agency could be located. Born in 1903, Ozu experienced the Meiji (1868–1912) reformation and ideals to westernize the country in his formative years. Ozu passionately consumed Western culture, often refraining from associating his work with Japanese traditional forms. Bordwell notes that "a causal explanation must specify why Ozu's work embodies these qualities more than other directors' work does."[53] Influence, for Bordwell, should be predicated on the historical conditions and industrial circumstances that facilitated the source material's transmission as well as director's urge to employ it. For Ozu, who was himself a modern boy (*mobo*), Hollywood "not only embodied the modernity of the West but offered an accessible model of narrative unity."[54]

Michael Raine also finds Hollywood cinema as the inspiration for Ozu, who in fact stood out among his peers for the "intensity of his imitations"[55] as well as for honing in his films the "subtlety" of Hollywood cinema that Ozu appreciated.[56] Ozu's contemporaneous critics in Japan and the studio blurbs constantly compared Ozu with foreign as well as Hollywood filmmakers like Chaplin and Lubitsch. However, Raine proposes considering the Japanese adoption and appropriation of Hollywood film style and cycles not as imitation, but as mimesis. The concept of "mimesis," Raine claims, "acknowledges both the fluidity it introduces into cultural identity and the multifaceted nature of 'imitation.'"[57] The mimetic practice in the local context of early Japanese cinema aims at "*recreating* Hollywood film in Japan, *parodying* the absurdities of American Cinema . . . in the Japanese context, and even *learning* from the gap between Japanese and Hollywood cinema."[58] Mimesis, which Aristotle construes as innate in human nature, certainly involves both representational

and heuristic aspects.[59] Mimesis can be playful and pleasurable (à la Aristotle) especially when the spectator recognizes it as such: "identifying this as an image of such-and-such a man, for instance."[60] The appreciation of Ozu's films in relation to Hollywood cinema would, then, lie in appreciating both the adoption and transformation of Hollywood cinema conventions in addition to the spectator's recognition of Hollywood references.

Both Bordwell and Raine underscore the industrial context and practices in which Ozu (and other Japanese filmmakers) worked; any specificity of an individual style and affinity between national cinemas should be contextualized within such practices. It is worth recalling the two attributes of influence—similarity and causality—in locating the various influences on Ozu as well as his influence on subsequent generations of directors. The relationship of influence can be construed as follows:

When we say that A has influenced B, we mean that after literary or aesthetic analysis one can discern a number of *significant* similarities between the works of A and B. We may also mean that historical, social, and perhaps psychological analyses of the data available about A and B reveal similarities, *points of contact*, between the "lives" or "minds" of the two writers.[61]

Without an adequate point of contact, the similarity detected would merely remain as a marked "affinity" rather than as a sign of influence. The distinction that Richie casually introduces between "he knew what they meant" and "he knew what he was doing" nicely contrasts the types of causality that film scholars attributed and established, either metaphorically or casually. If the humanist and culturalist tradition (somewhat naively or innocently or intentionally) turned to the "causal (or better cultural) basis" as the point of contact, the latter sought the "causal explanation," which can be historically traceable.

When one turns the mirror from cultural and cinematic influences on Ozu to his influence on subsequent generations of directors, however, similarity and causality as the two "principles" of influence appear to be insufficient. As Michael Worton and Judith Still argue, "[T]he object of an act of influence by a powerful figure (say, a father) or by a social structure . . . does not receive or perceive that pressure as neutral."[62] New Wave directors such as Oshima Nagisa, Shinoda Masahiro, and Imamura Shohei, for instance, criticized the commercially oriented filmmaking at Shochiku, challenging the conservativeness of Ozu's film style and themes. Imamura, who worked as assistant director on Ozu's *Early Summer* (*Bakushu*, 1951) claims, "I wouldn't just say I haven't been influenced by Ozu. I would say I didn't want to be influenced by him."[63] Kore-eda Hirokazu, who is often compared to Ozu, also denies Ozu's direct influence, seeing himself more aligned with Naruse Mikio or Hou Hsiao-hsien in terms of the tone of his films.[64] If there is any influence of Ozu

on these directors, it would be what Harold Bloom calls an influence as subli-
mation, a "defense against the anxiety of influence."[65]

A strong need arises, then, to distinguish between what I would call "forma-
tive" and "constitutive" influence; influence can be exercised as part of initial,
formative forces in positive and/or negative shaping of a canon, an individual
or group style, and a movement. Influence could further leave its footprints
through thematic and/or stylistic devices inherited and transformed in films
themselves. The Hollywood slapstick comedy of Harold Lloyd and the sophis-
ticated comedy of Ernst Lubitsch had influences in both senses of the term on
Ozu's early student comedy. Adam Bingham notes,

Ozu's earliest extant film, the Harold Lloyd-esque student comedy *Days Of Youth*
[1929], was edited almost entirely according to classical continuity conventions (Ozu's
immense love of American cinema and its influence on his early work have been
noted), most apparently 180-degree rule shot/reverse shot cutting and thus "correct"
screen direction, a conventional analytical breakdown of space, and establishing and
re-establishing shots.[66]

Ozu's constitutive influence can be traced in the specific components that are
transmitted to his contemporaries or successors. Bordwell locates Ozu's influ-
ence in such Shochiku directors as Sasaki Yasushi, Hara Kenkichi, and Shibuya
Minoru: "Hara's *A Happy Family* (*Kofuku na kazoku*, 1940) uses the 360-degree
space which Ozu pioneered. Sasaki's *Mysterious Man* (*Shimpi no otoku*, 1937)
contains a pensive passage in which two men leave the 'Arc-en-ciel' bar and
three shots linger on bar signs being switched; the scene reminiscent of *The
Only Son* (1936)."[67] As he discusses in his chapter of this volume, some of the
Ozuesque stylistic devices can be found in films like Suo Masayuki's *Sumo
Do, Sumo Don't* (*Shiko funjatta*, 1992) in its use of frontal framing and Wayne
Wang's *Dim Sum* (1985) and *The Joy Luck Club* (1993) in its narrative situa-
tions (marrying off children) and the use of domestic objects and lingering
cityscape.

Global film auteurs, who express their admirations for Ozu, could then be
discussed in terms of both formative as well as constitutive influence, and
many chapters in this volume are in fact dedicated to comparing Ozu with
such directors as Hou Hsiao-hsien, Kore-eda Hirokazu, Wim Wenders, Iguchi
Nami, Clair Denis, and Joanna Hogg. Certainly, Ozu is not the sole influence
on these directors; in the works of these directors, both cross-cultural yet
transformative aspects should be foregrounded; it is not the affinity, stylistic
or thematic, that matters, but the transformation of Ozu's sensibility mani-
fest in these filmmakers' work.

Reorienting Ozu: A Master and His Influence redirects the scholarship from
Ozu the auteur to Ozuesque—how his aesthetic sensibilities can be articu-
lated differently in light of the theoretical frameworks that yield the diverging

receptions of his films, as well as the historical contexts in which his films were produced, circulated, and consumed. This volume further traces the influence of Ozu on the films of directors of successive generations and/or differing nationalities. If Ozuesque, as some of the contributors to this volume delineate and propose, could be characterized *not* in terms of a fixed set of tropes and narrative structures manifest throughout Ozu's oeuvre, but instead approached historically and relationally, that is, in terms of how it has developed and been explored within the specific industrial and discursive context, it could still help us articulate the relationship between Ozu and global film directors. Ozuseque, construed historically, opens up the possibility of discussing the nature of influence as *operative* rather than mimetic. As alluded to previously, the Taiwanese director Hou Hsiao-hsien independently developed a distinctive style of film staging prior to his encounter with Ozu's work. Yet, as he became an internationally renowned director within the global film festival circuits, his films have increasingly (and explicitly) alluded to Ozu's films; Hou was also approached by the Japanese studio Shochiku to direct a film to celebrate the centennial anniversary of Ozu's birth—*Café Lumière* (2003). The aesthetic association between Ozu and Hou's later work should, then, be traced and situated within this particular global film culture and discourse.

Section I, "Branding Ozu," presents contemporary theoretical and discursive frameworks that help one re-examine Ozu's oeuvre and further explore the concept of the Ozuesque. This section begins with Bordwell's comprehensive overview of the legacy of Ozu's film style and tone and his influence on such directors as Suo Masayuki, Kore-eda Hirokazu, and Wayne Wang, as well as other global directors. Darrell Davis critically assesses one of the prevalent conceptions of Ozu in the West, especially the presence of Zen Buddhism in his work, and contrasts such characterization with Japanese scholarship advanced on Ozu, including that of Hasumi and Yoshida. Elaborating further on Hasumi, whose scholarship on Ozu has had a significant influence on the filmmaking and style of contemporary Japanese directors, Aaron Gerow examines the Japanese discursive formations that contributed to the revival of the interest of both Japanese filmmakers and audiences in Ozu, and the construction of Ozu as a transnational figure within Japan. Mitsuyo Wada-Marciano focuses her chapter on the Taiwanese director Hou Hsiao-hsien's *Café Lumière* (2003), a film dedicated to the celebration of Ozu's centennial birthday. She makes sense of, yet challenges, the palpable "Japaneseness" manifested in Hou's film by examining the production circumstances and marketing strategies that helped to create a "systemic sense" in Japanese audiences and critics—a concept that Japanese philosopher Ohashi Ryosuke adopts from the Greek philosopher Aristotle. Jinhee Choi proposes viewing Ozuesque as a sensibility that allows both constancy and malleability. Employing the notion of sensibility advanced by art historian Roger Fry, Choi examines how the combination of rigor and playfulness shapes Ozu's distinctive aesthetic sensibility.

Subsequent sections further help our understanding of Ozu both histor-ically and transculturally. Section II, "Historicizing Ozu," expands upon the existing scholarship on Ozu to examine his films that have not been widely circulated and discussed. Contributors view Ozu's work as a result of, and a response to, technological developments in the Japanese film industry, censorship, and sociopolitical changes within Japan. Michael Raine offers a metric analysis of Japanese silent cinema and attributes the function of more frequent deployment of intertitles in the late-silent films of Ozu to his way of replacing, or minimizing the role of, *benshi*, Japanese voiceover commentators for silent cinema. Daisuke Miyao challenges the auteuristic approaches to Ozu's film style, which has dominated Western scholarship on Ozu, by underscoring the sensitivity of Ozu's work to the new technolo-gies advanced in lighting and cinematography. Yuki Takinami entertains Ozu's critique of modern life in his lower-middle-class salarymen cycle (*shoshimin eiga*) in the 1930s. The term *shoshimin* is a Japanese translation of the Marxist term petit bourgeois, but the *shoshimin* films refer to a cycle of salarymen films, which often feature a low-to-middle-class office worker as the protagonist. Comparing Ozu's salarymen films with Vertov's modern-ist film *Man with a Movie Camera* (1929), this chapter critically assesses the political dimension of Ozu's work. The relationship between Ozu's films and nationalism will be explored in the next chapter. Junji Yoshida questions a simplistic trajectory often projected onto Ozu—from an innovative mod-ern to a "conservative" Japanese director. Focusing on humor in Ozu's films, he instead explores the constant negotiation that took place between Ozu's work and censorship.

Section III, "Tracing Ozu," is dedicated to Ozu's influence on the directors of East Asia and beyond. The theme of family, which is the main focus of Ozu's home dramas, provides an interesting site to trace the dissolution of family in Japanese cinema. Adam Bingham's analysis of *Dogs and Cats* (2004), which is the directorial debut of female director Iguchi Nami, demonstrates the shared style and pacing between the two directors, whose work focuses on the dis-integration and the absence of stable family structures. Contributors further assess the cross-cultural influence of Ozu in world cinema by examining the work of Jim Jarmusch, Claire Denis, Wim Wenders, Abbas Kiarostami, and Joanna Hogg. Sight gags, or the way Ozu counterbalances blankness with playfulness through sight gags, become for Manuel Garin and Albert Elduque a converging point between Ozu and Western directors such as Jarmusch and Aki Kaurismäki. Kate Taylor-Jones draws a parallel between Denis and Ozu in their postcolonial aesthetic, especially the way their films affectively engage the spectator with the texture of the films. Mark Betz argues that the father-daughter relationship manifested in Ozu's postwar films had become a formal inspiration for Wenders's "road" movies, such as *Alice in the Cities* (1974) and *Paris, Texas* (1984). Kiarostami's *Five, Dedicated to Ozu* is analyzed in light of

the philosophy of Deleuze in David Deamer's chapter. William Brown brings together Ozu and the British filmmaker Joanna Hogg in his discussion of the ecological perspective shared between the two directors, exploring how in their films the human subject is always considered and viewed as part of a larger environment or ecological system.

In this volume, for the Romanization of Japanese names (*romaji*), contributors follow the Hepburn style without macrons. Japanese proper names are referred to by family name followed by first name (e.g., Ozu Yasujiro), while for authors who publish outside of Japan in English, their names follow the Western order of first name followed by family name.

NOTES

1. Sonomura Masahiro and Nakamura Mariko, *Mystery of Yasujiro Ozu*, Big Spirit Comics Specials—Japanese Film Director Biographies (Tokyo: Shogagukan, 2001).
2. Muriel Barbery, *The Elegance of the Hedgehog*, trans. Alison Anderson (New York: Europa editions, 2008).
3. Mitsuhiro Yoshimoto, *Kurosawa: Film Studies and Japanese Cinema* (Durham, NC: Duke University Press, 2000), 8–49.
4. Noël Burch, *To the Distant Viewer: Form and Meaning in the Japanese Cinema* (Berkeley: University of California Press, 1979), 158.
5. David Bordwell, *Ozu and the Poetics of Cinema* (Princeton, NJ: Princeton University Press, 1988), 109.
6. Yoshida Kiju, *Ozu's Anti-Cinema*, trans. Daisuke Miyao and Kyoko Hirano (Ann Arbor: The University of Michigan Press, 2003), 126.
7. Donald Richie, *Ozu: His Life and Film* (Berkeley: University of California Press, 1974), 55.
8. Richie, *Ozu*, 65.
9. Paul Schrader, *Transcendental Style in Film: Ozu, Bresson, Dreyer* (Berkeley: University of California Press, 1972; repr., New York: A Da Capo Paperback, 1988), 43.
10. Shigehiko Hasumi, "Ozu's Angry Women," *Rouge*, 2004, accessed April 19, 2015. http://www.rouge.com.au/4/ozu_women.html.
11. Mitsuyo Wada-Marciano, *Nippon Modern: Japanese Cinema of the 1920s and 1930s* (Honolulu: University of Hawaii Press, 2008), 25, 51.
12. Kristin Thompson, *Breaking the Glass Armor: Neoformalist Film Analysis* (Princeton, NJ: Princeton University Press, 1988), 321.
13. Alastair Philips, "Pictures of the Past in the Present: Modernity, Feminity and Stardom in the Postwar Films of Ozu Yasujiro," *Screen* 44, no. 2 (Summer 2003): 159.
14. Ivone Margulies, *Nothing Happens: Chantal Akerman's Hyperrealist Everyday* (Durham, NC: Duke University Press), 79.
15. Ibid., 9.
16. Ibid., 98.
17. Ibid.
18. Gilles Deleuze, *Cinema 2: The Time-Image*, trans. Hugh Tomlinson and Robert Galeta (Minneapolis: University of Minnesota Press, 1989), 14.
19. Jonathan Rosenbaum, "Is Ozu Slow?," *Senses of Cinema* 4 (March 2000), accessed April 19, 2015. http://sensesofcinema.com/2000/feature-articles/ozu-2/.

20. Song Hwee Lim, *Tsai Ming-Liang and a Cinema of Slowness* (Honolulu: University of Hawaii Press, 2014), 85.
21. Deleuze, *Cinema 2*, 13.
22. Ibid., 17.
23. Ibid.
24. Ryan Cook, "An Impaired Eye: Hasumi Shigehiko on Cinema and Stupidity," *Review of Japanese Culture and Society* 12 (December 2010): 131.
25. Daisuke Miyao and Kyoko Hirono, translator's introduction to Yoshida, *Ozu's Anti-Cinema*, xvii.
26. Cook, "Hasumi," 138.
27. Daisuke Miyao and Kyoko Hirono, translator's introduction to Yoshida, *Ozu's Anti-Cinema*, xvii; 25.
28. Markus Nornes, "The Riddle of the Vase: Ozu Yasujiro's *Late Spring* (1949)," in *Japanese Cinema: Texts and Contexts*, ed. Alastair Phillips and Julian Stringer (New York: Routledge, 2007), 78–89.
29. Nornes, "The Riddle," 82; Yoshimoto, *Kurosawa*, 10.
30. Richie, *Ozu*, 52.
31. Ibid., 175.
32. Ibid., 50.
33. Ibid., 116.
34. Ibid., 113.
35. Ibid., 128.
36. Schrader, *Transcendental*, 27.
37. Donald Richie, "Yasujiro Ozu: The Syntax of His Films," *Film Quarterly* 17, no. 2 (Winter 1963–1964): 11–16.
38. Schrader, *Transcendental*, 38; emphasis added.
39. Ibid., 37–38.
40. Ibid., 37; emphasis added.
41. Yoshimoto, *Kurosawa*, 21.
42. Burch, *To the Distant Observer*, 160.
43. Ibid., 243–266.
44. Ibid., 161.
45. Ibid., 175.
46. Schrader, *Transcendental*, 38.
47. Ibid., 37.
48. Burch, *To the Distant Observer*, 175.
49. Richie, *Ozu*, 175.
50. Schrader, *Transcendental*, 53; emphasis added.
51. This is a line of thought that is shared by many revisionists, including Alastair Philips. See his "Pictures of the Past in the Present: Modernity, Femininity and Stardom in the Postwar Films of Ozu Yasujiro," *Screen* 44, no. 2 (Summer 2003): 163.
52. Bordwell, *Ozu*, 28–29.
53. Ibid., 26.
54. Ibid., 151.
55. Michael Raine, "Adaptation as 'Transcultural Mimesis' in Japanese Cinema," in *The Oxford Handbook of Japanese Cinema* (Oxford: Oxford University Press, 2014), 105.
56. Ibid., 107.
57. Ibid., 115.

58. Ibid.; original emphasis.
59. Aristotle, *Poetics*, trans. Stephen Holliwell (Chapel Hill: University of North Carolina Press, 2006), 34.
60. Ibid.
61. Ihab H. Hassan, "The Problem of Influence in Literary History: Notes towards a Definition," *The Journal of Aesthetics and Art Criticism* 14, no. 1 (1955): 68; emphasis added.
62. Michael Worton and Judith Still, *Intertextuality: Theories and Practices* (Manchester: Manchester University Press, 1990), 2.
63. Tayama Rikiya, *Nihon no eiga sakkatachi: Sosaku no himitsu* [Japanese filmmakers: Secrets of creation] (Tokyo: Daviddosha, 1975), 12; cited in translator's introduction to Yoshida, *Ozu's Anti-Cinema*, x.
64. Mark Schilling, "Kore-eda Hirokazu Interview," *Film Criticism* 35, nos. 2–3 (Winter–Spring 2011): 12.
65. Harold Bloom, *Anxiety of Influence* (Oxford: Oxford University Press, 1997), 115.
66. Adam Bingham, "The Spaces In-Between: The Cinema of Yasujiro Ozu," *Cineaction* 63 (2004): 49–50.
67. Bordwell, *Ozu*, 25.

SECTION I
Branding Ozu

CHAPTER 1

Watch Again! Look Well! Look!

DAVID BORDWELL

Ozu is a major presence in today's international film culture. When I began seeing his work in the early 1970s, about half a dozen circulated in film copies, and of those only *Tokyo Story* (*Tokyo monogatari*, 1953) was known to nonspecialist cinephiles. As late as the 1980s, I had to travel to several archives in Europe and the United States to see his rarer films. Now even the most obscure early 1930s titles are issued on DVD, and the films have been widely distributed in touring packages. They are screened all over the world, a process lovingly recorded daily on Twitter at http://twitter.com/Ozu_Yasujiro. Ozu is better known to a broad public than Mizoguchi Kenji is—an ironic turn of affairs, given that, at least in France, Mizoguchi was famous during the 1950s and 1960s, when Ozu was unknown.

Even more famous throughout the West was, of course, Kurosawa Akira. His influence on mainstream cinema has been robust and pervasive. If slow-motion violence has become a convention in American films since *Bonnie and Clyde* (Arthur Penn, 1967), that is directly traceable to the director of *Seven Samurai* (*Shichinin no samurai*, 1954). The use of very long lenses to cover a scene, common in American cinema of the 1960s and thereafter, owes everything to Kurosawa's strategies in films like *I Live in Fear* (*Ikimono no kiroku*, 1955) and *Red Beard* (*Akahige*, 1965). Editing on the camera axis for visceral impact, a Kurosawa signature technique, has bumped up the visual excitement in many American action pictures.

Ozu has not had such a direct influence. He is much less easy to assimilate. With few exceptions, his signature style has been far less imitated, and it has even been misunderstood. His effect on modern cinema, it seems to me, has

been far more oblique, with directors paying him tribute in discreet, sometimes unexpected ways.

BRAND OZU

Ozu was careful to mark his singularity. He designed his films to be markedly different from those of his contemporaries. His home base, the Shochiku studio, encouraged directors to develop personal styles, and he was allowed to make artistic choices that could only be considered eccentric. At first glance, Ozu's films may seem to melt into a broader idea of "Japanese artistic culture," but the more films we see from his contemporaries, the more idiosyncratic his works look.

Having allowed Ozu to make such singular films, Shochiku has exacted a reciprocal obligation: his legacy now serves as a trademark for a film studio. For the world at large, Japanese cinema is Kurosawa and Toho studios' Godzilla, Nikkatsu action, and anime. Shochiku had its tradition of modest, humane dramas of working-class and middle-class people, treated with that mixture of humor and tears known as the "Kamata flavor" (after the Tokyo suburb where the studio was located). This tradition was sustained by Ozu and his colleagues through the 1950s, and it was institutionalized as what we would now call a franchise. The forty-eight Tora-san films (*It's Tough to Be a Man* [*Otoko wa tsurai yo*]) became identifying marks for Shochiku from 1969 through 1996.

But as media became globalized, and as merchandising became central to sustaining filmmaking, Shochiku's product came to seem narrowly local. Accordingly, the firm focused on what had become its most famous employee. Shochiku's familiar postwar logo, a view of Mount Fuji, had become for Westerners part of Ozu's iconography. Now Shochiku tried to reclaim its trademark by reminding viewers that he belonged to a bigger family.

For the local market, Shochiku tried a bit of merchandising, such as phone cards with scenes from Ozu movies. More ambitiously, there was Shochiku Kamakura Cinema World, a theme park established in 1995 at a cost of $150 million. It held many attractions devoted to American cinema, and it even allowed customers to visit a movie in the making, but one wing was devoted to Shochiku's legacy properties, including a replica of a street from the Tora-san series. There were Ozu memorabilia as well, including a three-dimensional tableau of an effigy of Ozu directing a scene in *Tokyo Story*, along with a reconstruction of his work area at home.[1]

Cinema World closed in 1998, a financial failure. But Shochiku persisted and declared in 2003 that it would host a worldwide celebration of Ozu's hundredth anniversary. That celebration consisted of a new touring program of 35 mm prints of his films, with ancillary ceremonies and festival activities,

and several new DVD releases. Above all, Shochiku commissioned a film in homage to the great director: Hou Hsiao-hsien's *Café Lumière* (*Kohi jiko*, 2003). For festivals and arthouse cinemas, Hou's tribute was aimed to recall Ozu's greatness and, by association, Shochiku's place in film history.

As directors have sought to retain the Kamata flavor in later decades, we find hints and traces of Ozu as well. A film like *119: Quiet Days of the Firemen* (*119*, Takenaka Naoto, 1994), in which middle-aged men in a small village fantasize about romancing a young researcher, might bring to mind the overactive imaginations of the grown-up schoolboys of *Late Autumn* (*Akibiyori*, 1960). Kore-eda Hirokazu's *Still Walking* (*Aruitemo aruitemo*, 2008) is a family drama made in full awareness of the Ozu tradition. Not surprisingly, Yamada Yoji, an impresario of Tora-san, has invoked the Shochiku tradition in several productions, notably *Kabei: Our Mother* (*Kabe*, 2008), and *About Her Brother* (*Ototo*, 2010). At the start of 2011, Yamada, about to turn eighty years old, announced that he would remake *Tokyo Story*.

OZU COMES TO AMERICA

Since at least the early 1920s, Japanese cinema has been in continuous dialogue with American cinema. During the classic period, American films did not dominate the Japanese market, as they did in many other countries, but filmmakers were nevertheless acutely conscious of Hollywood. In particular, the founding of Shochiku in 1920, with a self-consciously modernizing orientation under Kido Shiro, created a ferment that changed Japanese cinema forever.

As with other Kamata/Ofuna directors, Ozu relied crucially on American cinema. There are visual citations (the *Seventh Heaven* poster in *Days of Youth* [*Gakusei romansu: Wakaki hi*, 1929]), lines of dialogue about Gary Cooper and Katharine Hepburn, borrowed gags (from a Harold Lloyd film, *A Sailor-Made Man* [Fred C. Newmeyer, 1921] in *Days of Youth*), even entire extracts (*If I Had a Million* [James Cruze, 1932] in *Woman of Tokyo* [*Tokyo no onna*, 1933]). More deeply, his early films absorbed the analytical découpage of 1920s Hollywood. He broke every scene into a stream of precise, slightly varied bits of information in the manner of Ernst Lubitsch and Harold Lloyd.

Ozu paid American cinema a deeper tribute. Having grasped the system of axis-of-action continuity that Hollywood had forged from the late 1910s, he created his own system as an alternative. Instead of a 180-degree organization of space, he proposed a 360-degree one. This allowed him to absorb the Americans' innovations and yet give them a new force. Cuts would use eyelines, shoulders, and character orientation, but would often show characters looking in the same direction and match them pictorially from shot to shot; a cut on movement could be made by crossing what American directors called "the line."

Further, Ozu realized that the establishing shot, that depiction of the overall space of the action, could be prolonged and split into several shots. The result was a suite of changing spaces that could be unified by shape, texture, light, or analogy. These transitional sequences substitute for fades and dissolves, turning ordinary locales into something at once evocative and rigorous. All of these transformations of Hollywood's stylistic schemata are rendered more palpable by a single, simple choice that is more single-minded than anything to be found in Hollywood: the camera is typically placed lower than its subject. This constant framing choice acts as a sort of basso continuo for the melodic variations that Ozu will work on for two-dimensional composition and three-dimensional staging.

This entire stylistic machine might seem to be aimed wholly at working out its own intricate patterns, and indeed to some extent that is what happens. The aficionado can appreciate the refinements, the theme-and-variants structuring, created by Ozu's cinematic narration. More importantly, all of these techniques serve to awaken our attention—to the possibilities of cinema, but also to the shapes and surfaces of the world as they change. Alongside the characters' drama is a realm at once stable and ceaselessly shifting; in fact, the characters and their drama are subject to the same forces of mutability. Ozu's modest pyrotechnics activate the world of his story, subject his characters and their actions to the same suite of transformations, and have the larger purpose of reawakening us to our world.

Ozu borrowed from America, but American directors have not returned the compliment. True, we have the moment in *Stranger Than Paradise* (Jim Jarmusch, 1984) when Willie reads off the list of horses running in the second race: "Indian Giver, Face the Music, Inside Dope, Off the Wall, Cat Fight, Late Spring, Passing Fancy, and Tokyo Story." After a pause, Willie says to bet on Tokyo Story. We know from Jarmusch's account of visiting Ozu's grave that he was a passionate admirer, but his films seem to me to show his debts chiefly in their "minimalist" approach to their action.

More elaborately, Wayne Wang offers a self-conscious homage in *Dim Sum: A Little Bit of Heart* (1985). This story of a widow, her brother-in-law, and her daughter transfers an Ozu situation to San Francisco and a Chinese-American community. Should the daughter marry and leave her mother alone? The uncle, who runs a declining bar, urges the girl to do so. The situation, he says, reminds him of "an old Japanese movie" in which a parent urges the child to start a family. As in Ozu, the generations are sometimes captured in "similar-position" (*sojikei*) compositions (figs. 1.1–1.2).[2]

To the generational split of the Ozu prototype, Wang adds the cultural division between modern America, the daughter's home, and Hong Kong, home not only to the mother but all the friends in her age group. The generational contrasts would be elaborated upon in Wang's later *The Joy Luck Club* (1993), which counterpoints the experience of four mothers and four daughters.

Figure 1.1.
I Was Born, But . . . (Otona no miru ehon—Umarete wa mita keredo, Ozu Yasujiro, 1932).

Figure 1.2.
Dim Sum (Wayne Wang, 1985).

Well aware of the Ozu parallels in the plot, Wang elaborates them through some stylistic choices. The film starts with a static thirty-second shot of curtains blowing alongside a sewing machine. The mother comes into the frame, pours tea, takes pills, and starts the machine. The next sequence consists of

isolated details—a birdcage, a table—followed by views of a street, then a bridge over San Francisco Bay, a young woman seen from the rear sitting on shore, and finally the water. This is an imagistic preview of details to be seen later. Not only will we come to recognize the young woman as the daughter Laureen, but we will see the household details, street locations, and bridge views later in the film.

The rest of the film is not as disjunctive as this opening, and Wang soon settles in to the sort of leisurely and loose plotting that characterized independent film of the period. Significantly, though, the objects and cityscapes we see do not become dramatically significant; they are part of the ambience of the characters, somewhat in the Ozu manner. But neither do they take on the elaborate variations and minute adjustments we find in Ozu's "hypersituated" objects and recurring locations. Still, of all American directors, Wang has most willingly adapted Ozu's aesthetic to his own personal concerns, while paying homage to a director who was just being appreciated as both storyteller and stylist.

Otherwise, the balance sheet seems to me virtually empty. Every young American filmmaker seems to have studied Kurosawa, but which of them knows Ozu—or, like Willie, have bet only on *Tokyo Story*? Filmmakers elsewhere have been more generous and discerning.

CITATION, PASTICHE, AND PARODY

Hou Hsiao-hsien, no cinephile in his youth, came to admire Ozu later in life, and he used citation in a more thoroughgoing way than Jarmusch had in *Stranger Than Paradise*. Liang Ching, the modern-day protagonist of *Good Men, Good Women* (Hao nan, hao nu, 1995), leads a sort of parallel life with a Taiwanese woman she is playing in a film, Chiang Bi-yu, along with her husband, who joined the anti-Japanese resistance on the mainland in 1940. But the parallel is a contrast as well, since Liang is unhappy in her love relationships and seems to lack any sense of social commitment. Her drifting, rather aimless style of living is counterpointed not only to the courageous and energetic Chiang but also, via a televised movie, to Ozu's postwar world.

Early in the film, Liang is awakened by the beeping of her fax machine. On her television monitor runs the bicycling sequence from *Late Spring* (*Banshun*, 1948). These cheerful shots of Noriko and Hattori on an outing provide yet another contrast to Liang's brooding torpor about the death of her lover, Ah-wei. They also suggest another way to be a heroine, quietly strong and capable of both love and defiance. And the chaste outing we see in *Late Spring* contrasts sharply with the intense eroticism of the flashback that follows this morning scene, showing Liang and her lover caressing each other before a mirror. Unlike Ozu's couple, they need a narcissistic

magnification of their passion. If *Good Men, Good Women*'s overall plot condemns the Japanese for their army's invasion of China, Hou from the start reminds the audience of another Japan, one that after the war became, at least in Ozu's hands, a place of humane feeling. This is no one-off joke as in Jarmusch's citations; the *Late Spring* extract deepens the thematic reverberations of the film as whole.

Likewise, instead of the sporadic invocations of Ozu's style provided by Wayne Wang, the early films of Suo Masayuki show more engagement with the Ozu manner—particularly because they are turned to comic ends. Suo's first feature, *My Brother's Wife: The Crazy Family (Hentai kazoku: Aniki no yome-san*, 1984) was a curiosity: a softcore pornographic film shot in a distinctly Ozuesque style. Only in Japan can an erotic film spare the energy to borrow so explicitly from a master of the cinema. While the newly married couple has thumping intercourse upstairs, the husband's father, sister, and brother sit calmly downstairs, sighing or frowning slightly in response to the gymnastics overhead. True to the exhaustive geometry of pornography, the brother graduates to sadomasochism, the adolescent son becomes fixated on his sister-in-law, and the young daughter takes up work in a "soapland" parlor. Thus is the Ozu family drama turned upside down, with the father observing everything with a bemused, helpless smile. Suo, who had studied film under Hasumi Shigehiko, turned in a well-crafted film that was a virtual parody of the late Ozu style.

In Suo's next films, parody turned into pastiche. *Fancy Dance (Fanshi dansu,* 1989) and *Sumo Do, Sumo Don't (Shiko funjatta*, 1992) display a fanatically precise understanding of Ozu's unique use of space. Suo adheres to the low camera height, builds scenes out of slightly overlapping zones, and avoids camera movement. He indulges in the master's penchant for head-on shots that can be matched graphically across a cut, leaving us to notice the variations of color and texture within remarkably similar compositions (figs. 1.3–1.6).

Westerners often ignore Ozu's penchant for social comedy in the Lubitsch vein, but Suo's films happily explore this dimension. While American and European filmmakers seem aware only of Ozu's postwar films, Suo the cinephile grasped that the 1930s college comedies offered fertile resources for his own stories. *Fancy Dance* and *Sumo Do* show young people giving up modern popular culture in favor of Japanese traditions that are so old that they become fashionably retro. A ragged college sumo team discovers that the sport turns them from slackers into adepts. A talentless rocker, forced to live in the Buddhist monastery he has inherited, eventually adapts and learns that Zen can be cool.

In *Shall We Dance?* (1996), Suo modifies the Ozu look into something more generically Kamata-toned, but he still shows traced of the master's rigor. For example, the first time that the camera moves is when the bored executive takes his first tentative lesson in ballroom dance. The film's social critique is

Figure 1.3.
An Autumn Afternoon (*Sanma no aji*, Ozu Yasujiro, 1962).

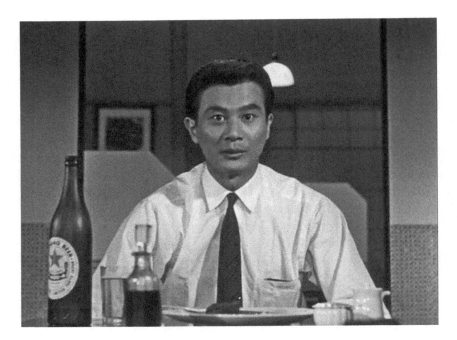

Figure 1.4.
An Autumn Afternoon.

Figure 1.5.
Sumo Do, Sumo Don't (*Shiko funjatta, Suo Masayuki*, 1992).

Figure 1.6.
Sumo Do, Sumo Don't.

not as harsh as that in Ozu's 1930s work, but it does dramatize the stifling limits put on both the salaryman and his family.

JUST-NOTICEABLE DIFFERENCES

The two most famous Ozu homages, both from his anniversary year of 2003, are more puzzling. For neither Hou's *Café Lumière* nor Abbas Kiarostami's *Five Dedicated to Ozu* can be easily categorized as citation,

assimilation, or pastiche. What is the nature of the tributes these two masters pay to him?

Café Lumiere could easily be simply a Hou Japanese production, so deeply is it imbued with his characteristic narrative maneuvers, themes, and style. Even the cutaway long shots of trains, recalling some of Ozu's urban iconography, would be perfectly at home in Hou's work, which has made memorable use of trains (*Summer at Grandfather's* [*Dong dong de jia qi*, 1984]; *Dust in the Wind* [*Lian lian feng chen*, 1987]). Likewise, Kiarostami's *Five Dedicated to Ozu* might seem to take Ozu as a pretext for a foray into "pure cinema" in the manner of *Shirin* (2008) or the video installations *Sleepers* (2001) and *Ten Minutes Older* (2001).[3] Unlike Hou, he did not conceive the film as a tribute; only after having premiered it at Cannes was he invited to attach it to the fall 2003 Ozu centenary. As a result, he changed the title from the original one, *Five*. In explanation, Kiarostami claims that the protracted long shots in the first four episodes are akin to Ozu's style:

His long shots are everlasting and respectful. The interactions between people happen in the long shots and this is the respect that I believe Ozu felt for his audience In his mise en scène he respected the rights of the audience as an intelligent audience. His films were not usually very technical, which would make them appear nervous and melodramatic in the manner of today's montage facilities.[4]

Although Kiarostami's statement is not perfectly clear in translation, he seems to suggest that Ozu favored lengthy and distant shots and avoided editing—a common misconception about the director. There is, in short, something of a mismatch between each of these directors' "Ozu films" and the oeuvre of Ozu.

Café Lumière has recourse to one of Hou's favorite maneuvers, casting rising pop-music stars in his films. Hitoto Yo, who had her first hit "Morai-naki" in 2002, became his lead performer. This was a shrewd marketing move, as she is of both Japanese and Taiwanese ancestry and personifies the "fusion" aspect of Hou's Shochiku project. Likewise, the male star Asano Tadanobu, an idol of Japanese cinema, has appeared in Thai, Russian, and even American films (e.g., *Thor*, 2011). Asano is also a pop musician and model. These strategic choices would, I think, have been appreciated by Ozu, who designed his scripts around Shochiku's biggest stars and was not above "product placement" of his favorite alcohol brands in his bar settings. Just as important, as with his Taiwanese films, Hou puts his young stars into a rigorously paced, controlled mise en scène—one owing little to Ozu technically, but a great deal to his model of incessant attention.

At one level, *Café Lumière* is a family drama, a little reminiscent of Ozu's *Tokyo Twilight* (*Tokyo boshoku*, 1958). While visiting her parents, Yoko tells her mother she is pregnant and has no intention of marrying the child's

Taiwanese father. Her family must come to terms with this, and the situation is handled with even more subdued reactions than we would find in Ozu. At another level, the film is about a search for sound. Yoko meets the book dealer Hajime while she is researching a Tawainese-Japanese composer from the 1930s. For his part, Hajime has the hobby of recording the sound of Tokyo subways, trains, and trams. Ozu leaves it to the viewer to notice the subtle attenuation of his music and noise effects, while Hou announces and thematizes these components as part of his cross-cultural drama.

Hou, like Ozu, is a director of "just-noticeable differences," the tiny details that change slightly across a shot or scene.[5] The first encounter that we see between Yoko and Hajime is a lengthy long-lens two-shot. Yoko pays for books that Hajime has kept for her, and as the couple moves slightly, we can glimpse Hajime's dog in the background. She moves aside to let us see it, then turns back to allow us to concentrate on their dialogue. This dynamic blocking and revealing of elements, characteristic of Hou's staging, shapes the space as an unfolding spectacle, with new facets for us to discover. And as the couple talk and listen to extracts of the composer's piano music, light reflected from the street outside ripples over the shop interior, a reminder of the city turmoil that lies outside this enclave.

The rest of the film will vary the locations to which we return—a coffee bar, Yoko's apartment—with slight differences measuring the time that has passed. Likewise, the minimal, barely-started romance, crystallized in meetings over coffee, is nuanced by ever-changing patterns of light. We must watch the people, their gestures and slight displacements, as well as the space that they inhabit and the changing levels of illumination. We must attend to the drama and its aura: both the café and the lumière.

Kiarostami calls *Five Dedicated to Ozu* "a real experimental film," and he is right; it could as easily have been called *Five Dedicated to Warhol*. Like American Structural Film, *Five* asks us to sink into a fixed frame showing landscape views, and to concentrate on minutiae. A piece of wood, caught on the waves lapping to shore, breaks in two. One piece stays on the sand, while the other is carried out to sea. People stride or stroll along the seafront. Unidentifiable objects at the water's edge shift uneasily and gradually become recognizable as dogs; but soon they dissolve into spindly black skeletons as the image brightens into dazzling abstraction. Ducks stroll through the shot, each one making a padding sound. Finally, the moon is reflected in a pond at night; the reflections quiver, broken by thunderclaps. For long periods the image is black, and we must listen to birds, frogs, and some mysterious creatures.

"I think," Kiarostami explains, "we should extract the values that are hidden in objects and expose them."[6] That sensitivity to just-noticeable differences that Hou achieves through the long take and intricate staging, Kiarostami achieves with the cooperation of nature. He is willing to trust to

chance, a force that will collaborate with him and invent something he could not conceive. Both filmmakers ask for a patience that most contemporary cinema cannot tolerate. In a general sense, Ozu becomes a model of a possible cinema—not through specific technical choices, as with Wang and Suo, but through an overall effect: a cinema attuned to the textures and weight of our world.

Still, something has been lost. To make us watch and wait today, the director must seize us and "gear us down" through long takes and stasis, by deferring, stretching, or purging narrative. Ozu, miraculously, solicits this heightened perception in less strenuous ways, through a cascade of cuts, rapid dialogue, and an engrossing story. The contemplative dimension of his cinema was simply another dimension of a work that incorporated dynamic storytelling. When cinema was new, much was permitted, however. Hou and Kiarostami, like Béla Tarr and a few others, have found in a slow pace and minimal drama today's best analogues to the sharp-edged awareness of the world that came so spontaneously to Ozu. In a larger sense, though, Ozu and Hou would agree with what Kiarostami claims could be alternate titles for his film: *Watch Again! Look Well!* or simply *Look!*[7]

NOTES

1. For some images from Kamata Cinema World, see https://www.cjspubs.lsa.mich.edu/electronic/facultyseries/list/series/ozu.php.
2. For more on *sojikei* staging in Ozu, see my *Ozu and the Poetics of Cinema* (Princeton, NJ: Princeton University Press, 1988), 84, 88, 94.
3. For more information on these video projects, see Alberto Elena, *The Cinema of Abbas Kiarostami*, trans. Belinda Coombes (London: SAQI, 2005), 182–183.
4. "Around *Five*," interview in the DVD release of *Five Dedicated to Ozu* (New York: KimStim), at 48:04–49:01.
5. See my discussion in "Hou; or, Constraints," chap. 5 in *Figures Traced in Light: On Cinematic Staging* (Berkeley: University of California Press, 2005), 186–237. There is further discussion of Hou's style, and other aspects of *Café Lumière*, in my video lecture "Hou Hsiao-hsien: Constraints, Traditions, and Trends," vimeo video, 1:08:51, https://vimeo.com/129943635.
6. "Around *Five*," at 6:44–6:52.
7. "Around *Five*," at 17:13–17:28.

CHAPTER 2

Ozu, the Ineffable

DARRELL W. DAVIS

A coincidence: film director Paul Schrader and I attended the same school. Calvin College, named after the sixteenth-century reformation theologian John Calvin, is a small liberal arts institution in Michigan known for its philosophy department and theological seminary. Schrader studied philosophy and learned his vocabulary in aesthetics from the faculty there (so did I). Calvin is the flagship school of the conservative Christian Reformed Church. Neither school nor church has any connection with the film industry, except for thorough skepticism of its calls to worldliness.

When Schrader makes films about the American Midwest, like *Blue Collar* (1978) and *Hardcore* (1979), I know where he is coming from (to use a phrase from the seventies). When he appeared at Calvin in 1980 to introduce his *American Gigolo* (1980), which was described by Leonard Martin as a "feeble morality play with some of the unsexiest sex scenes of all time," the good people of Grand Rapids were outraged, not so much by the film as by Schrader's outfit. He walked onstage dressed as a Catholic priest. Later at the party, Schrader said his parochial costume was only the latest Hollywood fashion; and he repeated his response to a question after the screening: "*American Gigolo* has nothing to do with the transcendental style." Schrader's statements—fashion and utterance—were so patently false, as they betrayed a desire to confound through paradox. Schrader's appearance that day was aiming for paradox; what he achieved, perhaps, was more like perversity. The appearance, the reputation, and the Calvin College pedigree were calculated to collide, in a (hopefully) creative fashion.

Paradox is what Schrader finds in the styles of Ozu, Bresson, and Dreyer. It is a necessary condition of what he calls transcendental style: the cinematic

invocation of the holy by means of puzzling, even confounding images. Transcendental style appears in three stages—everydayness, disparity, and stasis—and is indicative of sacred dimensions, and so varieties of paradox may flow from these areas. Schrader handles Bresson's and Dreyer's Christianity with a sure hand, but his discussion of Ozu is more tentative—and more dogmatic as well. Ozu is the prime example of transcendental style for Schrader, yet unlike his European counterparts, his religious motivations seem obscure. Schrader seizes on Zen Buddhism, itself notoriously paradoxical, to explain Ozu's invocation of the holy through film. Schrader reproduces a classic Zen aphorism, "When I began to study Zen, mountains were mountains; when I thought I understood Zen, mountains were not mountains; but when I came to full knowledge of Zen mountains were again mountains."[1] What this means is murky, but it makes *Transcendental Style in Film* very much a product of its time.[2] It is in line with the American counterculture's discovery of works by Daisetz Suzuki, Alan Watts, and Herman Hesse. These works were in the air at Calvin as well as at UCLA, where Schrader wrote his MA thesis in film criticism, which resulted in the publication of *Transcendental Style in Film*. If Schrader is a bit guarded about invoking Zen, he still insists that it is crucial to an understanding of Ozu's transcendentalism. He boldly claims that any study of Ozu the auteur "apart from traditional Zen values is meaningless."[3]

This is a gross overstatement. In most cases, even in the most transcendental, "Ozuesque" late works, explaining Ozu's style by resorting to Zen is unnecessary. Though I admire Schrader's description of transcendental style, Zen Buddhism clutters the otherwise elegant lines of his argument. In fact, Schrader himself seeks to separate transcendentalism from Zen in order to give his analysis cross-cultural validity. Logically, transcendental cannot equal Zen because that would make Bresson and Dreyer Buddhist, and not Christian directors. Articulations of transcendental (the holy) superintend both Buddhist and Christian faiths, and provide a rubric to unify European and Asian film styles. But in my view, Schrader's emphasis on Zen short-changes Ozu's artistic deliberations—those conscious, systematic choices he made as an artist and craftsman. It may be hard to separate the artistic from spiritual motivations but, for some reason, most Western critics need Zen as a cultural prop to set the stage for Ozu's otherwise bewildering style. Is there something mystical or ineffable about Ozu's working methods that incline to fastidious forms that seem to have no bearing on theme, character, and plot? I think not, but there may be something mystical about the impression these forms leave on audiences and critics. In the following pages I review critical writings on Ozu with a view to assessing the relevance of Zen to an understanding of his film style. To many Westerners, it seems Zen seems like a crutch or heuristic to gloss a film style that feels unfamiliar, yet moving and profound.

Paul Schrader, Donald Richie, and Noël Burch all resort to Zen as a pertinent norm for Ozu. Hasumi Shigehiko's "brilliant, eccentric" *Kantoku Ozu Yasujiro* (Director Ozu Yasujiro) almost completely rejects Schrader, Richie, and Burch with regard to uses of Zen to contextualize Ozu's aesthetic.[4] Hasumi points out that their characterization of Ozu as an ascetic director—"what they call abstemious" [*kinyoku to iu shudai*][5]—who refrains from variations in camera position, in movement, mise en scène, and subject matter, is entirely negative. Hasumi means that Zen-struck critics are keen to define Ozu's style in terms of what it is not, or, more precisely, what he repudiates. Ozu is thought to refrain from classical narrative techniques of classical Hollywood cinema that orients viewers, such as 180-degree shooting space, reframing, and spatiotemporal continuity (e.g., shot-reverse shot). Instead, he uses systematic formal choices that differ and depart from classical norms. Unfortunately for the ex-Calvinist Schrader, Hasumi dismisses this departure or withdrawal as puritanical. Where Schrader wishes to see Ozu steadily winnowing away superfluous techniques in his early work from the 1930s, he is devaluing the "apprentice" Ozu in favor of an essentialized, static Ozu, an Ozuesque that is deemed "complete," but (in Hasumi's view) lifeless. Instead, Ozu's films should be seen as continuous, evolving, and alive, just as Ozu's life is continuous, not fit for segmentation into a culminating logic of fulfillment—unless fulfillment is death. Both film and life fluctuate, waxing and waning, but of a piece, with nothing superfluous.

Hasumi keeps questioning whether Zen is relevant to Ozu's style. Incidentally, so does Ozu, when he states, "[Foreigners] don't understand—that's why they say it is Zen or something like that." The reporter to whom Ozu confided this in 1958 agreed: "Yes, they make everything enigmatic."[6] But if Hasumi rejects Zen, along with the cultural comparisons of Schrader, Richie, Burch, Bordwell, and Thompson, his own explanation is perhaps most enigmatic of all. "We are interested in Ozu's work not because it deviates from contemporary paradigms," Hasumi writes. Instead of a negative definition, he seeks out "the productivity of 'the sign' ['kigo' no seisansei] the moment when a film stops being a film—that is the condition of its life."[7] In an enigmatic, paradoxical way, Hasumi suggests that the life pulsing in the Ozu oeuvre lies precisely in those areas not accessible as film; the stipulation (*joken*) of a glimpse at the life of an Ozu film is the cessation of its life as a film.

Yet Ozu's films, both early and late, are anything but lifeless. In my judgment, their mischief and playfulness are diminished by absorption into Zen. Both Ozu's technical choices and his experimentation with various Shochiku genres show a spirit at odds with Schrader's dry garden profundities. Ozu's early films, which were dismissed by Schrader as "light comedy," are incompatible with Zen asceticism, whereas a more consistent treatment

of transcendental style would find it throughout Ozu's career. And so we do, if we keep a sharp eye. In *Dragnet Girl* (*Hijosen no onna*, 1933), there is an ingenious two-pronged joke based on Nipper, the RCA Victor dog. The action takes place in a music store where images and statues of Nipper abound, so it looks as if Nipper is eavesdropping on conversations; certain characters notice and remark on this, while other characters (unaware of the placement of Ozu's dialogue titles) appear to endow Nipper with speech! A rigorous yet unpredictable pattern of mise en scène, cutting, and titles results in a surprising, hilarious climax. As Bordwell puts it, "Nipper looks, listens, and speaks."[8]

It might hurt Schrader to hear it, but this too is transcendental. In his transcendental scheme, Schrader sets a tripartite structure of the everyday, disparity, and stasis, which resolves the initial rupture of daily experience. This three-part sequence represents an intervention of holiness, or Wholly Other, into quotidian patterns and affairs. Schrader also says that the transcendental entails confrontation, aiming to put viewers face to face with spiritual things. Though *Dragnet Girl* is a detective thriller, it establishes key expectations of conventional situations ("the everyday"), only to overturn them by withholding cues that mark departures from established patterns ("disparity"), resulting in a wariness toward style, story, and one's own viewing habits ("stasis"). Not that Ozu leads us astray, but that his patterns prompt awareness that he could do so, especially at certain moments of intermediate spaces, which compels heightened awareness and expectation. To use a musical/seduction analogy, "overtures" establish themes that are later "picked up" for reinforcement or variation via patterns set by the composer/initiator and shared with audiences.

If Schrader's idea of "transcendental" could be employed to underline the formal play to which Ozu persistently adheres across his entire oeuvre, an established genre like a detective thriller may be more suitable to the transcendent than the more "realistic" middle-class dramas of the postwar period. What could be more everyday, quotidian than a detective thriller? This was part of Shochiku Kamata's posture of cheerful modernity, incorporating Hollywood style and fashionable urban genres. Of the twenty-nine works Ozu completed before 1934, six are lower-middle-class stories (shoshimin film/*shoshimingeki*), including salaryman and "home drama" pictures, which Shochiku studio was known for; three, including *Dragnet Girl*, are hoodlum thrillers (*yotomono*); and nineteen are "*nansensu*" vehicles, the slender pretexts for slapstick and erotic mischief that include both student and domestic comedies. Ozu's first film, a notable failure, was a period film (*jidaigeki*). These generic categories overlap somewhat, but most of the films, including the lower-middle-class stories, lean toward the lighter side. The escapist movies like thrillers and light comedies, exemplifying the "Kamata touch," are thought to be incompatible with the "deep spiritual awareness" of transcendentalism.[9]

This is a lot of baggage to unload, if we follow Schrader that this is nought but apprentice work. Rather than taking transcendentalism to be some sort of ultimate disposition, let us instead take Schrader at his word and call it a form, which really means a cluster of characteristic techniques—regardless of subject matter. By 1950, however, Ozu's genres, like his personal style, were so firmly entrenched that audiences could have expectations that were extremely reliable (Burch would say excessively so), thereby permitting a minimum of narrative and technical permutations to play the game.

Schrader's teleological approach consigns the early work to a preparatory stage. Perhaps the *nonsensu* student comedies and lower-middle-class subjects do not seem to belong to the transcendental, but if the tripartite form is the requirement, one could find it in the 1930s films as well. For Schrader, I suspect the Kamata lightness in Ozu's early films is suspect, and Zen profundity is more likely found in the late work.

YOSHIDA KIJU'S REVISION

It is fitting that Ozu provides a subject for Yoshida (Yoshishige) Kiju. A member of the Shochiku New Wave, with films like *Eros Plus Massacre* (*Erosu purasu gyakusatsu*, 1969), Yoshida is a sharp critic and theorist. Because of his former status—iconoclastic postwar independent—Yoshida recasts Ozu's reputation as the most "Japanese" of Japanese directors. Yoshida, Oshima Nagisa, Imamura Shohei, and other filmmakers sought artistic and political rebellion from typical commercial practices in the industry. It was thought that *après guerre* filmmakers rejected all that Ozu stood for: sedate, well-to-do, academic. Yoshida's book, published in Japanese in 1998 (*Ozu's Anti-Cinema* [*Ozu Yasujiro no han eiga*]) is a sort of aesthetic *tenko* (recanting, or apostasy) that acknowledges the radical impulses implicit in Ozu's films, but that were denounced at the time.

Yoshida starts with Ozu's deathbed aphorism: "Cinema is drama, not accident."[10] It is a statement that puzzles Yoshida for years afterward. Yoshida contemplates it, putting it together with other recollections he has of Ozu, his former mentor at the studio. How does it sit with another of Ozu's statements, "directors are like prostitutes under a bridge, hiding their faces and calling customers,"[11] a cynical judgment of the film industry's realities? Ozu was drinking when he said this, and sharing cups with Yoshida, who had just written a critique of Ozu's film *The End of Summer* (*Kohayagawa-ke no aki*, 1961). Yet another image was Ozu's comparison of himself to a tofu maker, relying on the same method, recipe, and ingredients, to make the same film over and over.

Yoshida knows as an experienced filmmaker that a director's statements do not and cannot provide unfailing answers, so he sifts Ozu's films for

clues. Yoshida takes a chronological approach, from the early work as a director of silent comedies, to his proficiency with *shomingeki*, family dramas of stressed salarymen, to Ozu's wartime experiences, and then the stately postwar masterpieces. Yoshida outlines many variations and sudden shifts in tone despite apparent uniformity in Ozu's body of work. He discovers and sometimes invents correspondences between emblematic details in the films and Ozu's basic attitudes toward cinema and the world. He offers rhymes, replies, and recurrences, and tends to read Ozu's work as a single piece, a metatext that enfolds individual films into a virtual world that connects, echoes, and corresponds.

"There seemed to be a sacred and secret contract between Ozu-san and cinema,"[12] Yoshida writes. "We could say that Ozu-san's basic principle regarding cinema was that the world is chaotic. He regarded the world as terribly unruly and decided to make films with this presupposition."[13] This seems counterintuitive, even for Ozu's silent films, with their genre formats and occasionally cheeky humor. With respect to the postwar films, like *Late Spring* (*Banshun*, 1949), *Tokyo Story* (*Tokyo monogatari*, 1953), *Early Spring* (*Soshun*, 1956), and *Late Autumn* (*Akibiyori*, 1960), chaos and unruliness are totally opposite to the world of these films. Yoshida must be thinking of a different way of connecting the oeuvre with the artist. Enter the notion of "anticinema," an antithetical relation between film and its object, between work and world. That relation works as follows.

Given its essentially reproductive nature, cinema can be seen as a machine for imitation, repetition, perhaps even superfluity. Like a double, it photographically copies the world in flux. Unlike other art forms, cinema may work as a passive recording device—and this is why it evolved into a sophisticated storytelling medium. All the techniques of film production, sound, montage, narration, performance, marketing, and sales are mobilized to make meaning and give pleasure for commercial gain. Despite its affinity for things in all their mute "thereness," the movie camera usually binds and tyrannizes human perception, holding it hostage to narrative and emotional (and commercial) significance. Ozu's genius, says Yoshida, is the restoration of cinema's essential superfluity, presenting a presignifying world with things that look back at us. In addition, Ozu intended to atone for cinema's effrontery, its brazen appropriation of things to make anthropocentric, largely frivolous entertainment: "Ozu-san's filmmaking style can be seen as an act of penance for the sins of his camera's assault on the world."[14] Sins and penance, Yoshida writes, are images that could well reduce the distance between Ozu's Zen and Schrader's Christian transcendentalism.

Before evaluating these statements, here are more of Yoshida's claims. He calls *Tokyo Story* a film of divine revelation, apocalyptic in its overturning of human priorities in favor of plain objects. If human perception is always carelessly selfish, "looking in order to overlook,"[15] then the gaze of objects is true,

un-interested, and always correct. These "invisible gazes" are properties of manmade objects as well as brute things in nature, and Ozu's gift is to arrange these things, people, and events in a way that makes objective gazes (gazes of objects, gazes of the dead) available and open to viewers. Unlike conventional films built around dramatic stories and emotions, Ozu's anticinema mysteriously invites contemplation of nonnarrative, nonhuman agency, without sacrificing basic expressive means. Yoshida indicates Ozu's inclination to cinema's capacity to restore and open perception, rather than its dictatorial human interest, yoked and organized by commercial enterprise. This may even include narrative itself. In the chapter on *Late Spring*, Yoshida writes,

Paradoxically, Ozu-san's films never try to tell something new and dramatic. Ozu-san simply presented archetypal episodes that everybody already knew. For instance, if the father and the daughter regret or become disappointed that they are too late, it could be dramatic. Nonetheless, they don't because both they and the viewers know it is of no use. In this sense, it is as if Ozu-san's tales were gazing at the viewers, and not vice versa Ozu-san did not believe in the artifice of cinema and doubted the value of such grand narratives. All he could do was present episodes that everybody already knew. He thought that object and episodes had their own gazes. If the viewers recognized the gazes, they cannot help repeating "Really," just as the father in *Late Spring* does.[16]

It is notable that Ozu himself made a similar impression on some young filmmakers, like Shinoda Masahiro, who assisted Ozu on *Tokyo Twilight* (*Tokyo boshoku*, 1957). The master struck Shinoda "like an aloof deity observing the human world, perhaps looking for and finding that higher reality."[17]

Yoshida's approach could be described as phenomenological. He shares with French theorist Andre Bazin intimations of the mutual constitution of subject and object, mediated by embodied perception. Bazin was fascinated by the metaphysical and spiritual possibilities of cinematic representations, though his stake in Japanese film was Mizoguchi Kenji, with his "one scene-one cut" sequence shots. Ozu's montage, with its modular iconography, linked eye-lines, and artificial sets and behaviors, jostles with Bazin's calls for spatio-temporal continuity that models phenomenal perception.

Continuity in Ozu operates between films, not within them, as his films are famous for their violations of screen direction (360- not 180-degree shooting space) and canny placement of props. Actors and actresses were thoroughly recycled and drilled to eliminate human characteristics, reducing them to the level of objects, things, dummies. Yoshida says that Ozu basically prohibited actors from performing: "Viewers do not look at the films, but vice versa."[18] It is as if inner life was proscribed in favor of bright surfaces. "In Ozu-san's low-angle shots, actors are deprived of their freedom to perform. In these shots, the actual bodies of the actors are emphasized more than the roles that they

play. This was another example of Ozu-san's dangerous playfulness. By ignoring the roles of the actors, he might have destroyed the film's narrative."[19] Though Yoshida discusses the late films' aesthetic differences and even calls *Early Spring* Ozu's anti-*Tokyo Story*, Ozu kept repeating and remaking his films with slight variations. Eventually these variations become so minimal that the films seem to connect and form a "labyrinthine circle."[20] In this, Yoshida writes, there is both fear and pleasure. If we return to Ozu's description of himself as tofu maker in light of this intricate, unending circle, it is thus not sameness, but creeping, inevitable difference that sustains a continuing craftsmanship.[21] Absolute consistency, even in the hands of the greatest master, is impossible. For that, we need a machine. But ideas of modesty, simplicity, and respect probably are appropriate in this comparison between the most "Japanese" of directors and a very humble staple made from beans. As for Ozu's Japaneseness, Yoshida simply denies it, saying he was an artist with "no relationship with any conventional Japanese sense of beauty."[22]

Despite the apparent Japaneseness attributed to Ozu, Yoshida just sets it aside. *Ozu's Anti-Cinema* is bracing with of its rhetoric of antithesis, repetition, and allusion. Yoshida does not acknowledge any oddity in the idea that objects, or the dead, can look back at film spectators; he is confident that readers recognize this as a trope. The deep stillness in Ozu's films, felt by most viewers as traditional, resigned, or even reactionary, is presented as radical emptiness. Schrader calls this *mu*. Ozu's traditional associations, after all, were the standard excuse for the postwar rejection of Ozu and Japanese films by a younger generation. Thus the postwar New Wave confirmed a culturalist misunderstanding of Ozu's films, even while rejecting them. They rejected Ozu, but not for the right reasons. With few exceptions, critics in and outside Japan perpetuated this reductionist line, reaching out for Zen, *mu, mono no aware*, and other shibboleths. Yoshida's discussion through anticinema attempts to correct this, but only by reflecting his own personal history with Ozu. He does not come out and say we were wrong: Ozu is neither traditional, nor especially Japanese. But Yoshida does return to a sense of the films' sacredness, somewhat like Paul Schrader's account of Ozu's "transcendental" style. Schrader's aim, though, is to present a transcendental ideal, an Ozuesque that even Ozu-san sometimes failed to achieve. It is fine to present transcendental style as profound and ineffable, but it is even better when those elements allow play, mischief, and pranks. Transcendentalism need not reduce to awesome ritual or sacrament. Rather than "sinners in the hands of an angry God," we might picture a jovial Dalai Lama.

Yoshida's discussion is meandering, and, like the films, it returns obsessively to the same concepts, tropes, and expressions. Perhaps some of this is due to the translation, which lends a rather incantatory air in both diction and grammar. It is very easy to read, but not easy to understand, since many of Yoshida's pronouncements are gnomic, provocative, stripping away the clichés

that cling to Ozu's style and themes. Because of its upsetting of received wisdom, the book will likely prompt readers to return to the films, and try to see what Yoshida believes is there. As a master's sharp stick, Yoshida promotes a fresh, provocative take on Ozu-san's films.

I would submit that *Dragnet Girl*'s playful patterns of framing and cutting are also employed in the more earnest family melodramas in the 1950s and '60s. It is easy to clutch at Zen when watching these late melancholic stories of family dissolution. Yet transcendental style itself consists of the same minute, cut-and-paste patterns. In *Good Morning* (*Ohayo*, 1959), a film about the semiotics of farting, the patterns are obsessively repeated and manipulated across the whole film. The final, thematically resonant shot of washed underwear is a 180-degree reverse angle of the long shot that opened the film more than ninety minutes before! But you may need to be as obsessive as David Bordwell to spot this elaborate "play between unnecessary rigor and outlandish deviation."[23] It is doubtful whether audiences would be able to recognize it with just a single viewing. But one need not be conscious of a perceptual quality to be affected by it; one can subliminally appreciate it. We may not exactly map out the permutations of Ozu's intermediate spaces, hypersituated objects, and other techniques, but they affect us. It does not matter if we cannot articulate their effects, only that they register. As Hasumi says, the otherworldly abstractions that excite Schrader do not produce anything.[24] There should be something left over, some residual detail that proves fruitful: as it is often put, "God is in the details." The point is not to stretch the extensions of Ozu's comedy, or redeem it for Zen, but hold out for a transcendental style that embraces, not disdains, humor.

Admittedly, *Good Morning* is a loose remake of *I Was Born, But* (*Umarete wa mitakeredo*, 1932). However, this is strong evidence for Hasumi's point about the variegated continuity of Ozu's oeuvre, not a troublesome counterexample to Burch's claim that the late work is "petrification in academic rigidity."[25] Of course, the games Ozu plays in the 1950s and '60s are more sedate than before, but they are really the same game—flirtation with "the transcendent." An anticipation and recognition of patterns is the deepest level at which Ozu plays, and he does it in 1932 neither more nor less than in 1962. Bordwell calls this a principle of "ludic narration," turning narration itself into a game with story material—characters, emotions, beer bottles—as pieces to move about like so many poker chips.[26] These chips, seemingly interchangeable, may lose their referential quality and become games of perception for which there are no words, or even concepts; yet they are so scrupulously arranged that they have mathematical precision. This is the real paradox: the rigor of Ozu's piecemeal mosaics must be combined with their whimsicality, even silliness. They are indivisible. Here we come to the ineffable, but not the somber holiness offered by Schrader. Maybe that is his problem; Schrader is the articulate theologian, skilled at putting things into propositions. Ozu's style does not teach us of the transcendental; it invites us to *see*.

CONCLUSION

Recall the historical situation of Paul Schrader's account: the American coun-terculture, romanticizing Eastern religion, and relatively recent discovery of Ozu's films. Within the decade, a new Golden Age of Japanese cinema would be proposed based on the prewar work of Ozu, Naruse Mikio, Yamanaka Sadao, Shimizu Hiroshi, Gosho Heinosuke, and others. This does not invali-date Schrader's claims, but only "emplots" them in a specific context that was bound to change, subject to revision by new texts, methods, and assumptions. When putting transcendental style into dialogue with Hasumi, Yoshida, Burch, Bordwell, and others, we effect a kind of ventriloquism that voices historically separate writers. This is acceptable so long as we maintain perspective and try not to force proximity that seems unnatural. Ozu himself seemed baffled by Zen Buddhist hermeneutics, though his tombstone in Kitakamakura is inscribed with *mu*, the character for emptiness. It is possible that, while he was alive, Ozu dismissed religious interpretations of his work, but consented to Buddhist funerary as a Japanese layman. Given his resistance to critics' deployment of Zen to explain his style, this is curious, though Buddhist funer-als are the default practice for most Japanese families.

In an appealing speech given in 2005 at Doshisha University in Kyoto, Donald Richie covers some of the bases in "Buddhism and the Film."

Cinema . . . is famous for destroying the sense of self. Indeed, the reason we go to the movies is to be relieved for a time of this troubling companion. We habitually seek for situations where our difficult self (a homemade and ill fitting invention) is sloughed off—drink, drugs, sex, gambling. All of these are unifying activities which elude our ideas of who we are and instead allow us to experience a cohesion we might never oth-erwise encounter.

Film famously accomplishes something like this. It has been variously called a wak-ing dream, a mass illusion, pop propaganda, but no one has ever denied that it takes one out of oneself. This then is a promising beginning in any consideration of the Buddhist claims of cinema because this absence of self is precisely the condition which Buddhism counsels. From here, then, taking this theme as the ground, sounding its drone beneath our speculations, we may begin to enumerate a few qualities.[27]

Ozu liked to drink, especially when composing scripts with his writing part-ner. But the other vices he kept at bay; he had little use for these "unifying activities" that provide an illusory sense of cohesion. He had cinema, one that allowed proximity to transcendental elements. I imagine Ozu-san as a jovial priest of cinema, but quite unaware of his sacramental role. He may have had inklings of his reputation for the ineffable, but he felt it meet to keep them under wraps.

NOTES

1. Paul Schrader, *Transcendental Style: A Primer* for program of six double features at Pacific Film Archive, Berkeley, CA, April 1972. He begins his notes with two premises: "1) there are spontaneous expressions of the Holy or transcendent in every culture . . . (M. Eliade) and 2) there are universal artistic forms and style common to all cultures . . . (H. Wölfflin)."
2. Paul Schrader, *Transcendental Style in Film: Ozu, Bresson, Dreyer* (Berkeley: University of California Press, 1972; repr., New York: A Da Capo Paperback, 1988).
3. Schrader, *Transcendental Style*, 25.
4. Hasumi Shigehiko, *Kantoku Ozu Yasujiro* [Director Ozu Yasujiro] (Tokyo: Chikuma Shobo, 1983).
5. Hasumi, *Kantoku Ozu Yasujiro*, 15.
6. Donald Richie, *Ozu Yasujiro: His Life and Films* (Berkeley: University of California Press, 1977), 256.
7. Hasumi, *Kantoku Ozu Yasujiro*, 21.
8. David Bordwell, *Ozu and the Poetics of Cinema* (Princeton, NJ: Princeton University Press, 1988), 67.
9. Schrader, *Transcendental Style*, 46.
10. Yoshida Kiju, *Ozu's Anti-Cinema*, trans. Daisuke Miyao and Kyoko Hirano (Ann Arbor: University of Michigan Press, 2003), 2.
11. Ibid., 1–2.
12. Ibid., 45.
13. Ibid.
14. Ibid., 24.
15. Ibid, 90.
16. Ibid.
17. Donald Richie, *A Hundred Years of Japanese Film* (New York: Kodansha International, 2001), 204.
18. Yoshida, *Ozu's Anti-Cinema*, 150.
19. Ibid., 72.
20. Ibid., 128.
21. Ibid., 25.
22. Ibid., 21.
23. Bordwell, *Ozu*, 354.
24. Hasumi, *Kantoku Ozu Yasujiro*, 16.
25. Ibid., 157.
26. Bordwell, *Ozu*, 66.
27. Donald Richie, "Buddhism and the Film," *Kyoto Journal*, accessed July 27, 2014. http://www.kyotojournal.org/multimedia/buddhism-and-the-film/.

CHAPTER 3
Ozu to Asia via Hasumi

AARON GEROW

When considering the global influence of the Japanese film director Ozu Yasujiro, we have to ask first which or what "Ozu" we are talking about. This is not a question of reaffirming the real Ozu and confirming how those authentic traits transcend national boundaries and influence other directors in Asia or Europe. Rather, it is an issue of the role of discursive definitions of "Ozu" in the establishment of a transnational Ozu. This is partly a problem of gatekeeping, of the role of critics and scholars such as Donald Richie, Paul Schrader, and David Bordwell in creating versions of Ozu that, usually for reasons having as much to do with the conditions of reception as with the "original" Ozu, prove influential.[1] One would have to do this analysis with regard to Hasumi Shigehiko, the former president of Tokyo University and Japan's most dominant film critic since the 1980s. His *Director Ozu Yasujiro (Kantoku Ozu Yasujiro)*, first published in 1983, is arguably the most influential book on Ozu in Japan in recent decades. His "Ozu" has reigned in Japan, serving as the foundation not only for other critical appreciations of Ozu but also, for instance, Suo Masayuki's interpretation of Ozu in his "Ozu-does-softcore-porn" film *Abnormal Family: Older Brother's Wife (Hentai kazoku: Aniki no yome-san*, 1984).[2] His book has also appeared in French,[3] and portions have been translated into English.[4]

There are two potential problems with considering Hasumi's role in a transnational Ozu, however, especially with regard to Asia. The first is that it may still be too early to argue about Hasumi's influence on other Asian views of Ozu. A Korean translation of *Director Ozu Yasujiro* was published in 2001, but a Chinese one only came out in 2012. Research on such influence would be productive, but I would like to skirt this first problem by turning

the mirror around and considering how Hasumi has helped create a transnational "Ozu" within Japan: that is, how his views have been reflected in the conception within Japan of Ozu crossing borders. As one way of doing this, I would like to consider another director whom Hasumi was central in promoting in Japan: the Taiwanese filmmaker Hou Hsiao-hsien.[5] Hou, for better or for worse, has often been linked with Ozu, and in 2003 he directed a film, *Café Lumière*, sponsored by Ozu's studio, Shochiku, in celebration of the director's centennial.[6] Hasumi is not only credited in the film, but also has a cameo appearance. I would like to sketch a triangulation in which an Asian director becomes prominent in Japan via a critic looking at him through eyes fashioned in relation to Ozu. Ozu then crosses into Taiwan precisely through this discourse.

The second problem in considering Hasumi is his potential objections to the project of tracing Ozu's influence in Asia through Hou. Not only has he on several occasions strongly disagreed with attempts to call Hou "Ozuesque" (*Ozu-teki*),[7] but *Director Ozu Yasujiro* actually begins with an argument against the very project of determining what "Ozuesque" is. How can we sketch this triangulation when the pivot point, Hasumi, denies the relationship between the two other points and, what is more, rejects the method of identifying film through generalized properties (the "Ozuesque") that are usually used to claim the similarities that cross boundaries between films, filmmakers, and national cinemas? This is not an insurmountable problem, but it means our discussion will not just be about the relationships between Ozu and Hou that Hasumi enables, but also about the historical context—particularly the theoretical and discursive context—that constitute the imagination of a border-crossing Ozu in the 1980s and 1990s in Japan.

OZU VIA HASUMI

Publishing his first works on film in the late 1960s, Hasumi Shigehiko came to prominence as an alternative to existing modes of film criticism in Japan. While the 1960s was a period of experimentation in film writing as well as film making, the two dominant modes continued to be either a form of impressionist criticism, in which the film critic's educated sensibility served as the model for receiving a work (for example, Iijima Tadashi or Kitagawa Fuyuhiko), or various sorts of political critique, ranging from the Old Left Marxist writings of Iwasaki Akira and Yamada Kazuo, to the New Left critiques of Matsuda Masao and Saito Ryuho. One of the more prolific critics, Tadao Sato, could evince a mixture of the two, backing his impressions with broad sociological and cultural claims.[8] Hasumi, however, along with critics like Yamane Sadao and Ueno Koshi who were writing first in magazines like *Cinema 69* (*Shinema 69*), criticized the tendency to reduce film to either sociopolitical factors or an

unquestioned critical subject. They called for viewing film as film, not as politics or personal sensibility.[9] Phil Kaffen locates their criticism in a long line of what he calls image romanticism, which valorized the image as an occasion undermining meaning and narrative, but he singles out Hasumi for his more critical stance toward ideological operations that attempted to impose such meaning on cinema.[10]

Hasumi's *Director Ozu Yasujiro* is a milestone in this critical shift. Hasumi begins the book by challenging our sense that we know what Ozu is like. His point is not just to question our conventional wisdom or established scholarship, but to test our very approach to cinema.

The reason everyone knows Ozu—is certain they can live in an "Ozuesque" situation as if it were a game without any danger—is because no one is looking at Ozu Yasujiro's films. The "Ozuesque" is nothing but a game unrelated to cinema that is only possible after our eyes kill the image on screen. The moment people really look at Ozu Yasujiro's films, that is the moment they can no longer possibly enjoy the Ozuesque game. That is because no matter which Ozu film you consider, it in no way resembles the "Ozuesque."[11]

There is a touch of Russian Formalism here: the sense that our perception of Ozu, if not of cinema and the world, has become inured to reality, finding safety in conventional representations, and must be overturned by a reappreciation of the image on screen as it is. It is immensely difficult, Hasumi argues, to look freely, to notice the "infinitely open meanings" in a film. Most people not only "try to read a narrowly restricted set of meanings,"[12] but also "prefer to unite themselves with a narrative that is not there now, instead of receiving the ceaselessly renewed present exposed there."[13] Hasumi is reacting to the existing critical interpretations of Ozu at the time. The texts he cites in the beginning range from Donald Richie and Paul Schrader, who viewed Ozu through the lens of traditional Japanese aesthetics and religion, to Kristin Thompson and David Bordwell, whose first writings on Ozu considered him a modernist.[14] Following Roland Barthes, Hasumi calls these narratives "myths" and specifically criticizes all those who easily slide from the "Ozuesque" into myths of "Japaneseness," and find in his work the cinematic equivalents of Japanese *haiku* poetry, the pathos of things (*mono no aware*), or a profound, mysterious grace or beauty (*yugen*).[15] Hasumi's way of looking at Ozu is ideally a form of de-mythologizing, a resistance to dominant, often national meanings, one that makes us see anew.

Being one of the primary figures who introduced French poststructuralist thought to Japan, Hasumi is engaging in a radical, though still problematic epistemology of cinema. Consider his critique of interpretations of the famous vase shot in Ozu's *Late Spring* (*Banshun*, 1949) (fig. 3.1) offered by Schrader and Richie.[16]

Figure 3.1.
The "vase shot" in *Late Spring* (*Banshun*, Ozu Yasujiro, 1949).

The problem for Hasumi is not whether they read the vase accurately or not, but first their act of calling it a shot of a vase. There are a lot of other things visible in that shot: the *shoji* screen, the shadows on that screen, and so forth. "Calling it a vase shot when such a thing is impossible in cinema, and then having to make it an issue of cultural symbolism through calling it that, must be understood first and foremost as occurring because thought has, even before looking, called the fiction of convention [*monkirigata*] into action."[17] In calling for the elimination of such conventions, however, Hasumi is essentially asking us to watch Ozu without engaging "thought" first, without using linguistic generalizations such as "vase" to interpret or understand the image before really looking at it. As part of his rejection of categorization, Hasumi disavows the very notion of film style, which is "nothing other than a reduction [of cinema] to a motionless schema that is practically abstract,"[18] turning Ozu, in this case, into an "antique."[19] If style, to him, kills the (e)motion of cinema as an inherently tense, hybrid, and polyvalent experience, Hasumi aims for an approach to cinema that keeps that experience alive:

In order to free Ozu Yasujiro from the tacit arrangement of being "Ozuesque," we must continue looking at his films. We must slide from one image to the next, without privileging one even by mistake. The instant that interpretation starts, people will no longer be able to cease disposing of their eyes. We must place our bodies on the focal

point of these images mutually reflecting each other, and there experience the vanishing of our selves. "Nothingness" is not something depicted in a single film; it is the experience of being able to live within looking. Needless to say, that is a pleasure that borders on cruelty.[20]

This has tones of Barthesian *jouissance*, as Hasumi often describes his own experience of viewing in bodily terms, of relating to the film less intellectually than immediately and nonlinguistically through a body that seemingly must shake from tension and pleasure. The experience here is more visual than in Barthes, however, for Hasumi often offers a cinephilic celebration of cinema's unique capacity to evoke this pure present moment, when the self and intellect edge toward nothingness.

Earlier writings had laid the foundation for this approach. The 1980 piece "Cinema as a System," for instance, intervened in the currently politically charged film criticism of the day, which advocated for films that worked toward liberation from the system (of postwar Japan, for instance) by arguing that even the critique of systemicity (*seidosei*), or the placing of one system (radical politics) above another (classical Hollywood film), was itself a system: a division between what is possible and what is impossible. Such a system, however, or thought-as-system, often works by denying its own systemicity, by creating the illusion that liberation from systems is not impossible.[21] As Ryan Cook explains Hasumi's thinking,

Thought both determines and is determined by systems of its own, and is thus in the absurd position of being able to say nothing about systems that is not systemic. However, rather than confronting this absurdity, systemic thought attempts to forget it Far from seeing the world more clearly through films, the subject it seems does not even have the capability of seeing a film itself, since the moving image disappears into the systemicity of thought as it comes into being. What the fictional subject sees is the fiction of a film.[22]

Hasumi's solution is precisely for thought to confront this absurdity by in effect realizing its own "stupidity": "in acknowledging this impairment, and indeed in making disability the general condition of film experience, Hasumi finds a perverse strategy for actually empowering the eye against systemicity: to see in cinema nothing but impossibilities is to turn systems against themselves and to bring cinematic absurdity to the fore."[23]

This was the possible role of film criticism, but one based on a tragic impossibility. To Hasumi, "words should, before anything else, not take the existence of cinema as a given, but must be released toward the path where cinema might exist, and at the moment they manage to illuminate to a certain degree the shell of that point, they must be prepared for their own death."[24] This was not simply because cinema, as a visual medium, cannot be expressed

in language, but more pointedly, because cinema only subsists in the ever-changing (revolutionary) present, as a singular "incident/event" (*jiken*) that cannot be repeated, one that even exists before the categories of subject and object. The strategy of Hasumi's "surface criticism" (*hyoso hihyo*) is then, in Cook's words, "to surrender to the text"[25]—to make criticism itself "an experience that can only live as an incident."[26] This was part of the reasoning behind Hasumi's radical use of the Deleuzian concept of "stupidity," which "abandons subjectivity and knowledge and submits to cruel stupidity in order to encounter cinema as change and movement."[27] Hasumi conceived of criticism as a form of film viewing, a special one distinct from both regular film viewing and most forms of film criticism, both of which relied on narrative. Narrative, however, could not be totally avoided. The best one can do, to Hasumi, is perpetually battle that "movement of thought" that "robs the quality of transformation from 'culture,' eliminates incident, and expels movement, all the while ultimately building a flat horizon without those moments that expose the present. In other words, it installs before thought a universal and abstract space that will never disturb 'knowledge.'"[28]

Ozu takes up a privileged place in Hasumi's conception of cinema because his films are themselves, in Cook's words, a form of seeing "in cinema nothing but impossibilities" and thus of turning "systems against themselves and to bring cinematic absurdity to the fore."[29] They are, like true film criticism, a means of making apparent cinema as an incident, of bringing us into approximation with cinema "as change and movement." As such, however, it is just as impossible to write about Ozu for Hasumi as it is to write about cinema, to use narratives to describe Ozu even when his films are the pure present of incident. Perhaps emulating Derrida's notion that "there is nothing outside the text,"[30] Hasumi acknowledges he is working within the realm of the "Ozuesque," of linguistic representations of Ozu, while still trying to illuminate this wordless experience. His strategy is to "as best I can place myself in the gaps" between representations[31] and to evoke how Ozu suggests what cinema is.

The problem is not to confirm among ourselves Ozu's relative greatness from a film historical perspective. What is important is to vividly feel out, on the site of the "film experience," what film can be and what it simultaneously cannot be while directing our gaze at the light and shadow that metamorphoses on the surface of the film.[32]

This may appear to be the classical project of film theory—to determine what film is—but Hasumi focuses on cinema to the degree that it cannot be determined by theory. What interests him about Ozu is not that he serves as an example of what cinema is. Rather, to Hasumi, specifically arguing against Bordwell, Ozu problematizes film's existence:

We find Ozu stimulating not because he deviates from the cinematic code of some systems in a particular age. It is, more than that, because his works are filmed such that they expose the very limits of cinema as a form of expression. It is by constantly confronting the impossibilities of cinema itself that Ozu is "modern" and "radical." The productivity of the "sign" can be nothing other than the situation in which cinema, as its condition for living, continues existing in the moment when it ceases to be cinema.[33]

An example of Ozu revealing the limits of cinema is his peculiar eye-line matches. While Bordwell focuses on how Ozu's 360-degree space deviates from the Hollywood norm (Ozu defined negatively—by what he is not), Hasumi promotes Ozu as exposing what cinema is (Ozu defined positively). To Hasumi, it is impossible to show two people really looking at each other in cinema: doing it in one shot can only present them from the side, where it is hard to confirm where their eyes are looking; cutting back and forth only creates an illusion they are looking, one that hides the real impossibility of showing their gazes. "Cinema clings to this systemic technique of 'matching eyelines,' as though by preventing eyelines from unnaturally failing to meet it could make vanish the utter powerlessness of the camera in relation to the mutual gaze."[34] Ozu's peculiar eye-lines refuse to enforce the illusion of looking; he, by choosing to edit instead of only showing two people looking in one shot, does not simply follow what is allowed in film, but consciously foregrounds the problem. "The greatness of Ozu Yasujiro as a director," writes Hasumi, "lies in having exposed the systemicity of the technique of eyeline matching through his peculiar [kimyo] theater of gazes."[35] Treading the line between what is possible and what is impossible, Ozu's cinema to Hasumi is far more alive than those works that remain unconscious of or conceal film's limits.

This again may seem like a formalist conception of Ozu, but Hasumi specifically rejects that interpretation by attempting to ground the "nothingness" of his cinema in the "themes" (shudai) concretely visible in the text. Hasumi's "thematism," which owes a debt to the critique thématique of French literary studies, is in part a response to the negativity he sees in formalism: the tendency to see Ozu as what the norm is not, or as not using many common formal devices (such as camera movement, high angles, etc.). He recognizes that Ozu is, like any filmmaker, bound by narrative and its temporal and structural restrictions. On the narrative level, then, Ozu may be a director who is formally restrained or who restrains himself. But to Hasumi, any image has multiple meanings, not all of which are recuperated into narrative.

Cinema possesses another system that resists such linearity. That is the field of exaggeration and deviation, where an excessive detail that attracts the viewer's eye surpasses

the succession of images, even transcending the limits of the text, and resonates with another detail through some trifling resemblance. I call visual details that can resonate in this way "themes."[36]

Hasumi's thematic mode of analyzing Ozu concentrates on such themes as eating, changing clothes, or looking, but these are not narrative motifs because they focus on "unnatural" (*fushizen*) details (such as two people eating facing a wall, or young people in a line walking in step facing the same direction) that are narratively insignificant and may not even belong to an Ozu film. Hasumi's focus is in fact on "fragments" (*danpen*) that exceed or are wrested from the narrative chain, ones that freely play with other fragments, transcending time and space, but remaining within the realm of cinema. This play is a concrete and pleasurable cinematic practice that, to Hasumi, is alien to the negative dynamics of formalism (or of Saussurean semiotics, one might add). "It is the thematic system that is the place," Hasumi argues, "not just for Ozu, but for all filmmakers to fully free their creativity."[37] It is also the source for the real pleasure of watching Ozu's cinema. Ideally, it is not an intellectual pleasure because this place is also "freed of the control of intellectual reflection."[38] Far from denying the emotional power of Ozu, Hasumi focuses on an experience that is somatic and emotional, one that ultimately comes not from narrative, character psychology, or even formal strategies, but from the unique cinematic manipulation of these themes.

One can argue that this is the center of Hasumi's 1980s postmodern politics, one that envisions liberation not just from narrative, language, categorization, and intellectualism, but also from history, society, politics, time, even space—all those systems external to cinema that threaten to impose limits on this free play of meaning.[39] Hasumi acknowledges our ability to read Ozu's films through their historical or social background, but he ultimately downplays such explanations as inadequate: they just get in the way of the free interplay of themes. Cinema is what is here, now, relating at best only to a past cinematic moment, but in such a way that time—and all that is not there, such as history—is irrelevant.[40] But such a cinema is an "impossibility," so Hasumi constantly reminds us that cinema is cruel (*zankoku*), and thus that Ozu, for all his freedom, is always also restricted by and the victim (*giseisha*) of narrative, external categories, and critics who are not looking.

What is positive, if not also unique, about Ozu to Hasumi is his effect of making all this apparent. If what is special about Ozu is the "imbalance between narrative structure and the thematic system"[41]—between a narrative form marked by restraint and abstinence, and a supremely rich thematics— that then creates a world where thematic structures are not only foregrounded, but where "the excessive details enliven narrative continuity through their deviation from narrative structure, becoming the occasion for transformations that articulate narrative."[42] In other words, just as Ozu's themes can vibrantly

bridge gaps across the narrative or across films, so the themes can enliven the gap between thematic and narrative systems, affect the narrative, and create a vibrant cinematic experience. Hasumi elaborates on this motif of bridging gaps and sees in many aspects of Ozu the "co-existence" (*kyozon*) of different things,[43] the overcoming of binaries, the "extinction" (*shometsu*) of oppositions, and the "movement toward unification" (*yugo*).[44] This is not the transcendental style of Paul Schrader; rather, Hasumi, in an almost utopian fashion, sees in Ozu, as well as in cinema itself, the ability to transcend difference based on language and categorical thought.

HOU VIA HASUMI

Hasumi's declaration that Hou is not "Ozuesque," it should now be clear, is not an attempt to block all efforts to relate the two. As we have seen, given Hasumi's rejection of generalizations and narratives about cinema, even Ozu is like Hou in not being "Ozuesque." Moreover, Hasumi's explanation that Ozu's works are "films of editing" (*henshu no eiga*) whereas Hou's are "films of the scene" (*gamen no eiga*)[45] seems designed more to damn those critics who still use simplistic categories instead of looking at the film, than to truly argue their stylistic differences (remember that Hasumi objects to the concept of style).[46] His very concept of "theme," if not of "cinema," allows him to bridge such gaps. In fact, while he never cites any themes shared by Ozu and Hou (his focus with Hou is on trains or lamps[47]), the cinema he sees in Hou is essentially the same as the one he sees in Ozu. Not only does he praise Hou for refusing to do what "mediocre filmmakers" do and try to show two people looking at each other through alternating close-ups,[48] he also sees Hou bridging similar impossible gaps—"Hou Hsiao-hsien is a master of capturing and showing the invisible in film"—and presenting Tokyo in *Café Lumière*, for example, as the same kind of "place of co-existence" he finds in Ozu.[49] His description of the almost physical experience of seeing *Café Lumière* is also classic Hasumi: "Since each shot settles on the kind of cruelty that seems to declare that this film has never existed before and will never exist again, viewers can only face the screen knowing, at each instant, that their heart is being crushed."[50]

Regardless of whether stylistic or even thematic similarities exist between Ozu and Hou, Hasumi clearly sees both as engaging in cinema. His way of looking at them even celebrates the freedom, the cinematic ecstasy of connecting such filmmakers, despite their different national and cultural backgrounds. Just as themes cross the borders of time and space, Hasumi's film study can celebrate the cinematic crossing of national boundaries, in part so as to critique national and cultural explanations for their reductive categorizations. Hasumi's Ozu and Hou are thus always already transnational at the

moment they truly engage in cinema. The cost of this rejection of national cinema with Hou, as it was with Ozu, however, is the loss of history and politics. Frankly, Hasumi shows little interest in the political or historical dimensions of Hou's work. While Hasumi does not reify "Taiwan" or "Asia" in his discussion of Hou, his potential reification of "cinema" allows him to imagine a "movement toward unification" between film and viewer that does not have a place for the local, other than as fragments of film. The viewer's heart may be crushed by cinema, but the critic is privileged to have the power to disassemble films from Asia and enjoy playing with them in a way "freed of the control of intellectual reflection."

That may resist the oppression of meaning by politics, but the question is what kind of critic is being constructed. For instance, consider how Hasumi critiqued existing accounts of Ozu at the beginning of *Director Ozu Yasujiro*. The first chapter initially problematized the tendency to delineate what is "Ozuesque" through negation, through conceiving him as a director who does not use certain techniques (camera movement, high angles, etc.)—who essentially imposed limits on his films compared to the relative plenitude of cinematic possibility. Hasumi's conception of Ozu instead positively acknowledges that cinema itself is limited. Yet in this chapter, Hasumi curiously omits the Japanese accounts of the era, particularly that of Tadao Sato, who had published his two-volume work on Ozu several years before.[51] Sato himself engaged in defining the Ozuesque or the peculiar style of Ozu through negation and cultural generalization, arguing, for instance, that Ozu's famous low-camera position, lack of camera movement, geometrical compositions, and tendency to have the characters face the camera, effectively made the camera the guest to the characters as hosts, or vice versa. This explained, to Sato, how the characters always seem conscious of the eyes of others and act politely and stiffly, epitomizing Japanese culture's emphasis on shame and the opinion of others. Thus, "Ozu's pictures represent the Japanese sensibility in the most genuine style of all Japanese films."[52]

Hasumi does criticize Sato's interpretations twice later in the book, specifically his cultural reading of a scene in *A Hen in the Wind* (*Kaze no naka no mendori*, 1948) and his tendency to define Ozu as lacking camera movement even when given a scene with such movement.[53] These instances allow Hasumi to re-emphasize how cinematic operations can be overlooked in methodologies that stress meaning outside the text or the static definitions of style. He might have refrained from criticizing Sato out of deference for a senior colleague, but keeping these relatively few mentions of a fellow Japanese critic out of the crucial first chapter, thus in effect rendering the issue of "negation" an issue of the foreign—making foreign critics those who negate and, within Hasumi's critique, those who will be negated—essentially adds disturbing national tones to approaches to Ozu. His intention may have been to critique the Orientalist tendency to typify the Other, but the effect is to project the problem of blindness

to cinema on the Other. This construction of the subjectivity of the Japanese critic is exacerbated by Hasumi's rhetoric: his constant delineation in his writings of what viewers must necessarily experience when seeing such and such a scene (as if that experience is unified and natural—see the above quote about *Café Lumière*), one reinforced by his repeated use of the pronoun "we" (*ware-ware*). That only reinforces a natural viewing subject(s) defined by the Japanese language and conceals him and his readers from a self-critique of their own politics. Ozu and Hou then may be joined on the transnational level of the cinematic, but a level to which perhaps only the Japanese critic has access.

CONCLUSION

There is little doubt that Hasumi was the most influential and important viewer of film and of Ozu in Japan in the 1980s and 1990s, but certainly more research is needed to determine how much his way of seeing Hou through Ozu shaped the views of other critics and viewers. Scholars such as Yomota Inuhiko, a former student of Hasumi's who has written much on Asian cinema, have strongly criticized Hasumi and his followers for promoting an inward-looking cinema of quotation or for pursuing a "closed, decadent" film criticism out of date with the rise of other Asian film nations.[54] It would be tempting to historicize Hasumi's work in relation both to Japanese postmodern, bubble culture, and to the rise of Asia in Japan as a consumer object from that period, where his transnational consumption of cinema paralleled consumerist appropriations of Asia.[55] Subsequent accounts of Ozu in Japan, such as those offered by Tanaka Masasumi, have in fact been more historical than theoretical.[56]

Yet in the history of post-1980s criticism, one could also note transformations in Hasumi's approach to Ozu and cinema. Nakamura Hideyuki has outlined the changes Hasumi made in the revised edition of *Director Ozu Yasujiro* that came out in 2003, which appears to be more amenable to the concepts of negation, style, and depth (particularly psychological depth) beyond the surface. If Nakamura is right and these changes can be partially attributed to the publication of the Japanese translation of Bordwell's *Ozu and the Poetics of Cinema* in 1992, then perhaps other eyes on Ozu—or another structuring of cinematic eye-lines—have altered Hasumi's own gaze.[57]

Hasumi, however, might object to such efforts to categorize or define or historicize him, so perhaps we should borrow a page from his own book and not bring in such external categories. Staying within Ozu (and perhaps Hou as well), we must still ask about the status of Hasumi's own eye-lines, about whether his cutting between Ozu and Hou, Japan and Taiwan, is as self-critical about the possibilities and impossibilities of that visual system as Ozu's is. We, of course, should ask the same question of ourselves.

NOTES

1. See Paul Schrader, *Transcendental Style in Film: Ozu, Bresson, Dreyer* (Berkeley: University of California Press, 1972); Donald Richie, *Ozu* (Berkeley: University of California Press, 1974); and David Bordwell, *Ozu and the Poetics of Cinema* (Princeton, NJ: Princeton University Press, 1988).

2. Suo, the director of such hit films as *Shall We Dance?* (*Sharu wi dansu?*, 1996) was a student of Hasumi's at Rikkyo University, where Hasumi taught film course for many years as an adjunct professor.

3. Shiguéhiko Hasumi, *Yasujirô Ozu*, trans. Nakamura Ryoji, René de Ceccatty, and Hasumi Shigehiko (Paris: Éditions de l'Étoile, Cahiers du Cinéma, 1998).

4. Shigehiko Hasumi, "Sunny Skies," in *Ozu's Tokyo Story*, ed. David Desser (Cambridge: Cambridge University Press, 1997), 118–129.

5. Hasumi wrote his first article about Hou's work in 1987, before any of his films had been released in Japan.

6. Hou has had a long-lasting relationship with Japan. Not only did he use Japanese actors and Japanese locations even before *Café Lumière*, but some of the postproduction work on certain of his films was done in Japan, and Shochiku invested in several of his films from *Good Men, Good Women* (1995) on. He has also shot TV commercials in Japan.

7. See, for instance, his interview with Hou: "Eiga no gamen wa, kekkyoku, chokkan de kimaru to omou" [I think the cinematic image is in the end determined by intuition], in Hasumi Shigehiko, *Hikari o megutte* [About light] (Tokyo: Chikuma shobo, 1991), 276; or Hasumi Shigehiko, "Gankona junansa koso ga, eiga ni okeru kessaku no joken de aru" [A stubborn flexibility is the condition for a masterpiece in cinema], in *Eiga ni me ga kurande* [Dazzled by the cinema] (Tokyo: Chuo koronsha, 1991), 526.

8. Not much of the writings of postwar Japanese film critics has been translated into English. Tadao Sato's work is one exception, with two books translated in addition to a number of articles. See Tadao Sato, *Currents in Japanese Cinema*, trans. Gregory Barrett (Tokyo: Kodansha International, 1982) and Tadao Sato, *Kenji Mizuguchi and the Art of Japanese Cinema*, trans. Brij Tankha (Oxford: Berg, 2008).

9. For more on this history, see Aaron Gerow, "Critical Receptions: Historical Conceptions of Japanese Film Criticism," in *Oxford Handbook of Japanese Cinema*, ed. Daisuke Miyao (Cambridge: Oxford University Press, 2014), 61–78.

10. Philip James Kaffen, "Image Romanticism and the Responsibility of Cinema: The Indexical Imagination in Japanese Film" (PhD diss., New York University, 2011), 309–322.

11. Hasumi Shigehiko, *Kantoku Ozu Yasujiro* [Director Ozu Yasujiro], paperback edition (Tokyo: Chikuma shobo, 1992), 11.

12. Ibid., 241.

13. Ibid., 240.

14. See Schrader, *Transcendental Style in Film*: Richie, *Ozu*; and Kristin Thompson and David Bordwell, "Space and Narrative in the Films of Ozu," *Screen* 17, no. 2 (1976): 41–73.

15. See Hasumi, *Kantoku Ozu Yasujiro*, 11, 21–30.

16. For more on the English-language discourse on this shot, see Markus Nornes, "The Riddle of the Vase: Ozu Yasujiro's *Late Spring* (1949)," in *Japanese Cinema: Texts and Contexts*, ed. Alastair Phillips and Julian Stringer (New York: Routledge, 2007), 78–89.

17. Hasumi, *Kantoku Ozu Yasujiro*, 242.
18. Ibid., 24.
19. Ibid., 27.
20. Ibid., 258. The reference to "nothingness" is less a citation of Zen than of the character "mu" written on Ozu's grave. Ozu's grave is located in Engakuji, a Rinzai Zen temple in Kitakamakura, but Hasumi, refusing such biographical explanations of film, avoids using that to argue Ozu intended Zen meanings in his films.
21. Hasumi Shigehiko, "Seido toshite no eiga" [Cinema as a system], in *Eiga: Yuwaku no ekurichuru* [Cinema: The ecriture of temptation] (Tokyo: Chikuma shobo, 1990), 340–352. Originally published in Asanuma Keiji et al., eds., *Shin eiga jiten* [New film dictionary] (Tokyo: Bijutsu Shuppansha, 1980).
22. Ryan Cook, "An Impaired Eye: Hasumi Shigehiko on Cinema as Stupidity," *Review of Japanese Culture and Society* 22 (December 2010): 135–136.
23. Cook, "An Impaired Eye," 136.
24. Hasumi Shigehiko, *Eiga no shinwagaku* [The mythology of cinema] (Tokyo: Chikuma shobo, 1996), 51.
25. Cook, "An Impaired Eye," 141.
26. Hasumi Shigehiko, "Eiga to hihyo" [Cinema and criticism], in *Eiga: Yuwaku no ekurichuru*, 353. Originally published in Asanuma Keiji et al., eds., *Shin eiga jiten* [New film dictionary] (Tokyo: Bijutsu Shuppansha, 1980).
27. Cook, "An Impaired Eye," 137.
28. Hasumi, "Eiga to hihyo," 358.
29. Cook, "An Impaired Eye," 137.
30. Jacques Derrida, *Of Grammatology*, trans. Gayatri Chakravorty Spivak (Baltimore: Johns Hopkins University Press, 1976), 158.
31. Hasumi, *Kantoku Ozu Yasujiro*, 12.
32. Ibid., 19.
33. Ibid., 30. Hasumi is both arguing against Bordwell's formalist method of comparing Ozu to the dominant code, as well as rewriting what Bordwell had in mind when calling him a "modernist."
34. Hasumi, *Eiga: Yuwaku no ekurichuru*, 346. Here I am using Cook's translation: Cook, "An Impaired Eye," 133.
35. Hasumi, *Eiga: Yuwaku no ekurichuru*, 346.
36. Hasumi, *Kantoku Ozu Yasujiro*, 138.
37. Ibid. While often contrasting the thematic system from narrative continuity, with the latter often suppressing the former, Hasumi nonetheless eventually argues that the thematic system is what gives life to narrative: see ibid., 140–141.
38. Hasumi, *Kantoku Ozu Yasujiro*, 138.
39. The philosopher Nibuya Takashi sees Hasumi representing criticism in the 1980s, turning the scarcity of words into talkativeness by rejecting the age of change (the 1960s and 1970s)—in which the eventual inability to change society led to the inability to talk—and accepting the age of repetition (the 1980s). Hasumi's surface criticism, to Nibuya, is the "mimicry of perverse repetition." See Nibuya Takashi, *Tenno to tosaku: Gendai bungaku to kyodotai* [The Emperor and perversion: Modern literature and the collective] (Tokyo: Seidosha, 1999), 241–258.
40. Memory is still crucial, but it must be "cinematic memory": Hasumi, *Kantoku Ozu Yasujiro*, 56.
41. Ibid., 144.
42. Ibid., 145.
43. Ibid., 34.

44. Ibid., 40.

45. Hasumi, "Gankona junansa," 526.

46. We should not forget that the majority of Hasumi's students who have gone on to become filmmakers, such as Kurosawa Kiyoshi, Aoyama Shinji, and Shinozaki Makoto, have often shared his distrust of editing by using a long-shot, long-take style like Hou does. In the Japanese context, this reflects less the influence of Mizoguchi than of Ozu via Hasumi. For more on this style, see Aaron Gerow, *Kitano Takeshi* (London: BFI, 2007); and Aaron Gerow, "Aoyama Shinji," in *Fifty Contemporary Film Directors*, ed. Yvonne Tasker (London: Routledge, 2011), 27–38.

47. Hasumi Shigehiko, "Who Can Put Out the Flame?: On Hou Hsiao-Hsien's *Flowers of Shanghai*," in *Hou Hsiao-Hsien*, ed. Richard I. Suchenski (Vienna: Österrreichisches Filmmuseum, 2014), 106–117.

48. Hasumi, "Gankona junansa," 524.

49. Hasumi Shigehiko, "Hitomi ni wa mienai nanika ga eiga ni minagitte iru" [There is something abundant in cinema that the eyes cannot see], in *Eiga hokai zen'ya* [The eve before cinema's collapse] (Tokyo: Seidosha, 2008), 235, 238.

50. Hasumi Shigehiko, "Kamokuna imaju no yubensa ni tsuite: Hou Hsiao-Hsien shiron" [On the eloquence of taciturn images: An essay on Hou Hsiao-Hsien], *Bungakukai* 60, no. 3 (March 2006): 109.

51. Tadao Sato, *Ozu Yasujiro no geijutsu* [The art of Ozu Yasujiro] (Tokyo: Asahi shin-bunsha, 1978–1979). For an English translation of his writing, see Tadao Sato, "From the Art of Yasujiro Ozu," *Wide Angle* 1, no. 4 (1977): 44–48.

52. Sato, "From the Art of Yasujiro Ozu," 48.

53. See Hasumi, *Kantoku Ozu Yasujiro*, 53–55, 191–192.

54. Yomota Inuhiko, *Ajia no naka no Nihon eiga* [Japanese cinema within Asia] (Tokyo: Iwanami shoten, 2001), 140–150, 291–292.

55. For more on such consumption of Asia within cinema, see Aaron Gerow, "Consuming Asia, Consuming Japan: The New Neonationalist Revisionism in Japan," in *Censoring History: Citizenship and Memory in Japan, Germany, and the United States*, ed. Mark Selden and Laura Hein (Armonk, NY: M. E. Sharpe, 2000), 74–95.

56. See the posthumously published Tanaka Masasumi, *Ozu ariki* [There was Ozu] (Tokyo: Seiryu shuppan, 2013), as well as Tanaka's other books on Ozu and collections of Ozu's writings.

57. See Nakamura Hideyuki, "Ozu, or On the Gesture," *Review of Japanese Culture and Society* 22 (December 2010): 144–160.

CHAPTER 4

A Dialogue with "Memory" in Hou Hsiao-hsien's *Café Lumière* (2003)

MITSUYO WADA-MARCIANO

(Translated by Sean O'Reilly)

It is possible to categorize analyses of Hou Hsiao-hsien's films into two broadly defined methodologies. One seeks to situate his films in relation to their historical or cultural context, while the other focuses on formal elements of his films, for example his use of long takes and long shots, or on Hou's fade-ins and fade-outs, as the literary scholar Chang Hsiao-hung does.[1] The latter methodology also explores issues such as the relationships between film form and its mediations, form and the filmic ecology, and the films' extratextual surroundings. As neither a specialist in Taiwanese history nor a scholar whose research is primarily on Taiwanese cinema, I have found that the most interesting works are, from the former group, those like June Yip's 2004 *Envisioning Taiwan: Fiction, Cinema, and the Nation in the Cultural Imaginary*, and, from the latter group, works such as James Udden's 2009 *No Man an Island: The Cinema of Hou Hsiao-hsien*.[2] In addition to being a standout in terms of quality, Udden's work combines an analysis of Hou's film style with a focus on the history of Taiwan's film industry: in a word, he has managed to combine elements of both methodologies.

There are several reasons why, until now, these methodologies have been seen as polar opposites. First, in "national cinema" research heretofore, there has been a strong tendency to distinguish between scholars who know the language and those who do not. More specifically still, it is often characterized as a methodological divide between those who are able to use primary sources to situate films in their cultural context and those who focus on reading the

filmic texts themselves. This divide encourages each group to focus on its main strengths, which in turn has also given rise to a new generation, like James Udden, whose work features an intriguing level of methodological ambiguity and multiplicity. Needless to say, such language-governed methodological predilections are hardly limited to Taiwanese cinema, and are indeed common in many national cinemas. Yet this is a topic that has been exhaustively written about, so I will say no more here.

As regards film research on Ozu, one can see the same tendency toward a language-based dichotomy, as Markus Nornes illustrates in his essay on *Late Spring* (*Banshun*, 1949).[3] In the following section, I highlight the potential of Hou's films to defy the methodological dichotomy and argue that this feature by itself justifies comparing the work of Hou and Ozu, over and above the former's homage to Ozu in *Café Lumière*. Ozu once wrote, "I don't think film has a grammar. I don't think film has but one form. If a good film results, then that film has created its own grammar."[4] Both filmmakers presented what have been dubbed "good films" by both their own national audiences and cinephiles worldwide. Their films not only reflect the cultural and historical desires in each nation, but also present more rigorous, intrinsic stylistic norms than most any other filmmaker; in a way, this feature has made research on both Ozu's and Hou's films more intriguing and wide-ranging.

Hou's films often guide the employment of adequate methodologies, with a powerful invitation urging or interpellating the viewer to learn more of Chinese and Taiwanese history and culture. If this is the case, what can we make of Hou's first foreign-language film, *Café Lumière*? Released on December 12, 2003—not coincidentally the centennial of Japanese filmmaker Ozu Yasujiro's birth (as well as the fortieth anniversary of his death, which occurred on the same day)—*Café Lumière* was produced as a conscious homage to Ozu, premiering in Tokyo's Yurakucho district at Asahi Hall, accompanied by the Ozu Yasujiro Symposium on the Hundredth Anniversary of His Birth. Around the time when the film was given a wide general release, in September 2004, Japanese audiences had the opportunity to see a number of other "foreign" films set in "Japan." For example, *Lost in Translation* (Sofia Coppola, 2003) and *Kill Bill vol. 1* and *Kill Bill vol. 2* (Quentin Tarantino, 2003 and 2004, respectively), started, one after another, enlivening Japan's screens. *Café Lumière* was very warmly received by the majority of critics, with some praising it for "using a style that avoids portraying Tokyo except as a kind of *kakiwari* [a portable painting used in Kabuki theater as a backdrop],"[5] or for "taking locations that residents of Tokyo are used to and having them appear in an even more nonchalant depictive style than Japanese films can manage."[6] The film performed poorly at the box office, as though in inverse proportion to its rapturous critical reception, but this mirrors the box-office tendencies of Ozu's films. As if to prove the dictum that being critically well received does not always translate to box office success, Hou's film

thereby perhaps fulfilled in this ironic manner its raison d'être: to pay homage to Ozu.

Café Lumière was Hou's first foreign-language production, and given the fact that many Japanese viewers believed it to be a "Japanese film," it surely deserves attention. Here I would also like to underscore the fact that the impression of the film as somehow Japanese was not limited solely to the reception side. More importantly, it was already consciously and carefully embedded during production as a key component of the film. The para-text included in the DVD release of *Café Lumière*, a "bonus" disk featuring the French documentary *Métro Lumière*, gave regular viewers their first chance to experience this television documentary program, which had never been released in Japan.[7] In the documentary, Hou confesses that at the time he was making the film, "the theme had been decided from the very beginning, and what we meant to shoot was a 'Japanese film'" (see fig. 4.1). Indeed, from the planning stages it had always been conceived as an homage to Ozu, with the entire cast being Japanese and the story being set in Tokyo. Above all, it had been financed by a production committee comprised of five Japanese enterprises: Shôchiku, Asahi shinbun, Sumitomo Corp., Satellite Theater, and IMAGICA, all of whose names are listed in the credits. Considering this industrial and production context, very few could continue to doubt its status as a Japanese film. As a result, *Café Lumière* is an example of a film that succeeded in being seen as a "Japanese film" not only on the production side, but also on the reception side, indeed on a common sense level for the audience as they watched it. The seemingly contradictory reality that Hou Hsiao-hsien, a Taiwanese national, was able to make a "Japanese film" is precisely what invites our analysis; I would suggest that in this lies the film's intrinsic power to erase nationality.

What enabled Hou actually to resolve this apparent paradox? The primary goal of this chapter is to answer that very question. As Hou shot this film as a "Japanese film," and as many Japanese viewers sensed in it a kind of "Japaneseness," the film generated in its audiences a particular type of "common sense"; alternatively, it led them to share a "full-body sense," borrowing the term coined by Japanese philosopher Ohashi Ryosuke.[8] In creating this term, Ohashi treated as an entry point the concept of "common sense," which has existed in philosophy since the time of Aristotle, but he strongly emphasized the full-body (*zenshin kankaku*) or multisensory element involved in seeing, rejecting the typical meaning of "to see" as an ocular term, in order to stress the holistic nature of the viewing experience. In order to understand the "full-body sense" that is constructed and occurs in *Café Lumière*, one can point to strong parallels between the act of remembering something and the act of viewing a film. This is because the activation of "memory" (or the process of recalling a memory) is extremely similar to our building a particular relationship to a given film. In other words, when viewers sense that *Café Lumière* is a

Figure 4.1.
Hou Hsiao-hsien explaining to the interviewer his intention, with *Café Lumière*, to shoot a Japanese film, as indicated by the on-screen subtitle, which reads, "Toru no wa Nihon eiga desu" (*Métro Lumière*, a French documentary program included as a special feature in the *Café Lumière* DVD).

"Japanese film," the act of such "discovery" is comparable to the act of retrieving a memory—digging out some concept from where the mind has stored it away; viewers are retrieving, or clawing back to the surface of their minds, the kernel of "Japaneseness" that Hou buried deep in the innermost layers of the film. And this principle of "retrieving" guides, I would argue, Hou's own approach to his filmmaking in general.

We must pay special attention to Hou's remarks at the Ozu Yasujiro Symposium on the Hundredth Anniversary of His Birth. In particular, Hou quoted a phrase from a lecture given by Italo Calvino, which outlined the concept proposed by Austrian literatus and example par excellence of Viennese fin-de-siècle culture, Hugo von Hoffmansthal: "we must hide the depth of our works . . . where? On the surface."[9] And in fact, Hou's evocation of Calvino underscores Ozu's own aesthetic: Ozu's films depict the trivial events occurring on the surface of quotidian life, but they use that surface to offer glimpses of something deeper and more profound. In a similar manner, Hou emphasizes that in *Café Lumière* he was seeking to emulate Ozu's depictive form.[10] There is no need to debate whether Hou's reading of Ozu's work and/or of his own film is correct and adequate. Instead, what is important for our purposes is that Hou composes shots using both surface and depth, employing

in this film what may be called the structure of memory retrieval, which is strongly reminiscent of Ozu's work. In so doing, Hou's film reaches the status of a "Japanese film."

MEMORY-MAP

There still exists today, in manuscript form, Shochiku's proposal entitled "*Café Lumière*: A Theatrical Film Proposal," which was developed in January of 2003.[11] The extant document seems to have survived from the first stages of preproduction, reinforcing Hou's aforementioned claim that "the theme had been decided from the very beginning." Even before the final contours of the idea were hammered out on the Taiwanese side (by which I mean mainly Hou and producer Kosaka Fumiko), this proposal was a form of request from the Shochiku side to make "this kind of film." Shochiku proposed a film that "depicts a family-centered story that is aligned with Ozu's work, and will be shot in Japan with a Japanese cast." The proposal outlined a plot centered around a romance brewing between the second-generation owner (played by Asano Tadanobu) of a secondhand bookstore and the heroine (played by Hitoto Yo), a freelance writer; in addition to the romantic main plot, the proposal outlines a subplot that deals with family struggles between the heroine and her aged parents in both Tokyo and a rural locale.[12] When the finished film is compared to the initial proposal, one can see that Hou made one major change: instead of creating a story centered around the second-generation (male) owner of a secondhand bookstore, he shifted the focus of the story onto the female freelance writer, in effect replacing the male protagonist with a female one. Hou consistently focuses on her for the "family melodrama," for which Ozu is known. In addition, probably in an attempt to reflect the typical behavior of many contemporary Japanese families, he has entirely removed any hint of overt conflict or argument between the heroine and her parents. In other words, the finished film, which was ostensibly supposed to show "family struggles," actually shows, in the silence of the taciturn father and the restraint of the mother, a kind of ex post facto acceptance of the heroine's decision to have a baby without the involvement of the baby's father. In response to questions by novelist Yoshida Shuichi addressed to Hou, namely, "where does your conception of films come from?" and "where do you locate 'the contemporary' in your films?" Hou responded, "I took the establishment of 'the family' as the foundation of my films." It is safe to assume that for Hou, Shochiku's proposal that he make a "family melodrama" was actually quite a welcome request indeed.[13]

While Hou's film recreates on a formal level something very similar to what Ozu would have made—or in other words, it has an "Ozuesque" quality—its form also underlines differences between Ozu and himself: for example,

Hou's tendency to allude to his own directorial style, particularly his gestures toward the organic landscape in the open spaces. Hou has noted that he did not give detailed instructions on dialogue, telling his actors only the gist of what they were to say; in his own words, "[A]lthough I may have only a rough idea of the dialogue I want, I think long and carefully about the backbones of my characters."[14] In other words, Hou is interested less in the exact wording of the speeches the characters make in front of the camera than in "shooting the 'aura'" the characters generate.[15] At the same time, when Hou compares his own directorial style with Ozu's, he comments that in his own work, he painstakingly seeks to depict "the backbone of the characters as submerged in the deepest, most profound depths," and this has led him to declare that "my films, compared to Ozu's, are much, much more difficult to understand."[16] Here I would like to introduce Japanese actress Watanabe Marina's comments on Hou's directorial style. Watanabe had worked with Hou in a commercial film two years prior to the making of *Café Lumière*, and notes, "He gave only a general outline of the situation and then told me I should start from wherever I wanted; we had no idea, after starting, when the scene would end, [so Hou] uses a very hands-off approach."[17] In other words, in the aspect of "not letting actors perform," Hou's style resembles Ozu's, but whereas Ozu completely controlled the movements of these "non-performing actors," Hou does not impose the slightest external control on his actors' movements. Instead, Hou focuses on showing the atmosphere that results from intermingling the landscape and scenery with the actors' performances. The characters, who we expect to appear in the foreground/"surface layer" on screen, are instead embedded into what we might call the landscape, the background/"depths"; it is a composition that allows us to sense the "characters' backbones" by creating "actual scenery" out of this harmonious whole.[18] The importance, in this particular film by Hou, of "actual scenery" has been endorsed by Hou's longtime cinematographer Mark Lee Ping Bing: "The producer and editor on this film, Liao Ching-song, said that actual scenery works 'like punctuation,' and it really does. The film's cuts to actual scenery contain within them both lines of dialogue and meanings, and are certainly not mere shots of the landscape."[19]

This "actual scenery" so important in Hou's films is dependent, as the word "actual" might suggest, on maps of a real place, namely Tokyo. "During the shooting of this next film, I spent a long time poring over maps of Tokyo I relied on maps for 'coverage,' so to speak, of this world unfamiliar to me, in order to shoot the film objectively."[20] And it is true that a surprising proportion of *Café Lumière*'s total footage, from beginning to end, is devoted to the train sequences, a fact pointed out in *Le Monde*, a French evening newspaper, which says, "[A]s the balletic movement of Tokyo's intricate network of overlapping trains continues, one gradually starts to realize that this film's

true power lies in this movement itself, or in other words in the lack of words, 'in the perfection of magnificent signs devoid of exposition.'"[21] Trains make up the core in Hou's film, the central nervous system of the urban structure of Tokyo. And this film by Hou latches onto the map of Tokyo's labyrinthine train system, thereby adopting this urban space as the blueprint for its own spatial orientation. More precisely, not only are Tokyo's trains being envisaged here, but so too is the Joshin Line, a private local electric railway in Takasaki city in Gunma Prefecture running through the little neighborhood around Yoshii station, where protagonist Yoko's parents' home is located. Yoko's hometown, despite its distance from the capital, is shown to be nonetheless connected to it by means of the map showing the train routes. The "window" onto the capital when traveling to or from the city of Takasaki is Ueno station, via JR's Tohoku Line. Perhaps, taking into account her frequent trips to Taiwan as a freelance writer, this explains the reason that Yoko is living in the vicinity of Nippori, from which one can easily travel to Ueno station or to Narita airport. In such a reading, Yoko's decision to move to an apartment in Zoshigaya in Toshima Ward, which is still quite close to the Nippori vicinity, is no mere coincidence. On foot from her apartment in Zoshigaya, one could quickly arrive at Kishibojinmae Station and board the Toden Arakawa streetcar line, eventually arriving at Otsuka Station, where one can change to the Yamanote Line. This incredibly complicated yet all too accurate "commuting" route is shown in *Café Lumière* to a surprisingly definite rhythmic effect. The mapping of the landmarks in cities like these relies upon train route maps, and *Café Lumière* provides a correct sense of the spatial distance between the landmarks, confirming many viewers' spatial orientation and knowledge of Tokyo, which creates a kind of déjà vu during their film-viewing experience. That is to say, the Tokyo portrayed by Hou, especially through his use of train route maps, helps viewers to experience the film on a "bodily" level and retrieve their *memories* of the everyday commuting experience.

The *memories* of these viewers are not activated merely by the veracity of the depictions of spatial and temporal distance between landmarks, but are also deeply rooted in the multiple "histories" and "legends" inherent in, and presented by, each such landmark. Yoko functions as a kind of water pilot, guiding the film and its viewers past Tokyo's many landmarks, including the Seishindo used bookstore in Jinbocho (a district of Tokyo famous for its bookstores); the host of the Cafe Erika sporting a bowtie, a rarity in this day and age; the potato tempura shop, a long-familiar sight; the Tomaru book-shop in Koenji (which closed its doors in 2013), a fixture since before the war; the Cafe Momoya in Yurakucho (also now closed), and more. Naturally all these recognizable places function as the "landscape" of the film, but— and this is something we would do well to reaffirm—also the mental images of these places simultaneously trigger our memories. Each of these carefully

chosen landmarks is gradually revealed over the slow passage of time during the film, not only in accordance with the unique form and effect each landmark has but also in the light of these places' personal resonance both for characters in the diegetic world as well as film personnel. That is, Taiwan-born composer Jiang Wen-Ye (1910–1983), whom freelance writer Yoko writes about, made frequent visits to that very same secondhand bookstore; Yoko, meanwhile, chooses to do her work in that very cafe. Viewers also get to see the place that was often used for meetings between Kosaka Fumiko—the producer who almost singlehandedly made it possible for Hou to make a film in Japan—and Hou. The actual scenery most frequently deployed in the film is the view of Tokyo from the Yamanote Line, upon which Hou himself often gazed during his frequent visits to Japan. But the filmic landscape is dominated above all by the peaceful little secondhand bookstore at which Yoko spends such a blissful time with her friend Hajime. This kind of Tokyo urban "landscape" is not limited to the space of the film text, but instead embodies multiple spatiotemporal layers that also encompass the history and legends of the landmarks, and registers the backstory of the production sites and filmed locations; this multilayered spatiotemporality is a varying sign (or an outcome) of, and activator for, the multiple memories associated with these places. Among the various places in the film, there are a few examples of "actual scenery" presented as landmarks, including the area around the station or the view from the Hijiribashi bridge in Ochanomizu where three types of trains intersect; to the many viewers whose experience of "watching a film" is anchored in those very places, it is not far-fetched to say that these are instances of actual scenery that guide them into a fresh new intersection with their own memories.

SONIC MEMORY

The train sequences in *Café Lumière* visually help us recollect the space we call Tokyo, but they also go one step further: they help us *hear* Tokyo. It is train *otaku* (geek)—in recent years such figures have apparently begun to be called "Tecchan" (an affectionate term equivalent to "Train-boy")—and secondhand bookstore owner Hajime's daily routine to don recording equipment such as a microphone and headphones, and board trains. The train sounds, station announcements, and general cacophony of the surroundings of the Yamanote Line that he is hearing "now" through his headphones are also made available to us, the viewers, via the film. His act of "listening" can be identified with our own nearly simultaneous moment of listening, and in that moment a shared relationship centered on sonic memory is born. Hajime claims that through his repeated recording of the "same" experiences, which, Hajime stresses, "sound different every time," he is able

Figure 4.2.
Hajime (left) and Yoko as they quietly listen together, in his second-hand bookstore, to a CD recording of composer Jiang Wen-Ye's piano performance in *Café Lumière* (*Kohi jiko*, Hou Hsiao-hsien, 2003).

to transform the experience of listening from something beyond perception to something perceivable. Hajime's act of recording thus slowly but surely changes the soundscape of the city into what Chang Hsiao-hung calls the "plane of immanence"; the film, Chang argues, enhances this situation more than ever.[22]

Café Lumière is certainly not the sort of film that draws sustained attention to its sounds or music within the diegetic film space, but sound plays a critical role as part of the apparatus that invites us to return to our memories. For example, Hajime orders a CD of Jiang Wen-Ye's music for Yoko, to which they quietly listen in the storefront (see fig. 4.2). They lose themselves in one of Jiang's piano performances, and though the music originally emanates diegetically from a CD player in the store, it remains audible in the continuing sequence in which Yoko takes her suitcase out of a coin locker in Nippori Station on the Keisei Line (see fig. 4.3), meaning that the music has ceased to be diegetic and has become nondiegetic at some indefinable point. Thereafter, it lingers on only as an echo before it gradually fades into inaudibility.

In film production, it is not unusual to employ this sort of sound bridge, in which sound or music unrelated to the image is used as a fade-in or a fade-out. But in this particular scene, the use of this sound effect yields a form of temporality arguably akin to what is termed "internal time," to use Edmund Husserl's term. Husserl explains the consciousness of internal time as follows:

We accept, not the existence of a world-time nor the existence of physical duration, but precisely the appearance of time, and the appearance of duration . . . *to*

Figure 4.3.
Yoko removing her bag from a coin locker in Nippori Station on the Keisei Line. Jiang's piano performance piece that had been diegetically audible in the earlier sequence (fig. 4.2) continues into this scene, now sutured in as extradiegetic music.

be sure, we assume that some kind of time does in fact exist, but it is not the time of the phenomenological world but instead the internal time which flows from consciousness. We are conscious that an acoustic process, a melody we are hearing right now, exhibits a continuative relationship; this is something for which we have such incontrovertible evidence it is not possible to entertain any doubts or denials whatsoever.[23]

The continuation of the piano piece over the course of these two sequences seems to "ignore" the on-and-off nature of actual spatiotemporality, a cinematic technique that could be said to mimic the flow of "internal time" in Yoko's consciousness. We, the audience, can sense the continuation of this internal time in Yoko. While being anchored on the character present in the frame, we engage in the actual process of listening to the same music as Yoko, sympathetically resonating with her experience. At the same time, we are encouraged to take joint ownership, with Yoko and Hajime, of the *memory* of the precious moment they shared during their daily lives—that is, the moment they spent together in Hajime's store listening to the piano piece playing on the CD player. Even after these two sequences, this piano performance by Jiang Wen-Ye is repeatedly pressed into service as nondiegetic music throughout the rest of the film. Whenever it is so employed, it is always at a very moderate volume, as though it were just the same as the background music one might hear in any film. Yet in fact, because Jiang Wen-Ye functions as a personal anchor between Yoko and Hajime, this intermittently playing

music constantly prods us the viewers to remember their beatific experience of listening to it, something we had just taken joint ownership of only moments before.

Moreover, due to the sound interposed in *Café Lumière*, the *histories* that can be traced from the "inquiry" (from the Latin word *historiae*) into the official, public story of what actually happened, begins to mingle and intertwine with the private *memories* of "a story." Yoko is introduced as a freelance writer researching the politically unlucky and therefore obscure composer Jiang Wen-Ye, yet over the course of the film we see not a single instance of her making any concrete progress on this project. The film displays just one brief moment where Yoko seems confident in having sensed the existence of Jiang Wen-Ye, a figure otherwise fundamentally "absent," since his name and reputation have sunk without a ripple into the ocean of history. That moment is the scene in which Yoko meets Jiang Wen-Ye's wife, Nobu, and their daughter. In this scene, what she and we the viewers are shown visually is an old photo album in which several photographs of Jiang, taken over fifty years earlier, are on display, but Nobu's words of reminiscence, and her voice itself, add an overlapping aural layer to this visual tableau. This "history" of a colonial-era composer, whose life was at the mercy of the tempestuous times, is assimilated with an individual's experiences in the form of Nobu's "memories," or her oral history (see figs. 4.4 and 4.5).

"History" is not a mere listing of all the facts or what we call "reality," but is also the act of gathering together some of these innumerable events to tell a "story," as Hayden White indicated.[24] If so, what underlies the gap between us and the past—that is, the sense of distance between the official, public record called "history" and the private reminiscences called "memory"? Through the investigation of the protagonist, Yoko, *Café Lumière* evokes a sense of the "past," encouraging us, the viewers, into sympathetically identifying with her.

This film utilizes just two musical motifs: one is the music that accompanies the closing credits, namely "Hitoshian" (Taking some time to think), a theme song sung by Hitoto Yo herself that serves as a symbol of the present, while the other is the several piano performance pieces by Jiang Wen-Ye, which could be said to give concrete form to his own past. To us "listeners" watching the film, this merging of "the present" and "the past" surely does not cause us much discomfort or disorientation, in this film at least; I suspect this is due to the fact that this film works to intertwine issues of history and memory, public record versus private reminiscence, and "that which is buried in the past" with "that which continues to live on in the present."

Figure 4.4.
Yoko goes to meet Jiang Wen-Ye's wife Nobu (right). Nobu is discussing her deceased husband with Yoko.

Figure 4.5.
At the same moment, we are visually shown images/the "history" of this colonial-era composer, and we are also made to hear the "memory" of an individual, in the form of the reminiscences of his wife, Nobu.

IN LIEU OF A CONCLUSION

Let us return to the central question: how did a *Taiwanese* filmmaker, Hou Hsiao-hsien, manage to make a "Japanese film"? In this chapter, I have analyzed how *Café Lumière* successfully resolved this seeming contradiction;

I have also argued that the film employs a number of devices to showcase and construct multilayered memory. I chiefly focused my discussion of memory on "the memory-map"—which we could also term "the memory of spaces" or "the memory of landscapes"—and "the sonic memory," which alternatively could be called "the memory of music" or "the memory of voices." But it is possible to identify many more "memory" devices that have yet to be analyzed. Among these, I suspect "bodily memory" is especially important. In the case of this film, for example, there is Hou's talk of the "backbone of the roles," which, as I have outlined above, is a central element in his filmmaking, as well as the bodies of the actors themselves: the complicated identity of the Japanese yet ethnically Taiwanese Hitoto Yo playing the main character, and this identity duplicated in the character of Yoko, who embodies a "diasporic body," as well as the "body of the auteur," the evocations of Hou's own bodily memories of his countless trips to Japan.

As one example of the deployment of the body of the auteur, there is the sequence, which was cut from the completed theatrical release of *Café Lumière*, of Yoko going to meet her uncle in Yubari, Hokkaido. Hou chose that area because it is the site of the Yubari Film Festival (until 2010 it was known as the Yubari International Fantastic Film Festival), in which Hou has been a frequent participant, in the process forging a cordial and long-lasting relationship with the little city. In fact, in his *Millennium Mambo* (2001), he had the love-struck main character (played by Taiwanese star Shu Qi) bring her beloved not to New York or Paris, but rather to Yubari, a veritable storehouse of memories for Hou himself. In *Café Lumière*, his next work after *Millennium Mambo*, it is true that one could interpret the excising of the body of the auteur and his memories, by the decision to omit this scene, as simply a good-faith effort to honor the principle of narrative economy in filmmaking and reduce the film's running time; but it is also possible to interpret this decision—when looked at from outside the perspective of the auteur—as evidence that Hou, in the end, was unable to find significance in this attempt to trespass on his own memories in this film.

In a similar way, the auteur has also chosen to make his "memory" of a long-held friendship conspicuous in its absence. In his writing, "Hou Hsiao-hsien, Honkon no futo kara Hakusan dori no hodo e [Hou Hsiao-hsien, from the Wharf in Hong Kong to the Sidewalk in Hakusan Street]" that was included in the pamphlet sold at showings of *Café Lumière* in Japan, film critic Hasumi Shigehiko states,

As the last credit rolled, I noticed that my own name was listed among the actors, and I remember feeling a strange jolt in my sense of space-time as I began puzzling over which "I" could possibly have appeared in the film. The credits claimed that I had been filmed during the making of *Café Lumière*. Yet I did not appear in a single scene of the

finished film. Perhaps this is the *ultimate form of performance*, which Hou Hsiao-hsien was kind enough to choose for me.[25]

I imagine that to Hasumi, who was filmed as an "extra" buying a book in Hajime's store in a sequence that took half a day to shoot, the fact of that sequence having been totally, mercilessly removed from the finished film, surely caused him no small disappointment. Yet when we examine this episode in light of the memories of the auteur, and the memories between these two introduced under the name of "friendship," we might well conclude that in harmony with Hasumi's bemused assessment, this is the "ultimate form" after all. In other words, be all that as it may, the "memories"/feelings Hou has crafted here found in Hasumi one who fully felt them, or heard them loud and clear.

In closing, I would like to consider the aspects of "memory" I personally found most gratifying in this work. Many films, when considered under the rubric of "film history," are engaged in dialogue with innumerable kinds of "memory." Hou Hsiao-hsien, using trains as an intermediary, has placed *Café Lumière* into a kind of accord with his own work in the past such as *Dust in the Wind* (*Lian lian feng chen*, 1987). And this film, intended as it was to be a homage to Ozu, includes an extraordinary seriousness as well as a kind of intertextual dialogue with Ozu's work. Here I would briefly like to point to two stills: one (fig. 4.6) is from *Tokyo Story* (*Tokyo monogatari*, 1953), showing the moment when Noriko (played by Hara Setsuko) goes to her neighbor to borrow some sake for her father-in-law, who is visiting. The other (see fig. 4.7), from *Café Lumière*, shows Yoko engaged in a similar act, going to her landlord, who lives on the same premises as her, to ask a favor.

As I was writing this chapter, a very close friend of mine shared her impressions of *Café Lumière*; she repeatedly and very seriously remarked, "This film doesn't seem to know what era it is attempting to depict." When I responded, "the present," she retorted, quite rightly, "No, that can't be. In this golden age of convenience stores, and especially in a metropolis like Tokyo, what planet is she from that, having run out of alcohol, she would make the effort to go begging to a neighbor, landlord or not!" While I acknowledge the validity of her critique, for me it only reinforced my awareness that this sort of anachronism, this intentional "displacement" in time, is precisely what supplies the film with its charm. That is because it is through this kind of temporal displacement that this film, and furthermore the one-of-a-kind Hou, most clearly exposes their dialogue with the "memory" of Ozu's films. Both of these women, Noriko and Yoko, live alone yet have somehow managed to achieve independence, living in honorable poverty yet maintaining flexibility; their repeated acts of borrowing have become a kind of "memory" for me, and made a deep impression on my own heart. This could truly be described as a filmic

Figure 4.6.
Noriko (left, played by Hara Setsuko) goes to her neighbor's room to borrow some sake for her parents-in-law, who are visiting her small apartment in Tokyo in *Tokyo Story* (*Tokyo monogatari*, Ozu Yasujiro, 1953).

Figure 4.7.
A scene from *Café Lumière*, during which Yoko (played by Hitoto Yo) accompanied by her stepmother (played by Yo Kimiko), go to Yoko's landlord's house, which is on the same premises as her own apartment, and carry out the same action *Tokyo Story*'s Noriko had, namely asking to borrow some sake.

moment where I, as a film scholar, was able to experience a "common sense"—or rather, "full-body sense."

ACKNOWLEDGMENTS

This chapter is a translation from my original Japanese essay, which was published as a part of the anthology *Hou Hsiao-hsien no shigaku to jikan no purizumu* [Poetics of Hou Hsiao-hsien and their time prism], ed. Maeno Michiko, Hoshino Yukiyo, Nishimura Masao, and Xue Hua Yuan (Nagoya: Arumu, 2012). I thank my friend Sean O'Reilly for his precise translation. During the writing of the chapter, I was able to interview two important sources on this film; I am deeply grateful to Koga Futoshi of Nihon University's Fine Arts department and to Shochiku Co., Ltd.'s Yamamoto Ichiro, one of the producers for *Café Lumière*, both of whom agreed to be interviewed. I would also like to thank Deguchi Yasuo of Kyoto University and Shiraishi Eri of the International Research Center for Japanese Studies in Kyoto for their help and support while I was writing this chapter. I am grateful to Huang Yingzhe of Aichi University, and Hoshino Yukiyo, Fujiki Hideaki, and Maeno Michiko from Nagoya University, who were all very helpful on the occasion of the late June 2011 film symposium on Hou Hsiao-hsien, held in Nagoya. Lastly I would like to thank all the people at this symposium, including the many fans of Hou's films, director Hou himself, the writer and screenwriter Chu Tien-wen, and the noted producer Kosaka Fumiko; it was a great honor to meet all of you.

NOTES

1. Chang Hsiao-hung, "Shintai-toshi no fade-in/fade-out: Hou Hsiao-hsien to Kohi jiko" [Bodies and the city in fade in/fade out: Hou Hsiao-hsien], in *Taiwan eiga hyosho no ima: kashi to fukashi no aida*, ed. Hoshino Yukiyo, Hung Yuru, Hsueh Hua-yuan, and Huang Ying-che, trans. Hsu Shihchia (Nagoya: Arumu, 2011), 17–52.
2. June Yip, *Envisioning Taiwan: Fiction, Cinema and the Nation in the Cultural Imaginary* (Durham, NC: Duke University Press, 2004); James Udden, *No Man an Island: The Cinema of Hou Hsiao-hsien* (Hong Kong: Hong Kong University Press, 2009).
3. Markus Nornes, "The Riddle of the Vase: Ozu Yasujiro's *Late Spring* (1949)," in *Japanese Cinema: Texts and Contexts*, ed. Julian Stringer and Alaister Phillips (New York: Routledge, 2007), 78–89.
4. Donald Richie, *Ozu: His Life and Film* (Berkeley: University of California Press, 1977), 188.
5. Kawakatsu Masayuki, "Too Old to Rock'n Roll, Too Young to Die," in *TV Bros* 18, no. 9 (2009): 112.

6. "Eiga de Tokyo Sanpo" [Strolling through Tokyo in the movies], *Esquire Japan* January 2006, 56–59.

7. This special edition disk contains a total of approximately 195 minutes of special features, including "A Previously Unreleased Scene, Set in Yubari," "The Director Speaks: *Café Lumière*, on Location," "An Interview with Hou Hsiao-hsien," "An Interview with Hitoto Yo," "An Interview with Asano Tadanobu," "A French Documentary Program: *Métro Lumière*," "A Press Conference Announcing the Production," "The World Premiere," and "A Private Screening to Commemorate the Film's Submission to the Venice International Film Festival." *Café Lumière* special edition disk (DA-0603/2) (Tokyo: Shochiku video jigyoshitsu, 2003).

8. Ohashi Ryosuke, *Kiku koto to shite no rekishi: rekishi no kansei to sono kozo* [History as something heard: The structure and sensitivities of history] (Nagoya: University of Nagoya Press, 2005), 8.

9. Italo Calvino, *Calvino no bungaku kogi: aratana sennenki no tame no muttsu no memo* [Calvino's lectures on literature: Six memos for the new millennium] (Tokyo: Asahi shinbunsha, 1999), 121.

10. Hasumi Shigehiko, Yamane Sadao, and Yoshida Kiju, eds., *Ozu Yasujiro seitan 100 nen kinen 'Ozu 2003' no kiroku* [Record of 'Ozu 2003,' the international symposium celebrating the hundredth anniversary of the birth of Ozu Yasujiro] (Tokyo: Asahi shinbunsha, 2004), 142–143.

11. This film proposal, produced by Shôchiku and entitled "Theatrical Film Proposal for a 'Project Celebrating 100 Years since Ozu Yasujiro's Birth': A Work by Director Hou Hsiao-hsien Dedicated to Ozu Yasujiro," was lent to me by Mr. Koga Futoshi, then a reporter at the Asahi shinbun and also a producer for *Café Lumière*. On the front cover is a handwritten note, "Theatrical Film Proposal for *Café Lumière*, January 2003—not to be shown to anyone outside of the department."

12. At this stage, in January of 2003, it was evident that it had not been decided whether the role of the heroine would be played by Hitoto Yo, as there is a written entry that says, "Hitoto Yo OR Suzuki Kyoka."

13. Hou Hsiao-hsien and Yoshida Shuichi, "101 nenme no 'Ozu Yasujirô' no tameni, Hou Hsiao-hsien vs. Yoshida Shuichi, Tokyo no hikari, Taipei no kaze, Ozu seitan 100 shûnen kinen eiga Kohi Jiko" [For the Sake of the 101st year 'Ozu Yasujiro', Hou Hsiao-hsien vs. Yoshida Shuichi, Tokyo's Light and Taipei's Wind, the 100th year's memorial film, Café Lumière] *Shosetu Shincho* 58, no. 9 (September 2004): 258–265.

14. Hou Hsiao-hsien and Iwamatsu Ryo, "Taidan Hou Hsiao-hsien kantoku, Iwamatsu Ryo, wakarizurai sekai wo egaku to iu hyougen hoho" [A Dialogu between Director Hou Hsiao-hsien and Iwamatsu Ryo: About the Methodologies of Depicting the World that is not Easy to Understand] (a special edition report on *Café Lumière*) *Kinema junpo*, no. 1412 (September 2004): 50–54.

15. Ibid.

16. Ibid.

17. Hou Hsiao-hsien and Watanabe Marina, "Shinshun tokubetsu taiwa Hou Hsiao-hsien versus Watanabe Marina" [A special New Year's conversation: Hou Hsiao-hsien versus Watanabe Marina], *Kinema junpo*, no. 1347 (January 2002): 143–147.

18. Ibid.

19. Mark Ping Bing Lee, "*Café Lumière*," *Eiga satsuei* 163 (2004): 28–31.

20. Hou Hsiao-hsien and Yoshida Shuichi, "For the Sake of 'Ozu Yasujiro,'" 263.

21. Quoted in Hashiguchi Konosuke, "Eiga *Kohi jiko* no nichijosei" [Everydayness in the film *Café Lumière*], in *Chugoku kingendai bunka kenkyu* 7 (2004): 49.

22. Chang Hsiao-hung, "Fade-ins and Fade-outs of Body and City: Hou Hsiao-Hsien and *Café Lumière*" (lecture, Taiwanese Film Festival and Symposium, Nagoya University, October 30–31, 2010).

23. Edmund Husserl, *Naiteki jikan ishiki no genshogaku* [On the phenomenology of the consciousness of internal time], trans. Tatematsu Hirotaka (Tokyo: Misuzu shobo, 1987), 11; emphasis added.

24. Hayden White, "The Value of Narrativity in the Representation of Reality," *Critical Inquiry* 7, no. 1 (Autumn 1980): 5–27.

25. Hasumi Shigehiko, *Eigaron kogi* [Lectures on film theory] (Tokyo: University of Tokyo Press, 2008), 261; emphasis added.

CHAPTER 5

Ozuesque as a Sensibility

Or, on the Notion of Influence

JINHEE CHOI

At a conference on Ozu Yasujiro held in Berkeley, California, a few years back, the term "Ozuesque" was used as a descriptor among the participants to designate both Ozu's film style as well as the style of other directors ascribed as being inspired or influenced by him. Although many of the presenters were critical of the use of the term for other directors' film styles, "Ozuesque"—a handy term within quotation marks—has since become indispensible in tracing a linkage, stylistic or otherwise, between Ozu and the directors associated with him.

As Aaron Gerow examines in this volume, it is the Japanese critic and scholar Hasumi Shigehiko who has underscored the risk embedded in the notion of "Ozuesque," thanks to its generalizing or abstracting nature. Many viewers can identify Ozu's recurrent themes, narrative situations, jokes, manners (or mannerism), and gazes, which according to Hasumi could provide the spectator with apparent "rules of game" without encouraging the spectator to take any risk involved in encountering the unfamiliar—an un-Ozuesque moment—in the Ozuesque.[1] "The only possible rule," continues Hasumi, "is that Ozu's films do not correspond to Ozuesque."[2] What concerns Hasumi in the employment of the term "Ozuesque" here is a set of thematic and stylistic tropes that would constrain the way one sees and appreciates Ozu; "Ozuesque" can function as an empty analytic tool that would take the spectator away from the richness of his details.

The term "Ozu-like" is further used in a negative manner in order to highlight the tenuous relationship forged between Ozu and the following generations of directors who are influenced by him. Scholars on Japanese cinema question the first generation of scholars' approach to Japanese cinema, which attribute the distinctiveness of Ozu's cinema to the Japanese national character. Moreover, they repeatedly point out the lack of either historical evidence or sufficient stylistic affinities to prove "direct" influence of Ozu on various East Asian directors and other European auteurs. Despite an apparent association between Ozu and Hou Hsiao-hsien's early work that belongs to the New Taiwan cinema of the mid-1980s, Hou had not seen Ozu's films until the 1990s, after he had earned critical acclaim at film festivals. In their analysis of Hou's *A City of Sadness* (*Beiqing Chengshi*, 1989), Markus Nornes and Yueh-yu Yeh foreground how Hou is "un-like" Ozu.[3] In a similar vein, David Desser praises Kore-eda's confidence in evoking and alluding to Ozu in his directorial debut, *Maborosi* (*Maboroshi no hikari*, 1995), but he finds the stylistic connection between the two directors tenuous. The prevalent long take in Kore-eda's first feature, claims Desser, is "not attributable to Ozu, but more clearly to Hou and Tsai [Ming-liang],"[4] who were more immediate precursors of the aforementioned style at various film festivals and in Japan. Akira Lippit is compelled to evoke Ozu in his discussion of South Korean director Hong Sang-soo, "although the affect and style—and virtually everything else—are different, the structural relations between Hong's films are not unlike the internal logic that organizes Ozu's oeuvre."[5] Catherine Russell does not neglect to note the stylistic differences between Wim Wenders and Ozu when she says, "[D]espite Wenders's admiration for Ozu, his own filmmaking style could not be more different in *Tokyo-Ga*."[6]

In this chapter, I instead propose to consider "Ozuesque" as a distinctive individual sensibility that could historically and stylistically be rooted in and extrapolated from the thematic, stylistic traditions of both Japan and Hollywood. James Chandler, in his book *An Archaeology of Sympathy* (2013), examines "the Capraesque" as Hollywood director Frank Capra's meta-style that is built upon a narrative system (Griffith's in particular), style (the "Classical" Hollywood), and tone (of the sentimentalist tradition in both literary and cinematic forms).[7] Although Chandler defines the sentimental nature of the Capraesque as a disposition or mode that evokes the sentimental mood,[8] he never theoretically dissects the notion of disposition, other than providing a working definition that he derives from the etiology of *dispositio*, a term for "how some particular matter is disposed—how its component parts are ordered, organized, and arranged."[9] That is, the sentimental disposition and tradition from English literature of Laurence Sterne and Charles Dickens indeed helped to "order and organize the so-called classical narrative system of early Hollywood"[10] represented by D. W. Griffith. The sentimental disposition, then, underlies the structuring principles of Hollywood cinema and

Capra's films in particular that govern the employing and organizing of certain narrative and cinematic devices. Ozuesque, I contend instead, should be construed less as fixed rules or a meta-style than as a sensibility—a notion that is flexible enough to allow one's examination of both the historical formation of Ozu's distinctive sensibility and an acknowledgment of intriguing variations and violations within his own aesthetic.

Ozu's austere yet ludic style comprises his distinctive sensibility that is rarely emulated by any other director. Many scholars and critics, despite their divergence in methodology, locate Ozu's sensibility in the duality of his aesthetic. David Bordwell underscores "the basic aesthetic duality of unity and variety" that "becomes a dialectic of structural rigor and narrational playfulness."[11] Tony Rayns in the 2010 BFI catalog for the Ozu retrospective shares a similar observation, "a seamless synthesis of the emotional and the poetic within structures whose looseness belies their precision." Hasumi seems to agree, when he finds the coexistence of disparate elements in Ozu's work alongside their moving toward unity between the "narrative structure" and "themes."[12] Such assessments of Ozu, in fact, may well be demonstrated through the notion of sensibility. In order to delineate Ozu's aesthetic sensibility, I turn to the conception of sensibility advanced by art historian Roger Fry, who argues for a need to distinguish between the sensibility in design and the sensibility in texture, the latter of which he calls "surface sensibility."[13] Such a distinction not only helps identify Ozu's sensibility but also further explains the uneasiness in employing the term "Ozuesque" loosely in the discussion of directors who are influenced by, or pay homage to, Ozu.

OZUESQUE AS A SENSIBILITY

The caution revisionist scholars take toward tracing the stylistic genealogy among East Asian directors and beyond reflects their effort to correct the persistent orientalism and essentialist approach in film studies and criticism. Ozu has been treated, appropriately or inappropriately, as *the* principal intertext and frame of reference in discussing East Asian directors. In the process of debunking Ozu's influence on East Asian auteurs, however, the notion of the Ozuesque has been dismissed too quickly as impressionistic. If the notion of sensibility, as I demonstrate here, could provide a viable alternative to tracing a genealogy, stylistic or otherwise, in assessing the relationship among directors, it would help overcome as well as explain the anxiety over tracing Ozu's influence on East Asian directors.

In his seminal lecture on sensibility, Fry distinguishes two different forms of sensibility that correspond to two types of activities involved in creating an artwork: one is sensibility in designing and/or planning, and the other is in execution. For some artworks, the same artist both designs and executes the

work, which would carry the sensibility of one person, but for others, they do not necessarily converge. Obvious examples include music and architecture, where musicians and construction workers take charge of the performance and execution of a work. Or, consider a museum installation that is prepared with the help of museum employees or installation crews at a specific site. Film could also fall under this classification, as the majority of films' production and postproduction processes involve the labor and decision of crews in addition to those of the director.[14] A film as an end product is then an object that embodies the sum of the sensibilities of film crews, performers (executers), in addition to that of the director (designer).

Fry claims that the expressivity of an artwork could be manifest in both stages of design and execution. However, he sees a closer connection between the feeling expressed at the execution stage and the sensibility properly so called. It is worthwhile to pay attention to Fry's quick remarks on the difference between sensitivity and sensibility in order to properly grasp his notion of sensibility. He states,

> They speak of the artist's sensibility as revealed by the specific quality of his lines, by the relationship of his tone and colour and by the handling of his paint. Here the word is closely akin to sensitivity But the idea of sensibility implies more than this mere sensitivity to change. It implies that although, let us say, a contour shows subtle variations throughout its length it also has a constant or consistent quality, its variations are not random or fortuitous, they have some constant principle which underlies the variations.[15]

For Fry, the manifestation of a sensibility requires both consistency as well as variation. Sensibility, like disposition, is that which is sustained and across which particular qualities are manifest.[16] Some of the characteristics attributed to the notion of disposition in contemporary philosophy of science help to explain the double-sidedness of sensibility that Fry tries to articulate—its constancy and malleability. Nancy Cartwright cites Stuart Hampshire's earlier observations on disposition in the 1970s: "there are short-term and long-term dispositions, but a disposition cannot come into being, then pass away and then come into being again very rapidly."[17] A disposition may not manifest itself under certain test circumstances, but that does not imply that it has disappeared. It is, as Cartwright puts it, malleable in the sense that its manifestation could be triggered, impeded, enhanced, or weakened, subject to its enabling conditions.[18] Although Fry does not make recourse to the notion of disposition, sensibility can be considered a disposition in terms of its constancy and malleability. An aesthetic sensibility, unlike physical disposition such as fragility or solubility, is subject to a wider range of test conditions. As glass is likely to break when it is dropped on a hard surface, a sensibility could be muted due to not only external conditions, such as production

circumstances, but also internal ones, in light of a complex relationship forged between part and whole.

Sensibility narrowly construed, according to Fry, should be located in the "sensibility in texture of the creator"[19]—what he also calls "surface sensibility"—and can be further distinguished from the sensibility detected at the level of planning and design. Echoing Friedrich Schiller's distinction between the formal and the sensuous drive,[20] Fry continues, "we shall always find the tendency at once to recognize a law or fixed principle and at the same time never let the work of art become a mere enunciation of the law."[21] Fry's notion of sensibility underscores both the relationship as well as the irreducibility between the two levels of sensibility in any art, but it is particularly apt in describing and characterizing Ozu, whose aesthetic sensibility combines formal rigor with playful variations. Bordwell, in fact, tries to articulate Ozu's ludic principle as below, which can be aptly characterized as a sensibility in Fry's sense:

[Ozu's] films build into themselves an awareness of our gradual engagement with the explicit rules, the violations, and the more elusive rules behind the violations that each film offers Not the least accomplishment of Ozu's playfulness is to tease us with the possibility of a still broader unity that might enclose the entire dialectic; but it is a unity without closure, one that can never be confidently foreseen, one which we can only glimpse.[22]

Fry associates the surface sensibility with the realm of the subconscious and the organic, whose "intimate" and "varying" and "vital" rhythm escapes the mathematical order and formulas. Surface sensibility functions "in this region, then, which lies between rigid order and chaos."[23] Ozu's visual and sonic textures yield an intimate rhythm that is not easily explainable by appealing to Ozu's stylistic matrix—the use of 360-degree shooting space (a violation of 180-degree rule), transitional shots, low camera position, static camera in his later work, graphic match, and pictorial parallels of figures or objects in mise en scène, among others.

One may still wonder, however, whether the notion of sensibility would be adequate in discussing the texture of film. Is there a palpable sensibility that registers the film production as well as reproduction processes? Interestingly enough, in comparing handwriting with typeset, Fry observes that the latter may carry a sensibility of the typesetter and printer: "in print, we have the expression of the sensibility of the designer of the type in his choice of the proportions of each letter, and his sensibility to their possible combinations."[24] Courier font, to me at least, carries a different (say, retro or cute) surface sensibility than Times font; the choice of font size and spacing between lines would also register different sensibilities. Film production and postproduction involve processes certainly more complicated than typesetting, requiring

multiple and complicated decisions on cinematography, staging, lighting, and editing, which together would embody specific surface sensibilities of those who are in charge of specific technical elements under the guidance of the director and production circumstances. As Daisuke Miyao discusses in his chapter in this volume, "Ozu's" lighting is an outcome of both the studio's demand as well as the availability of technological equipment and the production value. For example, Ozu's color films carry a surface sensibility different from that of his black and white films—color adding a different texture to the consumerist desire of the middle and lower-middle class, for instance, when an object takes on such a vibrant color as red, as in the pair of red skis (see fig. 5.1) in *Good Morning* (*Ohayo*, 1959) leaned against the door of the English teacher's apartment, compared to those in the black-and-white film, *Days of Youth* (1929).

Ozuesque construed as a sensibility helps to address the reservations raised by Hasumi that the perception of "Ozueseque" could bring our attention only to the familiar (sensibility conveyed in the planning and design) in lieu of the surface sensibility in Ozu's oeuvre. Yet the concept of Ozuesque as a sensibility further allows one to discuss both the thematic and stylistic constancy detected by many critics and scholars as well as infinite permutations and variations manifest in the surface sensibility of each of Ozu's works. Sensibility further avoids the rigid divide between film narrative and style

Figure 5.1.
Red skis in *Good Morning* (*Ohayo*, Ozu Yasujiro, 1959).

or their hierarchical relationship, which has been the ground distinguishing between the Hollywood continuity system and what Bordwell terms the "parametric" style, to which Ozu is considered to belong.[25] The design for Fry, vague as it appears, refers to the relationship between part and whole, which does not need to be restricted to either narrative terms or style.

The notion of surface for Fry is closely tied to the intrinsic value in appreciating artwork, in contrast to Hasumi, whose "surface criticism" brings to the fore the ideological significance of surface. Surface, for Hasumi, constitutes a field or site in which the effects of a system can be exposed. Hasumi construes the "systemicity" of cinema, in Ryan Cook's words, as "an enunciation of cinema, a basic process of determining within an undetermined field or ground. Moreover, systems have a tendency to repeat and proliferate these basic divisions by further dividing and segmenting among impossibilities."[26] The Hollywood continuity system, for instance, guides and facilitates a certain type of fiction filmmaking, adopted by directors in and outside Hollywood. The surface is then "a placeless place"[27] that decenters one's orientations and expectations fostered by a system, nullifying the existing system's operating forces that govern the field. Ozu's style foregrounds "just how unnatural the absence of the camera in cinema in fact is."[28]

Fry defines surface in opposition to neither center—as Hasumi does—nor depth, another contrary with which surface is repeatedly paired in art history and aesthetics. Texture is a result, and sometimes a byproduct, of the execution of a design, during which surface sensibility could be "smoothed out" ("denied" or "suppressed").[29] An immediately recognizable surface sensibility, argues Fry, will fail to hold the viewer's attention for lengthy periods of time, while a subtle and complex texture will suggest to the viewer infinite variations. The surface sensibility of Ozu's films lies in both the density created through the excessive repetitions and parallels of pictorial and narrative elements, and the playfulness that results from their permutations and variations. In *Good Morning*, for example, a red Hula-Hoop is first seen outside a house in the introduction of the neighborhood where the story will take place. It makes an appearance at different households throughout the film and stylistically culminates with Isamu who hula-hoops out of joy toward the end of the film (see fig. 5.2), after having learned that his parents ordered a television set for him and his brother.

According to Fry, the intrinsic value in appreciating art lies in the pleasure in appreciating the double-edge of sensibility. Fry postulates two types of pleasure that correspond to the sensibility of design and that of texture. Fry first identifies "intellectual" pleasure, which he claims resides in finding answers for how an artwork operates in terms of its overall design. Some of the questions that we raise in relation to a work could be seen as causal ones. When one finds an answer to the question of why an artwork is as it is, it will yield an intellectual pleasure—pleasure that results from the "recognition of

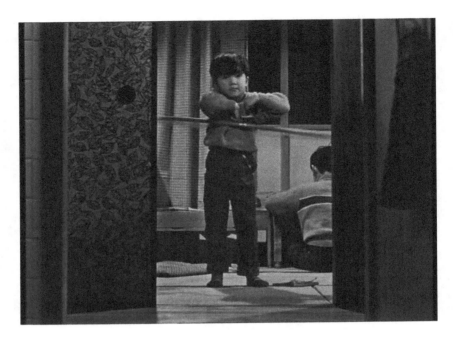

Figure 5.2.
Red hula-hoops in *Ohayo*.

the causes." As he puts it, the mind "passes from unrest to rest and satisfaction."[30] Noël Carroll has proposed a similar model for film narration—what he calls the "erotectic" model—in which a film generates questions that are answered as it unfolds.[31] However, this kind of pleasure, according to Fry, is unlike the intellectual pleasure arising from forms other than art, such as solving a mathematical problem or a quiz, as the pleasure emerging from appreciation of art does not disappear even after one finds an answer. Pleasure from intellectual inquiry over the overall design and part-whole relationship of a work cannot exhaust the pleasure in appreciating art. It is complemented by pleasure from the appreciation of texture.[32]

The texture of Ozu's films can neither be neatly summed up nor do they produce a unified response, as his narrative or stylistic units and tropes render distinctive surface sensibilities in each film. Frequently displayed domestic objects in Ozu's films, including beer bottles, sake cups, tea cans, and kettles, help to create the texture of the everyday and domestic space, yet each yields distinctive surface sensibilities. Dolls or toys, for instance, appear sporadically across Ozu's career, in such films as *Tokyo Chorus* (*Tokyo no korasu*, 1931), *Early Summer* (*Bakushu*, 1951), and *Tokyo Twilight* (*Tokyo boshoku*, 1957). Yet they are handled differently in each film. In *Tokyo Chorus*, a Snoopy-shaped stuffed animal peculiarly appears as the wife attends a baby sleeping on the floor. The doll found in Yabe's household in *Early Summer* is visually associated with,

and then replaces, Michiko, the young daughter of Yabe, whom Noriko marries. In *Tokyo Twilight*, which is one of what Chika Kinoshita calls Ozu's "dark" films,[33] dolls populate more densely across the film, gradually picking up more thematic significance as the film unfolds. Even such a "minor" trope as a doll demonstrates well Ozu's distinctive sensibility and how each of his films creates different surface sensibilities within each of, and across, his films.

To further elucidate, *Tokyo Chorus* features a doll in one scene; it is first placed near mosquito nets as if it attends to the baby sitting next to the wife. Is this Ozu's visual joke or a manifestation of his cute sensibility? Is it a convenient way to allude to the baby that is present but whose face and body are not directly shown? The toy creates a texture that is linked to, and subsequently counterbalanced by, the shots that follow. Shinji approaches the room, asking about his wife's day. As the film cuts to show both the wife and the husband together looking in the direction where the baby is, the position of the stuffed animal is changed, facing toward a corner of the shoji door on the screen right. As the conversation between husband and wife resumes, the film cuts again to frame the wife in one shot, accentuating the changed direction of the toy. This visual discord at the microlevel may signal the wife's attitude toward her husband—her humiliation felt earlier during the day at the sight of her husband working on the street—and her hesitation to face Shinji, foreshadowing a minidrama between the two that would shortly follow. She confesses that she saw Shinji working on the street on her way to visit her old classmate's father in Tokyo to see if he could help find Shinji a job. Shinji remains silent, drops the fan, and walks away to the next room. The wife learns that Shinji was assisting his former teacher to advertise the teacher's newly opened restaurant. While Shinji undresses to change his clothes and looks off screen, there are several cutaways to the smokestack and then to the clothesline hanging in the air. The juxtaposition of the sight of modernity and that of domesticity suggests the failed promise of the Meiji era, a recurring theme of Ozu's films of the 1930s and 1940s;[34] Shinji claims that he has lost his spirit. Shinji and his wife drop their heads and face in the same direction, a visual token of both their acknowledgment of their financial predicament and implicit reconciliation. The visual discord that the stuffed animal created earlier by changing its position in the previous shots has now been partially answered and counterbalanced by the shot composition of the husband and the wife. The wife then says she will volunteer to help at the restaurant. The visual order and balance of the room are further restored as the wife tidies up the room, hanging Shinji's suit on the wall.

In contrast to *Tokyo Chorus*, *Tokyo Twilight* employs several types of toys, first as a synecdoche indicating the presence of a child in the scene or in the vicinity. Shukichi (Ryu Chishu) returns home after a drink at a bar and finds his elder daughter Takako instead of his maid, Tomizawa. As Shukichi enters

the main room and checks on Takako's baby girl, Michiko, who is asleep, we see a stuffed toy sitting on the table on the screen left with its tail brightly lit (see fig. 5.3). Takako reluctantly reveals to her father her troubled marriage and the reason that she has left her husband, Numata, who has been drinking heavily and abusing their baby girl. Every shot of Shukichi's reactions includes the stuffed animal facing him. He volunteers to talk to Takako's husband, to which Takako shows less than a little hope. The scene ends with Shukichi toying with the stuffed animal (see fig. 5.4).

At first glance, the stuffed animal appears to be an instance of Ozu's gag, like the RCA Victor trademark dog, Nipper, in *Dragnet Girl* (*Hijosen no onna*, 1933).[35] As Bordwell convincingly argues, the placement of domestic objects in Ozu's films is for pictorial purposes—to create a graphic match, balance, and visual accent.[36] But as the film progresses, the addition of different toys increasingly takes on a thematic significance. Unaware that Shukichi's younger daughter, Akiko, is pregnant, the aunt visits Shukichi's household to discuss possible candidates for Akiko's marriage. Michiko, placed in her baby walker, is playing with a wooden toy, while Shukichi and the stuffed toy dog attend Michiko's playing (see fig. 5.5), reminiscent of the shot of the wife and the stuffed dog in *Tokyo Chorus* mentioned earlier. The graphic parallel between Shukichi and the stuffed toy now visually associates the two, rather than functions as a synecdoche for the presence of Michiko.

Akiko's abortion takes place off screen, and her returning home is preceded by Michiko's playing in the hallway. On her way to answer the door to greet Akiko, Takako kicks a toy on the floor by accident, which makes little rattling sounds. Akiko almost collapses in the hallway as soon as she passes the doorway, and Takako runs upstairs to prepare the room for her sister to rest. As Takako unfolds the futon, in the background left we see a baby doll. It may perhaps belong to Michiko, but unlike other toys that were seen in the vicinity of Michiko, the baby doll may allude to Akiko's abortion, adding a mood of eeriness and horror to this already darkly lit room.

The number of Michiko's toys increases as the film progresses, associated first with her presence and then the characters around her. The prolonged departure of the mother, Kisako, at the train station signals the coda of the film. Kisako, who had abandoned Takako and Akiko when they were young after having had an affair with Shukichi's assistant during the war, painstakingly looks through the train window out onto the platform for a possibility of Takako's showing up to see her mother off. Instead, we see Takako and Shukichi at home. Takako picks up the wooden toy from the floor and puts it on the table, occasionally blocking the toy as she organizes some magazines. She informs Shukichi that she would give it another try with her husband, Numata, so that Michiko does not undergo the same kind of loneliness that Akiko must have felt growing up under a single parent. Shukichi concurs with Takako's decision and moves to the adjacent room to pray in front of

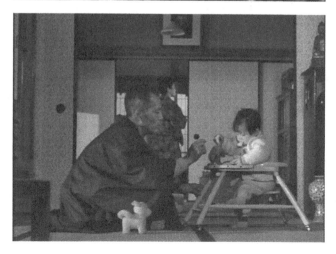

Figures 5.3, 5.4, 5.5.
Toys in *Tokyo Twilight* (*Tokyo boshoku*, Ozu Yasujio, 1957).

Akiko's altar. The camera cuts to show Takako from the opposite side of the room, and now the two toys—the stuffed dog on the floor and the wooden toy on the table—face in different directions (see fig. 5.6), yet form an inverse triangle with a cup on another table, hinting at the uncertain prospect of her marriage. The film ends with Shukichi getting ready to head to work one morning, assisted by the maid, Tomizawa. As he puts on his jacket, he glances at the rattle toy (barely visible to the spectator) on top of the wardrobe, shakes it a few times, and then to puts it down on the table (see fig. 5.7); its sound resonates the absence of both Akiko and Michiko. In his discussion of *Tokyo Twilight*, Mauricio Castro interprets the last shot as suggesting that "Shukichi is left with only a toy belonging to his granddaughter Michiko to remember the family he once had."[37] Yet, when one links the last shot with the shot where Takako kicks the toy by accident when she welcomes Akiko coming from the clinic, the sound of the toy is more intimately tied to Akiko than Michiko, and hence to abandonment more than memory.

The presence of the toys in *Tokyo Twilight* not only surprises the viewer with the density of their populations that reinforce, counterbalance, and undercut the changing atmosphere of the domestic space, despite their apparent jovial placement and tone. The failed marriages of both father and daughter's generations are acknowledged and discussed with the presence of the objects often associated with children—young and unborn. This strange surface sensibility,

Figure 5.6.
The composition hints at the uncertain prospect of Takako's marriage.

Figure 5.7.
The sound of rattle toy resonates the absence of both Akiko and Michiko.

perhaps, is Ozu's way of yielding what he calls a "low octave"[38]—not to overindulge in the melodramatic sensibility.

The texture of a work of art always carries a specific surface sensibility that is unable to be completely emulated by a work of a similar design or even a copy. Fry states that a copy would not be able to carry or embody the same "sensibility in texture of the creator."[39] A copy of an original painting, for instance, may succeed in approximating the original's overall structure and design, yet it cannot manifest exactly the same texture of the original lines drawn and/or colors smeared. Nonetheless, Fry reserves any value judgment in his comparison between a copy and the original; he acknowledges that the copy is not necessarily inferior to the original in terms of surface sensibility; it only manifests a *different* sensibility—the sensibility of the person who copies. Fry claims that this kind of pleasure from the surface sensibility would provide insatiable pleasure that "corresponds to our desire for variety, multiplicity, chance, the unforeseeable."[40] A similar sensibility governs Ozu's "remake" of his own films—*I Was Born, But . . .* (*Otona no miru ehon*, 1932) and *Good Morning* (1959), *A Story of Floating Weeds* (*Ukikusa monogatari*, 1934) and *Floating Weeds* (*Ukikusa*, 1959), *Late Spring* (*Banshun*, 1949) and *An Autumn Afternoon* (*Sanma no aji*, 1962)—by their shared plots and themes, yet the surface sensibility of each film would inevitably vary. Bordwell notes that Ozu's remake registers a different topical sensibility: "the film [*Ohayo*] resembles *I*

Was Born But . . . , not only in one of its central plot devices—two sons go on strike—but also in such particulars as a sinister gag with a cleaver. Yet *Ohayo* firmly remains a film of the 1950s."[41] One can note that the difference not only lies in their topical but also the auxiliary surface sensibilities of the two films; the objects colored in red accentuate the commodity fetishism, which Bordwell claims "is part of the texture of everyday life in the new Japan,"[42] while the maze-like layout of the neighborhood and space constructed accordingly in *Good Morning* reinforce a sense of uniformity in the aspired modern lifestyle.

Many of the reservations expressed about the notion of "Ozuesque," including those raised by Hasumi, as deterministic and limiting, then, result from the conflation between the two levels of sensibility and the corresponding appreciation. Sensibility comprises not only that which is manifest through the overall design and patterns but further consists in surface sensibility, through which Ozu's aesthetic sensibility is endlessly reconfigured. The relationships between the two levels of sensibility are not deterministic or reducible to one another, inviting the viewer to appreciate the texture of each image, scene, and film. A question further remains, however, to what extent the notion of sensibility suggested here helps to examine the relationship between Ozu and his successors.

ON THE NOTION OF INFLUENCE

The dilemma of tracing an influence, as Ihab H. Hassan articulates, consists of the following two horns:

The dilemma which confronts him [the scholarly critic] is often disagreeably concrete; for should he remain content to indicate the similarities between two authors, his efforts are deemed superficial, and should he be rash enough to discover an influence, his efforts are eyed with the suspicion due to a mountebank.[43]

That is, one must either be content with foregrounding formal similarities, or delineate the causal history between two artists, which may involve such murky concepts as intention and social and cultural mores. Revisionist scholars' anxiety has been directed toward correcting (often wrongly construed) the stylistic genealogy that is evoked in critical discourse. Nornes and Yeh point out that in Hou's *Café Lumière*, an homage to Ozu in celebration of his centennial birthday, "the train shot was taken from an angle that Ozu would never have considered."[44] Kore-eda's home drama "reminds" many critics of similar themes in Ozu's lower-middle-class films (*shoshimingeki*), but in an "understated

naturalistic style."[45] A romantic desire in Ozu's film is suggested yet remains unfulfilled, as in Noriko's outing with Hattori in *Late Spring*, while Hong's film interrogates a similar desire with a focus on its absurdity and bittersweet tonality.[46] Tsai's slow-paced films are slower than Ozu, with the average shot length of his films ranging between nineteen and seventy seconds,[47] in contrast to Ozu's slowest film (*There Was a Father*) being less fifteen seconds.[48]

Apparent formal similarities are further determined as insufficient grounds to establish causality; Gary Needham, for instance, points out how the low camera position in Hou's films (even prior to Hou's exposure to Ozu's films) could be attributed to the similar architectural design of houses built during the period when Taiwan was a Japanese colony between 1895 and 1945.[49] Bordwell also attributes the use of frontal framing in films directed by Kitano Takeshi to the director's lacking an apprenticeship and formal training in the field.[50] Namely, similar textual affinities mentioned did not necessarily originate from a direct influence.

Nonetheless, it is also limiting to require the approximation, if not the identity, of both levels of sensibilities in order to "prove" the influence of Ozu on world cinema directors. Influence can refer to many things, but certainly not approximation, as it can be exercised in not only establishing and reinforcing, but also in redirecting and transforming the existing traditions of a group and/or individual style. Ozu's home drama and aesthetic sensibility have become part of not just the Japanese but also the global canon, and moreover, a common denominator among filmmakers themselves and also between filmmakers and the spectator. Fry claims, "[W]e get this satisfaction more readily from an artist with whom we have already established a sympathetic rapport, because we can accept his answers readily."[51] In other words, an artist whose sensibility we share will ease the process of apprehending and appreciating the sensibility manifest in one's work. Nevertheless, this does not prevent one from appreciating a work of art with a novel sensibility.

But sometimes when we examine the work of an artist, which we do not like as a whole, it is quite possible that if we put some of these questions deliberately and consciously the artist may be able to answer our questions satisfactorily. It is indeed by some such process that we can extend our powers of comprehension of art, and increase the acuteness of our sensual logic.[52]

There certainly exists an epistemic risk in assimilating the unfamiliar to the familiar without a proper contextualization. Yet, when formal similarities and shared sensibilities are adequately contextualized, both historically and stylistically, the two modalities of influence[53]—formal similarity and causality— would function within the constraints of tradition and development.

As Hassan puts it, "[B]oth [tradition and development], while unlikely to render the idea of influence in every connection superfluous, can do much to limit its extensions, so often dubious, by putting the latter under some degree of pressure."[54] In appreciating an innovative art or a novel director, when properly contextualized, the value in drawing on familiar art or directors is twofold: according to Fry, it helps to not only broaden the purview of our experience and but also hone the sensuous logic.

Despite the ostensible evocation of Ozu in his work in terms of theme, motif, style, and genre, Kore-eda has been rather reluctant to acknowledge Ozu's influence. Instead, he openly acknowledges his indebtedness to the work of Hou and Naruse Mikio. "More than Ozu," claims Kore-eda, "Naruse is closer to my own feelings about people,"[55] when he answers the usual question on influence and inspiration. Nonetheless, the scholarship on Kore-eda never misses the lure of pairing the two directors together. Arthur Nolletti Jr. sees no harm in attributing the evocation of Ozu in Kore-eda to an unintended influence: "No doubt Kore-eda is tired of hearing this comparison, and has claimed that he was more influenced by the troubled families in Naruse's films. In fact, it is possible to see the influence of both filmmakers in the film. And that takes nothing away from Kore-eda's achievement."[56]

Ozu's guiding influence on Kore-eda through the home drama genre is hard not to notice. As Alexander Jacoby notes, "Korea-eda's film may be seen as an attempt to explore how the thematic concerns of the lower-middle class films (shomingeki) can be inflected in a different era and in the context of radical changes in Japanese society since the early postwar years."[57] Kore-eda's home drama certainly repeats the tropes of Ozu's home drama—death, family gathering, generational tension, and disappointment—yet with Ozu's usual plot reversed or with the change in focus. Jacoby ingeniously notices an inverse relationship between Ozu's Tokyo Story and Kore-eda's Nobody Knows in their narrative premises: "whereas Ozu's film is about parents neglected by their children, Kore-eda's is about children neglected by their parents."[58] Still Walking (2008) must be added, as featuring a reverse journey of Tokyo Story— a child's visit to his parents' home. The disappointment of, and bittersweet reconciliation between, parents and children provide another shared narrative backbone for both Ozu's I Was Born, But... and Kore-eda's Like Father, Like Son. In the latter, however, it is the father who learns of his relationship with his son as well as his father.

Cinematic allusion to Ozu's films further links Kore-eda to the Japanese master. Linda C. Ehrlich connects the opening close-up of food preparation in Still Walking—peeling of daikon and carrots—as "a covert tribute to the last film Ozu wanted to make"—which was entitled "Radishes and Carrots" (Daikon to ninjin).[59] Wada-Marciano pays attention to a shot of a small bouquet of flowers in a glass in the film, which is reminiscent of the famous shot of a vase in Late Spring. Furthermore, the framing of the film's protagonist,

Ryota, and his retired father, Kyohei facing the beach "reminds us of a morning scene in *Tokyo Story*, when Noriko views a beautiful dawn with her father-in-law in Shukichi."[60]

Kore-eda's films showcase more than the guiding influence of, and allusion to, Ozu in *Still Walking*. Although Kore-eda's camera is more mobile than Ozu's, the camera awaits the entrance of a figure, which creates and yields a slightly elongated rhythm to the continuity/discontinuity of an activity or movement, as if in clicking the shutter of slides by hand you never provide a perfect continuity. After the short introduction of Ryota's mother and sister—Toshiko and Chinami—who are preparing ingredients in the kitchen, Kyohei, who is Ryota's father, is seen leaving his clinic to take a walk. A brief chat with his neighbor, who will take a narrative significance later in the film, detains Kyohei momentarily. But as Kyohei resumes his walk, intercut with the food preparation in the kitchen, the stroll unfolds in several shots. The camera is positioned on, or perpendicular to, the axis of action with an occasional cut to 135 degrees (when Kyohei walks down the stairs), anticipating Kyohei's passing the streets of his neighborhood and then arriving at the footbridge.[61] The camera lingers on the overpass even after Kyohei exits the frame, followed by a longer shot of Kyohei now standing slightly away from the entrance of the bridge, overlooking the ocean in the background. The film cuts to the title shot of the film—a shot of the town—in which we see a red train pass by. In the film, Kyohei's stroll is edited as Ozu would for characters' action (such as standing up or exiting a room), expanding the range of editing patterns from a character's movement to his or her activity. The intercut between Kyohei's walk and the shots of food preparation further juxtaposes the Ozu-style of editing and Kore-eda's own, as Ozu rarely shows someone cooking in close-ups (with a possible exception of characters making tea).

While granting the diverging surface sensibilities of Ozu and Kore-eda, the manifestation of their sensibility—muted sensibility, or what Ozu called the "low octave"[62]—through domestic objects is nonetheless worth exploring. As discussed in the previous section, toys play an important trope in Kore-eda's poignant portrayal of four abandoned children in *Nobody Knows*. Four children—Akira, Kyoko, Shigeru, and Yuki—whose biological fathers all differ, are left alone in one-bedroom flat in Tokyo, as their mother, Keiko, moves out to live with her new man. Only the eldest child, Akira, who is introduced by Keiko to the landlord as her only child, is allowed to go outside. The rest of his siblings are confined in the space, and because the four children are not registered, they are unable to attend school. Throughout the film, the color red is consistently used, although it is more thematically charged with characters' desire than some of the red domestic objects in Ozu's films (such as the red tea kettle), and the cutaways to inanimate objects within the apartment.[63] Jacoby considers the cutaways in the film comparable to Ozu's pillow shot—which provides transitions from one scene to another and punctuates a scene.

I must modify Jacoby's observation here as that Kore-eda uses both cutaways to toys—in the absence of children—and close-ups of children playing with toys—mostly later in the film. The latter use of cutaways makes it challenging to characterize them as pillow shots, in their strict sense. Nonetheless, the allusion to Ozu's stylistic tropes, claims Jacoby, indeed helps to clarify the reworking of the theme of Ozu's film.[64]

Children's toys—Akira's red rubber ball that he throws at a park, Kyoko's red toy piano, and Yuki's pink stuffed rabbit—underscore the children's desires and wishes in the absence of their mother, Keiko. On Yuki's birthday, Yuki insists on going to the station to see Keiko. Her siblings, including Akira and Kyoko, relay that their mother will be back next week in the hope that they could talk her out of leaving the apartment. Yuki is persistent, and the camera cuts to show Yuki's hand and the pink rabbit hanging on the balcony's fence. The metonymic use of her toy indeed takes up a more narrative function later in the film, as Yuki falls from a chair while trying to reach a pot in the balcony, causing her death. After her fall, the film only shows parts of her body, such as her hand, or the pink rabbit nearby. As Akira and Kyoko put Yuki in the trunk in order to take her body to the airport and bury her there, instead of a clear view of Yuki, we see her body in the dark trunk with only a glimpse of the pink rabbit with a red string on its wrist, which reminds us of the red string bracelet that Keiko used to wear at the beginning of the film.

The presence of children's toys is not peculiar to Ozu and Kore-eda. But their narrative and aesthetic functions are rooted in a similar sensibility, which requires the viewer to discern the minute changes in the domestic spaces and objects. The aim of forging the relationship between Kore-eda and Ozu is not to derive the value of Kore-eda's work from the established mastery of Ozu, but to appreciate the diverging surface sensibilities in portraying family misfortune.

In this chapter, I have discussed how the notion of sensibility helps us characterize "Ozuesque" as a distinctive sensibility—the combination of rigor and playfulness. The notion of sensibility that is rooted in disposition, which is malleable to external circumstances and internal changes, avoids a dogmatic mapping of Ozu's individual film style to his systematics or matrix and the discussion of his influence on Japanese directors, such as Kore-eda, purely on formal terms. The constancy detected in a sensibility, as Fry reminds us, is not an ironclad rule; it is complemented by the surface sensibility, which is intimate, malleable, and infinitely varying.

NOTES

1. Hasumi Shigehiko, *Kamdok Ozeu Yasujiro* [*Director Ozu Yasujiro*], trans. Yun Yong-sun (Seoul: Hannarae, 2001), 8.

2. Ibid., 11.

3. Markus Nornes and Yueh-ye Yeh, *Staging Memories: Hou Hsiao-hsien's* A City of Sadness (Ann Arbor: Michican Publishing, 2014), accessed 16 April, 2015, doi:http://dx.doi.org/10.3998/maize.13469763.0001.001.

4. David Desser, "The Imagination of the Transcendent: Kore-eda Hirokazu's Maborosi (1995)," in *Japanese Cinema: Texts and Contexts*, ed. Alastair Philips and Julian Stringer (London: Routledge, 2007), 276.

5. Akira Mizuta Lippit, "Hong Sangsoo's Lines of Inquiry, Communication, Defense and Escape," *Film Quarterly* 57, no. 4 (Summer 2004): 23.

6. Catherine Russell, *Classical Japanese Cinema Revisited* (New York: Continuum, 2011), 37.

7. James Chandler, *An Archaeology of Sympathy: The Sentimental Mode in Literature and Cinema* (Chicago: University of Chicago Press, 2013), 29.

8. Ibid., 15.

9. Ibid., xiv–xv.

10. Ibid.

11. David Bordwell, *Ozu and the Poetics of Cinema* (Princeton, NJ: Princeton University Press, 1988), 54.

12. Hasumi, *Kamdok Ozeu*, 29, 32.

13. Roger Fry, "Sensibility," in *Last Lectures* (Cambridge: Cambridge University Press, 1939), 36.

14. This latter category of art, where the planning and execution often diverge, is comparable to what philosopher Nelson Goodman calls "allographic" as opposed to "autographic" art. But Goodman's distinction has more to do with the relevance of causal history in classifying a piece as an instance of artwork in question. For autographic art, it is; for allographic art, it is not. See his *Languages of Art* (Indianapolis: Hackett, 1976), 113.

15. Fry, "Sensibility," 24.

16. Stephen Mumford, *Dispositions* (1998; repr., Oxford: Oxford University Press, 2008), 21.

17. Stuart Hampshire, *Freedom of Mind and Other Essays* (Oxford: Clarendon Press, 1972), 34; cited in Nancy Cartwright, "What Makes a Capacity a Disposition?," in *Dispositions and Causal Powers*, ed. Max Kistler and Bruno Gnassounou (Hamshire: Ashgate, 2007), 198.

18. Nancy Cartwright, "What Makes a Capacity a Disposition?," 197.

19. Fry, "Sensibility," 26.

20. Friedrich Schiller, *Aesthetic Education of Man*, trans. Reginald Snell (New Haven: Yale University Press, 1954; Reprint, Mineola: Dover Publications, 2004), 118.

21. Fry, "Sensibility," 25.

22. Bordwell, *Ozu*, 121.

23. Fry, "Sensibility," 33.

24. Ibid., 26.

25. Bordwell, *Ozu*, 109.

26. Ryan Cook, "An Impaired Eye: Hasumi Shigehiko on Cinema and Stupidity," *Review of Japanese Culture and Society* 22 (December 2010): 132.

27. Ibid., 139.

28. Hasumi Shigehiko, "Seido to shite," in *Eiga, yuwaku no ekurichuru* (Tokyo: Chikuma Shobo, 1990), 347; cited in Cook, "Hasumi," 133.

29. Fry, "Sensibility," 34.

30. Ibid., 29.
31. Noël Carroll, Chapter 5 "The Power of Movies," in *Theorizing the Moving Image* (Cambridge: University of Cambridge Press, 1996), 88–89.
32. Fry, "Sensibility," 28.
33. Chika Kinoshita, "From Twilight to Lumière: Two Pregnancies" (paper presented at Relocating Ozu: The Question of an Asian Cinematic Vernacular, the University of California, Berkeley, February 2010).
34. Bordwell, *Ozu*, 41–43.
35. Ibid., 66–67.
36. Ibid., 110–112.
37. Elyssa Faison, "Tokyo Twilight: Alienation, Belonging, and the Fractured Family," in *Ozu International: Essays on the Global Influences of a Japanese Auteur*, ed. Wayne Stein and Marc DiPaolo (New York: Bloomsbury, 2015), 71.
38. David Bordwell, *Ozu and the Poetics of Cinema* (Princeton, NJ: Princeton University Press, 1988), 341.
39. Fry, "Sensibility," 26.
40. Ibid., 28.
41. Bordwell, *Ozu*, 348.
42. Ibid., 49.
43. Ihab H. Hassan, "The Problem of Influence in Literary History: Notes Towards a Definition," *The Journal of Aesthetics and Art Criticism* 14, no. 1 (September 1955): 66.
44. Nornes and Yeh, *Staging Memories*.
45. Arthur Nolletti Jr., "Introduction: Kore-eda Hirokazu, Director at a Crossroads," *Film Criticism* 35, nos. 2–3 (Winter 2011): 6.
46. Mathias Lavin, "Prolonger Ozu, avec Kiarostami, Akerman, Hong Sang-soo," in *Ozu à present*, ed. Diane Arnaud and Mathias Lavin (Paris: G3J Éditeur, 2013), 64.
47. Song Hwee Lim, *Tsai Ming-liang and a Cinema of Slowness* (Honolulu: University of Hawaii Press, 2014), 87.
48. Bordwell, *Ozu*, 377.
49. Gary Needham, "Ozu and the Colonial Encounter in Hou Hsiao-hsien," in *Asian Cinemas: A Reader and Guide*, ed. Dimitris Eleftheriotis and Gary Needham, (Edinburgh: Edinburgh University Press, 2006), 375.
50. Bordwell, *Figures Traced in Light: On Cinematic Staging* (Berkeley: University of California Press, 2005), 233.
51. Fry, "Sensibility," 31.
52. Ibid.
53. Hassan, "The Problem of Influence," 76.
54. Ibid., 74.
55. Mark Schilling, "Kore-eda Hirokazu Interview," *Film Criticism* 35, nos. 2–3 (Winter–Spring 2011): 12.
56. Arthur Nolletti Jr., "Introduction," 6.
57. Alexander Jacoby, "Why Nobody Knows—Family and Society in Modern Japan," *Film Criticism* 35, nos. 2–3 (Winter–Spring 2011): 69.
58. Ibid., 70.
59. Linda C. Ehrlich, "Kore-eda's Ocean View," *Film Criticism* 35, nos. 2–3 (Winter–Spring 2011): 139–140.
60. Mitsuyo Wada-Marciano, "A Dialogue Through Memories: *Still Walking*," *Film Criticism* 35, nos. 2–3 (Winter–Spring 2011): 116–117.

61. Bordwell claims that Ozu often has cuts of 0 or 180 degrees, but less frequently of 90 and 135 degrees, and seldom by just 45 degrees in relation to the previous shot. See his *Ozu and the Poetics of Cinema*, 93.
62. Bordwell, *Ozu*, 64.
63. Jacoby, "Why Nobody Knows," 69.
64. Ibid., 70.

SECTION II

Historicizing Ozu

A New Form of Silent Cinema

Intertitles and Interlocution in Ozu Yasujiro's Late Silent Films

MICHAEL RAINE

Foreign films have gone completely talkie, but most Japanese films are still silent. I know Japanese films will also become all talkies one day, but before they do I think we should create a new silent form [*sairento to shite no hitotsu no atarashii keishiki*].
—Ozu Yasujiro, *Kinema junpo*, January 1933[1]

INTRODUCTION

When Josef von Sternberg visited Japan in 1936, Ozu Yasujiro asked him at a gathering of the newly-formed Directors Guild of Japan why the overlap in his dissolves was so long.[2] Ozu, like many Japanese filmmakers of his generation, was highly sensitive to the technical aspects of cinema as a new medium of visual narration. Many young filmmakers regularly published detailed analyses of foreign films in journals such as *Film Science Research* (*Eiga kagaku kenkyu*), but Ozu was second to none in his attention to the specifics of film form.[3] This essay analyzes formal differences in Ozu's late silent films in order to reveal the distinct aesthetic projects that they embodied within the overarching mode of the "Kamata-style" melodrama.[4] Navigating Ozu's films in this manner reveals that his consciousness of form extends beyond camera level and the construction of space recognized by prior authors to include the signifying power of the intertitle as a form of "visual speech." That power was always conjunctural: Ozu's use of the intertitle was shaped by and set against the historical sonic conditions of cinemas in Japan created by the long transition to synchronized sound cinema. It is this deep attention to film form

and awareness of the relation between contemporary cinema and its audience, rather than any fixed style, that best describe Ozu's vision of cinema.

David Bordwell's *Ozu and the Poetics of Cinema* is a model for a historically aware formal analysis of Ozu's films. In his writing on Ozu's silent films, Bordwell focuses on norms of spatial construction and visual composition in order to revise Noël Burch's more extreme claims about form and meaning in the Japanese cinema.[5] He notes that it is in the silent films that Ozu gradually abandons dissolves and moving camera, establishes a default camera level, and develops editing schemes that construct diegetic space through eye-lines and setting rather than screen direction. More recently, Yuki Takinami's philosophically inflected dissertation pays similarly close attention to the audiovisual rhetoric of the early films and provides an even stronger discursive and historical context for Ozu's understanding of the "mobility and lightness" of the medium.[6] Even so, with the exception of two incisive pages in Bordwell's study, little attention has yet been paid to one of the defining features of silent cinema: the presence of intertitles in the image stream.

After declaring his goal of creating a new silent form, Ozu went on to say that simply including mimetic speech ("spoken titles" in Japanese) or poetic diegesis (Ozu gives the example of Yamanaka Sadao's repeated "flowing" titles) was not enough.[7] Takinami reads this rejection as a marker of Ozu's broader interest in "construction," which is surely the case. However, Ozu's occasional remarks on the difference between silent cinema and talkies often turned on the difference between dialogue and intertitles. During the extended conversion from silent to synchronized sound cinema, Ozu's intertitles highlighted the struggle over the place of speech and language in the cinema that was a central problem of the transition: the contest over agency and expression between filmmaker, actor, and live narrator (*benshi*). In what follows, I first provide a historical context for Ozu's engagement with the intertitle and then survey his changing usage, in particular in the late silent films from *Woman of Tokyo* (*Tokyo no onna*, 1933) to *College Is a Nice Place* (*Daigaku yoi toko*, 1936, lost). I argue that we can tease out a succession of aesthetic projects in these films: first, an exploration of the properties of intertitle syntax and experiments with frequency in the films of 1933; and then, a heretofore unrecognized exploitation of the "sound version" (films with music and sometimes sound effects and speech, but no synchronized dialogue) to *silence* the benshi while creating subtle, synaesthetic effects that we might liken to visual repartee.

INTERTITLES AND THE BENSHI

The intertitle may seem superfluous in Japanese cinema. As is well known, there is a special sense in which silent films were seldom silent in Japan. In

addition to the use of live music as accompaniment, Japanese film screenings featured a live narrator, or benshi, who would supply dialogue as well as verbal commentary for the film and who was perhaps the main attraction of the show. Also known as *katsudo* benshi, *katsuben*, *kaisetsusha*, and more respectfully as *setsumeisha* (explainers), benshi had their own fandom and would play to the crowd, which responded in kind by leaving presents on the stage and calling out praise (*kakegoe*) as if to their favorite actors in the kabuki theater.[8] The records, radio broadcasts, and fandom that surrounded the benshi suggest that the film screening was an event, always intermedia and even ancillary to the live vocal performance. Isolde Standish goes so far as to claim that even Japanese films of the 1920s and 1930s such as *Orochi* (Futagawa Buntaro, 1925) and *The Downfall of Osen* (*Orizuru Osen*, Mizoguchi Kenji, 1935) would leave space for a stream-of-consciousness "benshi cadenza" that was the main attraction of the film.[9] And yet there were many forces arrayed against this somewhat romantic version of the benshi's freedom. Understanding those forces reveals why intertitles in Japanese films from the Shochiku studio, where Ozu worked, were as frequent as in Hollywood silent films.

As Fujiki Hideaki shows, the price of the benshi's celebrity was his (the vast majority of benshi in the 1920s and 1930s were male) being assimilated as a solo performer within a scripted performance. As actors displaced the benshi's celebrity in the 1910s and new techniques such as the close-up were incorporated into the visual narration of self-consciously modernizing films such as *Orochi*, some film texts became increasingly resistant to the benshi's contribution. Fujiki quotes one benshi as saying, "The object of the audience's applause shifted from the benshi to actors I have decided that, when an actor's facial expression was highlighted, I would hold my tongue."[10] Also, Shochiku began distributing benshi scripts with Ito Daisuke's *The Woman and the Pirate* (*Onna to kaizoku*, 1923), the film that is taken to mark the transition from kabuki-style "old school" films (*kyugeki*) to the "period films" (*jidaigeki*) influenced by Western cinema.[11] Finally, from 1925, state censors required the benshi script to be checked along with the film, and a copy had to accompany the print so that police in the cinema could ensure that the approved script was being followed.[12] Even before the technological transition to recorded sound and synchronized dialogue, the benshi was part of a *dispositif*, a social and technical apparatus that governed the production of sound in the cinema.

Kitada Rie has examined how some benshi for Western films found work writing subtitles and sometimes recording voice-over narration for Western talkies after they were fired from the cinemas. She also argues that the fondness for the benshi in Japan continued long after the conversion to sound, in the form of *kaisetsu-ban* (interpretation versions) of Japanese films that incorporated the benshi's narration along with music and sometimes sound effects onto the soundtrack.[13] *The Downfall of Osen* was released as one such kaisetsu-ban, with Matsui Suisei's narration. Chika Kinoshita lends credence

to the benshi's popularity by showing that the soundtrack for this film was turned off and replaced by live benshi for some screenings in Osaka. On the other hand, she notes that this kaisetsu-ban is striking for the sparsity of Matsui's narration, which goes little beyond reading the intertitles.[14] Matsui had once claimed that the benshi was a "local idol" whose popularity was tied to accent and local identity, such that a benshi from Tokyo could not be popular in Osaka.[15] Perhaps this position informed his rote performance. Although the kaisetsu-ban was introduced by major studios such as Shochiku and Nikkatsu, it survived to the end of the 1930s, only in the form of cheap period films produced by small studios such as Kyokuto and Zensho.[16] Despite the insights Kitada provides, it is difficult to argue that the kaisetsu-ban was a strike against the introduction of recorded sound, since those films displaced the remaining live benshi and depended on the fact that by the late 1930s even those small cinemas had already been wired for sound.

Joining the Shochiku studio in 1923, Ozu was strongly influenced by the "Pure Film Movement," which called for a Japanese cinema that would restrict the benshi to serious explanation and emulate Hollywood style in order to stand up to foreign competition. Young critics such as Kaeriyama Norimasa promoted a self-contained form of visual narration that bypassed the ballyhoo of film showmanship and formed a more direct connection with the minds of its viewers.[17] Shochiku hired Henry Kotani from Hollywood and gained a reputation as a "modern" studio, appointing Osanai Kaoru, a producer of modern theater (shingeki), to head the Shochiku Cinema Institute. From the early 1920s, film studios and film directors adopted the Hollywood practice of spoken dialogue titles even though they were superfluous to narrative comprehension.

With the arrival of talkies in Japan in the late 1920s, studios sent personnel to the United States to study the new technology. Behind the scenes at Shochiku, Kido Shiro pushed hard to reverse-engineer sound recording, resulting in the first successful all-talkie in Japan, The Neighbor's Wife and Mine (Madamu to nyobo, Gosho Heinosuke) in 1931.[18] In the midst of a worldwide depression, cinema musicians as well as benshi could see the writing on the wall: they organized multiple strikes, perhaps the largest in the spring of 1932, mainly to secure more favorable redundancy terms.[19] Although the introduction of sound film exhibition as well as sound film production in Japan was rocky and complex, it was widely believed that the talkie was inevitable.

Even so, Ozu was committed to the silent film. He said he wanted to shoot the "last fade out of the silent film in Japan"—and therefore the world.[20] Although he agreed with the Pure Film Movement's goal of self-contained narration, for Ozu the talkie merely replaced one source of interference (the benshi) with another—the actor. As he declared in 1934, "[I]n the silent film,

facial expression belongs to the actor but titles are controlled by the intention of the film director. But in the talkie the dialogue becomes just part of the (actor's) expression . . . the value of the whole film depends on the skill of the actor."[21] Perhaps in response to those talkies, titles in Ozu's surviving silent films show a drive toward wresting mimesis from the actor's pantomime *and* the benshi's vocal coloring, competing with both those performers for control of the film's expressivity. From the beginning, Ozu's titles are strongly mimetic of Japanese vernacular speech, full of student neologisms such as *shan*, borrowed from the German expression *schönes Mädchen* (pretty girl) in *Days of Youth* (*Gakusei romansu: wakaki hi*, 1929). When Tokiko holds up her boss in *Dragnet Girl* (*Hijosen no onna*, 1933) she demands one hundred yen, saying, "Make it Shotoku Taishi" after the early constitutionalist on the one-hundred-yen bill—akin to demanding "Benjamins." Ozu was known for using the most accomplished actors in the studio, but his desire to control the relation of film and audience, so that he could make it subtler and more sophisticated, caused him to resist the actor as well as the benshi, as testified by the many stories of Ozu's demands on the performers. What we see in the intertitles in Ozu's films is not just a necessary hybridity but the mark of his independence as a filmmaker, an independence he was loathe to abandon. The remainder of this essay will trace Ozu's ambition to create a new form of silent cinema in his use of intertitles.

EARLY FILMS

As Noël Burch has noted and Yuki Takinami shows at length, Ozu was a strong reader of Hollywood découpage. *Eiga hyoron* critic Fukui Keiichi recognized Ozu's talent early on: "The person who brought that 'brightness' [of Hollywood cinema] to Japanese cinema is Ozu Yasujiro, a new Kamata filmmaker."[22] As Ozu himself said in 1931, "For a long time in the US there have been many films, like Chaplin's and Lloyd's, full of brightness and cheerfulness, gags and nonsense, broad satire and irony. I've never seen anything like that in Japan."[23] *Days of Youth*, Ozu's earliest surviving, slapstick-influenced college film, emulates the relatively abstract nonsense gags of Harold Lloyd comedies such as *Speedy* (1928) that feature similarly few intertitles (11 percent vs. Ozu's 9 percent). An even more specific intertextuality can be found in the Japanese translation of famous intertitles such as "I'm a very remarkable fellow!" from *7th Heaven* (Frank Borzage, 1927).[24]

In other words, Ozu's homage to Hollywood style in his early films extends to the content and syntax of his intertitles. For instance, the syntax of *Days of Youth* is constructed in a relatively orthodox manner: as in Hollywood films, spaces of conversation are articulated through eye-line matches and shot-reverse shots; intertitles are almost always preceded by a shot of the speaker and followed by another shot of the speaker or a shot of the listener.[25] Closer attention to

the syntactical patterns of intertitles within Ozu's work highlights the subtle salience of instances that break the pattern. For example, one of the only titles surrounded by neither speaker nor listener appears when Watanabe comes back to his apartment to see Chieko only for the landlady to tell him she's not there. That title is bracketed by two shots of Watanabe's shoes, pointing out (albeit indirectly) his sudden loss of interest as he unties, and then ties, the laces. This seems to me a kind of homage to Ernst Lubitsch's business with hands and feet in *The Marriage Circle* (1924—perhaps the film to which Ozu referred most often), but it also hints at some kind of parallel between the unstructured promise of second-floor romance and the motion of tying and untying. This, I claim, is what Ozu means by the "irony" that allowed the Hollywood films he admired to show without telling, to say more with less, and what later led one *Chuo koron* critic to call him "the film director who is most like an artist."[26]

Entering the 1930s, the ratio of intertitles in Ozu's more serious salaryman films increased to match those of Hollywood dramas with one exception: the expressionist crime film *That Night's Wife* (1930). We can certainly see echoes of influential Hollywood films such as *Underworld* (Josef von Sternberg, 1927) in the film's opening sequence, but at 6 percent, the paucity of intertitles matches the ideal of the "titleless film" represented by F. W. Murnau's *The Last Laugh* (*Der Letzte Mann*, 1924, released in Japan in 1926), or Murnau's later *Sunrise* (1927) at 5 percent of intertitles, or Joe May's proto-noir *Asphalt* (1929) at 8 percent. Indeed, *Asphalt* was a major touchstone for Ozu and his friends. It was a big hit in Japan, and Noda Kogo acknowledged its influence on the reduction of titles in *That Night's Wife* in a postwar round table with Ozu. Ozu replied to Noda's observation that he had written the latter film after seeing the former, and that they both contained only around forty titles by saying, "we used to think of titles as explanation, not expression. We didn't think it was pure to rely on titles So we tried to reduce them."[27] However, that aesthetic project lasted only for one film. Rather than the reduction of intertitles, it is their *proliferation* that characterizes Ozu's late silent films: in place of the silent cinema goal of pure visual narration, Ozu used the slow sound transition, during which silent films were exhibited alongside various forms of sound film, to experiment with intertitles as form of visual repartee.

1933

As Noël Burch observed, Ozu's editing became more radical around the time of *Woman of Tokyo*. It may not produce the "jolt" that Burch claims, but clearly the films are increasingly organized by principles other than continuity of screen direction.[28] Surely this is part of Ozu's project to create a "new form of silent cinema" even as the medium disappeared. *Donden* cuts across the "line of action" (the 180-degree line) in conversation scenes first appear in

Tokyo Chorus (*Tokyo no korasu*, 1931) and, after *Woman of Tokyo*, they are as common as "correct" shot-reverse shots. By crossing the 180-degree line, the orientation of the speaker in one shot (for example, facing left) matches the orientation of the speaker in the reverse shot, creating a portrait-like compositional equivalence between interlocutors at the expense of a clearly articulated dramatic space. This is part of what contemporary reviewers called Ozu's "photographism" (*shashinshugi*).[29] However, Ozu's formal experimentation with conversation scenes were not limited to the photographic sections of the image track but also included intertitles.

Ozu recalled in later years that he had always wanted to be a director, but since there was no place for him, he had joined Shochiku as an assistant cameraman. He gained a lot of experience in editing and construction, such as the placement of "cut backs" and intertitles, because release prints were made by editing prints of a rough master negative, and he was required to put together one print of each film.[30] David Bordwell has noted the ratio of intertitles in Ozu's early 1930s films hovered around 12 percent, close to the Hollywood average of 14 percent, only to suddenly increase in 1932–1933 to 27 percent. Bordwell ties this proliferation to experiments in intertitle narration shared with other directors of silent films in the sound film period such as Gosho Heinosuke, giving an example from *The Dancing Girl of Izu* (*Izu no odoriko*, 1933) that breaks with the typical Hollywood syntax of speaker-title-speaker or speaker-title-listener.[31] That syntax was established in Hollywood films in order to tie written speech to an image of the speaker, a primitive kind of synaesthesia that made it easier to follow the film's "dialogue." Bordwell is correct that Japanese diction already contains markers of gender and status that indicate the speaker more clearly than in English, but Ozu's films stand out from those of his contemporaries in their syntactical adventurousness. Bordwell is also correct that *The Dancing Girl of Izu* disrupts this syntax, usually by interposing an inanimate object between the speaker and the title (about 8 percent of the titles), but in my analysis the vast majority (71 percent) of the film's titles follow the speaker-title-speaker syntax of Hollywood cinema. Other Shochiku films such as *Marching On* (*Shingun*, 1930), like Hollywood films, typically prefer speaker-title-speaker intertitle syntax over speaker-title-listener in dialogue scenes, and they use those two sequences to the almost complete exclusion of any other combination. However, in *Woman of Tokyo*, only 22 percent of the intertitles follow the speaker-title-speaker syntax, while 7 percent of the titles are bracketed by shots of the *listener*, not the speaker, a syntactical construction of which I can find only one instance in Ozu's surviving earlier films, in *Where Now Are the Dreams of Youth?* (*Seishun no yume ima izuko*, 1932).

Woman of Tokyo was Ozu's *shinpa* film, a quickie melodrama shot in eight days without a finished script, dealing with emphatic emotions at a closer shot scale than any of Ozu's other silent films.[32] This was the film Ozu was

thinking of when he recalled in a postwar interview that he had started to incorporate talkie effects into his late silent films by "inserting a shot of A's dialogue into a shot of B listening."[33] In other words, in *Woman of Tokyo*, even before the ratio of intertitles increased drastically (it was still less than 18 percent), Ozu created something like a "reaction shot" with the "off-screen" dialogue cut into the image track instead of recorded on the soundtrack.[34] Of the eight sequences in the film to follow the listener-title-listener pattern, two are of the policeman receiving information about Chikako. The remaining six sequences take the place of off-screen dialogue, cut into a single reaction shot (sometimes the same shot, sometimes a minutely different setup) of Chikako or Harue. Those reaction shots focus our attention on their suffering, as when Harue confesses to Chikako that she told Ryoichi of the rumors about her, or when the newspaper reporter asks the grieving Harue what Ryoichi meant to her.

Woman of Tokyo does not start a title on the listener unless it ends on the listener too, but the next two films that Ozu made in 1933, *Dragnet Girl* and *Passing Fancy*, feature around 10 percent each of listener-title-listener and listener-title-speaker sequences. I have not found any other filmmaker at Shochiku who does the same: despite occasionally interposing an object between the speaker and the title, Gosho's *The Dancing Girl of Izu* has less than 1 percent of listener-title-listener sequences, and less than 2 percent of sequences that start on the listener and end on the speaker. No benshi scripts survive for Ozu's films, so we do not know what role the benshi played in relation to Ozu's experiments with intertitle syntax. Critics seldom saw films in the cinema, instead watching them in major cinema screening rooms seated alongside the benshi, who were not performing but watching the films that they would accompany the following week. For that reason, the critics generally made no comment on the sonic conditions of the films' exhibition, restricting themselves to praising Ozu's "delicate cinematic sensibility" and his talkie-like dialog titles, as well as their impatience that he had not yet made a full-blown talkie.[35]

Asked in the same round table whether Okada Yoshiko's dirty socks in *Woman of Tokyo* were intentional, Ozu replied dryly, "[M]ost things I do are intentional."[36] In that light, we should explain not only the increase in the number of titles in Ozu's silent films after *Passing Fancy*, but the sudden return to orthodox intertitle syntax in Ozu's last two surviving silent films, *A Story of Floating Weeds* and *An Inn in Tokyo*. Whereas unconventional syntax proliferates in the films of 1933 and in *A Mother Should Be Loved* (*Haha o kowazu ya*, 1934), in his last two surviving silent films, almost 90 percent of the intertitle sequences follow the standard Hollywood syntax. In the critical discourse on Ozu's films, then and now, there is almost no mention that these films (as well as the lost *An Innocent Maid* and *College Is a Nice Place*) were made as "sound versions"—films shot silent and released with a soundtrack of recorded music,

sound effects, and silence as a segregated space for the vocal performance of the benshi. The soundtracks to all but one of Ozu's "sound versions" have been lost, so that the aural environment is difficult to reconstruct, and since no benshi scripts to Ozu's films survive, the benshi's contribution is also hard to calculate. We only know that these formal differences made a difference to Ozu, and we must rely on the surviving soundtrack to *An Inn in Tokyo* as well as commentaries in nonspecialist magazines, written by critics who *did* see the films in the cinema, in order to speculate on what that difference might be.

THE SOUND VERSION

In her work on Mizoguchi's *Downfall of Osen*, Chika Kinoshita has argued that the slow transition to sound in Japan was exacerbated by the uneven conditions for screening films in urban and rural areas. Since few prints of films were struck, it was difficult to amortize the cost of synchronized sound, or even "sound version" production. Only in 1935 were most cinemas wired for sound; until then, many sound films were played silent (that is, with nonsynchronized music and a benshi) in the provinces.[37] However, there was another kind of unevenness at work in Japanese cinema: Shochiku and Nikkatsu were more highly capitalized than other studios in the early 1930s, and they moved to wire their cinemas for sound far more quickly than cinemas tied to smaller studios such as Shinko and Daito. Since the studios also wired the larger cinemas for sound first, by October 1933, 85 percent of Shochiku cinema seats in Tokyo were wired for sound. In Osaka, the figure was 87 percent, and even in more rural Yamagata it was 62 percent.[38] The bottleneck for large studios such as Shochiku and Nikkatsu was not the cinemas but the production facilities required to produce synchronized sound films. In 1934, Nikkatsu opened its new studio near the Tama river, and Shochiku announced that it would build the Ofuna studio and open it in 1936. Except for *Until We Meet Again* (*Mata au hi made*, 1932), Ozu's sound versions were all made after November 1934. This meant he could expect the great majority of his audiences to be auditors of his sound design as well as viewers of his images.

The Shochiku studio defeated its benshi in a major strike during the spring of 1932. The technologies that had extended benshi celebrity beyond the cinema in Japan had brought about his downfall: although the process was highly uneven, records began to replace live orchestras in Japanese cinemas after 1929, and sound recording and radio amplification technology formed the basis of the American and European sound cinema that was established in Japan by 1932.[39] Between 1932 and 1936, Shochiku used a growing number of "sound version" films to further displace the benshi and to enhance commercial tie-ups between film and the popular music industry. Kido Shiro said that the sound version obstructed the benshi's narration and was a "fatal blow"

to both benshi and live musicians (a good thing, from Kido's perspective).[40] Using a database of films provided by the Japanese Agency for Cultural Affairs (*Bunkacho*), it is clear that the production of sound versions matches the production of talkies in Japan, and even exceeds them at the Shochiku studio, between 1931 and 1935. It is also clear that 1936 was the first year in which the majority of Japanese films were produced with synchronized sound.[41]

By 1936, the benshi had vanished from the promotion that surrounded films—newspaper advertisements, posters outside the cinema, and film programs that were distributed freely inside. It is not clear, however, whether they had actually vanished from the cinemas: yes for cinemas showing Western films, but surely not for the smaller or provincial cinemas that specialized in Japanese films and particularly those aligned with small studios that produced many period films (*jidaigeki*). But would there have been a benshi in the urban Shochiku cinemas, with their large complement of talkies and sound versions that played alongside Ozu's *A Story of Floating Weeds* and *An Inn in Tokyo*, as well as the lost *An Innocent Maid* (1935) and *College Is a Nice Place* (1936)? Whether or not the benshi was actually present, I argue that Ozu made his late silent films *as if* they were not.

Unlike the benshi track on Mizoguchi's *The Downfall of Osen*, it seems that Ozu's films were simple "sound versions"—films with recorded music and sometimes sound effects, which would mostly have played in cinemas already equipped for sound. The role of the benshi in that new cinema soundscape is still unclear. Although latter-day benshi performances are amplified and mixed with live or recorded music, it seems that the unamplified benshi of Japanese silent cinema tended not to speak over the music. It must have been even more difficult for the benshi to speak over recorded soundtracks, which originated in the projection booth rather than the orchestra pit. As Kinoshita notes, quoting Jeffrey Dym's observation that the benshi tended not to speak over the orchestra, "The [latter-day] benshi's nonstop voiceover on the sound-track is an invented tradition made possible by the technology of mechanical reproduction."[42]

Ozu was criticized regularly for his failure to use sound creatively in his sound version films. Art critic and academic Itagaki Takaho thought the use of the sound of a steam train over the scene of the troupe arriving at the beginning of *A Story of Floating Weeds*, so that dialogue had to be rendered as intertitles, was a cheap gimmick and wondered why Ozu would show scenes of singing (*A Story of Floating Weeds*) or marching (*College Is a Nice Place*) and not match the image to the soundtrack.[43] It is not clear exactly what music Ozu used for these films, though two theme songs for *A Story of Floating Weeds* were announced in a newspaper and could have played over any of several long passages without intertitles, including the scene Itagaki points

out of the troupe drinking together before they disband.[44] Also, at least one account argues that Ozu used the non-diegetic music on the soundtrack to foreground his rhythmic editing. In an essay on *A Story of Floating Weeds* in *Kinema shuho*, Keio University Film Study Group member Hayashi Koichi argues that interiority in an Ozu film is expressed by its visual rhythm, and that the emotional tone of the fishing scene is sustained by the music as well as the images.[45] The sequence alternates shots of the synchronous gestures of father and son fishing with comic dialogue intertitles (twelve of thirty-three shots) in which the son mocks his real father, who he thinks is his ne'er-do-well uncle. The presence of music in this sequence would obstruct the benshi's commentary. In general, music in these films seems to have served a suppressive rather than expressive function: to quiet the benshi and allow the audience to create dialogue synaesthetically, by reading the titles. Perhaps this lack of musical expression that Iwasaki Akira, a Marxist critic who had regularly criticized Ozu for his insufficient radicalism after *I Was Born, But . . .*, attacked in his 1936 book *The Art of Film*:

I recognize that Ozu Yasujiro is a world-class silent film artist, but I discovered in *A Story of Floating Weeds* that he is completely tone deaf. Perhaps he simply treated the film as silent and took no responsibility for the soundtrack. But no one with any musical sense could allow music like that to sully and destroy the film he had worked so hard to make.[46]

Like Hollywood and most Japanese silent films, Ozu's next surviving silent film (sound version), *An Inn in Tokyo*, tends to introduce an intertitle with a shot of the speaker, often visibly speaking, and then follow it with another shot of the speaker, or a shot of the listener. Ozu gives us a clue to his method in an earlier comment he made contrasting silent films and talkies. In a round table, he agreed with Kitagawa Fuyuhiko that titles were frustrating, since it was impossible to represent an incisive "parting shot" (*sutezerifu*) with a title.[47] Yet six months later, in *An Inn in Tokyo*, that seems to be exactly what Ozu is trying to do. It seems to me that Ozu made this film as an aesthetic project, to be played with no benshi, or at least with a benshi suppressed by Ito Senji's commissioned score. In an early sequence of, we can see Ozu developing something like informal "repartee," using music to quiet the benshi (and to set a despondent tone) while the rhythm and syntax of the intertitles creates a flow of banal speech that is interrupted for dramatic effect.

The leftist intellectuals who watched Ozu's films while protesting that they never watched Japanese films complained that *An Inn in Tokyo* did not show enough of the factory conditions under which the father occasionally worked, and that the child actors, in particular, were too clean.[48] But Ozu seems to be aiming for something less programmatic, or more phenomenological: a wry

depiction of precarity and fecklessness conveyed through a synaesthetic experience of (audio)visual narration. *An Inn in Tokyo* steers between the proletarian film (that in any case had been suppressed by 1935) and the typical Shochiku melodrama that ended in reconciliation between clearly delineated bourgeois, petty bourgeois, and proletarian groups. In an early scene, the homeless father and his two sons walk across a wasteland, hungry. He asks them what they would like to eat: their lack of ambition is a sign of their genuine hunger, but after some uncomfortable moments, the children ask the father what he would like, and he replies that he would prefer a drink. Water? the older son asks—no, alcohol. In that case, no way! says the son, and the scene winds down.

Critics only mentioned intertitle frequency in Ozu's films to complain: saying, for example, that *An Inn in Tokyo* has "twice as many titles as it needs."[49] This simple sequence consists of thirty shots: longer establishing and concluding shots and then a series of twenty-seven short takes (the titles average only 1.8 seconds, the images slightly longer) that alternate photographic image and intertitle, all overlaid with Ito's lachrymose score. Quite remarkably for Ozu, most of the shots are tracking shots, which serve less to dynamize the image than to keep the figures static against the industrial backgrounds. This counterintuitive use of low-level tracking shots to reduce the movement of figures in the frame focuses our attention on the dialogue which, if the benshi is silenced by the music, we hear synaesthetically, by reading the titles.

The father says, in titles separated by a two-shot of the boys and a one-shot of the father turning around, "are you hungry?," "are you OK?," and "don't cry" (fig. 6.1). A pattern of alternation (speaker-title-listener, who then becomes speaker) is set up, only to be broken. After the "don't cry" title, the cut to a two-shot of the boys, similar to but more despondent than the previous two-shot, and then to a one-shot of the father almost identical to the previous one-shot, is not separated by an intertitle. The lack of an intertitle between the shots become a kind of *silence* that focuses our attention on the children's misery and the father's recognition that he is unable to help. The only other "missing" intertitle in the sequence is between shot 17 and 18: we see the father repeat the question that started a brief comic fantasy about eating rice balls and chicken and egg dishes with his older son: what do you want to eat? But the child's plaintive reply ("anything will do") leads to a slightly longer shot of the father, emphasizing his guilty displeasure: talking about food is no longer funny. The next shot, a title of the older son's question—"what would you like to eat, dad?"—is the first time in the sequence that a title has followed a shot of the listener, not the speaker. This slight rupture in the syntactical routine focuses our attention on the discomfort the father feels, and gives us the sense that the son is *changing the subject* when he turns the questions around, especially since the camera now cuts out to a long shot that includes both speaker and listener, and the tone of the sequence turns toward the absurd.

Figure 6.1.
Kihachi, Zenko, and Masako exchange words while walking across a wasteland early in *An Inn in Tokyo* (*Tokyo no yado*, Ozu Yasujiro, 1935).

Nothing much happens in this sequence, but without the interpretation of the benshi, who is suppressed by the soundtrack, Ozu's "delicate cinematic sensibility" is visible, and audible, in the pacing and placing of intertitles more than facial expression or composition, which are for the most part unchanged.

CONCLUSION

The cultural permeability of cinema to international influences during the transition to sound did not lead to homogenization but to a proliferation of forms. The difference in material conditions between Japan and the United States promoted strategies of reverse-engineering and intermedial compounds of recorded music and live voice, but also a medium-conscious use of music to displace the external narration of the benshi and focus audience attention on the image track alone. Ozu wanted to make a "new form" of silent cinema (which had never existed in Japan because of the benshi) before it disappeared—something sophisticated in a fragile medium that was forced to do obvious things. By silencing the benshi in *An Inn in Tokyo*, Ozu could obstruct the bathetic reduction of the benshi's populist emotional amplification—not by replacing emotion with critical distance but by allowing it to "float" as the unspoken disappointment behind banal dialogue, heard synaesthetically in the rhythm of alternating titles and images in a lyrical mise en scène. In Ozu's hands, Japanese silent film briefly *became* "silent"

at the point of its disappearance, by virtue of becoming a "sound" cinema. Thus, an aesthetic project focused on medium specificity emerged from the "conjunctural intermediality" of film, radio, and recorded music—from the changed protocols of sound and image during this transitional period, regardless of their actual implementation. In this period in which Western cinema had already switched to the talkie and Japan was in the process of doing so, Ozu took advantage of the brief hiatus between benshi-dialogue cinema and talkie-dialogue cinema to invent something like Hollywood silent cinema in Japan: a visual mode of narration with musical accompaniment and dialogue carried on the visual track as intertitles. Ozu used the "sound version" to *shut the benshi up*. His goal was to create, for the first and only time in Japanese cinema, films in which audible dialogue was displaced in favor of the intertitle as a form of "visual repartee."

NOTES

1. Quoted in *Ozu Yasujiro zenhatsugen: 1933–1945* [Ozu Yasujiro: Collected statements, 1933–1945], ed. Tanaka Masasumi (Tokyo: Tairyusha, 1987), 15.
2. Ozu Yasujiro, "Nihon eiga kantoku kyokai to Stanbāgu kangei no ichiya," [The Directors Guild of Japan and the welcome night for Josef von Sternberg], *Kinema junpo*, September 11, 1936; reprinted in Tanaka Masasumi, *Ozu Yasujiro zenhatsugen: 1933–1945*, 85–86.
3. Ozu's only contribution to the journal was to a round table published in the second issue. For a discussion of the journal and its place in Japanese film culture, see Iwamoto Kenji, *Nihon eiga to modanizumu 1920–1930* [Japanese cinema and modernism 1920–1930] (Tokyo: Riburopoto, 1991), 81–83.
4. For the development of "Kamata-cho" as the house style of the Shochiku studio around 1930, see Yuki Takinami, "Reflecting Hollywood: Mobility and Lightness in the Early Silent Films of Ozu Yasujiro, 1927–1933" (PhD diss., University of Chicago, 2012), 52–82.
5. David Bordwell, *Ozu and the Poetics of Cinema* (Princeton, NJ: Princeton University Press, 1988); Noël Burch, *To the Distant Observer: Form and Meaning in the Japanese Cinema* (Berkeley: University of California Press, 1979).
6. Takinami, "Reflecting Hollywood."
7. *Ozu Yasujiro zenhatsugen: 1933–1945*, 15. Ozu is referring to Yamanaka's lost *Koban shigure* (1932) in which the titles accompany a hat as it drifts down the river, establishing a new location. Shimizu Hiroshi also provides some powerful and amusing examples of expository titles in *Japanese Girls at the Harbor* (*Minato no Nihon musume*, 1933).
8. See J. L. Anderson, "Spoken Silents in the Japanese Cinema; or, Talking to Pictures," in *Reframing Japanese Cinema: Authorship, Genre, History*, ed. Arthur Nolletti and David Desser (Bloomington: Indiana University Press, 1992), 259–311. In *Benshi, Japanese Silent Film Narrators, and Their Forgotten Narrative Art of Setsumei: A History of Japanese Silent Film Narration* (Lewiston, NY: Edwin Mellen Press, 2003), Jeffrey Dym sees the benshi's "art of setsumei" as more tied to and reinforcing of narrative than does Noël Burch (75–80). More recently, scholars

have recognized that the benshi's popularity was subsumed as part of a larger apparatus in the 1920s; see Fujiki Hideaki, "Benshi as Stars: The Irony of the Popularity and Respectability of Voice Performers in Japanese Cinema," *Cinema Journal* 45, no. 2 (2006): 66–84.

9. Isolde Standish, "Mediators of Modernity: 'Photo-interpreters' in Japanese Silent Cinema," *Oral Tradition* 20, no. 1 (2005): 103.

10. Fujiki, "Benshi as Stars," 77.

11. See for example Iwamoto Kenji, *Jidaigeki densetsu: chanbara eiga no kagayaki* [The jidai-geki tradition: The brilliance of chanbara films] (Tokyo: Shinwa-sha, 2005), 107. Ito was particularly interested in "modernizing" the intertitle while at Shochiku, visiting the Yokohama customs house to make notes on their use in imported films and insisting that his films be presented by a solo benshi, not the old practice of dubbing voices (*kowairo*) by a group of male, female, and child benshi. See, for example, Saiki Tomonori, ed., *Eiga dokuhon Ito Daisuke: Hangyaku no passhon, jidaigeki no modanizumu* [Reader's guide to Ito Daisuke: Passion of resistance, Jidaigeki modernism] (Tokyo: Film Art sha, 1996), 51. Ito's animus toward the uneducated benshi is supposed to have extended to deliberately putting hard-to-read characters into his intertitles. My thanks to Moriwaki Kiyotaka of the Museum of Kyoto for that anecdote.

12. See Chika Kinoshita, "The Benshi Track: Mizoguchi Kenji's *The Downfall of Osen* and the Sound Transition," *Cinema Journal* 50, no. 3 (2011):15.

13. Kitada Rie, "Tokii jidai no benshi: gaikoku eiga no Nihongo jimaku arui wa 'Nihonban' seisei o meguru kosatsu" [The Benshi in the talkie period: A consideration of 'Nihonban' or the Japanese subtitling of foreign films], *Eiga kenkyu* 4 (2009): 4–21.

14. Kinoshita, "The Benshi Track," 14.

15. For Matsui's claim, see Nakatani Giichiro, Tokugawa Musei, Mori Iwao, Suzuki Toshio, Takeyama Masanobu, "Hobun taitoru mondai zadankai sokki" [Notes on a Round-table on the Question of Japanese Language Titles] *Kinema shuho* (February 13, 1931): 28.

16. Kitada, "Tokii jidai no benshi," 17

17. For more on the Pure Film Movement and the disciplining of cinema by reformers and government bureaucrats, see Aaron Gerow, *Visions of Japanese Modernity: Articulations of Cinema, Nation, and Spectatorship, 1895–1925* (Berkeley: University of California Press, 2010); and Laura Lee, "Japan's Cinema of Tricks: Optical Effects and Classical Film Style," *Quarterly Review of Film and Video*, 32, no. 2 (2014): 141–161.

18. See Mori Iwao, Kitamura Komatsu, Gosho Heinosuke, Tachibana Koshiro, Nagata Mikihiko, Horiuchi Keizo, Fushimi Akira, Noguchi Tsurukichi, Kawaguchi Matsutaro, Kobayashi Kichijiro, "*Madamu to nyobo* o meguru Nihon tokii zadankai" [Round-table about *The Neighbor's Wife and Mine* and Japanese Talkies] *Kinema shuho* (August 7, 1931): 8, for a contemporary account of the Tsuchihashi's examination of the Power's Cinephone.

19. For more on sound reproduction in the cinema and the benshi as *dispositif*, see Michael Raine, "No Interpreter, Full Volume: The Benshi and the Sound Image in Early 30s Japan," in *The Sound Culture of Prewar Japan*, ed. Michael Raine and Johan Nordstrom (Amsterdam: University of Amsterdam Press, under consideration).

20. Ozu Yasujiro, Hazumi Tsuneo, Shigeno Tatsuhiko, Kishi Matsuo, Tomoda Jun'ichiro, Kitagawa Fuyuhiko, and Iida Shinbi, "Ozu Yasujiro zadankai" [Ozu

Yasujiro round table], *Kinema junpo*, April 1, 1935; reprinted in *Ozu Yasujiro zenhatsugen: 1933–1945*, 65. Ozu's dry humor aside, he claimed not to be averse to shooting sound film but was simply taking his time to study it, and had promised his cameraman Shigehara Hideo that he would not make a talkie until he could use Shigehara's own Mohara-shiki sound system (the Japanese characters for Shigehara's name were colloquially read as Mohara). The system was used on the short documentary *Kagamijishi* (1935) and *The Only Son* (*Hitori musuko*, 1936), and then Ozu switched to the Tsuchihashi system like the rest of the Shochiku directors.

21. See *Ozu Yasujiro o yomu: furuki mono no utsukushii fukken* [Reading Ozu Yasujiro: the Beautiful Rehabilitation of Old Things] (Tokyo: Film Art sha, 1982), 25.

22. Fukui Keiichi, "Ozu Yasujiro to sono sakuhin" [Ozu Yasujiro and his works], *Eiga hyoron* 9, no. 1 (July 1930): 28; quoted in Takinami, "Reflecting Hollywood," 35.

23. Ozu Yasujiro, "Ojo-san e no jishin" [Confidence in *Ojo-san*], *Eiga no tomo*, [Film friend], January 1931; quoted in Chiba Nobuo, *Ozu Yasujiro to nijusseiki* [Ozu Yasujiro and the twentieth century] (Tokyo: Kokusho kankokai, 2003), 84

24. For a development of this argument, see Michael Raine, "Adaptation as 'Transcultural Mimesis' in Japanese Cinema," in *The Oxford Handbook of Japanese Cinema*, ed. Daisuke Miyao (Oxford: Oxford University Press, 2014), 101–123.

25. For a description of that orthodoxy, see Bordwell, *Ozu and the Poetics of Cinema*, 66.

26. Omori Gitaro, "Eiga jihyo" [Film Review], *Chuo koron*, November 1936, 234. See also Takinami's discussion of Ozu's "taste for sophistication" in "Reflecting Hollywood," 21.

27. Ozu Yasujiro, Noda Kogo, Kitagawa Fuyuhiko, Nagata Seiji, Iida Shinbi, "Eiga geijutsu no tokusei o megutte" [On the special characteristics of film art], *Kinema junpo*, January 4, 1950; quoted in *Ozu Yasujiro sengo goroku shusei 1946–1963* [A collection of Ozu's postwar statements: 1946–1963], ed. Tanaka Masasumi (Tokyo: Film Art sha, 1989), 81.

28. For the argument about this breaking of the "trap of participation," see Burch, *To the Distant Observer*, 159.

29. See, for example, Tsumura Hideo's newspaper review (as "Q") of *Passing Fancy* in *Asashi shinbun*, September 8, 1933, 5.

30. Ozu Yasujiro, "Ozu Yasujiro geidan (dai ikkai)" [Ozu Yasujiro talks about his art (part one)], *Tokyo Shinbun*, December 5, 1952; quoted in *Ozu Yasujiro zenhatsugen: 1933–1945*, 253.

31. Bordwell, *Ozu and the Poetics of Cinema*, 67.

32. Ozu Yasujiro, "Jisaku o kataru" [Speaking of my films], *Kinema junpo*, June 1952; reprinted in *Besuto obu Kinema junpo 1950–1966* [Best of Kinema junpo 1950–1966], ed. Kinema junposha (Tokyo: Kinema junposha, 1994), 125. According to my analysis, 43 percent of the shots in *Woman of Tokyo* are MCU (medium close-ups); another melodrama, *A Mother Should Be Loved* (*Haha o kowazuya*, 1934), is second at 25 percent.

33. Ibid. Ozu misremembers the film as *An Inn in Tokyo* (1935), and Bordwell (*Ozu and the Poetics of Cinema*, 67) misidentifies it as *Passing Fancy* (1933), but, as we have seen, it was *Woman of Tokyo* that best matches Ozu's recollection.

34. Perhaps Ozu was taking a hint from the "X-versions" of Western talkies that played with intertitles, in English or in Japanese, cut into the film. Although the former were universally mocked, some critics defended the Japanese-language X-version, arguing that it was better to double the eye (with the image and Japanese titles) than the ear (with English dialogue and a benshi translation). See Mori

Iwao "Renga to hanataba (8)" [Brick and Bunch of Flowers (8)] *Kinema shuho*, February 27, 1931, 18 for a description of the X-version.

35. Philosopher Tanikawa Tetsuzo, joined by essayist Nii Itaru, in Ozu Yasujiro, Ito Senji, Arata Masao, Itagaki Takaho, Sata Ineko, Kitagawa Fuyuhiko, Oki Atsuo, Nii Itaru, Tanikawa Tetsuzo, Murayama Tomoyoshi, Narasaki Tsutomu, Hayashi Fumiko, and Yamane Kenji, in Ozu Yasujiro et al., "Kantoku Ozu Yasujiro 'Tokyo no yado' o kataru" [Director Ozu Yasujiro talks about "An Inn in Tokyo], *Jiji shinpo*, October 23–24, 1935; reprinted in *Ozu Yasujiro zenhatsugen: 1933–1945*, 68.

36. Ibid., 70.

37. Kinoshita, "The Benshi Track," 5.

38. For data on cinemas and their sound playback equipment, see the directories of cinemas, equipment, and capacities in Ichikawa Sai, ed. *Kokusai's Motion Pictures Year Book (Japan) 1934* (Tokyo: Kokusai eiga tsushinsha, 1934).

39. See Raine, "No Interpreter, Full Volume" (forthcoming).

40. Kido Shiro, *Nihon eigaden: Eiga seisakusha no kiroku* [History of Japanese cinema: Record of a film producer] (Tokyo: Bungei shunju sha, 1956), 87.

41. See https://www.japanese-cinema-db.jp/.

42. Kinoshita, "The Benshi Track," 14.

43. Itagaki Takaho, "Nihon Tokii eiga no gendankai," [The current level of Japanese talkies], *Chuo koron*, July 1936, 69. Perhaps the steam train is an "homage" to an important intertext of *A Story of Floating Weeds*, the part-talkie *The Barker* (George Fitzmaurice, 1928). That sound effect featured prominently in the sound version of the film, though it was imported to Japan as a silent print.

44. http://blog.livedoor.jp/oke1609/archives/50370216.html has a reference to the printing of the theme songs to *A Story of Floating Weeds* in the *Shizuoka minyu shinbun*, September 6, 1934.

45. Hayashi Koichi, "*Ukigusa monogatari* kara" [From *A Story of Floating Weeds*], *Kinema shuho*, December 14, 1934, 30.

46. Iwasaki Akira, *Eiga no geijutsu* [The art of film] (Tokyo: Kyowa shoin, 1936), 83.

47. Ozu et al., "Ozu Yasujiro zadankai," reprinted in *Ozu Yasujiro zenhatsugen: 1933–1945*, 64.

48. Ozu Yasujiro, Ito Senji, Arata Masao, Itagaki Takaho, Sata Ineko, Kitagawa Fuyuhiko, Oki Atsuo, Nii Itaru, Tanikawa Tetsuzo, Murayama Tomoyoshi, Narasaki Tsutomu, Hayashi Fumiko, and Yamane Kenji, in Ozu Yasujiro et al., "Kantoku Ozu Yasujiro 'Tokyo no yado' o kataru" [Director Ozu Yasujiro talks about "An Inn in Tokyo], *Jiji shinpo*, October 23–24, 1935; reprinted in *Ozu Yasujiro zenhatsugen: 1933–1945*, 70.

49. Philosopher Tanikawa Tetsuzo, cited in Tanaka, *Ozu Yasujiro*, 68.

Ozu and the Aesthetics of Shadow

Lighting and Cinematography in There Was a Father *(1942)*

DAISUKE MIYAO

INTRODUCTION

The critic Hasumi Shigehiko calls Ozu Yasujiro a "broad-daylight director," when he examines the weather manifest in Ozu's films.[1] Similarly, David Bordwell argues, "Ozu insisted on a bright, hard-edged look to evoke the crisply defined images he had visualized in his notebooks. Even a film noir like *Dragnet Girl*, which is shot in a lower key than most of his works, remains generally committed to a high-key tonal scale."[2] With such brightness, Ozu's films appeared to faithfully follow Shochiku's official slogan, "Bright and Cheerful Shochiku Cinema [*Akaruku tanoshii Shochiku eiga*]."[3] But is it not too simplistic to regard Ozu's films as just bright and cheerful? The policemen's white gloves in *That Night's Wife* (*Sono yo no tsuma*, 1930) look ominously too bright to me. Or the sky in *Tokyo Twilight* (*Tokyo boshoku*, 1957) is not sunny, but gloomy. The very emotional quarrel between Nakamura Ganjiro and Kyo Machiko in *Floating Weeds* (*Ukigusa*, 1959) occurs near the dark entryway of a house under the suddenly darkened sky, accompanied by rain.

It is not my intention to agree with Paul Schrader's rather extreme observation that he made during the 2003 symposium at Columbia University. As I recall, Schrader stated that we do not understand Ozu's films without reading Tanizaki's *In Praise of Shadows*. Nonetheless, if the cohesive image of Ozu in auteur criticism by far is the director who consistently uses high-key lighting, I would like to question and complicate it, by examining the technologies

and techniques of cinematography and lighting employed in *There Was a Father* (*Chichi ariki*, 1942). I hope to underscore the internal challenge that Ozu's films issued to the dominant mode of filmmaking at Shochiku, especially when the so-called aesthetics of shadow (*kage no bigaku*) was emerging as the dominant discourse in film criticism and practice. By doing so, I contest some of the premises of the deeply entrenched model of the canonized auteur especially prevalent in Japanese film studies. Most academic works on Japanese cinema have focused on either a historical survey of popular films or canonized auteurs, including Ozu. The assumption of auteur theory is that the oeuvre of an auteur can be analyzed to uncover recurrent themes and aesthetic patterns that demonstrate the cohesion of his or her vision of the world. What is most lacking in the existing scholarship on Japanese film is a perspective that considers films to be the products of collaboration that exist beyond the control as well as authority of an auteur. In my analysis of Ozu, I instead emphasize that cinema has been a collaborative, industrial, and cultural form.

BRIGHT AND CHEERFUL SHOCHIKU CINEMA AND THE AESTHETICS OF SHADOW

Commenting on Ozu's 1942 film, *There Was a Father*, critic and expert in film technology Tanaka Toshio pointed out, "[The film's] too strong high-key lighting did not give any sense of four seasons [in Japan]."[4] He lamented, "Why did he [Ozu] use high-key light to be 100 [percent of brightness] and shadow only one [percent]?"[5] Similarly, another critic Yoshida Kenkichi complained that *There Was a Father* was "too bright," especially in the night scenes and in the sequence at hospital when Horikawa (played by Ryu Chishu) dies, which "would distract viewers from feeling for the end of Mr. Horikawa's life."[6] In contrast, Tanaka praised Ozu's *The Brothers and Sisters of the Toda Family* (*Todake no kyodai*, 1941), which was released one year earlier, for its "unusual beauty" compared to other Shochiku films that "display grotesque whiteness only" with "too much exposure."[7] Tanaka continued, "If the executives of [Shochiku's Ofuna] studio are willing to acknowledge the tones of *The Brothers and Sisters of the Toda Family*, I can be hopeful that they will make every effort to maintain the level of the tones as good as this film. I think it is the duty of the studio because it represents the current filmmaking in Japan."[8]

It was not only *There Was a Father* whose bright tone of lighting was severely criticized. Shimazaki Kiyohiko of the Japanese Association of Film Technology (Nihon eiga gijutsu kyokai) was disappointed at the lighting scheme of *Tank Commander Nishizumi* (*Nishizumi sensha cho den*, Yoshimura Kozaburo, 1940), despite the fact that the film was selected as the second-best film of 1940 in the critics' poll in *Kinema junpo* as well as the most profitable film for Shochiku that year. He considered the interiors of the base camp, supposedly lit only by

candles, to be too bright and "unnatural."[9] Shimazaki concluded that the film's cinematography "ended up as superficial beauty" when it should have depicted the "real battlefields."[10] Kaita Seiichi, a news film cinematographer, who in reality had been in the battlefields with Nishizumi, agreed with Shimazaki and critically observed that the film's lighting for the night scenes in the battle-fields was "irresponsibly" too bright and too beautiful.[11]

A brief sketch of critical discourse on the films of the early 1940s shows that critics (and numerous cinematographers outside of Shochiku) were rather unanimously attacking the lighting and cinematography of Shochiku films around the year 1940. Among those critics, Tanaka Toshio was the most vocal. He called Shochiku films "overlit, overdeveloped, and hopeless" and cried out, "It is not even high key. It is so terribly white that actors' faces look like masks, or even remind us of death masks."[12] Tanaka denounced Shochiku's executives as being so used to their habits of insisting on "more brightness" that they did not understand the "beauty of darkness" and how "valuable and tasteful it is."[13]

Not all critics turned against Shochiku. Kido Shiro defended Shochiku films as "bright, healthy, and entertaining," emphasizing their value in Japanese society. Kido states,

What? Are Shochiku films produced at its Ofuna studio excessively bright? Are they lacking contrasts? It is not fruitful to say such things. Cinema must be bright. I don't want to say bad things about Toho films, but they say that *The Battle of Kawanakajima* [*Kawanakajima kassen*, Kinugasa Teinosuke, 1941] is so dark that they cannot see it well. I am against making such a film. Shochiku films are clearly visible in any local the-aters of any regions. It is the most important issue Look at American films anyway. They are brighter than Ofuna films. Cinema should be bright in nature.[14]

Taketomi Yoshio, a Shochiku cinematographer, echoed Kido's claim. According to Taketomi, the Ofuna studio as a whole was aiming for bright tones because many of their projects contained "healthy" and "constructive themes," such as respecting family values and promoting a good work ethic. Their choice was necessitated by the themes of the films, and it was not for brightness per se on the surface. Taketomi concluded, "It is important for healthy films to have bright tones. Our efforts lie in how to express thematic motifs, and construc-tive themes are necessitated by the nation and expected by its people. I believe that the brightness of Ofuna films might not be artistic but practical and use-ful to society."[15] Kido and Taketomi were trying to endorse Shochiku's con-vention of filmmaking that was explicitly addressed by its company slogan, "Bright and Cheerful Shochiku Cinema."

The diverging critical discourses on the aesthetic and/or national value of "Shochiku style" cannot be properly appreciated, unless they are contextu-alized within the adamant style that Shochiku promoted. Shochiku initially

modeled itself after Hollywood when its own film studio was established in Kamata, Tokyo in 1920. Shochiku, aspiring to catch up with the standard of foreign films, to make its own products exportable, and to become competitive with the Hollywood film industry, was preordained to adopt the American-style, capitalist-industrial modernity, and the Hollywood production system, including filmmaking techniques and technologies, distribution practices, and the star system. The company invited various technicians from Hollywood, including a cinematographer "Henry" Kotani Soichi. What Kotani brought from Hollywood was expressive lighting. Working as a cinematographer in Hollywood in the 1910s under the renowned filmmaker Cecil B. DeMille, Kotani mastered the so-called Lasky lighting, which the film historian Lea Jacobs defines as "confined and shallow areas of illumination, sharp-edged shadows and a palpable sense of the directionality of light."[16] However, as I have discussed elsewhere, it did not take long for Shochiku to turn to their own kabuki roots when producing their films, especially in terms of lighting.[17] In kabuki, flat frontal lighting is used almost exclusively in order to evenly illuminate the entire stage, eliminate shadow as much as possible, and make onstage actions visible to the spectator. While Kotani introduced the expressive style of lighting from Hollywood, Shochiku decided not to fully adopt it. Shochiku did not want such expressivity because it cost much more to achieve it. In addition, general audiences did not seem to appreciate it. It was Shochiku's decision based on its policy of rationalization and its attitude toward modern audiences. Expressive photographic images were not Shochiku's top priority. Lighting had to follow the kabuki convention. Kotani left the Shochiku Kamata studio as early as 1922, less than two years after his celebrated arrival. The goal of Shochiku's film production was to produce "bright and cheerful" films. In addition to the bright and cheerful feeling, the "brightness" also guides its cinematography. In June 1922, after he left Shochiku's Kamata studio, Kotani disappointingly claimed, "In general, a cinematographer [in Japan] is only allowed to use the best of background, to make images cleanly visible He should not go beyond those."[18] As Shochiku became the most financially successful film company by the mid-1930s, their flat and bright lighting became the dominant mode in mainstream Japanese films, with the exception of challenges from the popular period drama (jidaigeki) genre.[19]

It was this style of lighting and cinematography that dominated Shochiku and that critics and non-Shochiku cinematographers began to oppose around 1940. It was a critical moment in the history of Japanese filmmaking when Shochiku's bright and cheerful cinema faced a challenge within the film industry, even though Shochiku had never lost popularity with general audiences. The box office record suggests that even in 1943, Shochiku's box office revenue of 9,903,392 yen was almost equal to Toho's 10,351,679 yen.[20] The criticisms of Shochiku films often emphasized their lack of Japaneseness despite the

fact that the film styles of Shochiku were rooted in kabuki. Tsumura Hideo of the *Tokyo Asahi shinbun* newspaper called Shochiku's *Aizen katsura*, the top film of 1938, "a banal and outdated tearjerker" and claimed that Shochiku films of this sort did not "seem to have the intention of working actively for the Japanese culture."[21] The rise of the discourse of the aesthetics of shadow that was leveled against Shochiku could be attributed to the rise of militarism and governmental control over film content, especially after the Film Law was promulgated on April 5 and enforced on October 1, 1939.

However, as I have demonstrated in *The Aesthetics of Shadow: Lighting and Japanese Cinema*, the aesthetics of shadow was not simply a nationalist and traditionalist project but a discourse that emerged as an amalgam of multiple desires: adoration of Hollywood cinema, desperation for material conditions in Japanese filmmaking, and rivalry between film companies, among others. There were Japanese cinematographers who adored the low-key lighting in Hollywood cinema. They despaired at the limited material conditions in Japanese cinema compared to Hollywood both financially and technologically. There also existed a strong rivalry between Toho and Shochiku. When Japanese cinematographers realized that it would be difficult to achieve such low-key cinematography of Hollywood style under the deplorable conditions of wartime Japan, they turned to one aspect of Japanese art—the use of shadows, which was easily available. They justified their newly adopted aesthetic practices in the name of the "Japanese characteristics in cinematographic technology."[22] In other words, they strategically connected the aesthetics of shadow to a nationalist discourse. As I discussed in my book, the aesthetics of shadow did not stem from the traditional Japanese aesthetics, but instead was a form of expanding the generic and compositional lighting from Hollywood. The advocates of the aesthetics of shadow justified their lighting scheme, which had originated in Hollywood, by resorting to the appreciation of shadow and darkness in Japanese architecture.

Shochiku films were then criticized for not being Japanese enough because they were not dark. What divides the aesthetics of shadow, originally addressed by the cinematographers at Toho and critics who tried to challenge the dominance of Shochiku in the film industry from the bright and cheerful style of Shochiku cinema, however, was not between Japaneseness and Americanism. In order to challenge Shochiku's dominance, the Toho group formulated the discourse and the practice by bending Hollywood cinematography in the name of realism, documentarism, and national Japanese aesthetics. Yet, when Hollywood films represented a medium of the enemy, especially after the Japanese attack on Pearl Harbor, such a conflict was consciously turned into a strategically constructed dichotomy: the aesthetics of shadow was the cultural document of Japan, and bright cinema was the vulgar entertainment and the representative of Americanism.[23] How was Ozu's 1942 film, *There Was a Father*, produced and received under such political and industrial conditions?

OZU'S EXPERIMENTS IN CINEMATOGRAPHY: *THERE WAS A FATHER*

As noted earlier, *There Was a Father* was extensively criticized for its lighting style by those who advocated for the aesthetics of shadow. Ironically, *There Was a Father*, which was produced as a Bureau of Information's National Film, received an award from the Bureau as an outstanding film and was selected as the second-best film of 1942 by the Japanese Association of Film Journals (Nihon eiga zasshi kyokai). This is evidence of how multifaceted and even contradictory Japanese film culture—often believed to be unilateral under ultranationalism and militarism—actually was during the war. More importantly, one must note that Ozu's films had never been pure representatives of bright and cheerful Shochiku cinema. In fact, when the discourse of the aesthetics of shadow was emerging, Ozu discussed the significance of shadows even in kabuki. In 1935, he appreciated the kabuki actor Onoe Kikugoro's challenging choice of dark lighting for the sake of realism in his kabuki play *Ushimatsu in the Dark (Kurayami no Ushimatsu)* that was performed in the year.[24] Critic Ando Sadao also argued in his essay "About Darkness" (*Kurasa ni tsuite*) which was published in the May 1938 issue of a new film journal *Eiga* (Motion pictures), "There is a deep current of darkness at the bottom of the nihilistic brightness on the surface of *shoshimin* [petit bourgeois, or the middle class]."[25] Ozu's silent films produced at Shochiku's Kamata studio consistently displayed an expressive use of lighting. But in most of such cases, since brightness is restored in a rather hyperbolic manner in the end, they can even be seen as satires of Shochiku's company policy. It might be a stretch, but Ozu's films even seem to provide from the inside the variations and renovations of the formulaic norms and dominant modes of film production at Shochiku—that is, bright and cheerful cinematography that was maintained throughout the period of war.

In Ozu's 1932 film, *I Was Born, But . . .* (*Umarete wa mitakeredo*), there is one scene set at night. Feeling humiliated after having witnessed his father's comic act captured in the home movie of his company's boss, the elder son Ryoichi (Sugawara Hideo) challenges his father (Saito Tatsuo) by asking fundamental questions about the class system in the capitalist economy. Upset by this, his father spanks his son on the bottom. Declaring a hunger strike, Ryoichi cries himself to sleep next to his younger brother, Keiji (Tokkan Kozo). Their mother (Yoshikawa Mitsuko) opens a *fusuma* sliding door, sits down, and looks at them sleeping. The sleeping room is dark, and backlight from the left—from the off-screen living room—places her, slightly in tears, in silhouette, except the rim of her hair shining. Then, the backlight is suddenly interrupted, which locates her in complete shadow. The following shot reveals that it is the father who stands at the *fusuma* sliding door and in a penitent manner

watches how his sons are doing. Such a sense of deadlock metaphorically and visually expressed in the dark tones is completely reversed in the following scene the next morning. The flat high-key lighting is extremely bright. It even looks as though it has been overexposed. The father and the two sons eat rice balls for breakfast under the bright sunlight and reconcile, even though neither the father nor anyone else gives Ryoichi clear answers to the questions that he raised the night before. The film's ending follows the moral of fidelity to the *shoshimin* family within the Japanese economic system, by embracing the humiliating act of the father witnessed by the boys. Possibly dismayed by this striking contrast, critic Wadayama Shigeru claimed that the social commentary of *I Was Born, But . . .* did not have any "relief" in the end. According to Wadayama, the film "fell completely into darkness in the end."[26]

I Graduated, But . . . (*Daigaku wa detakeredo*, 1929) follows the same pattern. The protagonist Nomoto (Takada Minoru) at first rejects an offer to work as a receptionist at a company and ends up being unemployed. He is literally a shadowy figure—a silhouette behind a frosted glass door—when he comes to the job interview. While he is unemployed and sarcastically calling his situation "Everyday Sunday"— referring to a popular Japanese journal, *Everyday Is Sunday* (*Sande mainichi*)—he is sidelit and placed in a contrasting lighting most of the time. Eventually, on a rainy day, he cannot help but to return to the company and ask again for the receptionist position. However, the company executives hire him for a regular position instead of the receptionist one and say, "You have suffered enough." On his first day at work, the sky is very bright and sunny. These endings under the high key could be regarded as a satirical metaphor of capitulation to the system's all-encompassing power.

As if avoiding such an authoritative power highlighted by extremely bright, high-key lighting, Kihachi (Sakamoto Takeshi) in *An Inn in Tokyo* (*Tokyo no yado*, 1935) tries unsuccessfully to hide in the dark. In the film, Kihachi steals money in order to save a sick daughter of a young woman. Electric lamps on the nighttime streets, a neon sign of "Club Toothpaste," which was actually one of the sponsors of Shochiku, among others, expose Kihachi in bright lights and create a dark shadow of his body on the walls. Even though the policemen do not wear white gloves in this film, unlike in *That Night's Wife*, their uniforms reflect electric lights and shine brightly in the dark. After letting his children go, Kihachi turns off an electric lamp right next to him and hides his body in the dark.

In *There Was a Father*, bright scenes look extremely bright. Acclaimed filmmaker Yoshida Kiju, who wrote an elegant and insightful book on Ozu, recalls that he cannot forget the moment when he watched *There Was a Father* with his parents at a theater in his hometown of Fukui city for the first time in 1942 because of a particular scene of fishing between the father and the son that is "filled with infinitely bright light."[27] Yoshida describes the scene:

If the son, who has just become a highschool student, fishes in the same manner as his father, it implies that he is becoming an adult. The two seem to regard each other as equal individuals beyond the father-son relationship and behave that way. Indeed, while the father is fishing, he tells his son to enter a dorm and live apart from him. In other words, the father tells his grown son that they had better live different lives as different individuals. The son stops his repetitive movement. He does not follow his father's action and nods his head. His rod no longer draws an arc, and the string is left completely stretched in the stream. At this moment, the son's rod has stopped its repetitive movement, revealing the difference between the father and the son and intimating their inevitable parting. It vividly expresses the severe conditions of human life. This is an excellent realization of the motif of repetition and difference that Ozu-san pursued. This scene between the father and the son in the stream under the bright sunlight is an exquisite and blissful moment.[28]

When we look at a scene like this, we are tempted to find Ozu's consistent use of inverse- symbolism—authoritative oppression associated with bright light, or a command by the father in this case—and to take recourse to another version of auteur criticism. However, such stylistic consistency in using the brightness in *There Was a Father* should be attributed to Atsuta Yuharu, the cinematographer of the film who strategically adopted this lighting pattern. In addition to this scene of fishing, Atsuta also shot the death scene of the father unusually brightly, which was criticized by Yoshida Kenkichi. Atsuta claims, "I wanted to make the lighting outside of the room where the father dies filled with the sunshine. I did not want to show the death scene in the dark. Because of the sunshine, I believe the sorrow of his death is enhanced. Therefore, I adopted such a lighting scheme."[29] According to Atsuta, Ozu liked the lighting of the scene very much.[30] Brightness used that way certainly allows the viewers a symbolic reading of death. But in contrast to the rather leftist or populist critique of the use of the electric light or sunlight had in Ozu's silent films for failing to capture the appropriate social reality, the emphasis on brightness (or darkness for that matter) in *There Was a Father* is more atmospheric and ambiguous. It is true that Horikawa the father (Ryu Chishu) is almost always associated with an abundance of brightness, especially in scenes that depict the strong relationship between the father and the son. In addition to the example that Yoshida Kiju describes, near the opening of the film, Horikawa and his son Ryohei (Sano Shuji) ride on a train to Ueda, where the son enters a boarding school. Unlike many conversation scenes in Ozu's other films, the conversation between Horikawa and Ryohei is captured in shot/reverse shots that follow the 180-degree line system and eye-line matches of classical Hollywood cinema. The scene was photographed on a real train of the Ome Line. While the sun was the main source of lighting, the actual light that came from the windows was so bright that the shots of the scene look nearly overexposed.

In addition to the aesthetic function of brightness in Ozu's aforementioned film, which I claim offers an innovative (and/or ironic) way to convey the social message, one must further pay attention to how such an aesthetic resulted from the production circumstances under which the film was made. Atsuta recalls that it was extremely difficult to photograph the scene in the train because he had to use Japanese Fuji film stock, which prevented him from creating the effects he wanted—that is, maintaining the brightness but getting rid of halo effect at the same time. He was not even allowed to use electric lamps on the train for budgetary reasons, even when he wanted to make up for the deficiency of the film stock. Most film production companies in Japan used Eastman Kodak film stock from the 1920s until the early 1930s. It was as late as January 1937 when the Japanese film company Fuji first released its own for talkies. In September of the same year, a law was implemented to control and reduce the amount of film stock imports and exports. By 1939, the market share of imported film stocks reached only 6.5 percent, and by the end of 1941, 0 percent. As a result, Fuji became almost the sole provider of film stock for film production companies.[31] However, the quality of Fuji's negative film was quite low. In 1942, the acclaimed cinematographer Sugiyama Kohei noted, "The quality of Japanese-made stock renders the contrast between light and dark sections too strong, which would distract the viewers."[32] In the same year, citing a report on the new negative by Toho laboratory, Nishikawa Etsuji, the head of film developing at Toho, pointed out that Fuji's newly introduced negative was even less sensitive to light than the previous version. Therefore, it would be necessary to "sacrifice" the lighting of bright sections to depict details of dark parts.[33]

Being well aware of such technical and technological difficulties, Atsuta took into consideration the quality of such film stock in his lighting scheme of *There Was a Father*. Atsuta took advantage of the low quality of Fuji's negative and decided instead to emphasize the strong contrast between brightness and darkness. Because the scenes between the father and the son, especially during the first train ride, are too bright, the darkness of the ending—another train ride—stands out.[34] After the death of his father, grown-up Ryohei goes back to Sendai, where he teaches chemistry at a junior high school, accompanied by Fumi, his newly wed wife (Mito Mitsuko). The shot/reverse shots between Ryohei and Fumi almost exactly repeat the ones between the father and the son in the earlier scene, but in a much darker tone. While it is too bright to see outside of the windows in the earlier scene, it is now too dark outside. Ryohei says, "He was a good father." Fumi bursts into tears. There is inserted a low-angle shot of a train running under the cloudy sky, in which the couple supposedly is having a conversation about the father. It is a very dark shot. More than half of the screen is occupied by the shaded body of the train. Apparently, this shot is photographed in day-for-night. Then, we see a medium shot of Ryohei turning gravely to the window. This shot is followed

by a medium shot of an urn on the luggage rack, in which his father's ashes rest. Strangely, this shot is rendered in a very contrasting manner. A relatively strong sidelight, whose lighting source is unclear, emphasizes the shining whiteness of the cover of the urn. It looks as if the urn radiates with its own light. Does it indicate a psychological reminiscence of Ryohei's memory of his father that has been almost always associated with extreme brightness? The lighting on the urn seems to fit with what the film historian Thomas Elsaesser calls "tactile values" in the lighting of some Weimar films.[35] Examining the UFA studio's lighting styles in Weimar Germany, Elsaesser argues, "Lighting turns the image into an object endowed with a special luminosity (being lit and at the same time radiating light) which is to say, light appears as both cause and effect, active and passive. In short it suggests 'authenticity' and 'presence,' while remaining 'hidden' and 'ineffable.'"[36] The exaggerated illumination in the train scene mentioned above can be seen as enhancing the "presence" of the urn (and the remain of Horikawa), which stand out from a dark background, and makes them, as Elsaesser puts it, "more-than-real in their 'there-ness' and 'now-ness.'"[37] The whiteness of the urn originates from, using Elsaesser's words again, a "special kind of luminosity" that "brings forth the illusion of a special kind of 'essence.'"[38]

There Was a Father ends with another low-angle shot of the train moving further into the landscape. Under the dark (or darkly lit) cloudy sky, the train turns into a small black dot on the screen. The screenplay of *There Was a Father* do not emphasize the darkness of the finale but instead indicate some brightness, similar to the endings of Ozu's silent films of the 1930s. The final stage direction reads, "A running train. The mountain at the far end floats in the sky near the dawn."[39] Curiously, those who criticized the brightness of *There Was a Father* did not refer to the darkness in the end, which appeared to be aligned with the aesthetics of shadow. If Ryohei is asserting paternal authority, why does he look so grave? Why does the train run into the dark when Ryohei goes back to his profession—duty to the nation? Critics might have found the darkness in the ending of *There Was a Father* not a clear fit to the aesthetics of shadow they endorsed, in part due to the film's simultaneous emphasis on brightness throughout the film, which was owing to Atsuta's technological choice in his adoption of the Fuji film stock, but was also due to the ambiguity amplified by the darkness.

In fact, darkness is consistently used ambivalently in *There Was a Father*. One outstanding example can be found in the backlit shots of Buddhist stupas, squat stone pillars consisting of stacked solids, which appear four times in this film. The stupas are in almost complete silhouette every time they appear. The first ones appear after the students of Horikawa have a commemorative photo taken in front of the statue of Great Buddha in Kamakura. Following the shot of stupas, which are, according to Hasumi Shigehiko, gravestones of the Soga brothers known for their faithfully avenging for their father, Horikawa's

students march on to Tokaido like an army under the bright sunlight.[40] After a shot of shining, white Mt. Fuji behind Lake Ashinoko, we see the students arriving at a hotel near the lake. One of the students is drowned in the lake under the bright sunlight. A shot of backlit stupa is inserted right before a shot of capsized boat. Another set of backlit stupa shots bookmark the scene of Horikawa and young Ryohei fishing in the river under the bright sunlight. It looks as if brightness were ominously contained in darkness.

In this essay, I have presented a technical, technological, and sociopolitical reading of a 1942 film, *There Was a Father*. The major focus here has been on locating the film within the contested industrial and cultural discourses of the time—"Bright and Cheerful Shochiku Cinema"—and the aesthetics of shadow. Ozu Yasujiro and his collaborators, the cinematographer Atusta Yuharu in particular, may not have had the direct intention of challenging both discourses through light and lighting, but their work offers a critical vision of the shifting power relations within the film industry—Shochiku's adoption of Fuji film stocks, Shochiku's new rivalry with newly emerging Toho, and so forth. The film also displays, in rather an implicit and ambivalent manner, a society that increasingly is defined by the authoritarian control of cultural discourse. But at the same time, the film's genius lies in the fact that it also contributes to the depth of a world of spectacle of light and shadow.

NOTES

1. Shigehiko Hasumi, "Sunny Skies," in *Ozu's Tokyo Story*, trans. Kathy Shigeta, ed. David Desser (Cambridge: Cambridge University Press, 1997), 120, 124.
2. David Bordwell, *Ozu and the Poetics of Cinema* (Princeton, NJ: Princeton University Press, 1988), 82.
3. Shochiku's slogan was not only about its dominant lighting scheme. It also referred to the company's specialty genre and its tone: a sophisticated style of comedy with a bright and cheerful feeling, which conspicuously displays images of everyday lives and experiences in modernizing metropolitan Tokyo. In May 1929, Kido Shiro, head of the Shochiku Kamata studio, clearly explained this slogan in the studio's journal, *Kamata Shuho*: "Kamata's modern dramas represent modern dramas in Japan. In order to develop our modern dramas further and make them available in the world, the contents must be better, which means they must be 'brighter and clearer,' in particular. They must always make the audience feel cheerful and never make them experience anything dark and depressed This is our precious mission." Kido Shiro, "Kicho daiichigen" [The first words after my return], *Kamata Shuho* 168 (May 26, 1929): 1.
4. Tanaka Toshio, "*Chichi ariki*" [*There Was a Father*], *Eiga gijutsu* 3, no. 5 (May 1942): 74.
5. Ibid.
6. Yoshida Kenkichi, "Eiga bijutsu jihyo" [Review of film art], *Nihon eiga* 7, no. 5 (May 1942): 31.
7. Tanaka Toshio, "Satsuei" [Cinematography], *Eiga junpo*, March 1, 1941, 34.

8. Ibid.

9. *Eiga to gijutsu* 12, no. 4 (December 1940): 192.

10. Ibid.

11. Ibid.

12. "Camera, rokuon, sochi: Zadankai" [Camera, recording, and equipment: Group discussion], *Shin eiga* 10, no. 7 (June 1940): 38.

13. Tanaka Toshio, "Sokoku no utsukushisa: Showa 16 nendo gijutsu kaiko" [The beauty of oppositions: Retrospective of technology in 1941], *Eiga gijutsu* 3, no. 2 (February 1942): 59; Tanaka Toshio, "Eigateki na bi, shu, kegare" [Cinematic beauty, ugliness, and stain], *Shin eiga* 10, no. 7 (June 1940): 45.

14. Kido Shiro, "Kenzen naru ren'ai wa egaite ka" [Healthy love scenes can be displayed], *Eiga junpo*, January 1, 1942, 31. Ozu also criticized the dark tones of *The Battle of Kawanakajima*. In 1942, he stated, "I saw *The Battle of Kawanakajima* in Yokohama. I couldn't see the images very well. I cannot stand such darkness whether they want to show an electricity poll, a post office, or whatever. Cinema shouldn't be so dark. Cinema must be visible." "Tanoshiku omoshiroi eiga o tsukure" [Make films cheerful and interesting], *Eiga no tomo*, March 1942; quoted in *Ozu Yasujiro zen hatsugen: 1933–1945* [Ozu Yasujiro: Collected statements, 1933–1945], ed. Tanaka Masasumi (Tokyo: Tairyu sha, 1987), 230.

15. Taketomi Yoshio, "Ofuna eiga ryu no akarusa no shakumei" [Explanation on the brightness of the Ofuna films], *Eiga gijutsu* 3, no. 4 (April 1942): 60–61.

16. Peter Baxter, "On the History and Ideology of Film Lighting," *Screen* 16, no. 3 (Autumn 1975): 99; Lea Jacobs, "Belasco, DeMille, and the Development of Lasky Lighting," *Film History* 5, no. 4 (1993): 408.

17. See Daisuke Miyao, *The Aesthetics of Shadow: Lighting and Japanese Cinema* (Durham, NC: Duke University Press, 2013), 15–66.

18. Kotani Henri, "Eiga ga dekigaru made (1)" [Until a film is complete (1)], *Kinema junpo*, June 11, 1922, 5.

19. See Miyao, *The Aesthetics of Shadow*, 67–118.

20. *Nihon eiga* 7 (1944), quoted in Kato Atsuko, *Sodoin taisei to eiga* [The national mobilization policy and cinema] (Tokyo: Shinyo sha, 2003), 160; "Kogyo seiseki kessan" [Record of box office], *Eiga junpo*, February 1, 1943, quoted in Kato, *Sodoin taisei to eiga*, 120–121; Furukawa Takahisa, *Senjika no Nihon eiga: Hitobito wa kokusaku eiga o mitaka* [Wartime Japanese cinema: Did people watch national policy film?] (Tokyo: Yoshikawa kobunkan, 2003), 173.

21. Tsumura Hideo, "Shochiku eiga ron" [A study of Shochiku film], *Kinema junpo*, May 1, 1939, 10–11.

22. "15 nendo Nihon eiga (geki) no satsuei gijutsu danmen" [A technological aspect of cinematography in 1940 Japanese (fiction) films], *Eiga gijutsu* 1, no. 2 (February 1941): 89.

23. See Miyao, *The Aesthetics of Shadow*, 173–254.

24. Ozu Yasujiro, Hazumi Tsuneo, Shigeno Tatsuhiko, Kishi Matsuo, Tomoda Junichiro, Kitagawa Fuyuhiko, and Iida Shinbi, "Ozu Yasujiro zadankai" [Discussion with Ozu Yasujiro], *Kinema junpo*, April 1, 1935, 173.

25. Ando Sadao, "Kurasa ni tsuite: Itami Mansaku ni kansuru oboegaki" [About darkness: Notes on Itami Mansaku], *Eiga* 1, no. 1 (May 1938): 19–20.

26. Wadayama Shigeru, "Ozu Yasujiro to no ichimon itto" [Q & A with Ozu Yasujiro]; quoted in Tanaka, *Ozu Yasujiro zen hatsugen 1933–1945*, 16.

27. Yoshida Kiju, "Ozu Yasujiro ron saiko" [Rethinking the arguments on Ozu Yasujiro], *Eureka: Poetry and Criticism* 636 (November 2013): 112.

28. Yoshida Kiju, *Ozu's Anti-Cinema*, trans. Daisuke Miyao and Kyoko Hirano (Ann Arbor: The University of Michigan, 2003): 48–49. If I retranslate the last sentence in a literal manner, it reads, "The sun at noon shines so infinitely bright that we cannot even look straight at the scene. A blissful moment just appears in front of us."

29. Atsuta Yuharu and Hasumi Shigehiko, *Ozu Yasujiro monogatari* [Ozu Yasujiro story] (Tokyo: Chikuma shobo, 1989), 214.

30. Ibid.

31. Okada Hidenori, "Nihon no naitoreto firumu seizo shoki no jijo (ge)" [Nitrate film production in Japan: The conditions of early period (2)], *NFC Newsletter* 31 (2000): 12–15.

32. Sugiyama Kohei, *Eiga to gijutsu*, January 1942, quoted in Hirai Teruaki, "Soko Nihon eiga satsuei shi 56" [Draft history of Japanese cinematography 56], *Eiga satsuei* 89 (July 1985): 73.

33. Nishikawa Etsuji, "Eiga gijutsu no saishuppatsu: Shin taisei kakuritsu dai 1 nen o mukaete" [Restart of film technology: In the first year of the new system], *Eiga gijutsu* 3, no. 1 (January 1942): 42–43.

34. The closure of *What Did the Lady Forget?* (*Shukujo wa nani o wasuretaka*, 1937) turns to dark as well. After a quarrel and a make-up, the husband (Saito Tatsuo) follows his wife (Kurishima Sumiko), who has seductively gone to bed early. The lamps at the corridor are turned off one by one. At the further end of the corridor, the husband's silhouette joyfully appears and disappears several times before he goes upstairs. The dark lighting here is not straightforward as in *Chichi ariki*, but here it is used in a comically erotic manner in favor of cheerfulness.

35. Thomas Elsaesser, *Weimar Cinema and After: Germany's Historical Imaginary* (London: Routledge, 2000), 44.

36. Ibid.

37. Ibid.

38. Ibid., 251.

39. Ozu Yasujiro, Yagi Yasutaro, and Yanai Takao, "*Chichi ariki* (dai ikko)" [*There Was a Father*: The first draft], in *Bungei bessatsu: Ozu Yasujiro* [Bungei extra: Ozu Yasujiro], ed. Nishiguchi Toru (Tokyo: Kawade shobo shinsha, 2001), 254.

40. Hasumi Shigehiko, *Kantoku Ozu Yasujiro: Zoho ketteiban* [Director Ozu Yasujiro: Expanded and definitive edition] (Tokyo: Chikuma shobo, 2003), n.p.

CHAPTER 8

Modernity, *Shoshimin* Films, and the Proletarian-Film Movement

Ozu in Dialogue with Vertov

YUKI TAKINAMI

While the signs of modernity never disappeared from Ozu Yasujiro's films throughout his career, the connection between Ozu and modernity is particularly prominent in his silent films. It is well known that Ozu indulged in the modern culture of the late 1920s, as can be seen in his early films such as *Days of Youth* (*Gakusei romansu: Wakaki hi*, 1929) and *Walk Cheerfully* (*Hogaraka ni ayume*, 1930), which celebrate the new lifestyles of college students and modern girls. However, by the early 1930s, Ozu began to take a more critical stance toward modernity in his *shoshimin* films such as *Tokyo Chorus* (*Tokyo no korasu*, 1931) and *I Was Born, But . . .* (*Otona no miru ehon—Umarete wa mita keredo*, 1932).[1] It is usually argued that as Ozu matured he gradually turned his back on modernity; this turn occurred during a dark time of rising militarism and nationalism. However, the relationship between Ozu and modernity is more complex than this explanation seems to suggest, and it calls for a more nuanced approach. This chapter offers such an approach by situating Ozu's shoshimin films in the context of proletarian film criticism and movement in Japan in the 1930s, which were both local and global phenomena.

I will begin by investigating the early reception of Ozu's films around 1930 with a focus on the multivalent meanings of the term "shoshimin," which designated not only particular subject matter in films, but also the attitude of directors. Used in critical reviews of Ozu's films, shoshimin refers to not only the social status of characters, often white-collar salarymen, but also Ozu as a

director, who presents films from a petit bourgeois standpoint. Consequently, the term "shoshimin film" (*shoshimin eiga*) did not indicate a focus on shoshimin lives or even a critical approach to that subject, as the term is used today, but rather exactly the opposite: a film whose critical standpoint is weak due to its shoshimin nature. After the survey of critical reception of Ozu in the context of the proletarian film movement in Japan, this chapter explores the work of Iwasaki Akira, a leading critic of proletarian film in Japan. Iwasaki's theory of film, which valorizes political motivation, especially Soviet montage, provides a historical and theoretical view for understanding how Ozu's critics assessed his films. The famous film-within-a-film scene in *I Was Born, But...* will be compared to Dziga Vertov's *Man with a Movie Camera* (Человек с киноаппаратом, *Chelovek s kinoapparatom*, 1929), following Iwasaki's distinction between shoshimin and proletarian film. Vertov was in the air in Japan in the early 1930s, and *Man with a Movie Camera* was released in Japan in March 1932—precisely when Ozu shot *I Was Born, But* As I will argue, *I Was Born, But...* should be considered within a globally shared horizon of film aesthetics. It is in this context that the complicated significance, both positive and negative, of Ozu's work, considered a masterpiece of shoshimin film, is revealed.

THE EARLY RECEPTION OF OZU'S FILMS

While Ozu was still unknown as a "film auteur" just after his debut in the late 1920s, his films enjoyed a solid reputation from the outset, particularly in terms of the art of film.[2] For instance, on Ozu's debut film, *Sword of Penitence* (*Zange no yaiba*, 1927), and his fourth, *Pumpkin* (*Kabocha*, 1928), critics in the Japanese film magazine *Kinema junpo* write,

The success of this film lies in the harmony of Mr. Noda Kogo's deliberate tone and nuance and Mr. Ozu Yasujiro's direction and taste, which gives an edge to the quietness and intensity of the story.[3]

The characteristics of Ozu's works can be found in his deliberate composition and compact setting. His works contain a lot of cinematic elements. We can expect a bright future for this young director.[4]

Throughout the 1930s, Ozu's films were praised for their artistry. Yet when Ozu was first acknowledged as a director of stature, it was rather due to the socially realistic aspects of his films.[5] Of particular importance in this respect are Otsuka Kyoichi's "Ozu Yasujiro ron" (On Ozu Yasujiro), published in *Eiga hyoron* in April 1930, presumably the earliest article that treats Ozu as an auteur, and *Eiga hyoron*'s special issue dedicated to Ozu in July 1930, which

can be considered the moment that Ozu received wide critical attention.[6] Otsuka's early essay and the three articles that appeared in the special issue help us see not only how Ozu's films were received, but also how Ozu was recognized as a socially realistic filmmaker. These articles further help contextualize Ozu's films within critical discourse on shoshimin.

Otsuka Kyoichi's article "On Ozu Yasujiro" both acknowledges Ozu's mastery of the art of film and situates Ozu's films in relation to the notion of proletarian film, which was emerging in Japan at the time. Otsuka opens his essay by mentioning that Ozu's reputation is increasing, and largely agrees with praise of Ozu's films in terms of their "technical aspects."[7] In highlighting Ozu's eminence, Otsuka contrasts him to Gosho Heinosuke, another director whose technique he holds in high esteem. According to Otsuka, Gosho's narrational approach proceeds from "a partial grasp of content" to "emotion on the whole" by tightly interweaving narrative and technique: "the camera angle of each shot, the way in which shots are linked, the speed of the tracking camera, and the moment when the tracking shot is cut to the next fixed shot . . . reflect the emotional content in detail."[8] In contrast, Otsuka argues that Ozu "starts from grasping the core of what to express" and then "properly arranges the details of the whole," particularly through his "steady direction of actors" and "cinematic manipulation at the key moment."[9] Evaluating thus Ozu's restrained film style in contrast to Gosho's more dynamic one, Otsuka concludes the main body of the article by arguing that Ozu demonstrates a new kind of "cinematic touch" (eigateki kanshoku).[10]

The term "cinematic touch" is itself interesting enough to be the subject of investigation, but Otsuka does not elaborate, and instead, jumps to a discussion of some recently released proletarian films:

Suddenly, I want to consider the success of What Made Her Do So? [Nani ga kanojo wo so sasetaka?, Suzuki Shigeyoshi, 1930] made by the Teikine Company and the unpopularity of Uchida Tomu's A Living Puppet [Ikeru ningyo, 1929]. A comparison of them alerts us on an important issue concerning the proletarian film movement, i.e., the direction that commercial films should take and what most audiences want to watch.[11]

Otsuka praises both What Made Her Do So? and A Living Puppet for their stylistic explorations, although only the former was commercially successful. (While A Living Puppet has been lost and cannot be analyzed, What Made Her Do So? contains a series of rapidly alternating close-ups of an angry proletarian maid and primordial clay doll, explicitly referring to Sergei Eisenstein's October: Ten Days That Shook the World [Октябрь, Десять дней, которые потрясли мир, 1928].) For Otsuka, commercial appeal is important, because proletarian film should be enjoyed by an audience of the masses. Otsuka ascribes the box-office success of What Made Her Do So? to its "melodramatic"

quality, which he praises, despite preferring Ozu's new cinematic touch to the melodramatic, which he considers to be "out-of-date." Nonetheless, because the task of proletarian cinema is to "impress and enlighten the audience," the difference between new and old modes does not matter. At the end of the article, Otsuka urges Ozu to reorient his films to melodrama in order to foster "direct interaction with the audience," a suggestion all the more necessary because Ozu has such excellent technique.[12] As Otsuka admits, his reference to recent proletarian films is somewhat abrupt, but in late 1929, Ozu made two socially critical films, *I Graduated, But . . . (Daigaku wa detakeredo)* and *The Life of an Office Worker (Kaishain seikatsu)*, which Otsuka would likely have had in mind when he wrote this article and suggestion.

For the special issue of *Eiga hyoron* on Ozu in July 1930, Otsuka contributed a short review of Ozu's *I Flunked, But . . . (Rakudai wa shitakeredo*, 1930), which was released in May. In this review, Otsuka laments that Ozu went the opposite direction that he had hoped he would. Following from his earlier article, Otsuka first praises Ozu's "careful direction of details," particularly those of cheating in the exam scene.[13] In the scene, Otsuka discerns a "satirical" quality, as the film portrays social inequality in a humorous manner. In *I Flunked, But . . .* , ironically, those who cheat pass the exam, while those who study hard fail; moreover, those who pass and graduate suffer unemployment, while those who fail continue to enjoy college life. However, while acknowledging a critical value in Ozu's satirical depiction, Otsuka questions its effect on the audience. Here again Otsuka requests that Ozu depict and criticize "the social conditions" in a more emotionally engaging way, which is to say in a melodramatic mode. The two evaluations by Otsuka share a similar perspective: he appreciates Ozu's technique and satire, which carry some social, realistic value, but he has reservations about the critical potency of this compared to melodrama. While the request that Ozu make melodrama was particular to Otsuka, the two other critics who wrote in *Eiga hyoron*'s special issue on Ozu, Sekino Yoshio and Hazumi Tsuneo, followed a similar argument, but more prominently featured the term shoshimin.

In his article, "Shinkyo-mono no hasan to Ozu Yasujiro no zento" (The disruption of sentimental film and the future of Ozu Yasujiro), Sekino Yoshio compares Ozu and Lubitsch,[14] who both make films that focus on the subject of "the ordinary affairs of the leisured class."[15] The "leisured class" (*yuukan kaikyu*) here is in fact a translation of "bourgeois" rather than petit bourgeois, but it provides Sekino with a convenient (roughly common) angle to compare the two directors. Sekino locates similarities in ways of depiction: "They both have a careful concern for the length and breadth of everything and make use of details in a good way, showcasing their admirable smartness [*sumatonesu*] and freshness [*furesshunesu*]."[16] By Sekino's estimation, the techniques of Ozu and Lubitsch "reach perfection." Yet he also carefully notes a difference between the two directors: "Whereas the former is good at depicting a love affair with a

married woman, the latter focuses on the anxiety [of class]."[17] Sekino suspects that these two directors, in their repeated treatment of the same subject, fall into the trap of "mannerisms."[18] As part of this criticism, referring to Ozu's mannerisms, Sekino turns to the idea of shoshimin.

By the term "shoshimin," Sekino designates broader classes than those depicted in the films, and extends beyond the characters in the film to the audience and Ozu himself. According to Sekino, Ozu "quite deliberately depicts the emotionless, servile, and generic lives of the shoshimin people and students, as well as their self-derisive and lethargic psychologies."[19] However, Sekino's criticism is directed not at the depicted subjects, but rather at the forms of engagement with the audience, which Sekino argues are mainly shoshimin: "I cannot but feel ill if the shoshimin audience sees a mirror of themselves in the films."[20] Sekino adds to this codependent relationship between film and audience a critique of Ozu's method of depiction. Like Otsuka, Sekino admits that Ozu's films manifest a quality of "satire," "irony," and "sober observation taken from a position one step behind."[21] However, it is precisely the satirical quality, the irony not oriented toward actually political engagement, that reveals the shoshimin nature of Ozu's film. As it is, Ozu's satire does not provide a full criticism of Japanese social reality, but rather only remains as a mere portrayal of shoshimin; what is worse, to the eyes of Sekino, is that the shoshimin audience may even feel "a romantic and sympathetic comfort" in watching Ozu's film, which reflects their own lives.[22] Sekino argues that there is a deep complicity in the tripartite relationship forged among the film, Ozu's attitude, and the audience; he criticizes Ozu for indulging in this vicious circle and being satisfied only with refining his technique.

The direction in which Ozu should move is toward proletarian film, Sekino argues, and here he uses the term shoshimin to address Ozu. Sekino urges Ozu to "make a leap, taking his films in a new direction" away from mere sophistication of his art:[23]

How about elevating the level? (Not the level of his consciousness or attitude, but the tone of disclosure. He has to thoroughly clear away the shoshimin quality [shoshimin-buri] typical of his consciousness and attitude.) He should make a film that anyone can understand and be sympathetic with, as he has done, but also a film that urges the audience to be rightfully suspicious at crucial points.[24]

The "tendency film" (keiko eiga) that came from German socially critical Tendenzfilm was also called "the disclosure film" (bakuro eiga). In this passage, Sekino suggests that Ozu elevate "the tone of disclosure," a disclosure of the falsehood of capitalist society. As the quote above shows, Sekino does not contrast proletariat and shoshimin cinema in terms of subject matter, but rather according to the degree of critical disclosure. Sekino criticizes Ozu's stance as

not critical enough to produce tendency films, which underscores the lack of full disclosure in the situation of shoshimin.

As the title suggests, Hazumi Tsuneo's "Ozu Yasujiro no shoshimin-sei" (The shoshimin quality of Ozu Yasujiro) is even more explicit in its criticism. In this two-page article, Hazumi, like Otsuka and Sekino, praises the artistry of Ozu's films; he also acknowledges their satirical value.[25] At the same time, Hazumi questions the critical strength of Ozu's films, again with recourse to the term shoshimin: "I am longing for the day when he [Ozu] liberates himself from his shoshimin quality [shoshimin-sei] and speaks to us from a new class position."[26] Hazumi continues,

Does the author of I Flunked, But . . . tell us about "reality" [shinjitsu]? By "reality," I do not mean "truth" [shinri]. I am asking whether or not he depicts "reality" from the standpoint of shoshimin, however fragile such a standpoint may be He always depicts a "good" shoshimin. They are all threatened by a difficult job market and unemployment, living in fear due to the instability of their social position. However, those who might fall into the abyss of a difficult life with a small slip go on with their lives too easily. There should be more suspicion and despair.[27]

While in this passage Hazumi uses the term "shoshimin" to designate people depicted in film, he questions whether or not Ozu captures the "reality" of shoshimin. Hazumi thinks that Ozu does so inadequately, an inadequacy that he ascribes to Ozu's shoshimin quality. Here, as in Sekino's usage of the term, "shoshimin" designates not only the subject of the film, but also, and more importantly, the attitude of the filmmaker in relation to political engagement.

As we have seen, while the social, realistic value of Ozu's films was acknowledged as early as 1930, Ozu's critical engagement was regarded as insufficient. The term "shoshimin" was already used in criticism of Ozu in this period, where it referred to both the subject matter of films and the filmmaker's attitude manifest in the films. In the next section, I will examine competing meanings of "shoshimin film" (shoshimin eiga) as a type of film.

TWO COMPETING MEANINGS OF "SHOSHIMIN FILM"

Criticism of Ozu's early works emerged in the context of the rising proletarian film movement in Japan. Although the term "shoshimin" refers to a certain "quality" of film in criticism in the 1930s, the term "shoshimin film" was not fully formed or associated with Ozu, who had yet to complete Tokyo Chorus and I Was Born, But . . . , which take as their subject the salaryman and are often considered Ozu's early masterpieces, if not also representative of shoshimin films. When and how did the term "shoshimin film" come to be employed in Japanese critical discourse in the early 1930s?

Presumably the first article to use the term "shoshimin film" is Ikeda Yoshio's "Shoshimin eiga hihan" (Shoshimin film criticism), which appeared in *Eiga hyoron* in April 1932. Commenting on the title, Ikeda opens by stating that "shoshi-min film criticism" can mean two different things: first, film criticism from the shoshimin standpoint, and second, criticism of shoshimin film. Ikeda, a quar-relsome proletarian film critic, argues that the former is impossible, because the shoshimin as a social class do not have their own standpoint from which to criti-cize. If Hazumi writes that the shoshimin standpoint is "fragile," then Ikeda goes further in declaring that shoshimin are devoid of class-consciousness. Ikeda's stated purpose in this article is thus to criticize shoshimin film, which he defines as not only "film treating the subject of shoshimin," but also "film governed by shoshimin ideology."[28] For Ikeda, shoshimin film is exemplified by the films of Ozu Yasujiro, in particular his work from *I Graduated, But . . .* to the more recent *Tokyo Chorus*. (At this time, Ozu had not yet completed *I Was Born, But*) By shoshimin ideology, Ikeda means "the intelligentsia's negative and decadent psy-chology," as well as "nihilism." Ikeda writes, "the characteristic of a shoshimin film is its delicateness, a nervously inflected depiction of emotion, with meticulous effort made for every detail of every shot."[29] It should be noted that Ozu was praised for his "delicateness" (*sen no hososa*) and "meticulous effort" (*sumizumi made no doryoku*), but Ikeda, a critic aiming at a bolder criticism of social reality, negatively assesses Ozu's "delicate" films. Discussing the ideological function of Ozu's films, Ikeda reaches a conclusion that is very much counter to more famil-iar approaches to shoshimin film. For Ikeda, Ozu's shoshimin films, far from crit-ical, "involve not only the intelligentsia of the city, but also the youth of rural areas in such an atmosphere [of decadence and nihilism]."[30]

In contrast, shoshimin film was also used in a positive sense, which is closer to how we use the term today. One of the earliest examples can be found in Ueno Ichiro's article "1932 nen kaiko: Nihon eiga kaiko" (Looking back on 1932: Looking back on Japanese film), which was published in December 1932. In this article, we find a section devoted to "shoshimin film." Interestingly, Ueno starts off by stating, "It is very difficult to delimit the category of the shoshimin film," which suggests that, even by the end of 1932, the meaning of "shoshimin film" was not fixed. Ueno continues,

In a broad sense, all films treating the life of shoshimin can be called shoshimin films. But that makes very little sense. Instead, we can distinguish shoshimin film in greater detail. There are a variety of ways to treat the life of the shoshimin By shoshimin film, I want to designate films that address the class problem of the shoshimin, and the agony of their lives. Representative works of this genre are, needless to say, the films of Ozu Yasujiro.[31]

Ueno praises Ozu's *I Was Born, But . . .* , which "treats the life of a salaryman realistically."[32] He continues, "Many in the audience were struck by the film

because Ozu depicts the life of a shoshimin seriously."[33] Ueno does not refer to the satirical quality of Ozu's films, which is often regarded as the source of their critical power, but he nevertheless uses the term "shoshimin film" in a positive way to refer to social realism, presumably for the first time (although he too addresses reservations about Ozu's "resigned viewpoint").

Even as "shoshimin film" took on more positive meanings, Ozu's films were thought to have become more critical of Japanese modernity in the years between 1929 and 1932, when he moved from directing college comedies to shoshimin films in the narrower sense of a salaryman's life. In 1931, the critic Iida Shinbi welcomes *Tokyo Chorus* on the grounds that Ozu "takes up the shoshimin subject more seriously" than his earlier college comedies. However, Iida also laments,

Despite the good subject matter, the power of the film is diverted. This can be attributed to the attitude of the filmmaker. For this reason, I cannot admire this film. This is also the case with the last scene. If the protagonist remained unemployed and the intertitle "City of Unemployment: Tokyo" appeared instead of the "miraculous" telegram that informs the viewer of his employment, what a strong impact this film would have had on viewers![34]

While acknowledging the direction of Ozu's films toward social realism, Iida argues that *Tokyo Chorus* is not critical enough.

After *I Was Born, But . . .* was released, Okamura Yasuo evaluates *Tokyo Chorus* more highly than Iida, but similarly traces the trajectory of Ozu's work:

Mr. Ozu captured the miserable life of a low-paid salaryman in *The Life of an Office Worker* and the dark shadow enclosing the future of college students in *I Flunked, But* in such a way that the weight of the reality was relieved by humor. In *Tokyo Chorus*, he stares at the reality so as to take unemployment seriously.[35]

Comparing *Tokyo Chorus* and *I Was Born, But . . .* , Okamura argues that while in the former the salaryman protagonist opposes his boss with temporary anger, in the latter the protagonist endures the unreasonable pecking order in the company; while in the former a happy ending occurs, it does not in the latter. Okamura concludes that Ozu has come to more realistically capture the trapped existence of the salaryman, which strengthens his critical stance.

The discontent expressed by critics in the early 1930s concerning how Ozu's films critically engage society, and shoshimin in particular, continues today.[36] Indeed, we often ascribe to Ozu's oeuvre a trajectory beginning with his early college comedies and moving to the shoshimin films *Tokyo Chorus* and *I Was Born, But . . .* , which supposes a teleology by which we can order and evaluate Ozu's films. Further, we often draw attention to the conflict between

Ozu and Shochiku Studio, attributing limitations of the critical aspects of Ozu's films to the constraints of working within a major studio. In so doing, we partially concede that Ozu's early films are not critical enough. However, what is revealing in the criticisms examined above is that criticisms of Ozu's shoshimin films was much stronger in the context of early 1930s Japan, when proletarian film began to appear and be advocated by Marxist critics. To more fully tease out the negative evaluation of "shoshimin film," in what follows, I will investigate the notion of "proletarian film" by focusing on two leading Marxist critics, Sasa Genju and Iwasaki Akira, who proposed that film should deliver a "direct impact" with a strong political purpose and the aim of urging the audience toward political engagement and revolution.

"DIRECT IMPACT:" FROM THE PERSPECTIVE OF PROLETARIAN FILM

The history of the proletarian film movement in Japan is considered to have started with the establishment of the Film Unit (Puroretaria eiga han) within the Left-wing Theater (Puroretaria gekijo). In June 1928, the Proletarian Film Federation of Japan was founded within the Proletarian Art Association, finally developing into the Proletarian Film League of Japan (Prokino) in February 1929.[37] Sasa Genju, a film activist and theorist, was at the center of these developments in Japan; in fact, the proletarian film movement before the formation of Prokino was virtually organized by Sasa alone. Sasa made a documentary of the May Day rally in 1927 and strike at the Noda Soy Sauce Company in March 1928, which he shot almost alone. Based on this filmmaking experience, Sasa wrote "Gangu/buki—satsueiki" (Camera—toy/weapon), which became a theoretical pillar for the proletarian film movement in Japan. Sasa advocates appropriating the small-gauge home movie camera, the 9.5 mm Pathé-Baby, which is a toy for the bourgeois but can be utilized for the political purpose of the proletariat and turned into a weapon for the revolution—particularly by capturing the "reality" of the working class. When Sasa speaks of "reality," the word carries more than its usual meaning:

At the Left Wing Theater Film Unit, we are making films and bringing them into daily life. We . . . expect to unify to make films in an organized manner for the liberation of the proletariat by bringing films into their daily life. Our films at the present stage awaken class-consciousness, explore facets of today's society, and truly root out various social contradictions.

The unorganized masses will become conscious of participants. The organized masses will understand their will to fight, and we must make films with unceasing effort.

Now, the road for our film productions, fulfilling objective and economic conditions, is nothing other than an extreme photorealism. It is a Sur-realism [*Sur-realisme*]. All materials have to be arranged and transferred.

Therefore, "editing" is the most crucial part of the documentary film.[38]

The reality that cinema reveals is the "sur-reality" of the proletariat. It is revealed, or constructed, through the cinematic operation of "arrange[ment]," "transfer[ence]," and "editing." Under cinematic operation, Sasa includes various film techniques: "camera angle, pan, light, cutting tempo, time and space, movement, double exposure, overlap, flashback, machine/director/technique, the phenomenon of editing, etc."[39] Through such techniques, cinema can act on audiences and bring to the fore their class-consciousness.

Thus, through documentary footage, proletarian film could attempt to capture the "reality" of the proletariat, but more importantly, as Sasa makes explicit, the "sur-reality" of it could be revealed by cinematic manipulation.[40] Such "(sur-)reality" is a direct power to awaken the audience. Iwasaki Akira, another leading figure of the proletarian film movement in Japan, assigns a similar power to cinema. After participating in the formation of Prokino in February 1929, Iwasaki wrote an article entitled "Puroletaria no eiga" (On proletarian film), which defined his project in relation to Prokino. According to Iwasaki, cinema is crucial for the proletarian movement because of its "mass nature" and "immediacy."[41] Admitting that existing feature films have a powerful impact on audiences, Iwasaki argues that proletarian film should pursue the documentary mode in view of the limitations on film finance and infrastructure.

More specifically, Iwasaki proposes three possible forms of proletarian film: (1) "news reel films" with "a firm standpoint of class-consciousness"; (2) "montage films" (*montaju firumu*) that "organize the proletarian logic through editing of documentary footage"; and (3) "culture films for the education of the mass."[42] It should be noted that Iwasaki argues "the proletarian logic" can be organized through "montage" and "editing" (rather than montage and editing be governed by this logic). Cinema has an immediate potential to organize the masses, and Iwasaki argues that the most radical potential of the proletarian cinema should be explored at the stage of exhibition and reception: "In the proletarian film, production is inseparable from exhibition. The exhibition is inseparable from the audience."[43]

Around 1930, Iwasaki's work involved activities ranging from the organization of Prokino to film production and critical writing, which provided a theoretical backbone for Prokino's activities by organizing world film history up to the early talkies and charting the history of film theories. Among Iwasaki's various works, it is important to consider his discussion of theories of Western silent films in order to draw attention to the term "direct impact." In "Eiga geijutsugaku no rekishiteki tenbo" (The historical view of

film aesthetics), first published in 1931, Iwasaki delineates three phases of European film theory.[44] First, argues Iwasaki, cinema was theorized according to the existing aesthetic norms—particularly those of theater—in the 1910s. While cinema was not necessarily denounced by comparison, this approach belongs to the first phase of film theory, where the value of cinema was gauged by existing aesthetic norms. Around 1920, however, aesthetics specific to cinema were explored with the emergence of film theorists such as Jean Epstein, Louis Delluc, Léon Moussinac, and Réne Clair in France. Dissociating cinema from existing art forms, these French theorists approached film by way of "cinegraphic rhythm," or "a spatiotemporal art, i.e., the synthesis of temporal continuity and spatial extension."[45] "As such," Iwasaki continues, "the idea that cinema embodies a specific form emerged. That was spatiotemporal rhythm." Further, "montage became the key feature as to what produces cinematic rhythm behind the continuity of images."[46] Iwasaki criticizes French theorists for their formalist approach and dedication to exploring film aesthetics for *l'art pour l'art*. In contrast, Iwasaki views Soviet approaches to montage as a kind of social activity, which begins a new phase of film theory. The second and third phases of European film theory are distinguished by film's capacity for social engagement.

Iwasaki's reference to Soviet montage theory is brief in his 1931 essay, but in his later book, *Eiga ron* (On cinema), published in 1936, Iwasaki goes into further detail. Iwasaki starts by distinguishing it from theories circulating in France. Whereas montage was considered as "a rhythmical organization of materials" in France, it was approached in terms of its "unique effect at the psychophysiological level"—that is, in relation to its impact on viewers—in the Soviet context.[47] He then introduces the four different types of montage proposed in Eisenstein's "The Fourth Dimension in the Kino: II."[48] After briefly mentioning "metric montage" and "rhythmic montage," both of which are viewed by Eisenstein as formal as well as artistic principles, Iwasaki writes at length on "tonal montage." Iwasaki praises this third type of montage, which Eisenstein discusses in terms of "the psychological and inner movement" or "affect" that leads to a film aesthetics that has an impact on the viewer.[49] Iwasaki further appreciates "the overtonal montage," which takes into account "the complex and diverse aspects of 'emotional sound'" more inclusively, without reducing them to the "dominant tone."[50] If the proletarian film's shows "reality" by different means of documentary footage or montage, its primary purpose is to awaken the viewers' consciousness and ignite their desire for revolution. Thus, the distinctive feature of proletarian film in Iwasaki's view should be its direct impact on viewers.

How, then, does Iwasaki assess Ozu's shoshimin film and aesthetics against the backdrop of the proletarian film's endeavor favored in his critical writings? In the light of Iwasaki's writings, I would like to draw attention to two points. First, like other proletarian film critics, Iwasaki was discontent with

the critical power of Ozu's films. Iwasaki writes of *Until the Day We Meet Again* (*Mata au hi made*, 1932),

His artistic sense and delicate touch are unusual. However, in *Until the Day We Meet Again*, Ozu throws away the realism of shoshimin life that he had elaborated from *Tokyo Chorus* to *I Was Born, But . . .*—however confined that realism may be to the petit bourgeois—and indulges himself in a terrible sweetness The shoshimin sentiment of evasion and disgust to the war is expressed.[51]

Though the print is lost and thus cannot be analyzed, *Until the Day We Meet Again* is usually regarded as an antiwar film. However, for Iwasaki, no matter how critical the film may appear, it is merely a portrayal of "the shoshimin sentiment of evasion" and weariness of war, which erodes rather than contributes to Ozu's critical strength.

It is important to note that Iwasaki uses the term shoshimin in a peculiar way, which is to designate the second tendency of film aesthetics (French avant-garde). In "The Historical View of Film Aesthetics," Iwasaki writes,

The emergence of this purism in film aesthetics can be explained as the unconscious expression of the shoshimin ideology under the dominance of the bourgeois The shoshimin as a social class is secluded from social reality as a noncombatant in the conflict, requesting pure cinema [cinéma pur] to rest at the dielectric of the rhythmical celluloid.[52]

Iwasaki argues that a longing for pure cinema reveals nothing other than the dilettantism of the shoshimin, which is determined by the social structure. (As we have seen, Ozu was also criticized as shoshimin due to his meticulous film techniques.) Iwasaki opposes the proletarian effort embodied by the Soviet montage to shoshimin seclusion. He argues that cinematic technique, montage in particular, has a direct power over the audience and should be used for political purposes.

To be fair, Iwasaki's critique of Ozu was not entirely overt. In the history of Japanese cinema, it goes largely unnoticed, because Iwasaki generally praised Ozu and Ozu never responded to Iwasaki—or any of his other critics, for that matter. Nonetheless, the contrast between "shoshimin film" and "proletarian film" that Iwasaki draws provides us with a new angle to reconsider Ozu by drawing attention to the question of whether or not Ozu's cinematic techniques were directed toward a political aim. From this perspective, I will compare the film-within-a-film scene of *I Was Born, But . . .* with Dziga Vertov's *Man with a Movie Camera*. As we shall see, there exist a number of thematic and stylistic similarities between these two films, which are exactly contemporaneous. While the shooting of *I Was Born, But . . .* started in November 1931, it was interrupted in the winter of 1931–1932, when the boy protagonist

sustained an injury, resumed in March 1932, and was completed in April of that year; *Man with a Movie Camera* was released in March 1932, precisely when Ozu resumed shooting of *I Was Born, But*[53] While there is no record of Ozu watching *Man with a Movie Camera*, the director might have been made aware of Vertov's film by Japanese critics' references to and reviews of its aesthetic. A comparison between these two directors as representatives of shoshimin and proletarian filmmakers helps us tease out the implications of *I Was Born, But* . . . beyond its usual reputation and perfunctory praise as the masterpiece of shoshimin film.[54]

OZU AND VERTOV

The film-within-a-film scene of *I Was Born, But* . . . has often been regarded as one of the most critical moments in Ozu's oeuvre. Near the end of the film, the brothers Ryoichi (Sugawara Hideo) and Keiji (Tokkan Kozo) attend a screening of a 16 mm home movie at the home of their friend Taro (Kato Seiichi). What is projected onscreen includes the bustle of the city and animals in the zoo, as well as their father (Saito Tatsuo) acting like a clown, busy to flatter his boss (Sakamoto Takeshi). Within the film's narrative, this scene serves as the moment that the protagonist brothers recognize the inverted social hierarchy of the adult world: while Ryoichi and Keiji lord over Taro, their father works under Taro's father. This film-within-a-film scene is all the more crucial because the recognition of this social reality is transmitted through the innocent gaze of a child.[55]

To be sure, in narrative context, this scene is intended to be critical of social reality, but its significance cannot be properly assessed without taking into consideration the Japanese critical discourse on shoshimin films and Ozu, as well as the Japanese release of Vertov's *Man with a Movie Camera*, which was admired as a radical proletarian film. There are many similarities between the two films. First, Ozu inserts fast-motion shots of the city taken from a camera mounted on a tram (fig. 8.1), just as Vertov does repeatedly throughout *Man with a Movie Camera* (fig. 8.2). Such shots are followed by a high-angle long shot of the crossroads where the tram runs (fig. 8.3), which is comparable to the panoramic shots of Moscow in *Man with a Movie Camera* (fig. 8.4). Lastly, both films emphasize the process of projection, inserting shots of projector, projectionist, and film can (figs. 8.5–8.6).

To what extent does such an undeniable visual and stylistic parallel between Ozu and Vertov invite us to reconsider the former's "shoshimin quality" and the criticisms of his films leveled by many Japanese critics? Unlike those of other Soviet film directors, such as Eisenstein and Pudovkin, Vertov's writings were not translated into Japanese, but his notion of "Kino-eye" was well known in Japan.[56] In his 1929 manifesto "From Kino-Eye to Radio-Eye,"

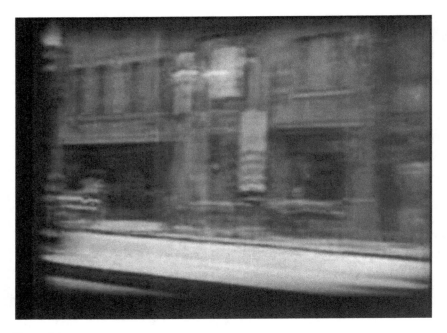

Figure 8.1.
I Was Born, But . . . (Otona no miru ehon—Umarete wa mita keredo, Ozu Yasujiro, 1932).

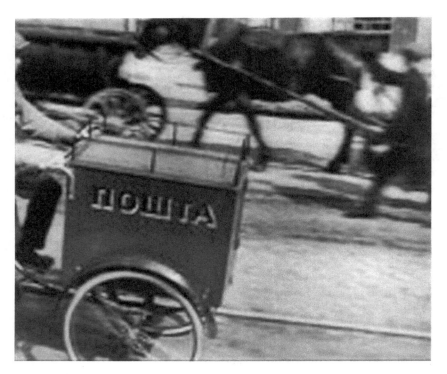

Figure 8.2.
Man with a Movie Camera (Chelovek s kino apparatom, Dziga Vertov, 1929).

Figure 8.3.
I Was Born, But . . .

Figure 8.4.
Man with a Movie Camera.

Figure 8.5.
I Was Born, But . . .

Figure 8.6.
Man with a Movie Camera.

Vertov writes that his methodology is based on two elements: first, the systematic recording on film of facts of life, and second, the systematic organization of the documentary materials recorded on film.[57] "Montage" for Vertov is not merely a technique of editing, but rather a term that encompasses "systematic recording" and "systematic organization." The principles of montage in this sense are

1. Correlation of planes (close-up, long shot, etc.)
2. Correlation of foreshortening
3. Correlation of movements within the frame
4. Correlation of light and shadow
5. Correlation of recording speeds[58]

Through such "montage," cinema can work on the viewer's sensorium, brain, and mind:

From the montage of visible facts which are noted down on film (Kino-Eye) to the montage of visible-audible facts which are transmissible by radio (Radio-Eye).
 To the montage simultaneously of visible-audible-tangible-olfactory, and so on, facts—
 to the filming unawares of human thoughts, and, finally—
 to the greatest experiments in the direct organization of the thoughts (and consequently of the actions) of all humanity—
 such are the technical perspectives of Kino-Eye, summoned to life by *October.*[59]

Vertov puts this theory into practice in a scene near the opening of *Man with a Movie Camera*. Mikhail Kaufman, the man with a movie camera, runs around Moscow in the morning and films a train, the street, and a store window; in a still sleepy city, people are just starting to go out and the tram to move. Shots of the city alternate with those of women who have just awoken in bed or on a bench. It is the camera and the man who cranks it that mediates and synchronizes these two series of awakenings—the city's and women's—through the correlation of planes, foreshortening, and movement within the frame. While Vertov allegorically depicts the women's awakening in the film, he more radically attempts to stir into action the actual audience through the truth revealed by cinema, or to "direct[ly] organize the thoughts" of the viewers and awaken their class-consciousness and desire for revolution. This is what Vertov calls "Kino-Pravda," or truth revealed by film.
 It is difficult to determine whether or not Ozu had seen Vertov's film prior to the completion of *I Was Born, But . . .* , but certainly Vertov was in the air at the time. Some of the writings of Japanese Marxist critics such as Sasa resonate with Vertov's notion of Kino-eye, for example his approach to the camera as a

weapon, discussed earlier. Although it is unclear whether or not he knew Vertov's theory in mid-1927, at that time Sasa believed that cinema could reveal reality for the proletariat through techniques of editing. By 1930, Vertov was already mentioned in critical writing such as Iwasaki's *History of Film Art* (1930): "Dziga Vertov belongs to the third and most radical current [in relation to Eisenstein and Pudovkin]. Revolting against all directors, all actors, all studios—in short, all existing biases—he claims that cinema is a factory of facts."[60]

When *Man with a Movie Camera* was released in Japan, reviews of the film were published in *Kinema junpo* in March and May 1932. These reviews pointed out discrepancies between Vertov's theoretical ambition and practice: "Dziga Vertov, as is well-known, asserts the notion of 'Kino-eye' and attempts to montage fragments of documentary footage However, his techniques might be regarded to be merely playful"; while Vertov's project is "to have an effect through montage," the result is "a confusion of the object, a kind of psychological disorder."[61] Ozu would likely have read these reviews, or at least have had an opportunity to read them, in *Kinema junpo*, the most widely circulated film journal in Japan at the time. In the film-within-a-film scene of his own film, Ozu demonstrates an extraordinary ability to capture the city's atmosphere, running tram, and gymnastics through excellent shooting and editing, which reveal the dynamics of profilmic movements. While the similarities are there, we see in Ozu's film a departure from Vertov. In *I Was Born, But . . .* , Ozu downplays direct interaction between the film and audience, despite the fact that the two brothers watching the screen within the film recognize social hierarchy in so doing. Ozu's references to film as a medium and to social reality are not like those of Vertov, who attempts to awaken the masses with moving images—through film's direct impact on the viewer's sensorium. Unlike *Man with a Movie Camera*, Ozu's film lacks any ambition to organize viewer consciousness through cinematic operations.

Might we be able to consider Ozu to be adopting a critical stance toward Vertov's almost impossible project of organizing viewer consciousness, a stance that is revealed in, for example, the cynical and comical portrayal of the father and his boss? If such a view is too far-fetched, then we might suggest that Ozu was interested in Vertov's cinematic techniques, but not their political baggage. Whatever the case may be, Ozu's seeming indifference to Vertov's political ambition suggests that *I Was Born, But . . .* is a shoshimin film in the negative sense, as criticized by Iwasaki: that is, *I Was Born, But . . .* is an apolitical film interested only in technique. When situated historically and within critical discourse on shoshimin films at the time, the common perception of *I Was Born, But . . .* as a masterpiece that critically captures shoshimin life is called into question. Does the historical and comparative analysis of *I Was Born, But . . .* provided in this chapter impact the evaluation of this film within Ozu's oeuvre? While there is not sufficient space in this chapter to attempt a satisfactory answer to such a question, I would like to suggest that Ozu quite

rapidly developed his own film aesthetics, including an idiosyncratic editing pattern of shot/reverse shot, shortly after *I Was Born, But . . .* was completed in April 1932, particularly from late 1932 through 1933. As I have argued elsewhere, Ozu sought to advance his ideal of film, which differed from Soviet filmmakers and their approach to montage, and explored a cinema of "light-ness" rather than "attraction" or "direct impact."[62]

Returning to the question posed at the beginning of this chapter, was Ozu critical of modernity? In a related question, how have we come to dissociate the shoshimin film from its negative reception among Japanese critics in the early 1930s? It is important here to remember the Japanese state's increased efforts to purge leftists from early 1933. (A novelist, Kobayashi Takiji, was killed in February of the same year.) The proletarian film movement's May Day rally was canceled due to government intervention, and all official activities by Prokino members were banned shortly thereafter.[63] With this annihilation of movements surrounding leftist film, strong criticism from a proletarian standpoint vanished. Ozu once said to the critic Hazumi Tsuneo,

I finished the script for *College Is a Nice Place* [*Daigaku yoitoko*] before *Passing Fancy* [*Dekigokoro*] in August 1933. I wrote how meaningless college is. But I tried to make a profit for the company before making it [*College Is a Nice Place*]. The result was *Passing Fancy*.[64]

Ozu's remarks suggest his struggle with and within the studio's policy of commercialism, which preferred *Passing Fancy*, a light comedy, to *College Is a Nice Place*, a dark film focusing on college students with no jobs and future. Ozu finally completed the film in March 1936. There is no doubt that Ozu was critical of modernity and his own studio's commercialism. However, I question the extent to which praise of Ozu as a critical filmmaker is productive for scholarship of his oeuvre and Japanese modernity. From 1934, there were no longer any severe criticisms of Ozu as a "shoshimin" filmmaker, which is to say criticisms of Ozu's films for lacking politics or even contributing to the reproduction of class division. The absence of such criticisms of Ozu on ideological grounds is a direct result of state suppression of proletarian film (and, along with it, critical circles) after 1933. We would do well to keep in mind the political context for celebrating Ozu's shoshimin films as a critical picture of modern life, which was grounded in a post-1933 paradigm. Ignoring the original context in which Ozu's shoshimin films were received is an injustice to proletarian critics, filmmakers, and activists in Japan, and leads to a distorted view of Ozu's early work. In contemporary scholarship on Japanese film, Ozu's early works are renowned primarily, and all too often only, for their treatment of modern life, but his films were made in the context of modernity, specifically the aesthetics of avant-garde silent film. It is in this context that we begin to see the significance of Ozu's early films in a new light.

This chapter is a revised version of one chapter from my dissertation and published in a different version in Japanese as "Ozu Yasujiro no shoshimin eiga saikou—doujidaiteki hihan (Rethinking Ozu Yasujiro's shoshimin films: contemporary criticisms)," *Johogaku kenkyu* 83 (2012): 31–50.

NOTES

1. *"Shoshimin"* is the original Japanese translation of "petit bourgeois" and can be translated as "middle class," but in fact it designates the "salaryman" or "white-collar worker" and is quite different from "middle class" in the specific historical context of Japanese modernization. For this reason, in this chapter, I maintain the term "shoshimin" rather than adopting a perhaps misleading English translation.
2. A major contemporary film journal, *Eiga hyoron* [Film criticism], published special issues focusing on filmmakers such as Ernst Lubitsch, Josef von Stenberg, and Ushihara Kyohiko in the late 1920s. There were also articles on young Japanese filmmakers such as Gosho Heinosuke and Mizoguchi Kenji. Thus there was a discourse centering on film directors in Japan in the late 1920s, and I use the term "film auteur" in this context.
3. Uchida Tokio, *"Zange no yaiba"* [Sword of Penitence], *Kinema junpo*, November 21, 1927, 59.
4. Okamura Akira, *"Kabocha"* [Pumpkin], *Kinema junpo*, November 1, 1928, 102.
5. Throughout this chapter, I use the terms, such as "socially realistic filmmaker" and "social realism," but I would clarify that I use this term of "social realism" in distinction of "socialist realism" particularly of the USSR. While the latter designates the glorified representation of some heroes of the society, the former means the descriptive or distanced—if not distantiated—depiction of everyday life of ordinary people.
6. Otsuka Kyouichi, "Ozu Yasujiro ron" [On Ozu Yasujiro], *Eiga hyoron* 8, no. 4 (April 1930): 40–45. The July issue of *Eiga hyoron* in the same year also includes the following articles: Sekino Yoshio, "Shinkyo-mono no hasan to Ozu Yasujiro no zento" [The disruption of sentimental film and the future of Ozu Yasujiro], 20–24; Hazumi Tsuneo, "Ozu Yasujiro no shoshimin-sei" [The shoshimin quality of Ozu Yasujiro], 24–26; Fukui Keiichi, "Ozu Yasujiro to sono sekai" [Ozu Yasujiro and his world], 26–30; Otsuka Kyouichi, *"Rakudai ha shitakeredo"* [I Flunked, But . . .], 30–31.
7. Otsuka, "Ozu Yasujiro ron," 41.
8. Ibid., 41–42.
9. Ibid., 42–43.
10. Ibid., 44.
11. Ibid.
12. Ibid., 45.
13. Otsuka, *"Rakudai ha shitakeredo,"* 31.
14. Sekino, "Shinkyo-mono no hasan to Ozu Yasujiro no zento," 20.
15. Ibid.
16. Ibid.
17. Ibid.
18. Ibid.
19. Ibid., 21.

20. Ibid.
21. Ibid.
22. Ibid.
23. Ibid., 22.
24. Ibid., 23.
25. Hazumi, "Ozu Yasujiro no shoshimin-sei," 24.
26. Ibid., 25.
27. Ibid.
28. Ikeda Yoshio, "Shoshimin eiga hihan" [Shoshimin film criticism], *Eiga hyoron* 12, no. 4 (April 1932): 118.
29. Ibid., 120.
30. Ibid.
31. Ueno Ichiro, "1932 nen kaiko: Nihon eiga kaiko" [Looking back on 1932: Looking back on Japanese film], *Eiga hyoron* 13, no. 6 (December 1932): 70.
32. Ibid.
33. Ibid.
34. Iida Shinbi, "*Tokyo no korasu*" [*Tokyo Chorus*], *Kinema junpo*, September 11, 1931, 78.
35. Okamura Yasuo, "*Umarete ha mitakeredo*" [*I Was Born, But . . .*], *Kinema junpo*, June 21, 1932, 50.
36. For example, Tadao Sato demonstrates this theological view in his seminal work, *Ozu Yasujiro no geijustu* [Film art of Ozu Yasujiro] (Tokyo: Asahi shinbun shuppansha, 2003), 254–293.
37. On Prokino in general, see Markus Nornes, *Japanese Documentary Film: The Meiji Era through Hiroshima* (Minneapolis: University of Minnesota Press, 2003), especially chapters 1–3; Makino Mamoru, "Rethinking the Emergence of the Proletarian Film League of Japan," in *In Praise of Film Studies: Essays in Honor to Makino Mamoru*, ed. Markus Nornes and Aaron Gerow (Victoria: Trafford / Kinema Club, 2001), 15–45; Tadao Sato, *Nihon eigashi* [Japanese film history], (Tokyo: Iwanami Shoten, 1995): 1:305–313; Namiki Shinsaku, *Purokino zenshi* [The history of prokino] (Tokyo: Godo Shuppan, 1986).
38. Sasa Genju, "Gangu/buki—satsueiki" [Camera—toy/weapon], *Senki* 1, no. 2 (June 1928): 33. Part of this work is quoted in Nornes, *Japanese Documentary Film*, 23–25, but the translation has been modified.
39. Sasa, "Gangu/buki—satsueiki," 30; Nornes, *Japanese Documentary Film*: 22.
40. As recent studies point out, such a view on cinema as the machine that makes seeable the realm beyond human perception prevailed in avant-garde discourse in the late era of silent cinema. See, for instance, Malcolm Turvey, *Doubting Vision: Film and the Revelationist Tradition* (New York: Oxford University Press, 2008); Ian Aitken, *European Film Theories: A Critical Introduction* (Bloomington: Indiana University Press, 2001).
41. Iwasaki Akira, *Eiga to shihonshugi* [Cinema and capitalism] (Tokyo: Ouraisha, 1931), 225.
42. Ibid., 230.
43. Ibid.
44. Iwasaki Akira, *Eiga no geijutsu* [The art of film] (Tokyo: Kyowa Shoin, 1936), 12–13.
45. Iwasaki Akira, *Eiga-ron* [On cinema] (Tokyo: Mikasa Shobo, 1936), 44.
46. Ibid., 44, 48.
47. Ibid., 73.

48. See Sergei Eisenstein, "Methods of Montage," in *Film Form: Essays in Film Theory*, ed. and trans. Jay Leyda (San Diego: A Harvest Book, 1977), 72–83.

49. Iwasaki, *Eiga-ron*, 83.

50. Ibid.

51. Iwasaki Akira, "Toukii-teki zuii" [My view on talkie cinema], *Kinema junpo*, January 11, 1933, 52.

52. Iwasaki, *Eiga no geijutsu*, 53–54.

53. On the production of *I Was Born, But . . .* , see Tanaka Masasumi's commentary in Ozu Yasujiro, *Ozu Yasujiro sengo goroku shusei 1946–1963* [An anthology of Ozu Yasujiro's words after World War II: 1946–1963], ed. Tanaka Masasumi (Tokyo: Film Art sha, 1989), 441.

54. As to the film-within-a-film scene of *I Was Born, But . . .* , it might belong to the genre of city symphony represented by Walter Ruttmann's *Berlin: Symphony of a Metropolis* (*Berlin: Die Sinfonie der Großstadt*, 1927), which was also widely known in Japan at the time. However, I would like to compare it with *Man with a Movie Camera* in particular due to the tight thematic and stylistic connections and the exact contemporariness of the two films.

55. Recent scholarship also shares such a view. See, for instance, Mitsuyo Wada-Marciano, *Nippon Modern: Japanese Cinema of the 1920s and 1930s* (Honolulu: University of Hawaii Press, 2008), 59–61; Alastair Phillips, "The Salaryman's Panic Time: Ozu Yasujiro's *I Was Born, But . . .* (1932)," in *Japanese Cinema: Texts and Contexts*, ed. Alastair Phillips and Julian Stringer (London: Routledge, 2007), 32–33.

56. On the reception of Soviet montage theory in Japan, see the seminal study Iwamoto Kenji, "Nihon ni okeru montaju riron no shokai" [Study on the introduction of montage theory in Japan], *Waseda daigaku hikaku bungaku nenpo* 10 (1974): 67–85.

57. Dziga Vertov, "From Kino-Eye to Radio-Eye," in *Kino-Eye: The Writings of Dziga Vertov*, ed. Annette Michelson, trans. Kevin O'Brien (San Diego: A Harvest Book, 1977), 87.

58. Ibid., 90.

59. Dziga Vertov, "Man with a Movie Camera, Absolute Kinography, and Radio-Eye," in *Lines of Resistance: Dziga Vertov and the Twenties*, trans. Julian Graffy, ed. Yuri Tsivian (Pordenone: Le Giornate del Cinema Muto, 2004), 319.

60. Iwasaki Akira, *Eiga geijutsu shi* [History of film art] (1930; repr., Tokyo: Yumani shobo, 2004), 150.

61. Iijima Tadashi, *"Kore ga Roshia da"* [*This Is Russia*], *Kinema junpo*, March 11, 1932, 31–32; Anno Hatsuo, "Kamera wo motta otoko shikan" [My view on man with a movie camera], *Kinema junpo* May 11, 1932, 46. Note that "This is Russia" was the original title of *Man with a Movie Camera* when it was first released in Japan. Yuri Tsivian refers to Stalin's response to Vertov's project in the following way: "He is out of his mind." See Yuri Tsivian, "Dziga Vertov and His Time," in *Lines of Resistance*, 14.

62. In my dissertation, "Reflecting Hollywood: Mobility and Lightness in the Early Silent Films of Ozu Yasujiro, 1927–1933" (PhD diss., The University of Chicago, 2012), I explore this process in terms of "lightness" as opposed to "attraction" (as related to Eisenstein), or "direct impact" in this context.

63. See particularly Namiki, *Purokino zenshi*.

64. Hazumi Tsuneo, "Kare no shinkyo: Ozu Yasujiro tono ichimon ittou" [His thoughts: Interview with Ozu Yasujiro], in Ozu Yasujiro, *Ozu Yasujiro zenhatsugen: 1933–1945* [Ozu Yasujiro: Collected statements, 1933–1945], ed. Tanaka Masasumi (Tokyo: Tairyu-sha, 1987), 31.

CHAPTER 9

Laughing in the Shadows of Empire

Humor in Ozu's Brothers and Sisters of the Toda Family *(1941)*

JUNJI YOSHIDA

Ozu Yasujiro's apprenticeship at the Shochiku Kamata studio in the 1920s coincided with the steady rise of comedy in Japanese film. Film scholars acknowledge that in his early career, before he developed his signature urban middle-class genre film, Ozu was immensely influenced by the works of Charlie Chaplin, Harold Lloyd, and Ernst Lubitsch.[1] It is widely believed, however, that Ozu's interest in comedy had dissipated by the time the Film Law was implemented in 1939, and then resurfaced in his postwar films, such as *Late Spring* (*Banshun*, 1949). This idea of a polarization between early and late Ozu—that is, between the director influenced by silent Hollywood comedies and the tradition-bound creator of postwar family melodramas—is bolstered by his wartime productions *Brothers and Sisters of the Toda Family* (*Todake no kyodai*, 1941, *The Toda Family* hereafter) and *There Was a Father* (*Chichi ariki*, 1942). These two so-called national policy films have played a pivotal role in asserting Ozu's increasingly ideological bent. Due to the unavailability of English subtitles and difficulties in dissecting the dialogue, most Anglophone scholars have approached *The Toda Family* as a reification of Japanese patriarchal tradition. Furthermore, they reduce it to what Michel Chion calls a *verbocentric* text, meaning that speech is the center of attention.[2] But these critics are blind to Ozu's humor as well as his overall strategy of delivering it via a holistic audiovisual montage.

This chapter aims to critique this assessment by threading through Ozu's uneasy encounters with the surge of Japanese nationalism after the Manchurian Incident. After examining the ways in which the rising tide of nativist xenophobia impinged on Ozu's "*shoshimin* (middle class or petit bourgeois) films," which often feature white-collar salaryman as the protagonist, I look at a new range of strategies to evoke the humor he began to employ. Ozu's battlefield experiences in China in 1937–1939 did not turn him into a patriotic zealot, but they furnished him with a better understanding of the relationships between cinematic narration and its ideological effects. I argue that humor in Ozu films was neither exemplary of "Japaneseness" nor mimetic of classical Hollywood comedies; instead, it was a product of his struggle to recalibrate his signature genre of shoshimin film for the requirements of patriotic war efforts. I intend to complement some of the previous approaches to Ozu's films as advocating the Japanese, patriarchal value. In contrast to the previous scholarship driven by culturalism, a group of scholars, including David Bordwell, Mitsuyo Wada-Marciano, and Michael Raine, has sought to resituate Ozu's films closer to the interwar Japanese "project of emulating Hollywood [that] was not specific to Ozu."[3] Central to this reorientation is an appreciation of urban cosmopolitanism that had appeared in interwar Japan. As Wada-Marciano insightfully observed, the portrayal of Ozu as traditional "occurred only in the postwar discourses in comparison with new, politically overt directors such as Oshima Nagisa, Imamura Shohei, and Yoshida Yoshishige."[4]

These more historical approaches, advanced as of late, make me wonder why Ozu's wartime films have continued to be grasped as a reification of revived traditionalism. My reading of Ozu's wartime experience as a solider along with the extension of his apprenticeship in Hollywood comedy suggest that Ozu's use of, as well as departure from, Hollywood continuity editing, yields a subtle sense of humor, which enabled him to reconcile the competing demands of propaganda film production and vernacular comedy for local fan entertainment.

THE POLITICS OF MODERN BOY/GIRL (*MOBO/MOGA*) BASHING

Discharged from his two-year military service in the summer of 1939, Ozu collaborated with Ikeda Tadao to compose a script for *The Flavor of Green Tea over Rice (Ochazuke no aji)*. It is noteworthy that he prophesied the film to be a "comedy" during an interview in January 1940:

The story revolves around three housewives of the leisure class who kill their boredom by visiting kabuki plays and hot springs. One of their husbands is embarrassingly uncouth, heedless of his appearance or public reputation; for example, he would pour miso soup over rice at dinner, smoke a cheap cigarette, and ride trains

on economy class. Humor erupts each time his rustic behavior is shown to irritate his pompous, Tokyo-born wife. When the disreputable husband receives his call-up notice, his wife loses her composure; the husband, in contrast, is shown taking a nap on the day before his departure. His self-composure makes her evaluate his manliness. At midnight on that day they apologize to each other and savor a humble meal of green tea over rice.[5]

This banal story of conjugal love did not make it to shooting because it depicted "family pathos when a man is called into the army" and "pleasure-seeking and degenerate lifestyles," which in August 1937 the censor bureau of the Home Ministry had warned film producers not to depict.[6] Moreover, the censors insisted that a "departure for the army should have been a joyful occasion, to be celebrated with festive red rice, not with a humble green tea over rice."[7] In protest, Ozu dropped the whole project.[8] For those who are familiar with this famous incident, a funny scene from his last film, *An Autumn Afternoon* (1962), seems even more humorous: when a former navy crewman (Kato Daisuke) bumps into the captain of his battleship (Ryu Chishu) at a bar, after a couple of drinks, the crewman frankly opines, "Captain, I am so glad that the war is over. Nowadays, those idiots who used to drag us around are gone. I am not speaking of you. You are an exception."

The so-called *ochazuke* (green tea over rice) incident is often called the dawn of militarist incursion into the film industry, but it might make more sense to view it as a logical culmination of the ideological discord that Ozu and the Shochiku studio had steadily developed against jingoists during the 1930s. Of the major film studios, Shochiku was especially influential in popularizing American jazz, dance halls, fast cars, and Hollywood glamour.

Some historical background is necessary in order to accurately capture the significance of the ochazuke incident. In September 1931, Japan's Kwantung Army bombed the South Manchurian Railway and blamed it on Chinese dissidents as a pretext for establishing a colonial puppet state called Manchukuo. When the League of Nations tried to contain Japan's bellicose territorialism with the Lytton Report in February 1933, Japan withdrew from the League of Nations. Despite this, the majority of Japanese remained avid consumers of American movies and Western fashions. This resilience of urban mass culture exasperated Japanese militarists. The conservative *Osaka mainichi* (Osaka daily) newspaper collaborated with Army General Araki Sadao to release a two-hour lecture film entitled *Japan in Time of Crisis* (*Hijoji Nippon*, 1933).[9] Released on the cusp of Japan's departure from the League of Nations, this talkie works hard to gloss over the Kwantung Army's culpability. For example, after projecting an iconic image of a modern boy (*mobo*) and modern girl (*moga*) strolling around Ginza, Araki's voice-over castigates "these traitors who obsequiously ape Westerners," warning that their behaviors could send an erroneous impression that "the Japanese can be easily swayed under external

いまだったら 僕ちよいと中学の
算術の試験難かしいですね

Figure 9.1.
What Did the Lady Forget? (Shukujo wa nani o wasuretaka, Ozu Yasujiro, 1937).

pressures."[10] Belching out xenophobic language, *Japan in Time of Crisis* displaces diplomatic debacle onto the "frivolity" of modern boys and girls.

Being a modern boy himself, Ozu could have felt alarmed or irked by Araki's antimodern boy/modern girl gambit. In fact, he directly mocked Araki at the opening of *College Is a Nice Place (Daigaku yoitoko,* 1936) by having a military drill instructor recite Araki's hyperbole, "Time of Crisis." The censors deleted the whole scene before the film's release.[11] In August 1937, the Home Ministry censors division warned film producers to avoid "subjecting the army to ridicule."[12]

In this same directive, they warned film producers to avoid "depictions of pleasure-seeking and degenerate lifestyles." *What Did the Lady Forget? (Shukujo wa nani o wasuretaka,* 1937), released five months earlier, did not comply. Or, rather, it is likely that this film and others spurred the issuance of the edict. The film features a quintessential modern girl who smokes cigarettes and flirts with traditional geisha. Fig. 9.1 shows that the lead actress, Kuwana Michiko, wears the Western costume, makeup, and hairstyle of the anonymous actress castigated by *Japan in Time of Crisis*[13] (see fig. 9.2).

Yet despite this uncanny resemblance, Ozu's modern girl turns out to be old-fashioned at heart, siding with her uncle, a henpecked husband (adeptly played by Saito Tatsuo) when his pompous, kimono-clad wife (Kurishima Sumiko) trumps his patriarchal authority. Cast as the daughter of a well-off

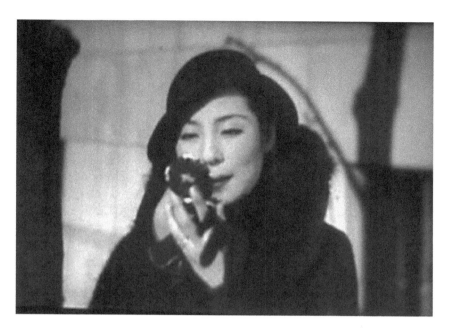

Figure 9.2.
Japan in Time of Crisis (1933).

family from Kansai, Kuwana, a captivating beauty, speaks in a Kansai dialect that connotes mercantile brawn. The comic alliance between a timid, middle-aged professor and his young and brazen niece embodies the triumphant unison of modern boy and modern girl over conventional social mores. Thanks to Kuwana's brilliant performance, Ozu fractures Araki's malicious deformation of the modern girl as ugly, egotistic, and masculinized.[14] By this point, Ozu had established himself as a leading director of sophisticated comedies.

I believe that Ozu's affection for comedy did not wane even after the ocha-zuke incident. He said in a September 1940 interview with the newspaper *Miyako shinbun*, "I had never imagined that the script of *The Flavor of Green Tea over Rice* would occasion a trouble. My priority for this project is its consummation, so I settled with a familiar theme of maternal love that I had worked on previously. Frankly, I was smitten by the thought of shooting another comedy, but since satire and caricature could incur another run-in, I gave up the plan."[15] This proclaimed abstention from comedy was refuted in 1943 when he confessed, "In terms of overall tones, *The Toda Family* was similar to *The Flavor of Green Tea over Rice*. That's why I deliberately chose to centralize the maternal affection as its motif."[16]

Many personal statements by Ozu from 1939 to 1943 suggest that he may have attempted to direct *The Toda Family* as a diluted form of shoshimin film. When it was released on March 3, 1941, it was both commercially successful

and critically acclaimed, as evidenced by a special round table devoted to it in the film journal *Eiga junpo*. That prestigious journal voted it the best motion picture of the year. In 1952, Ozu ranked this piece as one of his all-time favorite works.

PERCEPTIONS OF OZU

The story of *The Toda Family* begins with the death of a well-off patriarch, Toda, who leaves behind an immense debt that the surviving family members must pay off by selling his mansion and antique collections.[17] His frail widow and youngest daughter, Setsuko, are forced to move in with the families of the other children who disrespect and abuse them. For instance, the eldest son's egocentric wife plays the piano past midnight to torment them. Setsuko finds moral support in a former classmate, Tokiko, who supports herself and her mother with a full-time job. Inspired by Tokiko's independence, Setsuko and her mother relocate to a dilapidated family villa. On the first anniversary of Mr. Toda's funeral, the mother's misery comes to the attention of her youngest son, Shojiro, who is visiting back from China. After censuring his siblings for their hypocrisy and breach of filial piety, Shojiro pledges to take his mother and sister to China. The story ends on a merry note when Setsuko promises Shojiro, to his apparent dismay, that she will arrange a perfect marriage for him: her friend Tokiko.

Most critical commentaries on *The Toda Family* have come together into two competing currents. One revalues the film as a precursor to postwar family melodrama. Situating both *The Toda Family* and Harry Millarde's *Over the Hill to the Poor House* (1920) under the rubric of what he calls "social metabolism film," Yamamoto Kikuo posits that industrialization in the United States and Japan entailed a gradual dissolution of large-scale traditional family households. To recuperate from this traumatic and alienating experience, a genre of maternal affection emerged in both countries.[18]

The second group defines the film as wartime propaganda.[19] Quoting Maruyama Masao's scathing critique of the family system as "the bulwark of reaction in Japan,"[20] Joan Mellen characterizes Shojiro's behaviors as an embodiment of tradition. Mellen correctly notes that Ozu misrepresents war-ravaged China as "a favorable place of advancement for hard-working Japanese."[21] But her allegation that Ozu had "never valued a democratic philosophy" and considered it "a threat to the preservation of the old ways" seems inadequate given his track record of producing shoshimin films.[22] David Bordwell gives a more nuanced interpretation of the story as a social critique of the failed promise of Meiji modernization, but he also discerns a patriarchal trope: "[Masculine] authority, so often lost in Ozu films, is regained by

a diffident, casual youth who likes fishing."[23] Both readings paint Ozu as a defender of the traditional family system.

This obsessive focus on traditionalism as a key motif of *The Toda Family* overlooks its comic tenor as a shoshimin film.[24] As is widely known, *The Toda Family* was a loose adaptation of Leo McCary's *Make Way for Tomorrow* (1937), though the banquet scene is missing from McCary's original. What motivated Ozu to supply this additional sequence? Many critics (including Bordwell and Mellen) have considered Shojiro's censuring of his elder siblings an example of Confucian filial piety.[25] His action obviously violates the Home Ministry's July 1938 mandate of "imbuing respect for fathers and elderly brothers."[26] In fact, one nationalistic film critic revealed his displeasure because Shojiro's moral maturity at the end is not fully motivated or foreshadowned by earlier scenes in this film.[27]

To ask why Ozu added this controversial scene requires explaining that Shojiro and Ozu shared personal traits such as an attachment to a Leica camera and hesitancy at the prospect of marriage. According to Sato Tadao, Shojiro is Ozu's avatar. When Shojiro intemperately remarks that "one can learn quite a bit by spending a year overseas; the best way to handle those [flippant] guys is to smash them over the head," it recalls Ozu's protest over the ochazuke incident, which was still fresh in the memory of wartime Japanese fans. Shochiku assistant director Inoue Kazuo recalls that the popular banquet scene actually helped the film's commercial success.[28] Only under a sanctimonious gesture of filial piety could Ozu salvage an "Anglo-American" notion of individual autonomy.

Ozu's cautiously guised response to wartime censors has been misconstrued as a sign of ideological collaboration. This led to the assumption that wartime Ozu was a master less of shoshimin comedy than of traditional virtues.

VERNACULAR HUMOR AND THE "AMERICANIZED" SENSORIUM OF SPECTATORS

To return to our story: on the night before his death, Mr. Toda (Fujino), seated side by side with his wife, has a blissful moment chatting about their grandchildren. After taking off his glasses and massaging his face, he fumbles around for his glasses like a blind person. This stint induces what Gerald Mast called the "comic climate,"[29] as his spectacles are clearly sitting right in front of his nose. He shrugs off his folly, saying, "Oh, I am tipsy." His round black celluloid spectacles echo Harold Lloyd, and his performance of a merry drunkard is reminiscent of Charlie Chaplin. This mild "act of frivolity" survived censorship, but Shojiro's flirtation with a geisha at a tea house had to be deleted.[30] Such was the brutality and unpredictability of wartime film censorship that the production of humor had quickly shifted from a profilmic act of a

あゝ　お書きしました
これはあの明日朝刊に出ると

Figure 9.3.
The eldest son Shinichiro receives a briefing from Mr. Suzuki after Mr. Toda's death in *The Brothers and Sisters of the Toda Family* (*Todake no kyodai*, Ozu Yasujiro, 1941).

comedian to a director's external controls over camera position, shot composition, editing, and sound effects.

Ozu's fabrics of cinematic humor, I suggest, relate to what Michel Chion designates the *verbocentric* style. This style, he says, is "the classical form of the sound film that was established by the late 1930s and is still common today."[31] On the night of Toda's wake, the eldest son, Shinichiro, rests in his study. His right-hand man, Mr. Suzuki, shows up to give a briefing on important chores ahead. Shot from a distance with little action, the sequence is highly *verbocentric*. The spectator is informed, for example, that Suzuki has already contacted major newspaper companies to print "this" (*kore*)—meaning Toda's obituary—in the upcoming morning edition (fig. 9.3).

After the briefing, Suzuki leaves the study and bumps into Setsuko, who descends the stairs with him and wends her way through the corridor melancholically. The loose framing enables us to scan every detail of her action. When she swivels her body around a corner (fig. 9.4), the lower lapel of her black *kimono* flips over to reveal its white underside. Even though this infinitesimal gesture is recorded by two separate shots from different angles, the cut is made invisible by Ozu's rigorous match-on-action editing. Ceaseless tapping of Buddhist gongs further contributes to the overall impression that the

Figure 9.4.
After Setsuko bids her farewell to Mr. Suzuki at the bottom of stair case, each one of her steps is steadily shown on screen. Here we note how Ozu has developed a continuity system as a way to build up a smooth flow of time through banal repeated action (*The Toda Family*).

diegetic event is unfolding without any omissions. Ozu's masterful grasp of continuity turns his viewers into real-time observers.

> SETSUKO: Where have you been, Brother?
> SHOJIRO: I was in Osaka. I read the morning newspaper, to my astonishment. When did Father pass away yesterday?
> SETSUKO: 7:36 a.m.
> SHOJIRO: What was the cause of his death?
> SETSUKO: Heart attack.
> SHOJIRO: Was he in pain?
> SETSUKO: Yes, very much.

The banality of this conversation belies playfulness. If Toda had died in Tokyo at 7:36 a.m. on the previous day and Suzuki arranged the obituary on the same day, Shojiro's return from Osaka should be happening at least thirty-six hours after Toda's death.[32] Nonetheless, as soon as Suzuki leaves the study and descends the stairs with Setsuko, the latter is about to greet Shojiro. The dialogue above happens only forty seconds of screen time after Suzuki walks out of the study and meets with Setsuko. During this crucial forty seconds,

大阪行ってたんだよ
今朝新聞見て驚いたんだ

Figure 9.5.
Shojiro returns home from Osaka after reading his father's obituary arranged by Mr. Suzuki (*The Toda Family*).

each shot with Suzuki or Setsuko is joined with straight cuts rather than dissolves or fades, implicitly insisting that nothing has been compressed or omitted. Thus, Shojiro's claim of having read a newspaper obituary back in Osaka is not credible (fig. 9.5).

How does Ozu pull off this subtle joke? The answer lies in his superb command of the actress's eye-line and the spectator's gaze. After Setsuko parts with Suzuki, the camera tracks her movement without any omissions. She advances from the deepest plane to the shallowest screen space, then suddenly stands still and pitches her eye-line off screen (fig. 9.6). We are prompted to anticipate its reverse shot. Since such a reciprocating shot does not happen immediately, a retardation of narrative flow solicits our yearning. This is how Shojiro's entry is introduced—through her point of view. The close-up of Setsuko's tearful face makes the viewer imagine how patiently she has been waiting for his return—which implies a passage of considerable time.[33]

Three things should be noted. First, our hasty acceptance of Shojiro's return is powerfully motivated by the visual economy of classical Hollywood continuity editing. Second, Ozu deploys the normative principles of classical Hollywood only to throw its realist effect into disarray. Third, and most importantly, this playful joke has eluded the attention of Ozu scholars and film historians despite the postmortem prominence he has achieved. I have gone into

Figure 9.6.
Setsuko's puzzling gaze solicits our curiosity (*The Toda Family*).

this scene in detail in order to demonstrate how irrevocably the sensory and perceptual schema of wartime Japanese spectators was shaped and structured by what Miriam B. Hansen termed the "first global vernacular" of classical Hollywood cinema.[34] Unlike General Araki, who pitted Japanese tradition against Western mass culture, Ozu soberly admitted the cultural hybridity of cosmopolitan interwar Japanese film culture.[35]

Hansen contends, "To write the international history of classical American cinema, therefore, is a matter of tracing not just its mechanism of standardization and hegemony but also the diversity of ways in which this cinema was translated and reconfigured in both local and translocal contexts of reception."[36] Ozu's humor operates within classical Hollywood traditions to reconfigure the local politics of film censorship; his adoption of said traditions was propelled by his "localized" need to outsmart his pigheaded censors. Despite the strained relationship between Japan and the United States, Hollywood's hegemonic standardization of film editing, sound, and acting styles had kept alive Shochiku's tradition and the vernacular spirit of shoshimin film. No matter how desperately jingoistic censors tried to expel "dangerous influences of Western thought," they could not change the fact that ordinary Japanese moviegoers had internalized Hollywood syntax as part of their own "tradition." Ironically, the censors' obsession with written scripts on the page backfired, foreclosing their chance of squelching a humor of montage.

Another risible moment of editing can be analyzed in order to illustrate my point: the stricter the censorship became, the more ingenious Ozu's invented jokes became. The days when he could get away with overtly parodying General Araki were gone. Take a look at the brief scene where Shojiro burns incense for his late father. This sequence is orchestrated with a fastidious structure of seven shots. The first two cover his entrance from the corridor to his approach at the flowered altar. The last two trace his retreat from the altar to the corridor. The first and the seventh use the same shot size and camera angle. So do the second and the sixth, so that the opening and ending run in parallel. Given the ephemerality of life punctuated by Buddhist gongs and the remarkable formal symmetry, the whole scene achieves a monumental sense of solemnity comparable to that of Mizoguchi Kenji's *The 47 Ronin* (*Genroku chushingura*, 1941–1942).

Filmed from behind, the third shot blocks our sight of Shojiro's face (fig. 9.7). As a result, the next bust shot effectively concentrates our attention *on* his face—his tightly closed lips and his shining eyes (fig. 9.8). Toda's absence works powerfully to evoke his central presence. When we finally get a glimpse of his photographic image from Shojiro's point of view (shot five), the camera reveals that Toda tilts his head nearly thirty degrees and casts a wry glance over his shoulder in the square frame (fig. 9.9). His droll manner stands in a stark contrast to the austerity of Shojiro's expression. Because Shojiro

Figure 9.7.
Our access to Shojiro's sorrow is blocked in this mise en scène (*The Toda Family*).

Figure 9.8.
Now Shojiro's eye-lines are fixated upon his father (*The Toda Family*).

throws his eye-line to the upper-left corner of frame in the fourth shot and Toda's eye-line falls to the left of the camera's Y-axis in the fifth, "false eye-line matching" produces a jarring effect, as if he had dodged his son's gaze. The joke briefly reveals the zaniness of this dandy old man. The use of a diagonally angled shot for a funeral picture was atypical, judging by similar scenes in other films of the same era, for instance Ozu's *A Mother Should Be Loved* (*Haha o kowazuya*, 1936) or Kurosawa Akira's *Ikiru* (1952). Juxtaposing a ceremonious rigor with an eruption of playfulness in the close-up, Ozu prohibits his spectators from investing excessive emotion.[37]

PHENOMENOLOGY OF BATTLEFIELD EXPERIENCE

Ozu, a veteran, recalled in one journal interview how quickly actual battles shattered given stereotypes of the cowardly Chinese.[38] Disclosing such stereotypes as fabrications circulated by the media, he cautiously added that he was also reassured of the "invincibility of the Imperial Japanese Army soldiers." If Chinese cowardice was a cliché, why could not Japanese invincibility also be? In fact, Ozu's battlefield memorandum mentions how Japanese soldiers lost their hopes under intensified attacks.[39] His contradiction remains enigmatic. In another rarely cited anecdote, Ozu witnessed a bucolic landscape of

extravagantly flowering apricot trees. The white petals were suddenly shaken off when Chinese artillery created powerful vibrations in the air. This ineffable beauty wiped out his preconceived notion of what "war movies" should look like.[40]

Both of these experiences touch upon a dialectical relationship between fascist state control of mass media versus lived experiences that elude existing hegemonic language structures. This awareness perhaps steeled Ozu's resolve to guard against opportunistic jingoism that permeated wartime literature and films. Coping with a similar innervation of the human sensorium by the technology of the filmic apparatus, Walter Benjamin contends in the second version of his famous essay entitled "The Work of Art in the Age of Technological Reproducibility" that "the most important social function of film is to establish equilibrium between human beings and the apparatus. Film achieves this goal not only in terms of man's presentation of himself to the camera but also in terms of his representation of his environment by means of this apparatus."[41] For Benjamin, the camera occupied an important role of defamiliarizing the familiar using techniques such as close-up and slow motion.

We might imagine Ozu coming to a similar realization with regard to how mass media can shape and distort our perceptions of people and the world. Having spent two years on the China front, he was bitter at "embedded

Figure 9.9.
Mr. Toda's jaunty style undercuts a monumental tone of the sequence (*The Toda Family*).

journalists and novelists" such as Hino Ashihei, who visited China for a couple of weeks, stayed in the safety zone, and wrote about soldiers back in Tokyo as if he could accurately convey the psychological truth of war. When the Home Ministry censors demanded to replace "green tea over rice" with festive red bean rice for the sake of hackneyed patriotism, Ozu adamantly refused. After all, it was shoshimin with contradictory desires and competing sentiments who sacrificed themselves and thus carried the heaviest burden of war.

Increases in red tape also encouraged Ozu to gain a baroque sensitivity. He said in his 1940 interview cited earlier, "Just as each chef/artisan [shokunin] today has to distinguish himself by his individual skills because the price of each meal or dessert has been fixed by official quotation, so does a film-maker have to start with rationed materials. In my impression, our competition will boil down to the [technical] question of how to modify scripts and directions."[42] Using a culinary metaphor, Ozu articulated the dilemma of the wartime film director. This adversity, in fact, elevated the role of artisanal skills rather than thematic motifs or plotlines to the effect of accommodating contradictory urges to invoke and reinterpret the idealized projection of "Japanese tradition." As I show shortly, this situation resulted in a paradigmatic affinity between parodic humor and the activity of criticism in general. Ozu's use of close-up reflects Benjamin's theoretical reflections of mass mediation as a cardinal problem of his age.

In an essay entitled "The Fascist Longings in Our Midst," the cultural theorist Rey Chow redefines fascism as "projectional idealism."[43] Chow insists that in order to understand the operation of fascism correctly, "the 'false-true' dichotomization" must be discarded because it "leads us to believe that good intentions cannot result in cruel behavior, and conversely, that the fact of cruelty can only be the result of hidden evil motives."[44] The truth is more complicated because our rational subjectivity does not exist a priori and then get muddled or tricked by lies and ruses of propaganda. She points out that "it is precisely in this kind of interpretive cross-over from rhetoric to deed, from 'lies' to 'truth,' from 'beautiful pictures' to 'ugly reality,' that critics have downplayed the most vital point about fascism—its significance as image and surface; its projectional idealism."[45] Drawing on Thomas Elsaesser's phrase "to be is to be perceived," Chow emphasizes the constitutive primacy of visual technology in the construction of a normal "rational" subjectivity. Reversing the intuitive order of cognitive processes, Chow holds that "projection, instead of being preceded by 'being,' is itself the basis from which 'being' arises."[46] Therefore, those who seriously desire to resist and dismantle fascist ideology must begin with interrogating the origins of one's own self as an entity constituted by visual projection.

Under the pressures of increasing constraints of given motifs and styles, Ozu grappled with what the Japanese historian Takashi Fujitani has described as a modern, post-Meiji system of "visual domination" installed by the emperor's

pageantry.[47] In the film, Shojiro and his drinking friends wonder whether or not Toda was cognizant of his son's callow habit of stealing his books and antiques for quick cash. Shojiro half-jokingly says, "Even the Buddha would have no clues."[48] His friends disagree: "No way, your father must have known your misdeeds." Toda is thus associated with a mythic patriarch of unconditional love. According to Fujitani, "In the course of the post-Meiji years many national subjects began increasingly to imagine the emperor's gaze as the loving, forgiving, all-embracing, protective, and self-sacrificing look."[49]

The comparison of Toda with the emperor may seem farfetched, but Setsuko's supplications under his elevated photo flesh out the linkage. Darrel William Davis noticed it: "[When Setsuko] is feeling oppressed, the daughter silently appeals to the photograph of Grandfather Toda, who gazes down from his gilded frame like an omniscient imperial benefactor."[50] Though I agree with Davis's suggestion that Setsuko's prayers are allegorical, I assert a presence of irony because Grandfather Toda does not "gaze down . . . like an omniscient imperial benefactor" but looks upward over his shoulder, producing the jarring effect I explained earlier. Even though the rhapsodic music on the soundtrack prompts viewers to identify with Setsuko, Setsuko's point-of-view shot holds Toda's portrait for a few seconds in order to emphasize the physical objectivity. When Setsuko collapses onto the floor in the last, wide-angle shot, the absence of any spiritual rapport becomes painfully clear. Is not this precisely an "exploration of commonplace milieu through the ingenious guidance of the camera" that Walter Benjamin explored in his famous aforementioned essay?[51]

In addition, this poignant sequence reiterates Elsaesser's theorem: "To be is to be perceived" for our recognition of a sinister mechanism of fascist subject formation. It is by standing below the photograph and feeling "perceived" by the imaginary gaze of the Father that Setsuko is interpellated as a subject. Her prayer appears twice more in the film to remind us that an omniscient benefactor is not a given but needs to be reproduced through everyday ritual practices. It would be silly to claim Ozu as a critic of emperor worship; however, the contrapuntal montage works to divide the spectator's embodied consciousness between Ozu as a *perceiving subject* of intentional investment, on the one hand, and Setsuko, a fictive character, as a *perceived object* of visual expression, on the other. The film elucidates the degree to which Ozu relentlessly grappled with the conundrum of visual projection as constituting social identity.

CONCLUSION

Vivian Sobchack's phenomenology of vision defines the filmic body as *perception* and *expression* in correlation, an entity always dialogic and open-ended. So far, film scholars have approached the "filmic body" of *The Toda Family* as

an expression of Japanese patriarchy or traditional values. Neglecting the subtlety of the film in its balancing of the apparent status quo and its critique through humor, some scholars discerned a celebration of conservative traditional family values.

But this is not what the film is expressing. What is lacking is a balanced awareness of this film as the *perception* of a filmmaker who abided by a vernacular spirit of ordinary people. My reading of humor attempts to restore the film body as the *perceiving subject* of the world, not just the *perceived object*. Any production of filmic signification involves correlations between two addresses: the intentional address of the eyes and a cinematic address modeled by the means of the technological apparatus. According to Sobchack, the task of film critics is to appreciate and document rather than to simplify or erase dialectical differences between film as perception and film as expression.[52] Ozu playfully bifurcated his narration into dual layers to circumvent the state-centered address of the apparatus.

When the totalitarian logic of the empire placed studio film production under strict controls, scriptwriters and directors responded in ingenious ways. Out of this irreconcilable contradiction between nationalist imperative and transnational technological revolution, movies introduced some of the best jokes in wartime Japan. When a radical vision of political revolution could no longer sustain itself, the imperiled genre of shoshimin film resuscitated itself. Ozu's extrapolation of this genre into the register of national policy films forced him to collaborate with the state.[53] My reading tries to illustrate how the survival of shoshimin film resulted in an ironical popularization of a propagandistic film such as *The Toda Family*.

A careful reading of the humor in *The Toda Family* not only reveals multiple flows of ideological forces, but also explicates how dual modes of addresses were soon distorted, simplified, and forgotten under the Cold War historiography of conversion so that a patriarchal Ozu could be reinscribed as a ghostly shadow of the Japanese empire. Japanese imperialism has to be repudiated and critically understood, but one must remember that critiques of Ozu as a propagandist can easily mobilize a new cycle of the fascist longing that Rey Chow interrogates.

NOTES

1. David Bordwell, *Ozu and the Poetics of Cinema* (Princeton, NJ: Princeton University Press, 1988), 152.
2. Michel Chion, *Film, a Sound Art* (New York: Columbia University Press, 2009), 73–76.
3. Michael Raine, "Adaptation as 'Transcultural Mimesis' in Japanese Cinema," in *The Oxford Handbook of Japanese Cinema*, ed. Daisuke Miyao (New York: Oxford University Press, 2014), 105. Kristin Thompson and David Bordwell, "Space

and Narrative in the Films of Ozu," *Screen* 17, no. 2 (1976): 41–73. Mitsuyo Wada-Marciano, *Nippon Modern: Japanese Cinema of the 1920s and 1930s* (Honolulu: University of Hawaii Press, 2008).

4. Wada-Marciano, *Nippon Modern*, 112–113.

5. Ozu Yasujiro, *Ozu Yasujiro zenhatsugen: 1933–1945* [Ozu Yasujiro: Collected statements, 1933–1945], ed. Tanaka Masasumi (Tokyo: Tairyusha, 1987), 162.

6. Peter B. High, *The Imperial Screen: Japanese Film Culture in the Fifteen Years' War, 1931–1945* (Madison: University of Wisconsin Press, 2003), 292.

7. Ibid., 173.

8. In his postwar interview, Ozu allegedly said that "I wish I could have changed it [script], but it was ridiculous to rewrite it that way so I forgot it." *Kinema Junpo* journal originally conducted the interview which was translated by Leonard Shrader and Haruji Nakamura into English. See Ozu Yasujiro, "Ozu on Ozu: The Talkies," *Cinema* 6, no. 1 (1970): 3.

9. Ginoza Naomi, "Koharu biyori no heiwa ni okeru hijoji" [Time of emergency during the interval of peace], in *Nihon eiga to nashonarizumu: 1931–1945* [Japanese film and nationalism: 1931–1945], ed. Iwamoto Kenji (Tokyo: Shinwasha, 2004), 30.

10. *Hijoji Nipponn* [Japan in Time of Crisis] (Osaka: Osaka mainich shinbunsha, 1933), 35mm, 120 min. My analysis is based on the 16 mm reprint stored at the Library of Congress.

11. High, *The Imperial Screen*, 172.

12. Ibid., 292.

13. I noticed this incredible similarity when I screened a copy of *Japan in Time of Crisis* at the Library of Congress. Given Ozu's well-known citation of other films, it is quite possible that Kuwana's modern girl (*moga*) was modeled after this quintessential "*moga*" actress.

14. Ginoza, "Koharu biyori no heiwa ni okeru hijoji," 50. For a reference to this film in English, see Abé Mark Nornes, *Japanese Documentary Film: The Meiji Era through Hiroshima* (Minneapolis: University of Minnesota Press, 2003), 89.

15. Ozu, *Ozu Yasujiro zenhatsugen: 1933–1945*, 162.

16. The statement appeared at the epilogue of the script entitled *Brothers and Sisters of the Toda Family* published in 1943.

17. My synopsis is based on David Bordwell's with my minor modification. See Bordwell, *Ozu and the Poetics of Cinema*, 282.

18. Yamamoto Kikuo, *Nihon eiga ni okeru gaikoku eiga no eikyo* [The influence of foreign films on Japanese films] (Tokyo: Waseda daigaku shuppanbu, 1983), 224, 229.

19. High offers a careful study of Ozu's unfinished 1943 film. See Peter B. High, "Ozu's War Movie: *Haruka nari fubo no kuni*," in *In Praise of Film Studies: Essays in Honor of Makino Mamoru*, ed. Aaron Gerow and Abe Mark Nornes (Victoria, BC: Trafford; Yokohama: Kinema kurabu, 2001), 199–216.

20. Joan Mellen, *The Waves at Genji's Door: Japan through Its Cinema* (New York: Pantheon Books, 1976), 152.

21. Ibid., 155.

22. Ibid., 153.

23. Bordwell, *Ozu and the Poetics of Cinema*, 288.

24. The dialogue between Setsuko and her proletarian friend Tokiko at a fancy Ginza café broached everyday issues such as the difficulty of achieving financial independence, the persistence of habitual differences between employers and employees, and the basic rules of ordering food at restaurants with the three criteria of

taste, portion, and price. Here is how shoshimin pragmatism can easily shift into patriotic slogan of fighting conspicuous consumption.

25. Bordwell, *Ozu and the Poetics of Cinema*, 286; Joan Mellen, *The Waves at Genji's Door*, 155.

26. High, *The Imperial Screen*, 292.

27. A nationalistic critic, Tsumura Hideo was highly critical of Shojiro's protest because it was not compositionally motivated in earlier scenes. Other participants refuted Tsumura, arguing that Shojiro's disrespect to elder brothers could be sensed from his tardiness at the family photo shooting. For details of this roundtable discussion, see Ozu, *Ozu Yasujiro zenhatsugen: 1933–1945*, 177–178.

28. Ozu Yasujiro, *Ozu Yasujiro sakuhinshu* [The collected works of Ozu], ed. Inoue Kazuo (Tokyo: Rippu shobo, 1993), 259.

29. Gerald Mast, *The Comic Mind: Comedy and the Movies* (Indianapolis: Bobbs-Merrill, 1973), 9.

30. Ozu, *Ozu Yasujiro zenhatsugen: 1933–1945*, 162–163.

31. Michel Chion, *Film, a Sound Art* (New York: Columbia University Press, 2009), 73.

32. To emphasize the miraculous nature of Shojiro's return, one of his elder sisters asks him where he has been and what he was doing so that his answers may remind us of the joke.

33. Ozu manipulates the spectator's sense of time and space with false cues in scenes where the father and son visit a noodle shop or they spend afternoon at an old castle in *There Was a Father* (1942).

34. Miriam Bratu Hansen, "The Mass Production of the Senses: Classical Cinema as Vernacular Modernism," *Modernism/Modernity* 6, no. 2 (1999): 67.

35. When censors imposed the "rejection of slangy or foreign expressions in dialogue" in July 1938, Ozu deliberately inserted an English interjection "you know" at the drinking party scene in *The Toda Family*. Here this English expression also sounds like "*yu no*," which means "as is often said" in a stodgy Japanese dialect. To hide this, Shojiro's friends close their sentences with "*ja no*" (isn't it?).

36. Miriam Bratu Hansen, "Fallen Women, Rising Stars, New Horizons: Shanghai Silent Film as Vernacular Modernism," *Film Quarterly* 54, no. 1 (2000): 13.

37. The subtlety of the joke has been erased when Darrell W. Davis holds that "it is Ozu's rigorous style, however, that makes this film monumental, despite the lightness of his characterization. Specifically, the editing patterns in *The Toda Family* are very tightly structured, making the sanctimonious gravity of other monumental films seem loose and undisciplined by comparison." See Darrell William Davis, "Back to Japan: Militarism and Monumentalism in Prewar Japanese Cinema," *Wide Angle* 11, no. 3 (1989): 23.

38. Ozu, *Ozu Yasujiro zenhatsugen: 1933–1945*, 108–109.

39. Ozu, *Ozu Yasujiro sakuhinshu*, 248.

40. Yonaha Jun, *Teikoku no zan'ei* [After-images of empire] (Tokyo: NTT shuppan, 2011), 75.

41. Walter Benjamin, "The Work of Art in the Age of Technological Reproducibility," in *The Work of Art in the Age of Its Technological Reproducibility, and Other Writings on Media*, ed. Michael William Jennings, Brigid Doherty, and Thomas Y. Levin (Cambridge, MA: Belknap Press of Harvard University Press, 2008), 37.

42. Ozu, *Ozu Yasujiro zenhatsugen: 1933–1945*, 162.

43. Rey Chow, *Ethics after Idealism: Theory, Culture, Ethnicity, Reading* (Bloomington: Indiana University Press, 1998), 23.

44. Ibid.

45. Ibid.

46. Ibid., 20–21.

47. Takashi Fujitani argues that "imperial pagentry was part of a cultural apparatus that helped fashion Japan's modern emperor into a transcendental subject, one who could be imagined as casting a single and centralizing gaze across all the nation and into the souls of all the people." See Takashi Fujitaini, *Splendid Monarchy: Power and Pageantry in Modern Japan* (Berkeley: University of California Press, 1996), 24–25.

48. The Japanese term for Buddha, *"hotoke,"* can also mean "a deceased person." So, Shojiro uses a Japanese equivalent of "Mr. Buddha" to refer to his late father. Ozu also twists the familiar patriotic rally cry of "luxury is our enemy" by playing with Japanese term for "luxury" (*zeitaku*) as a pun for "being fastidious and picky in one's choice of romantic partner."

49. Fujitani, *Splendid Monarchy*, 242.

50. Davis, "Back to Japan," 24. Davis's articulation of the monumental style seems to rely too heavily on the conventional notion of "Japanese tradition." For ordinary interwar-era Japanese, however, tradition would have included Americanism, not just *bushido*, Heian scroll paints, or Buddhism.

51. Ibid. Benjamin, "The Work of Art in the Age of Technological Reproducibility," 37.

52. Vivian Sobchack sums up the issue very clearly as follows: "the spectator and the film often share the same *interest* in the world. They do *not*, however, share the same *place* in the world, nor the same *body*. Their respective visual address *to* the world may, indeed, transcendently and intersubjectively converge in the world and its objects, but their address *in* the world is always discrete in its immanence and thus never the same." See Vivian Carol Sobchack, *The Address of the Eye: A Phenomenology of Film Experience* (Princeton, NJ: Princeton University Press, 1992), 286.

53. Wada-Marciano, *Nippon Modern*, 128–129.

SECTION III
Tracing Ozu

Autumn Afternoons

Negotiating the Ghost of Ozu in Iguchi Nami's Dogs and Cats (2004)

ADAM BINGHAM

As one of Japan's most revered filmmakers, Ozu Yasujiro has inspired a number of directors in a multitude of different, diverse ways. Several acclaimed international figures have made films variously indebted to Ozu—including Hou Hsiao-hsien (*Cafe Lumière* [*Kohii jiko*, 2003]), Edward Yang (*Taipei Story*, 1985), Abbas Kiarostami (*Five Dedicated to Ozu*, 2003) and Claire Denis (*35 Shots of Rum* [*35 Rhums*, 2008])—and likewise he has cast a long shadow in Japan. However, the extent of his significance in his native country has not always been as clearly defined. Arguments regarding Ozu's direct influence on some directors have been proposed largely by critics rather than the filmmakers—as is the case with Kore-eda Hirokazu[1]—while some points of influence have been made more or less explicit on the part of the directors themselves, as with Ichikawa Jun[2] and in particular Yamada Yoji, who has remade Ozu's most famous and acclaimed film, *Tokyo Story* (*Tokyo monogatari*, 1953), into *Tokyo Family* (*Tokyo kazoku*, 2013).

The prevalence of Ozu within Japanese cinema is inevitable, especially within the *shoshimin* film and *shomingeki* model of domestic dramas of middle-class life within which Ozu worked in the later years of his career and which has retained some measure of currency since his death. Such films almost inexorably enter into a dialogic relationship with Ozu's work, whether by commentary or corollary, and this is by no means an exclusively contemporary phenomenon. Maureen Turim has characterized Oshima Nagisa's *Boy* (*Shonen*,

1969) as a film whose use of red asks "that we see this family melodrama in reference to Ozu's corpus,"[3] while in the 1980s a series of exaggerated home dramas used Ozu as a point of departure, working variously satirical and parodic variations upon his films in order to explore the gulf between modern Japan (and by extension its cinema) and the country that he documented. Films such as *The Family Game* (*Kazoku gemu*, Morita Yoshimitsu, 1983), *Crazy Family* (*Gyakufunsha kazoku*, Ishii Sogo, 1984), *The Funeral* (*Ososhiki*, Itami Juzo, 1984), and *Abnormal Family: Older Brother's Bride* (*Hentai kazoku: Aniki no yome-san*, Suo Masayuki, 1984) all subvert or circumvent Ozu's stylistic and narrative sensibilities. Indeed, as Kirsten Cather has noted, Suo Masayuki intended *Abnormal Family: Older Brother's Bride* to be a sequel to Ozu's *Late Spring* (*Banshun*, 1949) and made this film as pornography in order to facilitate an "Oedipal relationship to Ozu and to Ozu criticism":[4] in other words, to make plain the extent to which the director wanted to revolt against Ozu as a perceived cinematic father figure, and moreover to undermine the canonization of said figurative patriarch by producing through the medium of pornography an implicit statement on the consumption and commodification of the auteur in contemporary Japanese cinema.

Unsurprisingly, a number of contemporary films also feature in this dialogue. Among the most interesting of said works is the first feature by a young female filmmaker who has become a key figure in a new generation of Japanese female directors. Iguchi Nami's *Dogs and Cats* (a.k.a. *The Cat Leaves Home* [*Inuneko*, 2004]) is not alone among her female peers' work in referring to Ozu and the *shomin* film—another debut, Nishikawa Miwa's *Wild Berries* (*Hebi ichigo*, 2003), offers another example—but *Dogs and Cats* does so more subtly and completely, and this essay will trace the ghost of Ozu in the film and ask what is the cumulative effect of his intertextual presence: how Iguchi uses such a notable cinematic father figure to help define not only her protagonists and the country in which they live but also her own status as a Japanese filmmaker at a particular socio-historical juncture. Iguchi synthesizes the generic foundation and subject matter of Ozu as a point of departure in her work, but she tempers overt pastiche in order to suggest a more complex relationship to this preeminent forebear. Iguchi's observational style (including long takes and long shots), her narrative focus on individuals estranged from any viable familial context, and wryly comedic, at times deadpan, tonality do not immediately suggest Ozu as a direct influence. But individual references to his work abound throughout the film, to the extent that a tension between similarity and difference (between the directors' respective styles and subjects) becomes central to its narrative, thematic, and contextual core. This essay will trace and probe said tension as a means of elucidating both Iguchi's film and the place of Ozu therein: the structural presence of the latter that illuminates the specificity and cinematic approach of the former. It will explore precisely how this intertextuality is developed and what it means with regard to *Dogs*

and *Cats'* place within the specificity of contemporary Japanese cinema, and in so doing it will examine the ongoing position of Ozu on a young generation of directors for whom the golden age of Japanese cinema represents a time of canon formation (both nationally and internationally) and thus a tenable heritage whose importance has become particularly marked over the last fifteen or twenty years. To this end, the ways in which Iguchi alludes to while also deforming Ozu and this lineage will occupy the chief focus herein.

A CINEMA OF REGRESSION

Dogs and Cats concerns two young women, Suzu and Yoko. Like the titular pets (that appear sporadically throughout the film) they appear to be polar opposites but find themselves becoming housemates when the former leaves her apparently inattentive and selfish boyfriend and begins living with the latter while she is house-sitting for a mutual friend named Abe who is studying in China. These girls are certainly different to look at—particularly as Suzu has much shorter hair while Yoko's is long and straight—which may reflect their ostensibly contrasting behavior: Suzu's gregarious impetuousness as distinct from Yoko's slightly more reserved and demure demeanor. However, in a twist on an otherwise generic scenario, their fractious relationship is increasingly revealed to be the result of their similarities rather than their apparent differences. It is revealed that they have always shared a predilection for the same type of man, which has resulted in a long-standing enmity, and both are depicted as distinct *shojo* (girls) even though they both live away from the family home. Indeed, they are often childish in their attitudes and actions, which surfaces in particular over their respective relationships with men—where Suzu befriends a boy whom Yoko likes and Yoko in turn tries to seduce Suzu's ex-partner—and also with work. Neither Yoko nor Suzu has a full-time job—the former is employed part-time in a convenience store while the latter takes a job walking dogs—and neither has any long-term plans or professional goals.

This feature of the protagonists' lives is underlined at the very end of the narrative. In a paradigmatic instance of the peculiarly Japanese concept of kawaii (cute) culture, the film closes with credits that feature crudely animated animals, as though from a young child's flipbook, which helps to crystallize Yoko and Suzu's immaturity, the fact that they have not really grown or developed (over the course of the story and indeed of their lives). Given that kawaii is frequently regarded as a gendered phenomenon (a feminine trait employed to aid in physical attractiveness), this aspect of Iguchi's film suggests a performative dimension to gender identity as connected to a frivolous and largely carefree femininity that, as juxtaposed with Ozu's autonomous, family-oriented, responsible, often professional female characters,

implies a marked regression and lack of personal stability. Indeed, Yoko and Suzu's exchange of romantic partners precipitates a figurative exchange of identities, or at least a sense that their individual selves become increasingly indistinguishable from one another. In one scene, Yoko buys yellow flowers for the house after work and arrives home to find an identical bunch already arranged by Suzu. In rhyming scenes, Suzu tries on Yoko's spectacles, and as a result Yoko borrows both Suzu's contact lenses and her dress, in addition to which she also helps in her housemate's job as a dog-walker. Iguchi even underlines this similarity visually when she shoots Yoko struggling to find the right home and dog in precisely the same way as she had earlier shot Suzu, with the same camera set-up and same jump cut to comically denote her having taken the wrong road (this in addition to closely mirrored moments at different times in the film that feature first Suzu and then Yoko leaving the house and running through the streets following an altercation with her housemate).

The sense of an almost single identity between the characters offers a starting point for considering Iguchi's intertextual "relationship" with Ozu, as it facilitates a discourse on similarity and difference as key thematic referents in the film (Suzu and Yoko's fractious likeness casting light on Iguchi and Ozu's comparable difference in diversity). The director immediately signals this debt with the opening credits of *Dogs and Cats*, which unfold over a beige burlap backdrop identical to that used by Ozu in all but one of the six color films with which his career concluded—typically employed in works like *Equinox Flower* (*Higanbana*, 1958), *Good Morning* (*Ohayo*, 1959), and *Late Autumn* (*Akibiyori*, 1960) to embolden the bright red and white characters of the credits themselves. Coupled with the aforementioned final credits, Iguchi's choice of this sequence serves to bracket the narrative; it suggests a "development" wherein both of these characters, and by extension the director, in fact "regress," retreat from a place within an established world into one fundamentally dissociable, an internalized and insular world removed from the phenomenological reality around them. This world, in particular the house in which the girls come to reside, then becomes a liminal sphere, a site in between both adolescence and adulthood and past and future. In other words, the film begins with an overt reference to a cinematic parent, a past, yet goes on to portray a young woman who in effect rejects the adult world of working through heterosexual relationships and gaining a measure of independence. It traces a series of infantilizing gestures that mark out the liminal space of the *shojo* by suspending the protagonists between the beginning and the end of the film: between childhood and dependency, on the one hand, and the strictures of responsibility and maturity, on the other. In this way, Iguchi both distinguishes her work from Ozu's and reflects on an apparently inexorable relationship to him that places her as a cinematic child, one both bound by and standing in opposition to a filmic patriarch.

This in itself is a significant acknowledgement, as it infers a protoallegorical narrative on Iguchi's part. At several stages during the key instances of upheaval and change highlighted by Tezuka Yoshiharu as defining the history of modern (post-1868) Japan,[5] Japanese cinema has had extensive recourse to the youth film (*seishun eiga*) genre of stories centered on alienated, often aimless adolescents. Youthful and adolescent concerns over growth, maturation, and identity formation became a symbolic canvas on which to reflect upon the travails of a nation reborn, and although Ozu arguably never worked directly in this genre, his sporadic use of two young and mischievous boys in films like *Passing Fancy* (*Dekigokoro*, 1933), *Good Morning, Tokyo Story*, and *I Was Born, But...* —to say nothing of the abandoned boy in *Record of a Tenement Gentleman* (*Nagaya shinshiroku*, 1947)—may be read along these lines, particularly as they frequently serve as a narrative chorus that comments directly upon the adults around them, most often bemoaning what they regard as their officiousness, antiquation, or stern moralizing. Most overtly, the nascent materialism of the boys in *Good Morning*, released in 1959, tellingly relates to the cusp of Japan's miraculous economic prosperity that accelerated in the 1960s and that reinvented Japan anew, fracturing old and contemporary, traditional and modern, to the extent that Alex Kerr has argued that the marked failure of the latter "lies at the very core of its [Japan's] cultural meltdown."[6] From this point of view, the generational divide over a television set in Ozu's film may be seen to narrativize this disjunction, the capitulation to technological modernity an inevitable facet of Japanese life satirically suggested to be a means of pacifying a young generation.

Iguchi in turn suggests an apparently terminal adolescence in *Dogs and Cats*, a landscape cut off from the past (figured in the break from Ozu) but unable to accede to any viable alternative, any meaningful future. The liminal youth of Suzu and Yoko—their apparent freedom that in fact becomes a foil for aimless, even retrograde containment in domesticity (almost wholly bound as it is to men and a desire for them)—offers a useful contrast to Ozu's female protagonists and the social pressures brought to bear on them. Abstracted as they are from any immediate familial home, Iguchi's girls are subject to no such pressures. They remain ostensibly free, without ties or obligations; however, they merge together, find their identities becoming fluid, in flux, precisely because of this pronounced lack of any tangible external world or influence. Ozu's characters are typically defined by the world in which they live (whether that be in concordance with or in defiance against their immediate milieu); it is a world that, for all its upheavals, tensions, and indeed transformations still offers a foundation upon which to construct a sense of self. The largely featureless universe inhabited by Suzu and Yoko offers no comparable presence, no tangible world beyond the borders of their fluid minds and identities. Thus the girls find themselves turning inward in lieu of said world; they figuratively become identical and play out an increasingly performative series

of rituals that serve no overt purpose other than prolonging the enervation of their lives.

Attendant on these precepts is the fact that *Dogs and Cats* immediately reverses the narrative pattern of most of Ozu's postwar *shomin-geki*; here a domestic partnership is immediately terminated and a period of apparent freedom ensues. However, Iguchi's protagonists, though nominally autonomous, show themselves to be without any means of meaningful independence or autonomy; they are each beholden to their friend for a (temporary) house in which to live, and they each court relationships with men almost as a default position, a residual urge designed as much to challenge the other than to express genuine attraction. If, as Robin Wood suggests, one gets the sense from several female Ozu protagonists that happiness does not reside in the socially determined establishment of a marriage and a family,[7] then Iguchi here stresses the indomitable inculcation of the same institutions, the extent to which they hang over the sociopolitical landscape of Japan and the dearth of anything positive in their stead. It is a picture of a country stagnating, unmoored, cast loose from its traditions yet unable to progress to anything viably different as Japan itself did in the wake of World War II by modernizing along Western lines but ultimately finding the attendant economic prosperity an unstable, untenable model. In this sense, Iguchi updates rather than subverts Ozu, and this further helps to characterize the complexity of her relationship to this director. Indeed, the film contains its own embedded metaphor for this relationship, a sly narrative motif that structures Iguchi's intertextual imperatives.

Sight Unseen: The Social and the Domestic

Iguchi's picture of perennial *shojo* in *Dogs and Cats*—an insular state that the protagonists cannot see beyond—helps to establish vision and blindness as a significant antinomy and recurring motif in the film. Suzu and Yoko both have literally compromised vision and need spectacles or contact lenses, and this is extended by the director to encompass their, as it were, general shortsightedness with regard to their behavior and attitudes. After Suzu's initial act of defiance toward a man who has been treating her poorly, her relationships not only demonstrate a regression into adolescence but also a lack of awareness on her part of their status as such, a figurative blindness. Indeed, in both the girls' relations with men, they are placed in a subordinate position of ostensible "to-be-looked-at-ness," almost demanding the objectification that Suzu at the beginning summarily castigates and casts off. The complete eschewal of point-of-view shots throughout the film refracts this precept, underscoring the struggles of the characters to see—both literally and figuratively—and their concomitant desire to be seen, both of which remain disproportionate

and out of sync, the lack of the former in inverse proportion to the excess of the latter.

In other words, Yoko and Suzu's inability to move beyond their own personal desires and frustrations is stylistically made manifest as a marker of subjectivity found wanting. These girls look, or attempt to look, as a means of asserting a measure of agency in their lives; but rarely do they see—often misinterpreting situations or being deceived into erroneous beliefs, especially where men are concerned—and such a landscape of myopic distance bespeaks not only the insularity of the girls' lives but also a gulf between themselves and the aforementioned forebears in Ozu's work. Thus the particular use value of these themes, configured as they are as narrative touchstones, is to suggest something of Iguchi's own position with regard to her view of Ozu. Iguchi, like Suzu, is initially seen as bound to a man—in her case to Ozu (through the credits of her film that stress the inimitable influence of his cinema)—after which she departs from said paradigm to offer a contrapuntal vision that implicitly juxtaposes past and present with regard to both their respective protagonists and indeed to the respective eras in which they worked: the two dramatic sociopolitical traumas (defeat in the Pacific War and the economic recession of the 1990s) in the wake of which they produced their films. The latter, Iguchi's film suggests, has formed a decisive break but has led only to liminality. Japan, so far as a national body may be discernible in the interior world of *Dogs and Cats*, seems in a state of in-between-ness; there is little sense of a past or traditional lineage beside or even against which they can define themselves (narrativized in Suzu leaving an old, problematic life behind at the beginning of the narrative only for it to return, as well as being felt in Iguchi's departure from yet simultaneous debt to Ozu), and the future prospects for the characters appear at best negligible, ambiguous, open to question.

This encoded ambivalence toward both past and future is also significant here, as it echoes a central dichotomy within Ozu's own films. The Japan that he carefully, minutely documented throughout the country's postwar reconstruction is predicated on a clearly defined and immediate contemporaneousness that is perennially negotiating a tenuous future by dealing with a problematic past. In his work, the present remains suspended at a confluence of national history and individual futures. Alastair Philips has examined in detail the dictates of past and present in Ozu's postwar work, and indeed has seen femininity as a key factor in his films' construction and representation of modernity.[8] For Ozu, the gendered domestic space becomes the key battleground for social progress or conservatism; the contrastive spheres of home as depicted in *Tokyo Story* or *An Autumn Afternoon* (typically suburban family abodes and urban tenement flats) tend to present constituent parts of extended families as they have been dispersed, and as such they offer an experiential catalogue of the modern Japanese metropolis. That is, there is a tenable modern city space to anchor the contemporaneousness of the people, and

by extension to provide a barometer against which the contrastive attitudes that are enacted within the home can be measured.

By way of contrast, *Dogs and Cats*—whose domestic sphere is only a temporary (liminal) domain for characters who have retreated from their "real" lives—offers a more literal but less resonant battleground. Domesticity is more illusory here, a transitory realm to which neither character really belongs; and this, coupled with the fact that Suzu's ex-partner is also seen to be almost entirely ineffectual around his house—in particular, we see his vain attempts at preparing a simple meal—suggests that the gendering of such a space is no longer necessarily a sociopolitical undertaking. It no longer echoes traditional divisions between male and female, even though traces of these are discernible (more of which later); rather, they are reflective of a society in which traditional strictures are not necessarily still in place but which have not been fully dealt with, neither digested nor superseded: an in-between or indeterminate space that the protagonists' lives and liminal identities reflect.

This engagement with families of both filmmakers further reflects a specific tension (between being a member of a family and of a society) that both Donald Richie and Sato Tadao have argued is a central facet of Ozu's work.[9] To these critics' minds, his characters appear to be members of the former over and above the latter, the implication being that they lack a social identity even while their personalities are inextricably bound up in their familial unit. In Iguchi's film, this dichotomy becomes both predicated upon and complicated by a symbiotic relationship. "Society" is a much more amorphous entity here than in Ozu, its contours and parameters less clearly defined, and this puts the focus on interior rather than exterior precepts. Like a playful spin on the central female relationships in, say, Ingmar Bergman's *Persona* (1966) or Jacques Rivette's *Celine and Julie Go Boating* (*Céline et Julie vont en bateau*, 1974), Yoko and Suzu enact an apparent exchange of identities in a way that complicates any perceived notions of stable or cogent selfhood. This then throws light on the aforementioned similarities between the protagonists (of taste, lifestyle, physical afflictions, etc.) and as such on a lack of individuality in a scenario where commonality connotes corrosiveness; and there are a number of ramifications of this thematic. It suggests Ozu as a point of departure rather than a fanciful homage, teases us to see *Dogs and Cats* as more than mere pastiche. More pointedly, it is also a slyly satirical portrait that takes some of the implicit dictates of feminist discourse and undermines its implied and desired address to a unified and empowering female experience by considering through the ghost of Ozu what this discourse means within a Japanese context. In the 1950s, when women in Japan were subject to the (enforced and qualified) sociopolitical reforms of an occupying power,[10] Ozu's work depicts and mobilizes not the struggles of this problem but rather the pressures inherent in increasingly conflicting social demands and expectations. *Dogs and Cats*' emphasis on similarity both slyly pastiches Ozu's canon—his

late films' ostensibly narrow, often repeated scope, style, and subject matter—
and Iguchi's own comparable film. The wider point of this is to facilitate—as
Ichikawa Jun does—a discourse on the extent to which gender relations have
changed in the past fifty years. Japan was recently ranked fifty-fourth in a
United Nations poll that looked at gender inequality,[11] while a symposium in
2009 argued that figures pertaining to cinema attendance in the country saw
female viewers significantly outnumber their male counterparts.[12] As such,
this particular juxtaposition serves to augment a wider concern with the
vagaries of gender, modernity, and social-cultural activity or agency that lie
beneath the surface of Iguchi's film. To this end, Yoko and Suzu both appear
to remain at the behest of, in a way subservient to, the men around them, the
ex-partners and potential lovers in between whom their personal animosities
and rivalries come to the fore and find expression. The travails of their fore-
bears in Ozu remain alien to them; the small, tenuous, but very real and costly
means of personal independence achieved by some of Hara Setsuko's protago-
nists from *Tokyo Story* through to *Late Autumn* and *The End of Summer* seem
a world away from these young women who for the most part almost relish a
regressive, retrograde attitude and behavioral pattern. The fact that the afore-
mentioned Ozu films saw Hara's characters progress from daughter-in-law to
sister to mother (as it were child to parent) suggests something of the increas-
ing cost of her decisions, their wider ramifications and resonances. This stands
in contradistinction to the opposite scenario of greater freedom, which one
may think to hold true as these women live in what is an ostensibly more lib-
eral, more westernized era. In point of fact, Ozu documents not a more regres-
sive society or more conservative Japan (though in contrast to what some
have claimed about him, there is a measure of truth to this); instead, this dra-
matic through-line contributes to a dramatization of how specific values and
value schemes become a product of a symbiosis between individuals and their
social environment. Here again gender division can be ascertained. Numerous
Ozu males—most overtly Saburi Shin's patriarch in *Equinox Flower*—seem
at once progressive and antiquated in their thinking depending on the con-
text in which they find themselves (most often both celebrating and decry-
ing arranged marriages). And against this, the uniformity of certain female
character types across this director's oeuvre offers a standard that informs
and questions concepts of sociopolitical progression and reformation, a stable
point of reference on the perennially shifting sands of postwar Japan's recon-
struction as an economic superpower.

 Dogs and Cats refracts this discourse. The issue of Ozu's conservatism (or
otherwise) has long been a contested aspect of his work. Writing in 1979, Joan
Mellen argued that Ozu laments the loss of feudalist familial doctrines and
thereby underlines its sanctity and sanctuary: "the family . . . [as] a bulwark
against the cruelties of the world."[13] This point of view has been felt by com-
mentators like Robin Wood or David Bordwell to sentimentalize Ozu's view of

the position and role(s) of women in modern Japan, at least those of an older generation, who in their eyes have been ill-served by any semblance of a traditional upbringing or by a perceived need to retain a connection to the past, to hold onto its socio-cultural specificity. This particular tension informs *Dogs and Cats* throughout its narrative. Beginning with a scene in which a young woman appears to forcefully contravene the male expectation that she should be ensconced in the domestic sphere and remain entirely subservient to her partner's needs and desires, the film goes on to comically suggest that these young women by themselves fall back on and reinforce conservative assumptions about womanhood, as if any concrete social reforms or revisions were at this stage so far beyond their means as to be unthinkable.

Or at least this is ostensibly the case. Iguchi does not cast a stern or moralizing eye over this scenario—indeed, she rather takes the characters at face value as though she has happened upon them, observing them much as if the titular pets were focalizing the narrative and casting a quizzical eye over human affairs—but if juxtaposed with Ozu, hers is a vision that takes on specific qualities pertaining to gender politics. The almost careless expectations of the conservative men on the periphery of *Dogs and Cats* seem ultimately to meet a point of receptivity in the protagonists and their behavior and feelings about themselves. It is certainly these reactionary values and assumptions that facilitates the latter as it initially provokes Suzu's leaving home—her escape that in effect becomes a regression—and as such it is a significant feature of the film's thematic landscape. Yet this is not particularly pronounced or marked in the drama. Iguchi does not really stress or underline these points in the way that Ozu did, so that one is invited to question (rather than confront) the extent to which gender remains a problematic feature of contemporary Japan. Again, the performative dimension to the girls' actions and the almost ritualized habits of Suzu's ex-boyfriend (his expectations of domestic servitude from his partner) reinforce this more complex and ambiguous thematic: the fact that they behave in ways that seem to be self-conscious or based specifically on enculturation within their society. For example, Yoko's searching out of Suzu's ex-boyfriend is undertaken as much, if not more than, out of spite over her housemate's activity with the boy she herself likes, rather than out of the attraction that she has apparently always felt but that she has hitherto kept successfully under wraps. As such, the spheres of the personal and the social are unstable, amorphous, the latter a distant entity but still vaguely present to the extent that the characters' motivations are predicated on presenting a face to others and to the outside world, to perform within it and thus to color in some of its blankness—as, perhaps, Iguchi is doing with the autumnal mise en scène (more of which later) that visually brightens up the aforementioned featureless universe of her film.

If problems pertaining to gender norms and institutionalized attitudes therein bespeak Japan's increasing fragmentation with regard to aspects of

national identity (*Nihonjinron*), then it is a tension that is felt throughout the very fabric of Ozu's cinema. It is striking that his most acclaimed works should so carefully map out the hinterland between conflict with and capitulation to the West—between defeat in World War II and the 1964 Tokyo Olympiad; or, to paraphrase historian Ian Buruma, between the fall of an empire and the beginnings of an economic miracle[14]—as much of his postwar work retains a broad uniformity of style, outlook, theme, and attitude. In other words, it offers a concordance of characters and narrative patterns whose stability provided a veritable barometer of social development. It was also during the 1950s that a cinematic golden age occurred in Japan—a period dominated by Ozu, Kurosawa Akira, Mizoguchi Kenji, Kinoshita Keisuke, and Kobayashi Masaski among others—and there developed an increasing tension between these directors and those who followed them. Both the emerging new wave of Oshima, Yoshida, Imamura, Shinoda, and Masumura in the 1960s (who each took issue with the way in which Ozu worked as well as his work itself) and the aforementioned films of the 1980s (whose films unpick the perceived staid, middle-class worldview and rigid formality of his films) throw into relief the more studied ambivalence of postmillennial intertextual Japanese cinema. That is, Iguchi's film, when placed alongside these films and filmmakers, offers a less overt critique of Ozu, and by extension of his particular melodramatic mode, and instead argues for his significance as a point of reference as much as a point of departure: a fulcrum in constructions of Japan and *Nihonjinron* whose (national and international) canonization serves as a potential arbiter of a tenable past, even if this past remains beyond reach as a model. She defines herself almost inexorably against his work but at the same time retains it as a marker of the last vestiges of the recent past: a sign of contemporary ennui and, perhaps more significantly, a pertinent indication of the discursive problems pertaining to national identity as a stable or coherent concept.

A CINEMA OF DEFORMATION
Style and Construction

The burlap material already noted as a defining feature of numerous Ozu credits sequences (not only for his color films) bespeaks something of the artisanal view of his work that this director upheld throughout his career. Iguchi, as evidenced in her credits sequence (the gesture of alluding to Ozu at the beginning only to then depart from him), implicitly rejects this precept in her construction of narrative throughout *Dogs and Cats*. The film's de-dramatized emphasis on daily routines and rituals, the way in which Iguchi seems to stand back and observe her characters, to respect their most quotidian moments (one scene, for instance, patiently depicts Yoko cutting her toenails), bespeaks a contravention of any dramatic narrative exegeses, any pervasive sense of

a cogent scenario wherein characters develop—where conflicts build and are resolved. This model is not of a piece with Ozu. As Bordwell has noted of this director, his emphasis on everyday activities is such that one encounters "a simple story that seems to tell itself":[15] that is, in which the drama becomes so diffuse, disseminated through minutely observed and naturalistic gestures, attitudes, and details often at the expense of key story points (which are frequently elided altogether), that the films become, in Kathe Geist's words, "deformed."[16] Indeed, Geist has uncovered a prevalent structure of Ozu's post-1949 work wherein these deformities instill a tension between an apparent or surface series of events and a subtextual narrative schema that disturbs them and works to subtly confound audience expectations. The interplay between these contrapuntal, at times contradistinctive, narratives then informs how we relate to the protagonists and their respective actions and decisions. One may point here to the elision of the marriage ceremony in *Late Spring* or of the mother falling ill in *Tokyo Story* as markers both of Ozu's interest in reaction and consequence over action (a feature of his elliptical structures) and as a feature of the limits that he places on representation. He envisages through these dramatic eschewals not only a "deformed" narrative in which significant events are not depicted (thus disseminating their significance in a subjective manner) but also a narrativized extension of the narrow view of his diegeses inherent in his static compositions, and it is through an inherent juxtaposition with this method of narrative construction, along with a reference to and an assimilation of stylistic features such as Ozu's much-vaunted low and immobile camera, that *Dogs and Cats* signals both its debt to and its departure from this particular director.

Iguchi constructs *Dogs and Cats* in a manner that seems bound to Ozu's quotidian scenarios and his incremental accrual of small details as repositories of drama; however, she does wholly contravene his deformed or distended structural sensibility, and in so doing offers her own deformity of Ozu. She elides very little after the practice of her forebear; yet her narrative is more diffused than even that of Ozu, so that unlike his work, there is little in the way of "narrative" events to be omitted, and indeed there exists here an apparent conflict: as far as the ostensibly significant events in her protagonists' lives are concerned, their arguments and respective dalliances with men anger the other and cause friction between them. But the only overtly noticeable elisions are for comedic effect: namely, the aforementioned jump cuts that denote Suzu and Yoko having gotten lost on their way to the former's employment as a dog-walker. These rhyming moments both foreground and in a sense frustrate temporal elision as a dramatic marker. The lives of the protagonists are characterized as fundamentally inert, anodyne, remaining as they do without any narrative developments that could meaningfully be excised or the kind of events that could be elided or eschewed for dramatic purpose or effect. Their problems are relatively insignificant, their conflict immature, and

Iguchi's patient, protracted depiction thereof bespeaks something of the gulf separating them from their cousins in Ozu's cinema.

In their stead, a more subtle method of forging the relationship among characters begins to accrue as the film progresses. Iguchi begins to underline the autonomy of individual shots, much as Wood has suggested that Ozu almost always retains the spatial integrity of his composition by showing characters never entering or exiting by way of the limits of the shot (the parameters of the camera) but always behind a visible diegetic screen or doorway.[17] In *Dogs and Cats*, Iguchi frequently cuts between shots in such a way as to subtly infer their autonomy and disconnection, by opening a shot in advance of the beginning of any action and/or, à la Michelangelo Antonioni, holding the shot beyond the completion of its ostensible incident(s), or by presenting disjunctive actions across two contiguous shots. For example, she cuts from a long shot of Yoko tending to her bandaged finger, framed along with Suzu's legs in close-up in the foreground of the frame (fig. 10.1), to a medium close-up shot of the former (fig. 10.2) into which Suzu suddenly appears beside her (fig. 10.3). It is, on the one hand, a symbolic as much as a continuity edit in that these traits stress both connection and disconnection, or connection in disconnection—of the characters from their society, from each other, and potentially of Japan from its historical lineage. However, it may also be regarded as a broadly parametric aesthetic,[18] and in this it offers a correlative to Ozu's own perceived parametric narration that is based around a contravention of continuity editing, presenting both an allusion to and a departure from his films.

There are notable elisions that inform Iguchi's treatment of peripheral characters in the film, in particular their mutual friend Abe. On the day of her departure to China, as the protagonists help with her luggage, she notes that she needs to find a convenience store with a fax machine so that she can let her school in China know of her imminent arrival. As the three are discussing whether this is a viable procedure—whether such a store would have a fax machine—Iguchi cuts away first to a low-angle shot of a plane flying overhead and subsequently to Yoko and Suzu watching said plane at the airport, as much as to affirm narrative elision in connection to characters with a goal, a purpose, in short a real life,[19] as well as to offer a playful variation on Ozu's method of elliptical narrative construction.

The director further "deforms" Ozu, by subtly parodying Ozu's style, in particular his famously immobile camera. On one occasion early in the narrative (after Suzu has walked out on her partner), the static camera remains steadfastly in place as she walks directly toward it until she appears to collide with it as her body momentarily fills the image, with the film then cutting 180 degrees to frame her walking away from the camera.[20] This technique draws attention to the stasis of the camera as a potentially limiting feature, as though the (artistic) decision to keep it still was incommensurate with the

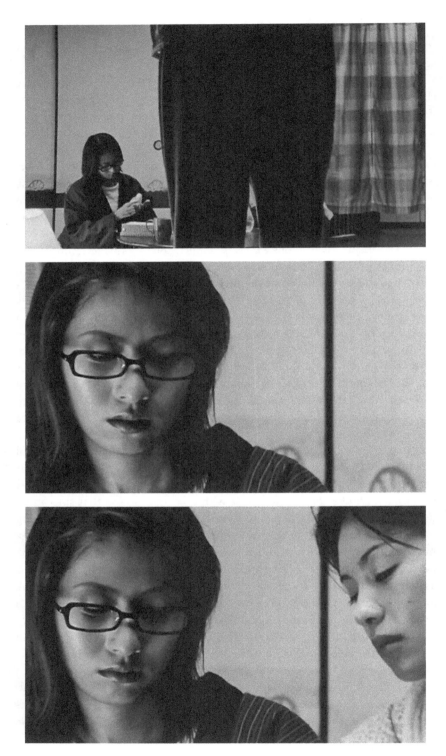

Figures 10.1, 10.2, 10.3.
Dogs and Cats (*Inuneko*, Iguchi Nami, 2004).

film's stylistic protocols in that it entails an imposition upon its characters and narrative. Ironically, however, the camera appears to learn its lesson from this moment; when a comparable scene at the end of the narrative occurs—after Suzu has confronted her ex-partner about allegedly sleeping with Yoko before storming away from him down the same flight of public stairs—the camera tracks backward as though to prevent a repeat of the earlier incident, keeping Suzu in frame in long shot.

The aforementioned running scenes that occur reasonably late in the narrative also appear to be moments in which Iguchi's camera in effect acknowledges its earlier, erroneous stasis and moves in order to follow the characters and retain their presence as the central figures in the drama: in other words, to react to their movement as though it had happened upon the scene as opposed to imposing technique and meaning upon it. The fact that in both instances the camera struggles to keep Yoko and Suzu in the frame, first lagging behind before subsequently going too fast and tracking past them, further underlines its fallibility and imperfection, this time as contrasted with Ozu's precise framing and insistent cinematographic methodology. Iguchi even includes a crane shot at the very end of the film that rises to reframe Yoko after she has appeared to undergo a moment of personal triumph. When Yoko is walking a dog in place of Suzu, she removes a bandage from the damaged finger that has remained a problem for her throughout the narrative, and thus the camera visually inscribes, perhaps parodies or even mocks, her apparent elation at the same time as it stresses its own agency at the expense of the characters it surveys.

Ozu himself, despite the apparently insistent rigors of his style, was sporadically given to almost self-reflexive camera movement, in his case very much by moving in lieu of any profilmic motion. His early crime film *That Night's Wife* (*Sono yo no tsuma*, 1930) perennially features both a static camera recording motion and a moving camera capturing onscreen stasis, while both *The Flavor of Green Tea over Rice* (*Ochazuke no aji*, 1952) and *Early Summer* employ tracking shots and, in the latter, a crane shot only in the wake of any movement within the frame: in several cases, either before characters enter a scene or after they have exited the frame altogether (as in *Early Summer* when, at the theater, the camera tracks forward into empty space following the characters leaving the shot). By these means, one is made acutely aware not only of the import of movement but also by extension of its opposite, of the centrality of stasis. At the time during which these films were made, there were the aforementioned dramatic changes occurring in Japan, and against this sociopolitical flux, Ozu's style facilitates a reflection on stasis as (arguably) a desirable facet of contemporary life. In other words, the constant minutiae of day-to-day life in Ozu's work is felt to be a particularly rich, almost discursive site of familial and professional relations, hence the ostensible repetitions of characters, themes, and stories across numerous films that signal a recondite center of meaning within Japan.

This is a discourse to which Iguchi contributes. As already noted, *Dogs and Cats* is fundamentally about stasis in life, as Suzu and Yoko in effect mark time, put their (adult) lives on hold for a year while they house-sit for their friend, and appear to regress into adolescence. They feed one another's incredulity, and each contributes to the other's disaffection—with themselves as much as each other. They may be said to visualize what each finds unappealing in their own personalities, and as such literalize a certain masochistic tendency that relates in part back to Iguchi's own cinematic connection to Ozu. This as it were hierarchical relationship between the two directors is narrativized in the mise en scène of *Dogs and Cats*, as a number of very steep, imposing hills dominate the exterior scenes of the Tokyo suburb in which her film is set. Typically the protagonists have to navigate these often vertiginous inclines (tellingly, Suzu runs downward after leaving her partner in the opening scene), something that is most keenly felt when the pair help Abe up a particularly punishing road with her luggage. Personal burdens and interpersonal tensions are literalized along with the sense of Iguchi's own standing vis-à-vis her classical forebear, the fact that she seems compelled to work her own variations on his material in order to situate herself as a filmmaker, arguably to legitimize and/or substantiate her status as a Japanese filmmaker and artist.

Beauty and Sadness

Another salient aspect of Ozu's work that is echoed in *Dogs and Cats*—and indeed in Iguchi's second film *Don't Laugh at My Romance* (*Hito no sekkusu o warau na*, 2007)—is its sense of seasonal specificity. This perceived traditional precept of Japanese aesthetics and culture has frequently been read (particularly by Western critics[21]) as a reflection of *mono no aware*, or the gentle sadness of the passing of time. The English-language titles of three of Ozu's late color films directly invoke autumn as a means of demarcating their narratives' respective images of finality, even death (though not all are particularly somber or portentous films), and Iguchi reflects this with an explicitly autumnal mise en scène in each of her film's exterior scenes. This encoded intertextuality challenges us to consider Ozu's emphasis on the everyday as a site of philosophical explication and discourse. He retained this particular tension in terms of the contradistinction between a static, stable viewpoint on a world perennially in motion, perennially unstable,[22] and Iguchi employs it both to reframe Ozu's concerns and to subtly question their veracity, something that she achieves by almost parodying her intertextual jouissance. For example, Yoko and Suzu's cat is named *Mu* (meaning nothingness, the character for which Buddhist precept is the sole adornment on Ozu's gravestone), and the creature figures as an important part of *Dogs and Cats*. In Ozu, the prevalence of such a worldview attests to the director's attempt to suggest a

tension between a religious, philosophical view of life as a whole (something Paul Schrader in particular has valorized in this director[23]) and the mundane, quotidian, practical realities of those small moments that constitute the day-to-day experience of that life. This then underpins the tension between thought and deed or action and reflection that in films such as *Tokyo Story* or *Late Spring* structures the salient conflicts and crises.

In Iguchi's narrative, this becomes a sly means of underlining the critical tendency to overvalue or canonize the former in Ozu. In point of fact, the sporadic cutaways to Mu the cat that pepper the narrative—one of which in fact closes the film (as Yoko, not for the first time, calls him back home for a meal)—become an intrinsic silent chorus that figures as a metonym for the philosophical within the quotidian, the infinite within the minutiae of the finite, with the two inseparable to the extent that the former facilitates the latter, or at least forms the basis or foundation upon which it becomes predicated. *Dogs and Cats* seems from this perspective to be a piece of Ozu criticism, a corrective to perceptions of this director that he valorizes a Zen-based worldview that does not completely accept or consider the material or emotional problems that people face in their day-to-day lives. Wood, for instance, has criticized Richie's reading of the denouement of *Late Spring*, when the marriage (largely against her wishes) of a single father's daughter leaves him alone and facing an uncertain future.[24] The latter sees this development as demonstrating a becalmed, Zen Buddhist view of human relations and temporal impermanence, while the former counters by describing it, quite insistently, as an unqualified tragedy.[25] Iguchi scrupulously avoids and eschews almost any story details that could similarly be classified. Yoko and Suzu encounter no ostensibly life-changing or even overtly dramatic events over the course of the film; their lives are driven by relatively small-scale problems, and even the apparent breakup of Suzu's relationship does not really seem to cause her much consternation or concern other than the immediate problem of needing somewhere to live, which is solved as a matter of course almost straightaway (significantly, the prospect or possibility of returning to live with her family is never even raised). There is no real question of any philosophical import here—no grand attempt to understand or distill the nature of being alive—and the lurking presence of the cat is a constant, mischievous reminder of the quotidian at the heart of the apparently philosophical—that the two are intertwined and the latter cannot be extricated from the former—and of Ozu at the heart of Iguchi.

CONCLUSION

What, then, is the import of this dialogic relationship between Iguchi and Ozu? The nominal departure from Ozu already identified as a key feature of

Dogs and Cats should not be seen as a fracturing of Iguchi's dialogic relationship with Ozu; rather, it should be taken as a reflection on Ozu's narrative schema and what has been perceived as his perennial thematic preoccupation. Richie has stressed the extent to which almost all of Ozu's films are concerned with "the dissolution of the family,"[26] and Iguchi offers what may be termed a postfamilial milieu, a social landscape in which to all intents and purposes the family unit has become an almost invisible, negligible aspect of Japanese society (something prevalent in Japanese cinema since the late 1990s). Elsewhere this relationship is treated playfully by Iguchi, reminding us of Ozu's own penchant for light and comedic stories (something that goes back to almost the earliest years of his career as a director) in which he would typically build his work around adolescent travails.

In addition, the fact that Iguchi questions her protagonists' individuality as an adjunct to and extension of her own cinematic autonomy (vis-à-vis Ozu) can be read as a comment on the relationship between contemporary Japanese cinema and its perceived golden age of the 1950s and 1960s. Iguchi does not particularly lament or lambaste the contemporary (social or filmic) milieu of which she is a part. Indeed, it is representative of the same; stories of female bonding, friendship, and rivalry have been common in postmillennial works: from the postmodern fantasy of *Kamikaze Girls* (*Shimotsuma monogatari*, Nakashima Tetsuya, 2004) and the offbeat adolescent travails of Iwai Shunji's *Hana and Alice* (*Hana to Arisu*, 2002) to the sober sexual dynamics of Ando Momoko's *Kakera: A Piece of Our Life* (*Kakera*, 2010) and the emotional rigors of Yamashita Nobuhiro's story of an all-girl music group *Linda Linda Linda* (2005) and Lee Sang-Il's *Hula Girls* (*Hula garu*, 2006). There is even a black comedy by Tsutsumi Yukihiko entitled *2 LDK* (2003) that concerns the increasingly violent relations between two young actresses living together in a small Tokyo apartment.

These precepts demonstrate that both the significance and the relevance of Ozu in the twenty-first century is a matter both undeniable and ambiguous; they are demonstrably in evidence on the one hand, yet on the other more complex and multifaceted than has generally been allowed. David Desser has referred to him as a "filmmaker for all seasons"[27] for the ways in which his work both figuratively conveys temporality (his seasonal titles) and literally examines a range of accessible human dramas, and *Dogs and Cats* reflects this precept. If the tension between past and present (figured as textual, intertextual, and extra-textual antinomies) is in several ways a key to Iguchi's feature debut, then it is useful to consider it as a representative text in contemporary Japanese cinema, which in its postmillennial years in particular has frequently returned to earlier films, filmmakers, models, and styles as a way of defining and delineating itself. *Dogs and Cats* may be seen not only to represent but indeed to visualize this situation; it follows two young women struggling to move forward with their lives and more importantly their individual

identities—where their past continues to impinge upon the present and thus to define their (ambiguous) future. In other words, an ongoing negotiation with history characterizes the characters as well as the director, and indeed has marked social ramifications for Japanese women at a time when a period of perceived equality in the 1990s had rather swiftly given way to widespread regression in what Vera Mackie terms "the politics of everyday life and everyday relationships."[28]

Ozu's cinema remained in dialogue with a particularly turbulent era of Japanese history, a series of detailed documents showing how the seismic changes being wrought at this time were experienced and understood by the country's middle classes. In structure, style, and characters, Iguchi's film proffers an internal symmetry (of characters and narrative situations) that foregrounds its several juxtapositions as representative of its dialogic engagement with its predecessor on these grounds. And thematically it follows suit, examining concordance and discordance, commonality and difference, within the context of a social milieu that remains ostensibly divorced from its recent past and a cinematic one that reaches back to recall said past, even if this tradition can only be recalled, not recapitulated or revived (much as the distant yet tenable, ghostly presence of the contemporary world alluded to earlier haunts the characters). It is for this reason that it should be considered a key contemporary Japanese text, a film about, rather than merely representative of, the particular status of a new generation of films and filmmakers.

NOTES

1. Numerous commentators in both Japanese and English have likened *Still Walking* (*Aruitemo aruitemo*, 2008) to the work of Ozu. However, Kore-eda himself cites Naruse Mikio as a more prominent influence on his film. See R. Kurt Osenlund, "Still Walking," *Cineaste* 34, no. 3 (2011): 55.
2. The titles of numerous Ichikawa films—*Tokyo Siblings* (*Tokyo kyodai*, 1995), *Tokyo Lullaby* (*Tokyo yakyoku*, 1997), *Osaka Story* (*Osaka monogatari*, 1999), and *Tokyo Marigolds* (*Tokyo marigorudo*, 2001)—reflect the fact that they refract the narratives of Ozu's canonical works. *Tokyo Siblings* in particular has numerous visual and narrative echoes of Ozu that serve to frame its contemporary story of familial relations in a very specific context and to facilitate a juxtaposition of past and present and a questioning of how such relations have or have not changed. See Donald Richie for a more detailed elucidation and a quote in which Ichikawa himself likens this film to Ozu. Donald Richie, *A Hundred Years of Japanese Film* (Tokyo: Kodansha International, 2001), 232–233.
3. Maureen Turim, *Oshima Nagisa: Images of a Japanese Iconoclast* (Berkeley: University of California Press, 1998), 93.
4. Kirsten Cather, "Perverting Ozu: Suo Masayuki's Abnormal Family," *The Journal of Japanese and Korean Cinema* 2, no. 2 (2010): 133.
5. Yoshiharu Tezuka, *Japanese Cinema Goes Global* (Hong Kong: Hong Kong University Press, 2012), 9–11.

6. Alex Kerr, *Dogs and Demons: The Fall of Modern Japan* (London: The Penguin Group, 2001), 191.
7. Robin Wood, *Sexual Politics and Narrative Film* (New York: Columbia University Press, 1998), 107–110.
8. Alastair Philips, "Pictures of the Past in the Present: Modernity, Femininity and Stardom in the Postwar Films of Ozu Yasujiro," in *Screening World Cinema*, ed. Catherine Grant and Annette Kuhn (Oxon: Routledge, 2006), 86–100.
9. Donald Richie, *Ozu* (Berkeley: University of California Press, 1974), 5; and Tadao Sato, *Currents in Japanese Cinema*, trans. Gregory Barrett (Tokyo: Kodansha, 1982), 142.
10. Vera Mackie, *Feminism in Modern Japan: Citizenship, Embodiment and Sexuality* (Cambridge: Cambridge University Press, 2003), 1–5.
11. Adam Bingham, *Japanese Cinema Since Hana-Bi* (Edinburgh: Edinburgh University Press, 2015), 171.
12. Ibid.
13. Joan Mellen, *The Waves at Genji's Door: Japan through Its Cinema* (New York: Pantheon Books, 1976), 321.
14. Ian Buruma, *Inventing Japan: From Empire to Economic Miracle 1853–1964* (London: Weidenfeld and Nicolson, 2003).
15. David Bordwell, "A Modest Extravagance: Four Looks at Ozu," in *Ozu Yasujiro 100th Anniversary*, ed. Li Cheuk-to and H. C. Li (Hong Kong: Hong Kong Arts Development Council, 2003), 16.
16. Kathe Geist, "Narrative Strategies in Ozu's Late Films," in *Reframing Japanese Cinema: Authorship, Genre, History*, ed. David Desser and Arthur Nolletti Jr. (Bloomington: Indiana University Press, 1992), 93.
17. Wood, *Sexual Politics and Narrative Film*, 109.
18. David Bordwell defines parametric narration as one governed by style for its own sake. See David Bordwell, *Narration in the Fiction Film* (London: Routledge, 1987), 210–374.
19. Early in the film, Abe tells both Suzu and Yoko that they are ignorant of the real world when they prove incapable of arranging a futon to sleep on.
20. This is a dramatic trope familiar from films such as Martin Scorsese's *Cape Fear* (1991).
21. See Roger J. Davies and Osamu Ikeno, *The Japanese Mind: Understanding Contemporary Japanese Culture* (Boston: Tuttle Publishing, 2002), 153–158.
22. Mark Cousins in particular has identified this antinomy as central to Ozu's films. See Mark Cousins, *The Story of Film* (London: BCA, 2004), 126.
23. See Paul Schrader, *Transcendental Style in Film: Ozu, Bresson, Dreyer* (Berkeley: University of California Press, 1972), 15–56.
24. Wood, *Sexual Politics and Narrative Film*, 114.
25. Ibid.
26. Richie, *Ozu*, 5.
27. David Desser, "A Filmmaker for All Seasons," in *Asian Cinemas*, ed. Dimitris Eleftheriotis and Gary Needham (Edinburgh: Edinburgh University Press, 2006), 17–26.
28. Mackie, *Feminism in Modern Japan*, 1.

CHAPTER 11

Playing the Holes

Notes on the Ozuesque Gag

MANUEL GARIN AND ALBERT ELDUQUE

The sweetness of the air announces spring, just like a mirage, like the butterfly that flies over the trenches in *All Quiet on the Western Front* [Lewis Milestone, 1930], the one that Paul (what a wonderful death!) hopes to seize before he dies ... with a slight difference: in my mirage it would be a wallet instead of a butterfly!

—Ozu Yasujiro, January 31, 1939[1]

This paragraph was written by Ozu in the trenches of the Sino-Japanese War, feeling hungry, exhausted, and undeniably depressed. Compared to the brief, almost telegraphic notes on food, sake, and other daily routines that occupy most of his diaries, this particular entry stands out for its ability to film a scene without a camera: detached from his life as a filmmaker, unable to shoot images—only human beings—during the war, Ozu captures a powerful cinematic sequence with paper and pencil, a moment of "truth" one might say ... But why do we open a chapter on gags with such a dramatic anecdote?

Beyond being a beautiful definition of tragedy, this diary entry summarizes four key dimensions of what we may call the Ozuesque gag: (1) a gesture of reaching for the butterfly, which is not necessarily humorous, becomes (2) a *cinephilic* quotation of a Hollywood film (cinema echoes cinema), and (3) an ironic contradiction, since Ozu imagines a wallet instead of a butterfly (which could be seen as an inside joke about his Shochiku salary), and yet, on top of those three meaningful layers, (4) the gesture still conveys an everyday, human view of mankind and nature (spring, the mirage, war). Where others

might stress grandeur, art, and drama—Chaplin for instance—Ozu makes a joke on being an underpaid salaryman (*sarariman*). The tragedy is there, in addition to the realistic and poetic sensibility, but they all remain playful, down-to-earth, warm . . . thanks to the gag.

In this chapter, we hope to explore how Ozu understood, filmed, and used gags while tracing his influence on contemporary directors, in particular Aki Kaurismäki and Jim Jarmusch, who share the master's ability to combine realism and playfulness, family drama and comic relief, in a unique recipe for creating gags. We will argue that the Ozuesque gag has been tremendously influential thanks to not only mise en scène but also a mode or tone—a combination of irony and nostalgia—that many contemporary filmmakers revere and embrace. The first part of the chapter highlights the key aspects of Ozu's gags, including modularity and stable irony, while the second explores how other directors have reinterpreted such elements in their oeuvre.

We have deliberately chosen the word "gag" instead of the word "comedy" in the title of this chapter for pragmatic, aesthetic, and moral purposes. To begin with, using the term "gag" to discuss Ozu's work grants a higher degree of continuity throughout his work (and his life), a continuity that the word "comedy" could never attain: no one would dare to label his late films as "comedies," but we can easily agree that such films contain a significant number of gags.[2] Furthermore, despite the fact that we call many of Ozu's early films "college comedies," they seem more concerned with the playfulness and modularity of gags than with traditional comedic structures or plots; his nonsense (*nansensu*) reels are more gag than comedy-oriented. As Audie Bock puts it, "[T]he real essence of the genre is comedy based on sight gags, and a plot is merely incidental to the gags, if it exists at all."[3] So, in order to grasp the continuity of Ozu's style, it seems more useful to explore its comic dimension *through the gag* than the other way around.

As we have already observed with the butterfly/wallet joke quoted earlier, Ozu quickly learned to use gags as a tool to counterbalance sorrow. Sometimes to alleviate the serious tone of allegedly dramatic, emotionally charged scenes, as when parents and sons end up arguing and hitting each other in his movies. Other times, to mix by-the-book nonsense routines with anagnorisis, as in *I Was Born, But . . .* (*Umarete wa mita keredo*, 1932) when the children watch their father making a fool of himself. But most times, Ozu uses gags to highlight the irony of life while remaining warm to his characters, as witnessed in the famous ending of *An Autumn Afternoon* (*Sanma no aji*, 1962). No matter how we expand the meaning of the word "comedy," it never seems to do justice to the wide range of gags (sometimes tragicomic, sometimes satirical) employed in Ozu's work, and more importantly, the gags themselves remain free, memorable, and polysemic without such constraints. In François Mars's words, "to claim that a gag has to be mandatorily comic is to impose a humiliating restriction on its powerful independence."[4]

A practical student of Lubitsch and Vidor, Ozu would most certainly agree with that.

Even so, to study gags instead of comedy may evoke the wrong impression, since the word "gag" seems to imply formalistic connotations. Far from it, throughout the chapter we will address the narrative and thematic aspects that gags carry in addition to their formal traits. We will focus on the specificity of the Ozuesque gag by exploring various elements of filmmaking, not only forms. In an often-cited debate with Donald Crafton regarding the relationship between gag and narrative, Tom Gunning points out how a gag can contribute to as well as question storytelling, because gags make things fall apart but also put things back together sometimes.[5] Although Gunning talks about American slapstick comedy, we can trace that bifold nature of the gag in Ozu's work: some of the narrative situations in his films may fall under the rubric of a melodrama, such as the night Okajima spends with a woman of easy virtue in *The Lady and the Beard* (*Shukujo to hige*, 1931), but Ozu manages to alleviate the dramatic tone in a ludic way, in this case with a series of sewing gags that stress their childish behavior. So the gag clarifies narrative traits about the characters but still questions the overall meaning of the situation. Precisely, Bordwell and Thompson underline how sight gags carry out *multiple functions* beyond eliciting laughter, how they contribute to storytelling in a complex and multilayered process, enriching narrative as a whole.[6] And that is the type of plurality we would like to underline in this chapter: let gags speak for themselves, even when they remain silent.

AGING GAGS: MODULARITY AND (STABLE) IRONY

From Luis Buñuel to Preston Sturges, from René Clair to Rainer Werner Fassbinder, many filmmakers have used gags for various purposes throughout film history. What makes the Ozuesque gag unique? Although he uses the term *Ozuian* instead of *Ozuesque*, Bordwell acknowledges how other Japanese filmmakers already identified and even copied "Ozu-like gags" in the late 1930s, which confirms the specificity of his method: "Ozu was no mere copyist. His films were so influential that his ludic narration was imitated by many directors. Furthermore, his approach differs from that found in the work of his peers."[7] Other authors, such as Hubert Niogret, have stressed how Ozu's gags evolved beyond the realm of comedy and matured throughout his career, both in terms of form and narrative.[8] When depicting the quotidian situations of Japanese contemporary drama (*gendaigeki*), Ozu seems more interested in recycling Hollywood slapstick routines (*nansensu*) than in exploring the genres of traditional Japanese humor (*rakugo, kyogen, joruri*).[9] Sato Tadao considers that this freedom allowed Ozu to go beyond the self-depreciating and masochistic humor of Japanese comedians of his time like the Soganoya

Brothers: instead of making fun of working-class traits, the Ozuesque gag was aimed at the establishment (college, adult life, authority), mirroring the chaotic puissance of slapstick.[10] But how do his gags differ from those of the American films he admired?

One of the most distinctive traits of Ozu's gags is modularity. While Hollywood comedians increasingly used gags to structure narrative as well as mark turning points within the story, a process that crystallized in the '30s' greatest screwball comedies,[11] Ozu filmed gags to play around narrative conventions, focusing on repetition, circularity, and symmetry: his goal was not to clarify the plot, but to question it. His gags certainly have superb storytelling capabilities, as they inform the audience about his characters (as we will shortly see), but they always seem loose, playful, and even interchangeable, resulting in an ingenious combination of structural rigor and narrational playfulness.[12] In a film like *What Did the Lady Forget?* (*Shukujo wa nani o wasureta ka*, 1937) the social extraction of the characters and the overall atmosphere are not that far from those of a sophisticated screwball comedy of Mitchell Leisen, but the gags and humorous situations filmed by Ozu are way more important than the story itself: the gag's purpose is not to reinforce *what* the movies tell, but to celebrate *how* its characters (mis)behave.

Modularity-wise, in Ozu it is not only about the role that a gag may play in a single film, but also how the same gags and situations reappear in different films, echoing each other, as we can see with the student's puns in *Dreams of Youth* (*Wakodo no yume*, 1928) and *Where Now Are the Dreams of Youth?* (*Seishun no yume ima izuko*, 1932), or the kids' grimaces in *Tokyo Chorus* (*Tokyo no korasu*, 1931) and *An Inn in Tokyo* (*Tokyo no yado*, 1935), not to mention the troupe's routines in *A Story of Floating Weeds* (*Ukigusa monogatari*, 1934) and *Floating Weeds* (*Ukigusa*, 1959). As tight as it may appear, the connection between a story and a gag is, nonetheless, secondary in Ozu. What matters is the slight repetitions and variations of the same old stories and the same old gags, such as people eating, children crying, and fathers drinking (everyday situations that Ozu often films *as* gags). A humorous gesture of Ryu Chishu smiling and sharing sake in *Late Spring* (*Banshun*, 1949), repeated as a running gag throughout the film, is undeniably important for the movie itself, but it becomes way more significant if we compare it with the same gesture performed by Sakamoto Takeshi in *Passing Fancy* (*Dekigokoro*, 1933) or Saito Tatsuo in *I Flunked, But . . .* (*Rakudai wa shitakeredo*, 1930). Thus the running gag becomes an *aging* gag, because times goes by, and both the characters and the viewers age together.

Critics like Hasumi Shigehiko, Sato, Donald Richie, and Bordwell have all observed on the modularity of Ozu's cinema, but among the different situations he repeats and recycles, gags seem the most modular of them all. Manny Farber even compared Ozu's scenes, always similar and adaptable, with Morse codes: segment of family drama/silence/shots of a brewery/joke/another

piece of middle-class soap opera.[13] Stories, situations, and characters are interchangeable among different movies from different periods, just as puns and running gags are; but they do so for a reason, to reinforce the symmetries between what we see on the screen and what we experience in our own lives, to foster intimacy between the film and its audience, thus questioning social and cultural processes.

A simple action of sticking out the tongue, one of Ozu's favorite gags, may recall the happy games of childhood, as we see when the two kids teach a little girl how to do so in *An Inn in Tokyo*. But that same gesture may evoke the riddance of getting old, the burdens of adult life, like when the father asks his daughter to stick her tongue out to amuse a suitor in *The Munekata Sisters* (*Munekata kyodai*, 1950). In the first case, the gesture seems innocent and free; in the latter, it becomes a social imperative: she *has* to stick her tongue out because she *should* get married, according to the traditions of engagement. As Nakamura Hideyuki points out, when comparing Ozu's gestural series with Kafka's, the gesture becomes modular in order to break causality and question (the logics of) storytelling: "the series of gestures shows the relationship between the latent *puissance* of the body and various manifest forces, and in doing so reveals social and historical dimensions."[14] In a way, the gag has grown old, because although the gesture of sticking out the tongue remains the same, the little girl is almost thirty now, and the father's hair is gray. Social and cultural changes are highlighted by the mere fact of repeating a gag throughout different movies: gags *age* with their audiences.

"In the cinema, a society that has lost its gestures tries at once to reclaim what it has lost and to record its loss."[15] Giorgio Agamben's quote evokes a sense of resistance that lies deep in Ozu's cinema, through the gestures of his characters: gags *reclaim* what has been lost (hope, innocence, dreams of youth) and *record* its loss at the same time. His scenes are modular because life itself runs in loops and parallels; the purpose of the gag is, then, to remind us of such repetitions and echoes. Watching "the same gag" again, years later, becomes a way to acknowledge how everything else—friendship, society, family—has changed in the meantime. But, once more, Ozu's unique style makes all that possible without being too explicit: humor suggests instead of asserting, and the gag *shows what cannot be said.*[16]

This brings us to the second key dimension of the Ozuesque gag: (stable) irony. In spite of the differences between Japanese and European or American notions of farce, satire, and irony,[17] most scholars have linked Ozu's work with ironic playfulness in one way or another. For Richie, a Chekhovian irony is expressed through the characters' behavior,[18] while for Paul Schrader irony is Ozu's way to cope with disparity, "the temporary solution to living in a schizoid world."[19] Bordwell points out how a Lubitsch-like irony lurks in the small details of Ozu's films (movie posters, military evocations, ambivalent music),[20] and Audie Bock identifies "a sober yet half-smiling acceptance of life

as it is and as we seldom bother to look at it."[21] But in spite of the differences between each author (Schrader is prone to exaggerate, Richie focuses on performance, Bordwell on mise en scène), there is a common idea in these various interpretations of Ozu's irony: acceptance—something is being accepted by laughing.

As Sato points out, the danger of acceptance is to end in resignation,[22] and yet, in our view, that particular word (to resign, to give up, or quit) does not account for Ozu's unique use of irony. From *Tokyo Chorus* to *Where Now Are the Dreams of Youth?*, from *Tokyo Story* (*Tokyo monogatari*, 1953) to *An Autumn Afternoon*, we grow accustomed to scenes where sadness and drama (kids fighting, elders feeling lonely, families distancing) give way to smiles or funny gestures, without a hint of resignation. For Gregory Barrett, the evolution of Japanese film comedy is a constant tension between two poles, that of affinity (*ninjo kigeki*) and that of satire: in "bad" films, the former becomes conformism and the latter cruelty, but in "good" ones, affinity and satire work together, intertwine, and enrich each other (as in Ozu's).[23] In other words, the Ozuesque gag makes audiences feel for, as well as question, what they see: "nostalgia is qualified and criticized, often by the characters who indulge in it Ozu manages to make us feel the intensity of nostalgia while maintaining ironic distance on it."[24]

But how can irony be sharp and inclusive at the same time? In his book *A Rethoric of Irony*, Wayne C. Booth proposes a kind of *stable irony* that seeks firmness, mutual affinities, and community building; in contrast to Kierkegaard's view of irony as infinite negativity, stable irony can bring people together through a series of agreements on where to set the limits, what is and is not ironic, and how to interpret the ultimate meaning of it all.[25] As playful and differential as they may be, Ozu's gags make the best of this *ironic stability*, the audience feels close to the characters in spite of their questionable choices, and that intimacy makes room for critique as well as for nostalgia. The filmmaker uses everyday situations that viewers can bond to, like singing in a party with friends as we see in *I Flunked, But . . .* or *Tokyo Chorus*, but he does so in a way that fosters both empowerment (singing *feels* good) and detachment (the singing *has to* end). Therefore, Ozu's gags look stable because they are easy to recognize, down to earth, but they are still ironic in their own way, since they punctuate the sorrows of everydayness, the ups and downs of life.

In that sense, the stable irony of Ozu's gags is deeply rooted in the tradition of Japanese humor. For philosopher Tada Michitaro, the relationship between gestures and aesthetics in Japan should always be read through the concept of nodding or echoing (*aizuchi*), the awareness of being connected to others; and that sense of collectivity is in fact the origin of laughter (*warai*).[26] In the traditional legend, the goddess of light, Amaterasu, hid herself in a cave, bringing on an eclipse and many disasters, and the only way to fix the problem was to make her laugh: all the gods of heaven and earth (*yaoyorozu-no-kami*) had to

make Amaterasu laugh, and to do so, they decided to laugh together first. For Tada, that explains the psychology of *communal laughter* in Japan, why everyday gestures—laughing and smiling among them—become a way to share the burdens and wonders of everydayness: we humans laugh to make the gods laugh, in order to echo and share (our own solitude).

As the final sequence of *Tokyo Chorus* suggests, communal bonding (laughing with your old pals) and personal detachment (feeling old) often coalesce, so the modular irony of the Ozuesque gag is always a path to more complex and paradoxical ways of not only living, but *aging* together. As Bordwell beautifully points out recalling Ozu's death, modularity and irony are not only the basis of his gags, but they also traversed his own life until the very end: "Perhaps it was an awareness of this nostalgia and an ironic recollection of the lachrymose bedside scene which climaxed the typical Kamata/Ofuna film that led Ozu, dying in the hospital, to murmur to Kido Shiro: 'Well, Mr. President, after all—the home drama.'"[27] Accustomed to mix scenes of very ill children with small gags (*Tokyo Chorus, Passing Fancy, An Inn in Tokyo*), Ozu applied the same playful modularity and the same ironic acceptance to his own death.

DESOLATION *IS* A GAG

We have explored so far the two main constituents of what we may call the Ozuesque gag: modularity and stable irony. Those two key traits allowed Ozu to transform the regular running gags of other filmmakers into *aging gags*, scenes that echo similar scenes from previous films and, therefore, combine nostalgia with ironic acceptance. As time goes by, gags grow old, and so do we. Luckily, Ozu's style survives in the films of other filmmakers who embrace his taste for modularity and irony. Among them, Jim Jarmusch and Aki Kaurismäki stand out as devoted—but still rebellious—followers of Ozu: his influence on their work has been fully acknowledged, not only in exhibitions and retrospectives such as the one at the Lincoln Center Film Society, on New York in 2013 (where they shared space with other heirs of Ozu such as Claire Denis, Hou Hsiao-hsien, Pedro Costa, Kore-eda Hirokazu, and Wim Wenders), but also in statements by the directors themselves.

Jarmusch, who literally quoted Ozu's films by the names of racehorses ("Late Spring," "Passing Fancy") in *Stranger Than Paradise* (1984), wrote a text describing his visit to the director's tomb in Kitakamakura;[28] and Kaurismäki has praised the purity of Ozu's style[29] while borrowing undeniably Ozuesque images to end his films, like the cherry blossom shot that closes *Le Havre* (2011). On top of such explicit references to the Japanese master, Jarmusch and Kaurismäki follow the *themes-and-variation* pattern in designing gags, a technique that Bordwell and Thompson related to the Keatonesque gag, and that Ozu used extensively.[30] But what is noteworthy is how both filmmakers

blur the limits of what is or is not a gag, by playing with genre conventions and modular narratives, similar to Ozu.

Jarmusch's films such as *Night on Earth* (1991), *Coffee and Cigarettes* (2003), and *Mystery Train* (1989) share a pattern—a clear modular construction—where characters, situations, and objects become interchangeable: five taxi encounters, eleven dialogues, and three simultaneous storylines, respectively. While the different episodes maintain a certain autonomy, several connections are established or at least suggested by means of little gags—gestures, objects, topics of conversation—that move from one module to another, of which the characters remain unaware.[31] In fact, Juan Antonio Suárez has underlined how scenes that may seem redundant in terms of narrative, tend to be the most humorous in Jarmusch's films.[32] For instance, coffee meetings are a fundamental piece of machinery for Jarmusch, an aging gag that evolves through time, similar to Ozu's sake scenes: it matures inside one movie as in *Coffee and Cigarettes* but also grows old from one film to another, like Lautréamont's coffee quote in *Permanent Vacation* (1980), Bill Murray drinking at the kid's tea table in *Broken Flowers* (2005), or the ironic Madrid café in *The Limits of Control* (2009).

The modularity of Kaurismäki's gags may not be as overt, but just like Ozu's contemporary drama (*gendaigeki*), the same familiar situations are repeated in slightly different ways throughout his work. For instance, the humorous deadpan gazes of Kati Outinen in *Shadows in Paradise* (1986), *Take Care of Your Scarf Tatiana* (1994), or *The Man Without a Past* (2002), not to mention the ironic "happy" endings of *The Match Factory Girl* (1990), *Drifting Clouds* (1996), and *Le Havre*. When reflecting on *Calamari Union* (1985), Peter von Bagh points out how its excessive accumulation of gags suppresses almost all traces of narration, in the footsteps of *Un chien andalou* (1929).[33] Such a gag overdose became a bit steadier in his two films devoted to the Leningrad Cowboys, a troupe of quixotic musicians in *No Man's Land*. In their double-headed round trip from Russia to Mexico through the United States (*Leningrad Cowboys Go America*, 1989) and from Mexico to Russia through Europe (*Leningrad Cowboys Meet Moses*, 1994), each stop on the road remains similar to previous ones; repetition fosters humor: Leningrads drinking in a bar, Leningrads playing in a concert, Leningrads getting in and out of a car, Leningrads feeling hungry, and so on. In fact, the modularity of gags surpasses the two movies, since the Finnish director filmed a whole concert of the band (*Total Balalaika Show*, 1994) and two of their video clips as well (*Those Were The Days*, 1992; *These Boots*, 1993). The Leningrads' pointy boots and crazy toupees are utterly hilarious, but the musicians themselves become the true running—or aging—gag.

Both filmmakers use modular structures, not only within specific films but also across their entire careers: it is not about the dramatic cohesion of a story per se, but about its holes, echoes, and meanderings. In the same vein, Donald Richie underlines that some Ozuesque symmetries and parallels (as the ones

in *The End of Summer* [*Kohayagawa-ke no aki*, 1961] and *An Autumn Afternoon*) are way more beautiful because they remain mysterious and uncertain.[34] But for Jarmusch and Kaurismäki, such parallels not only respond to mysteries in the circular flow of life; they also highlight specific cultural differences, contagions, and contrasts. The Mexican cousin of the Leningrad Cowboys is not a mere source of humor, but embodies a cultural paradox—to say nothing of the Japanese couple visiting Memphis in *Mystery Train*. There is two-way traffic between the global and the local, change and permanence, *ici et ailleurs*, in terms of the way gags are placed in the middle of cultures that are in contrast: Soviet musicians play tangos or country songs, and Japanese youngsters listen to rock and roll.

While the irony of Ozuesque gags flourishes in the quotidian, Kaurismäki and Jarmusch make the best use of it in creating cultural clashes. As Jarmusch himself puts it in describing *Stranger Than Paradise*, humor may well be a cocktail: "a neorealist black comedy in the style of an imaginary Eastern-European director obsessed with Ozu and familiar with the 1950's American show *The Honeymooners*."[35] The situations that give rise to gags are more extreme, exceptional, and estranged than in Ozu's case, because in Jarmusch's deadpan world, deadpan characters with deadpan gestures need to find a way to survive, to assume their loneliness in a funny manner. But how does all this relate to the Ozuesque *stable irony* mentioned before?

Pauline Kael's critique of *Stranger Than Paradise* may help us answer that question: "there's no terror under or around what we see—desolation is a gag. . . . Those blackouts have something of the effect of Beckett's pauses: they make us look more intently, as Beckett makes us listen more intently—because we know we're in an artist's control. But Jarmusch's world of lowlifes in a wintry stupor is comic-strip Beckett."[36] During an interview before the release of *Down by Law* (1986), the director was reminded of Kael's verdict and stated, "Well, I would take that comment about a comic strip Beckett to be a . . . compliment."[37] So in her attempt to criticize the film, the *New Yorker*'s star critic touched upon a fundamental point: in fact, desolation *is* a gag.

That sentence may be the key to understand the influence of Ozu's irony in both Jarmusch and Kaurismäki, because it confronts nothingness with caricature, drama with comedy, social tragedy with acceptance: a perfect breeding ground for irony. Characters in Ozu's films are mostly Japanese, residing within limited spaces (the house, the bar, the office), and although some movies may contain trips, the aged fathers, the young daughters, and the groups of children tend to stay in a familiar environment. They may not feel at home, but they do live in one. In contrast, Jarmusch and Kaurismäki place immigrants and outcasts in *No Man's Land*, lost in a foreign country (*Stranger Than Paradise*) or excluded from their own societies (Finland in the Proletariat trilogy). Their characters find themselves in jail, planning to commit suicide, unable to communicate: the degree of estrangement is so high that the gag has to

be ten times more wry, contradictory, and artificial. In fact, desolation *can only be* a gag. Compared to the Amaterasu Japanese legend previously mentioned in relation to Ozu, in Jarmusch and Kaurismäki, there are no gods to laugh with, no daughters to marry, no retirement plans; the only thing that remains is the gag itself, silent and resilient . . . but still making us laugh.

PLAYING SHARED HOLES: A GAME OF SYMMETRY

On the occasion of the DVD release of *Down by Law*, Tom Waits coined a beautiful term in describing the way that he, John Lurie, and Roberto Benigni acted in the film: "it kind of waves—a line comes and then there's a fall, and then the wait, and then there's another line [W]e played more the holes than the lines." Jarmusch and Kaurismäki constantly make their characters *play the holes* from desolation to humor, ironically approaching the personal abysms in between them. Therefore, gags not only bring out, but also question, the loneliness of their characters. The idea of playing the hole is intimately related to the Chinese character *mu* (the nothingness that exists between all things), which is inscribed on in Ozu's tomb. In fact, Ozu used *mu* not only as a contemplative device but also to underline comical separations between characters, making the best of silences and hieratic moments. Not by chance, nothingness lies in the core of humor, as Kant (and also Larry David) pointed out: "Laughter is the result of an expectation which, of a sudden, ends in *nothing*."[38]

The cinema of Jarmusch is full of images of isolated characters sitting next to each other, *doing nothing*, and looking off-screen blankly, as when Lurie and Eszter Balint watch TV in *Stranger Than Paradise*, and when the Japanese couple face the Memphis night in *Mystery Train* (not to mention Bill Murray's deadpan gazes in *Broken Flowers*). Likewise, the characters in Kaurismäki's films spend a considerable amount of time looking nowhere while doing nothing, as in almost every bar scene he has ever filmed: the multiple Franks in *Calamari Union*, the crazy cook in *Drifting Clouds*, or the three friends in *La Vie de Bohème* (1992). The connection of these two directors with Ozu is rather obvious, as discussed earlier. But what is more interesting is how the apparent solitude of each character is mirrored in the gestures of another adjacent to him. Hasumi already points out why the lyricism in Ozu's pictures is not related to any psychological symbolism (the regarded objects), but to how characters move in sync while looking in the same direction.[39] This tends to happen when two individuals observe a landscape or drink sake in a bar, but also in other situations, as seen in *A Story of Floating Weeds*, where father and son act in unison while they fish.

Bordwell links such parallel gestures between characters with the *sojikei* effect, a traditional visual composition with two figures repeating the same

gesture with comical results, which dates back to Japanese theater and commedia dell' arte.[40] We see this when little children—especially brothers and sisters—echo each other's moves and grimaces in so many Ozuesque gags: playing rock-paper-scissors in *An Inn in Tokyo*, lying down like a corpse on the ground in *I Was Born, But . . .*, or provoking simultaneous farts in *Good Morning* (*Ohayo*, 1959). In the college comedies, for instance, we get to see large groups of students repeating the same gesture in a row; rooting for the university team in *I Flunked, But . . .* and *Where Now Are the Days of Youth?*, or preparing for gym class in *Tokyo Chorus*. So by placing his actors in line, forming consecutive rows, Ozu heightens the *sojikei* effect.

Kaurismäki tried out similar row shots in *Calamari Union* before perfecting them in the Leningrad Cowboys' films, where characters walk, sunbathe, and starve in lines. But while the Finnish director multiplies gestures in order to stylize and depersonalize his characters (he once compared the trajectories of the Leningrads to a cattle drive),[41] Jarmusch instead has gone deeper into the emotions created by such symmetries. One of the sketches in *Coffee and Cigarettes* shows us two twins, a boy and a girl, who want to appear as different as possible, but every time the waiter asks them something they cannot help but answer yes/no simultaneously. All the possible permutations of answers are given (both saying "yes," both saying "no," one "yes" and one "no") and, sometimes, they say the same word with contradictory meanings. Connections tie and untie intermittently, in a hilarious tête-à-tête, so we get to know a bit more about the twin's differences by simply witnessing how they mirror each other's attitudes and gestures (other duets in the film, such as Waits and Iggy Pop or the two Cate Blanchetts, deal with diverse attitudes in rather similar compositions). *Coffee and Cigarettes* is full of witty, playful dialogues, and yet, most of the comedy arises thanks to the eccentric gestures of characters; in fact, Jarmusch learnt about the importance of nonverbal communication by watching Japanese movies: "if you watch an Ozu film not subtitled, believe me you'll understand what the characters are feeling."[42] In a world of language problems and cultural misunderstandings, gestures become the most effective tool to understand the Other.

That kind of *sojikei* gags shape the most memorable sequences of *Down by Law*. In this fable about three men who meet in jail, the characters are secluded in the modular cell where they remain imprisoned, and they behave in a modular way themselves. Roberto Benigni is an extreme case: similar to the little brother in *Good Morning*, he repeats some words in English without fully understanding their meanings, and his actions seem completely self-absorbed. Gestures remain autistic, just as Lurie swinging his body rolled in a blanket, or Waits scratching in the wall the days they have been imprisoned. The dissociation between the gaze and its object, which Hasumi underlines when comparing Ozu's first comedies with his later, more stylized work,[43] turns here into dissociation between voice and receptor, or gesture and world.

In fact, the sentence that Benigni repeats over and over, "it's a sad and beautiful world" (often used by Jarmusch to sign autographs), was the result of a series of misunderstandings between him and the crew while shooting in New Orleans: Benigni was supposed to say "it's a sad and beautiful *music*" but ended up saying, "it's a sad and beautiful *word*," to which Tom Waits replied, "it's a sad and beautiful *world*." So that chain reaction misspelling (music/ word/world) proves why Jarmusch's gags are both a failure and a miracle of communication.

Later on, the tongue-twister "I scream, you scream, we all scream, for an ice cream," which Benigni has memorized to improve his English, is introduced during a card game and repeated many times by his partners Lurie and Waits. The three of them start dancing in loops: each one executes a distinctive gesture, but they all coincide in the same song. Eventually, all the prisoners in the corridor synchronize voices and join this humble choir: there is neither dialogue, nor "real" exchange, but a single sentence shared by all the—isolated, modular—inmates. Just as we witness in the clapping game in *Tokyo Chorus* and the rock-paper-scissors scene in *An Inn in Tokyo*, the synchronization of gestures brings people together, no matter how depressed or isolated they may feel. Not by chance, the jail sequence in *The Leningrad Cowboys Go America* uses the same Ozuesque mechanism when the musicians start hitting the cell's walls and furniture with empty beer cans: there is no dialogue to complain, not even words to protest, so noise becomes the only thing to share.

The most relevant parallels in gestures and behaviors in *Down by Law* occur between Lurie and Waits. They attempt to talk to each other but do not succeed, and yet, they always act symmetrically, have similar names (Jack and Zack), and form a 2 + 1 structure with Benigni (just like the twins and the waiter in *Coffee and Cigarettes*). The end of the film reinforces that pattern beautifully. Stumbling upon a crossroad, they agree on taking different directions and exchange jackets. Waits pretends to shake hands with his pal, but when Lurie approaches his hand, Waits withdraws his in a hitchhiking gesture: it is a joke, but still a way to *play the hole* between them. However, when they split, walking in opposite directions, they both stretch their arms and laugh to say goodbye. The contact may seem impossible, but symmetry brings distant characters together. Thus, in Jarmusch's cinema (as in Ozu's), the hole between two hands is always there, but hands end up being shaken after all. Another related example is found in *Mystery Train*. The Japanese girl tries to elicit a smile from her boyfriend while they sit together and look into the distance, but as she becomes tired of failing, she kisses him, leaving a lipstick-mark smile on his mouth. That is an instance of stable irony: we may not reach the other, but we kiss the void, sharing emptiness through laughter.

If Jarmusch draws upon symmetrical actions, Kaurismäki often combines the *sojikei* effect with camera movement, in the manner of Ozu's early comedies. As Bordwell observes on *I Was Born, But . . .* ,

"[T]he camera tracks down a row of salarymen working at their desks, and each one yawns on cue as the camera passes. Then the camera glides past one who does *not* yawn. The camera backtracks to him, and then he yawns. It is not that the camera catches some independently existing action; rather, the narration acknowledges its power to *create* the profilmic event and to synchronize it with a camera movement for the sake of the gag."[44]

That synchronization is a typical pattern for gags in Kaurismäki's Leningrad films, as well as an aging gag resumed by Ozu's years later in *Where Now Are the Dreams of Youth?* But, although camera movement is relatively common in Ozu's silent films (rows of students at college, of unemployed in the streets, and of spectators in the theater), that particular gag from *I Was Born, But...* stands out, as it underlines the interaction between an actor's gesture and the camera's mobile framing.

Gags resulting from the character's chain reactions may seem a bit formalistic, but even so, they are a powerful critique of modern mass production, in the tradition of René Clair's *À nous la liberté!* (1931) and Chaplin's *Modern Times* (1936).[45] In these films, the camera's lateral movement mirrors and compartmentalizes the characters' automatic gestures, criticizing mechanical reproduction. And while Ozu's gags are not as explicit as Chaplin's, they usually take an ironic stance toward money (the wallet in *Passing Fancy*), business hierarchies (the vice president's speech in *Where Now Are the Dreams of Youth?*), or academic authority (the students cheating in *I Flunked, But...*). So the chain of actions is meant to make us laugh but also question the logics of social functioning, revealing the automatisms that shape and govern modern life, which we generally take for granted.[46]

That is exactly what Kaurismäki exaggerates in the Leningrad's movies, where characters are designed to follow an almost-Marxist schema: the contrast between the manager Vladimir (a koulak) and the musicians (moujiks) is underlined with lateral movements.[47] When Vladimir gets out of a restaurant with leftovers, the camera follows his trajectory in front of a row of hungry Leningrad Cowboys seated on the sidewalk. But instead of feeding the ravenous musicians, he hands the leftovers to his dog, while the camera frames their faces in a lateral tracking shot, one after another. The visual parallel between Ozu and Kaurismäki is strong, even more if we recall how Hasumi stressed the importance of food in Ozu's cinema,[48] but while Ozu lets his characters share (meals, beer, sake), Kaurismäki does not: the only thing the Leningrads are allowed to share is hunger. The Leningrads can neither consume any food, nor produce a single gesture—they can only share the camera movement, nothing else. The gag becomes wintry and minimalistic because the only real bonds between the characters are hunger, resistance, and symmetry. We get to hear the sound of their empty bellies, swallowing the hole.

SYMPTOMS OF CHILDHOOD, ADULT BURDENS

An entire book could be devoted to Ozu's gags, and another to their influence on contemporary filmmakers. The conclusion of this chapter is thus meant to be tentative and partial. Precisely because of that, instead of summarizing the ideas presented so far, we would like to close the essay with a final hypothesis: how the Ozuesque gag draws on the tensions between childhood and adult life. Conflicts between order and anarchy, as well as between responsibility and playfulness, are central to Ozu's gags. In fact, the concept we have coined earlier in this chapter, *the aging gag*, is to refer to how such conflicts evolve over his films, from school years to retirement. Likewise, the humorous moment in Jarmusch and Kaurismäki often arises when a character should behave as a "responsible adult," when all she or he wants is to misbehave like a child. For instance, Bill Murray pretends to be the father he is unable to be in *Broken Flowers*, and in *The Match Factory Girl*, Kati Outinen ends up poisoning people at random, like a vengeful little girl. On that note, contemporary Japanese filmmakers such as Kitano Takeshi, Ishii Katsuhito, or Kore-eda Hirokazu have also explored similar conflicts between childhood and adulthood, in and out of the gag.

In his texts on caricature, Baudelaire presents one of the most intriguing and beautiful definitions of laughter: "Laughter is merely a form of expression, a symptom, an outward sign. Symptom of what? That is the whole question."[49] To think about gags as symptoms is an extremely suggestive way to reconsider how they influence the story and tone of a particular movie. In the case of Ozu, it is pretty clear that his gags deal with the problems of everyday within the pre- and postwar Japanese society. In a way, his films detect the symptoms of a world under transformation in terms of family structure, American colonialism, and Japanese national identity while making us laugh about them.

Some of the best Ozuesque gags are symptoms of social malfunctions: a son sees his father acting as a submissive clown in front of his boss (*I Was Born, But . . .*), and the gag becomes symptomatic of Japanese servile attitudes in work environments; a family plays hand clapping games to forget their hardships (*Tokyo Chorus*), but the adults still look worried about unemployment; an aged man jokes and sings a Japanese military anthem with an old pal from the war years (*An Autumn Afternoon*), but their loneliness—their sense of defeat—remains there no matter what. However, the best example of those childhood/adulthood symptoms takes place when two characters fight and start hitting each other in loops, a frequent scene in Ozu where the accumulation of a repeated gesture turns violence into humor.

What other directors would stage as a dramatic climax is treated by Ozu as a gag, radically shifting the tone: in *Passing Fancy*, for instance, the son

starts slapping his father's face in such a repetitive and artificial way that the scene becomes humorous (while still being sad). Precisely, Noël Burch locates the aesthetic basis of slapstick in how "we perceive the beauty of its structure through the laughter provoked by an aggression,"[50] and Tada Michitaro describes how children's quarrels (*kenka*) were considered a logical step for education in Japan, a chance to be free and laugh (*waratte uchitokeru*).[51] When kids play with each other in Ozu's films, the boundary between laughing and fighting becomes blurry: because humor and drama are not black or white, they mix in a greyscale. It is true that Ozu minimizes the comical elements in some of his late films, like *Floating Weeds*, where the violence is quite dramatic. But other postwar movies still feature family tensions in a humorous way, as when a little kid mocks his father when the older brother gets scolded (*Early Summer* [*Bakushu*, 1951], *Good Morning*). That 2 + 1 formula, with two kids fooling their father in a *sojikei* effect, is a by-the-book Ozu routine dating back to *I Was Born, But . . .* , the perfect example of those kid/adult aging gags.

In all those cases, the responsibilities of adult life coalesce with the dreams of childhood, and the gags help us cope with the one universal problem: getting old. That is, perhaps, the key idea that summarizes the spirit of Ozuesque gags, where irony and modularity become ways to cope with time, to come to terms with age. Among the aforementioned Japanese filmmakers, Kitano might be the one who better understands that relationship between childhood and adulthood, violence and humor, as we can see in films like *Sonatine* (1993), *Kikujiro* (1999), or, the most Ozu-like of them all, *Kids Return* (1996). In the latter, Kitano pays tribute to *Where Now Are the Dreams of Youth?* and unveils the mystery of the Ozuesque gag: family quarrels are decisive moments, because adults become children again, and, simultaneously, children discover the burdens of adulthood. In both films, the selfless friendship of youth (Horino and Saiki in *Where Now Are the Dreams of Youth?*, Masaru and Shinji in *Kids Return*) is the only thing that helps the characters deal with the sorrows, lies, and failures of adult life.

Every gag hides a hole, and every hole needs a gag. Like those old friends we are always glad to meet again, the gags of Ozu reappear as a remembrance of things past, but also as a warm comfort. Watching them from time to time is like reuniting with your old pals to share drinks and songs around the table, playing the holes of (each other's) life as time goes by. Like the drunken salarymen of Ozu, the deadpan couples of Jarmusch, and the hungry bands of Kaurismäki, the gag meets the audience and sings an old song of relief. Laughter soothes sadness; irony fights nostalgia. So perhaps, as Ozu, Jarmusch, and Kaurismäki would say, the best way to age may very well be to sit, share something (sake, coffee, vodka), and play the hole.

NOTES

1. Ozu Yasujiro, *Antología de los diarios de Yasujiro Ozu*, trans. Núria Pujol and Antonio Santamarina (Valencia: Filmoteca de la Generalitat, 2000), 90. English translation is ours.
2. Like Frank Capra and Leo McCarey, one of Ozu's earliest jobs in the movie business was to think up jokes for other directors. See Donald Richie, *Ozu* (Berkeley: University of California Press, 1974), 29.
3. Audie Bock, "Ozu Reconsidered," *Film Criticism* 8, no. 1 (1983): 51.
4. François Mars, *Le gag* (Paris: Éditions du Cerf, 1964), 119. English translation is ours.
5. Tom Gunning, "Crazy Machines in the Garden of Forking Paths: Mischief Gags and the Origins of American Film Comedy," in *Classical Hollywood Comedy*, ed. Kristine Brunovska and Henry Jenkins (New York: Routledge, 1995), 96. The debate is further expanded in Donald Crafton, "Pie and Chase: Gag, Spectacle and Narrative in Slapstick Comedy," and Tom Gunning, "Response to 'Pie and Chase,'" included in the same volume.
6. David Bordwell and Kristin Thompson, *Film Art* (New York: McGraw-Hill, 2004), 221.
7. David Bordwell, *Ozu and the Poetics of Cinema* (Princeton, NJ: Princeton University Press, 1988), 66.
8. Hubert Niogret, "Introducing: Yasujiro Ozu: ou pour la première fois à l'écran," *Positif* 203 (1978): 6.
9. Gregory Barrett, "Comic Targets and Comic Styles: An Introduction to Japanese Film Comedy," in *Reframing Japanese Cinema: Authorship, Genre, History*, ed. Arthur Nolletti Jr. and David Desser (Bloomington: Indiana University Press, 1992), 210–228.
10. Sato Tadao cited in Barrett, "Comic Targets and Comic Styles," 216.
11. Steve Neale and Frank Krutnik, "The Case of Silent Slapstick," in *Hollywood Comedians: The Film Reader*, ed. Frank Krutnik (London: Routledge, 2003).
12. Bordwell, *Ozu and the Poetics of Cinema*, 54.
13. Manny Farber, *Farber on Film: The Complete Film Writings of Manny Farber* (New York: Library of America, 2009), 688.
14. Nakamura Hideyuki, "Ozu, or on the Gesture," *Review of Japanese Culture and Society* 22 (December 2010): 152.
15. Giorgio Agamben, *Means without End*, trans. Cesare Casarino and Vincenzo Binetti (Minneapolis: University of Minnesota Press, 2000), 53.
16. Agamben uses that particular sentence ("the appearing of what cannot be said") to define the gag, borrowing it from Wittgenstein's definition of the mystic. Ibid., 60.
17. For a closer analysis on such transnational differences, see Marguerite A. Wells, "Satire and Constraint in Japanese Culture," in *Understanding Humor in Japan*, ed. Jessica Milner Davis (Detroit: Wayne State University, 2006), 193–217. For a specific discussion of irony in Japanese Cinema, see Ian Buruma, "Humor in Japanese Cinema," *East-West Film Journal* 2, no. 1 (1987): 30.
18. Richie, *Ozu*, 25, 50.
19. Paul Schrader, *Transcendental Style in Film: Ozu, Bresson, Dreyer* (New York: Da Capo Press, 1988), 45–46.

20. Bordwéll is one of the authors who have found more uses of irony among Ozu's films: *Ozu and the Poetics of Cinema*, 26, 45, 72, 123, 130, 157.
21. Bock, "Ozu Reconsidered," 51.
22. Sato cited in Barrett, "Comic Targets and Comic Styles," 217.
23. Barrett, "Comic Targets and Comic Styles," 225.
24. Bordwell, *Ozu and the Poetics of Cinema*, 372.
25. Wayne C. Booth, *The Rhetoric of Irony* (Chicago: The University of Chicago Press, 1974), 49.
26. Tada Michitaro, *Gestualidad japonesa*, trans. Tomiko Sasagawa Stahl and Anna Kazumi Stahl (Buenos Aires: Adriana Hidalgo Editora, 2007), 49, 105.
27. Bordwell, *Ozu and the Poetics of Cinema*, 26.
28. Jim Jarmusch, "Two or Three Things about Yasujiro Ozu," *Art Forum* 42 (October, 2003), accessed February 8, 2015. http://www.a2pcinema.com/ozu-san/ozu/influence/jarmusch.htm.
29. Peter von Bagh, *Aki Kaurismäki* (Locarno: Cahiers du Cinéma, 2006), 176.
30. Bordwell and Thompson, *Film Art*, 220.
31. Richie, *Ozu*, 50.
32. Juan Antonio Suárez, *Jim Jarmusch* (Urbana and Chicago: University of Illinois Press, 2007), 65. In *Coffee and Cigarettes*, as well as in *Stranger than Paradise*, the production circumstances induced the modular structure of the movies, since different sections were filmed in different time periods and even released independently.
33. Von Bagh, *Aki Kaurismäki*, 43–44.
34. Richie, *Ozu*, 43.
35. Jarmusch cited in Suárez, *Jim Jarmusch*, 8.
36. Pauline Kael cited in Jane Shapiro, "Stranger in Paradise. 1986," in *Jim Jarmusch: Interviews*, ed. Ludvig Hertzberg (Jackson: University Press of Mississippi, 2001), 59.
37. Jarmusch cited in Shapiro, "Stranger than Paradise. 1986," 59.
38. Immanuel Kant cited in Henri Bergson, *Laughter*, trans. Cloudesley Brereton and Fred Rothwell (Rockville: ARC Manor, 2008), 45. The comedian Larry David also related humor to nothingness when he defined *Seinfeld* (NBC, 1989–1998) as a show about nothing.
39. Hasumi Shigehiko, *Yasujiro Ozu*, trans. Nakamura Ryoji, René de Ceccatty, and Hasumi Shigehiko (Paris: Éditions de l'Étoile, Cahiers du Cinéma, 1998), 156–158.
40. Bordwell, *Ozu and the Poetics of Cinema*, 84.
41. Von Bagh, *Aki Kaurismäki*, 97.
42. Jim Jarmusch cited in Geoff Andrew, "Jim Jarmusch Interview," in Hertzberg, *Jim Jarmusch: Interviews*, 185.
43. Hasumi, *Yasujiro Ozu*, 129.
44. David Bordwell, *Ozu and the Poetics of Cinema*, 66.
45. For similar accumulative humorous movements and chain-reaction gags, see Manuel Garin, *El gag visual. De Buster Keaton a Super Mario* (Madrid: Cátedra, 2014), 73–79.
46. Rob King has stressed how slapstick gags brought out the hidden fears of the '20s society while being a therapy for those same fears: "Uproarious Inventions: The Keystone Film Company, Modernity and the Art of the Motor," in *Slapstick Comedy*, ed. Tom Paulus and Rob King (New York: Routledge, 2010), 123.

47. Von Bagh, *Aki Kaurismäki*, 96.
48. Hasumi, *Yasujiro Ozu*, 51.
49. Charles Baudelaire, *Selected Writing on Art and Artists*, trans. P. E. Charvet (Cambridge: Cambridge University Press, 1981), 150.
50. Noël Burch, *Life to Those Shadows* (Berkeley: University of California Press, 1990), 147–151.
51. Tada, *Gestualidad japonesa*, 93–94.

Rhythm, Texture, Moods

Ozu Yasujiro, Claire Denis, and a Vision of a Postcolonial Aesthetic

KATE TAYLOR-JONES

While few global studies situate the experience of Japan at the heart of the postcolonial narrative, Japan was one of the most influential non-Western modern empires.[1] Although the Japanese colonial period is a rapidly growing area of research when compared with the number of studies focusing on the colonial past and the postcolonial present of France, Germany, Italy, or the UK, the lack of systematic engagement with Japan as a site of colonial power is a problematic oversight. This chapter engages with questions of a postcolonial aesthetic and examines the work of Ozu Yasujiro from this angle alongside French director Claire Denis, who has openly expressed how Ozu continues to inspire her own work.[2] The hegemonic experiences of the colonizing nation are at the heart of many of Claire Denis's films as she struggles to articulate the French postcolonial moment, and therefore a clear argument can be made with regards to her work. However, while the environments that Ozu was working inside of are not part of the prototypical representational dynamics of the colonial and postcolonial moment, nevertheless can an interrogative and postcolonial aesthetic be found in his work in the years following Japan's defeat?

The colonial experience of Japan and France are clearly very different. Japan's empire, although the longest non-Western manifestation of Empire, was under half a century old, while France maintained colonial territories from the sixteenth century onwards until now just a few overseas territories

remain as testimony to its colonial past. Japan's defeat means she lost all her territories almost overnight, while France underwent a long period of imperial decline as gradually more and more nations called for their independence. With this in mind, I am certainly not arguing in any way for us to see postcolonial as a specific "genre," but rather to see it as an approach. The main aim of this chapter is to debate the question of what *is* or *could be* a postcolonial aesthetic and to suggest ways in which this aesthetic approach can be utilized in the analysis of film.

The question of what a postcolonial aesthetic might be raises a series of questions that debates the very nature of both terms. If for Immanuel Kant aesthetics could be characterized as an "analytic of the beautiful,"[3] via the work of early poststructuralism, aesthetics was linked with notions of value and thereby prejudice. In short, aesthetics became "a tool of diverseness, enmity and oppression."[4] However, rather than continuing the insistence of aesthetics as related to the construction of beauty, recent work has developed and refined the debate. Rather than an examination of beauty per se, aesthetics has become a "specific kind of human experience,"[5] one that allows us to challenge "our intellects as well as our perceptual and emotional capacities. To meet all these challenges simultaneously is to experience aesthetically."[6]

This focus on the aesthetic experience would be a preoccupation of Theodor Adorno, who announced that aesthetics ultimately declares an untruth. For him, there is the inescapable fact that the aesthetic remains "allied to ideology,"[7] and the question of the relationship between truth and representation remains a site of tension. Thereby, as Elleke Boehmer comments, the aesthetic lies between two poles of differentiation—as "autonomous, in-and-for-itself" and the "aesthetic as deeply complicit."[8] The aim of this chapter is not to refute other scholars engagement and reading of the films but rather to open the debate up further. The goal is to write less *about* and more *though* the films as I explore how postcolonial aesthetics allows for the development of what Kaja Silverman calls the "productive look."[9] Although I do not wholeheartedly subscribe to the psychoanalytical background of Silverman's consideration of the aesthetic, her engagement with images as a site of affective development is helpful. In short, the process though which the normative process of identification making is ruptured via the ability of the cinematic image to allow what was previously hidden to be made available for scrutiny. The rich array of (re)presentations that the aesthetics calls forth allows for an illumination of ideals that would otherwise remain hidden; thus, in their presentation, we see a rupture between the idealized image and our engagement with it. As Silverman puts it, "[W]e cannot idealise something without at the same time identifying with it" in the case of film, vis-à-vis the "formal and libidinal properties of highly charged images."[10] Therefore, the aesthetic can operate in two ways: firstly, as a process by which the memories that the dominant culture

seeks to repress are highlighted, and secondly, by simultaneously requiring the subject to learn to love that which is not him- or herself. In her discussion of Chris Marker's *Sans Soleil* (1983), Silverman states,

[The film] opens itself up to "penetration" by them [other cultures], and it repeatedly registers and retransmits the shock of that encounter. It provides an extended dramatization of and meditation upon the operations of memory, which it puts to highly unusual purposes. It "remembers," and encourages the viewer to "remember," what might best be characterized as "other people's memories." In the process, it both radically revises what it means to look at Japan and Africa and engages the viewer in an exemplary self-estrangement.[11]

This "productive look" therefore means to "confer identity, not to find it," and it is this process of distance, deferral, and reconstitution that proves a powerful argument when it comes to seeing the aesthetic as more than "just beauty" and a relevant and productive tool in the box of postcolonial studies. Boer's study *After Orientalism* develops this productive look and aims to allow us to learn "to see differently, but only after having recognized the necessary struggle with the dominant elements on the screen."[12] The aesthetic therefore is inseparable from the order it critiques. Alan Shapiro describes the aesthetic as "that emphatic power of entering into the moral experience of others," and he adds that this "capacity for ethical discrimination . . . can alter the very conventions which inform it."[13] Thus the aesthetic is defined through this "theoretical confusion," and, as Geoffrey Galt Harpham notes, through "the indecipherability between object and subject freedom and repressive law, critical and uncritical passages, grievous and necessary misreading, even art and ideology."[14] In other words, aesthetic texts come from the context in which they are set, but they "provide access to the privileged signifiers of those contexts."[15]

To summarize Boehmers's comments, a postcolonial aesthetic text "would be that which most successfully, movingly, harmoniously, interrogated and integrated the language of the former empire."[16] Inside this vision, we need to explore how the related ideas such as postcolonial, the neocolonial, and the postimperial often operate inside the same imagined spaces. Hence, we cannot draw a clear border between, for example, France's previous territorial control and her continuing desire to maintain economic neocolonial power over former territories. With Japan, the colonial past, the Pacific war, and the experience of American occupation become part of a continuing and interlinked narrative that has been created and then recreated for a wide range of political and cultural needs. There is no sense of "after" (hence postcolonial not post-colonial), but rather a continual process that moves across the aesthetic engagement with past, present, and future.[17]

OZU, DENIS, AND A TEXTURE OF POSTCOLONIALITY

Seeing Japan in the lexicon of postcolonial raises two key issues—Japan as *colonizer extraordinaire* with an extensive colonial and imperial empire[18] and Japan as *colonized* in the American occupation of 1945–1952. Thus, the work of Ozu is doubly entangled in the processes of the loss of one colonial narrative and the imposition of another.[19] I turn here to Herbert Marcuse's comments on the aesthetic as a place of transformation:

"Aesthetic form" means the total of qualities (harmony, rhythm, contrast) which make an oeuvre a self-contained whole, with a structure and order of its own (the style). By virtue of these qualities the work of art *transforms* the order prevailing in reality. This transformation is "illusion," but an illusion which gives the contents represented a meaning and a function different from those they have in the prevailing universe of discourse.[20]

There is a tension between content and form, in that the content may give the specifics, while the form—"the total qualities that make the work of a self-contained whole set off from external reality"[21]—allows for a transcendence of context. For Marcuse, the aesthetic is capable of breaking though reality and enacting a potential of positive change.[22]

So what are the aesthetics in the work of Ozu and Denis? Both directors have had a series of studies devoted to their aesthetic traits. For Laura McMahon, Denis's works "combine an emphasis on materiality with modes of anti-representational minimalism, decoupling film from the constraints of narrative in an elaboration of the textured facticity of images and sound."[23] This can be most clearly seen in films such as *Beau Travail* (1999), *White Material* (2009), and *Trouble Every Day* (2001), where there is a consistent fracturing of image, sound, and narrative to create a space where all the characters are marked with a sense of ambiguity. This ambiguity provides a resource of potential connotation that can be utilized in the articulation of the complications and ambivalences of the postcolonial. As Homi Bhabha notes, "[I]t is in the emergence of the interstices—the overlap and displacement of domains of difference—that the intersubjective and collective experiences of nationness, community interest, or cultural value are negotiated."[24]

The English-language scholarship on Ozu's aesthetics has, to date, been largely based on notions of nationality. Paul Schrader's definition of Ozu as "transcendental" and Burch's construction of Ozu's works as a direct refusal of Hollywood modes of dominant representations have frequently served to place Ozu in a distinct category of his own where aesthetics is concerned.[25] Bordwell and Thompson's work on Ozu, with their notions of parametrical style, has helped to revisit the distinction between Japan and Hollywood, yet the work of Ozu has still become a key marker in the debate on the "Japaneseness" of

the filmic image. While this approach has been contested in several quarters, the aesthetics of Ozu is often defined in terms of the auteur rather than seeing it as a potential part of a wider debate on aesthetic representation.

What both Denis and Ozu share can be seen in the textured pattern of images and sounds that dominate both of their respective works in a variety of ways. An example of this is the texture of repetition that can be found prominently in Ozu's *A Hen in the Wind (Kaze no naka no mendori*, 1948). *A Hen in the Wind* has certainly not been the most lauded of Ozu's work, with Ozu himself apparently branding the film a failure,[26] and to date the film has suffered much neglect in English-language film scholarship. Yet, when seen in terms of form and content, it is a valuable addition when considering Ozu's oeuvre in the postwar period. The narrative of this little-discussed film focuses on a young mother who is forced into a night of prostitution when her young son is taken ill. On confessing this event to her husband, who has just been repatriated from war, she is shocked as he demands the intimate details of the encounter and then rapes and beats her. Finally, after seriously injuring her when he knocks her down the stairs, and after he has made a failed attempt to visit a prostitute in revenge, he decides to forgive her. The film returns again and again to the same images as the family seeks to deal with the trauma that has befallen them.

Taking as a key example the rape scene, we see a flight of stairs become a key focus in the traumatic interplay between husband and wife. The scene is mostly in medium or medium-long shot and is marked by the movement of the camera between a series of static images interspersed with the couple arguing and the eventual assault and rape of the wife. The image that is returned to again and again and eventually concludes the scene, is a medium-long shot of the stairs that divide the two floors of the house. Dark, narrow, and seemingly meaningless given the context of the argument, they become a key focal point of the scene and indeed the film more broadly. The progression to the rape is almost staccato in appearance and is punctuated by repeated images throughout the short scene. The stairs are therefore a key element in this process of repetition. The curious shot/reverse shot framing of the two characters alternating from their faces to their backs gives a tremendous sense of disconnection, and for a comparatively short scene, we have a remarkable number of shots. Many of these shots are superfluous to the narrative of the husband demanding information, but they serve to provide the sense of the dissolution of the family unit.

Hen in the Wind is very unusual among Ozu's films, in that violence and aggression are clearly shown (and perhaps this is why it has been neglected, as it fails to conform to the dominant images of Ozu's works), and yet, this violence serves to present the trauma of the wider social moment. The stairs that return again and again throughout the film become a working metaphor for flux and change that the social space has entered into after the war

period. Hasumi Shigehiko notes that stairs themselves are a rare presence in Ozu's films,[27] and in this case, the film returns to the exact same shot, which makes the terrible fall that Tokiko takes near the film's conclusion all the more startling. The repeated images and their interplay serve to open up a textual space that moves beyond the film's narrative to create a sense of the postwar moment that is clearly interacting with Japan's colonial past. The film is littered with empty shell casings and references to US domination, including vast cola signs and movie posters adorning shabby walls. Outside the home space, visually the most dominant element is the large gas tower, which is shown repeatedly throughout the film. Its position within each shot shifts, alerting us to the passing of time, which has passed indeterminately—hence the film enters into a temporary flux, where the external activities are dislocated from the internal tensions that are taking place in the home. There is a rupture between the internal spaces of family life and the external spaces of postwar Japan. The home is no longer a space of safety and respite; it becomes the stage where the postcolonial moment will be enacted. Inside the brothel space while Tokiko commits her act of prostitution, there is a circular movement by which we move from the shot of sake on the table, a futon with a fan, and then the corridor of the brothel. This is then enacted in reverse as we move from the brothel back to the home of Tokiko. This reverse movement of camera confuses and cross-cuts the two respective domestic spaces and is perhaps an ideal example of why Japanese film critic Sato Tadao's identifies Tokiko as the site of the loss of national purity, as the sanctity of the home becomes embroiled in the results of war and defeat.[28] Tokiko's actions and Shuichi's violence, rather than being placed as sites of individual responsibility, are seen as a collective result of the failure of the imperial moment, the brutalizing effect of war on all aspects of society, and the resultant loss of empire followed by the American occupation. At an earlier point in the film, the brothel had been intercut with scenes from a children's playground, making the perhaps not so subtle link between the reason for Tokiko and many other women in the postwar period to enter into prostitution.

This interplay between the internal and the external as an articulation of the colonial past is also seen in Denis's works, most clearly in *White Material*. While in *Hen in the Wind* the empty shell casings litter the field of vision and the family unit is dissolving under the pressure of events, *White Material* shows the land as covered in the bodies of the dead and the remains of the burnt-out buildings destroyed by conflict. The family unit is completely dysfunctional, primarily due to the inability of its matriarch, Maria, to realize the truth about her lazy and violent son, and the fact that the colonial moment has passed. As a result, her family is no longer able to survive in the new country being formed around them. The survival kits that are dropped by the French army helicopter are stark reminders that this is a landscape fraught with danger. This is a territory where French colonials are profoundly unwelcome. The

title of the film itself directly refers to the colonial rulers and their unwanted status—white materials literally do not fare well in the African sun. As the DJ in the film comments, "for the white material the party is over"—and yet Maria's own arrogant sense of ownership precludes her from understanding that her belief in her own superior sense of belonging to the land was built on falsehoods and colonial aggression. Her attempts to maintain a neocolonial status (seen most clearly via her desire to maintain her control over the crops and the local workers) inside a nation that no longer wishes to engage with the previous narratives of colonial subjugation ends in tragedy for the whole family. The film's aesthetics are fractured and dislocated as it moves from the bright outside landscape to the dark and repressive family home. The dichotomy of movement and stasis can be seen as reflected in both *White Material* and *Hen in the Wind*, and as in Ozu, images are repeatedly shown and build up a textured pattern that allow the audience to enter into a flux of affective relations between image, sound, and narrative. What becomes a key element in all of these films is the sheer *unknowability* of the postcolonial moment.

FLOATING SIGNIFIERS AND THE PROCESS OF UNKNOWABILITY

Returning to Ozu, I now turn to the film made prior to *Hen in the Wind*, which in English goes by the inaccurately translated title of *Record of a Tenement Gentleman* (*Nagaya shinshiroku*, 1947).[29] The basic story revolves around Otane, an elderly and rather curmudgeonly woman, who ends up having to take care of an abandoned boy. Although she initially tries to drive him away and treats him with general disdain and verbal abuse, she eventually learns to love and care for him. This film, unlike *Hen in the Wind*, has received more attention from scholars, and its role in the postwar moment has brought about a series of debates about the symbolism of the shots and images shown. Edward Fowler focuses on the futon that the young boy urinates on due to his night terrors as symbolizing an America flag that has literally been "pissed on." For Fowler, the film "operates at widely varying levels of concealment."[30] This process allows for the narrative and the visual to take slightly different pathways, with the tale of a woman taking care of an orphaned boy (acceptable to the US occupation cinema codes) juxtaposed with images that imply "a blunt and xenophobic message to his Japanese audiences without getting caught by his American one."[31]

A key example of this approach is the statue of Saigo Takamori, leader of the Satsuma rebellion and a radical nationalist and an early and active supporter of the invasion of Korea and the establishment of the Empire of Japan. At the conclusion of the film, after Otane has decided to adopt another boy, she is informed that many orphaned children go to congregate there in Ueno

park. So the question is raised about whether the children collected at the bottom of this bird-dropping-covered statue represent a critique of the colonial past or a longing to return to it? Is the status a criticism of the American occupation or indeed a criticism of Japan for its imperial past that led to such events? The loss of the Japanese empire becomes most apparent in the images of a colonial past that are now being given new meaning. Saigo Takamori no longer just represents a glorious past; rather, his statue can now be read as the affective symbol of Japan's defeat by the orphaned children gathered around him. While a precise reading remains opaque and subjective, the very presence of this image raises some key questions about the film's intention and its status in the cannon of a potential postcolonial Japanese cinema.

Opening up clear signifiers of the postwar occupation is not a process of pronouncing right and wrong but rather of inviting a viewer to read his or her own engagement into the narrative. Both Denis and Ozu are directors who are marked by a mise en scène of fragmentation, creating a process by which signification remains floating. There have of course been endless debates on the meaning behind the vase in *Late Spring* (*Banshun*, 1949) (which I am not going to re-debate here, as it is generally well covered elsewhere),[32] and what becomes clear is that the unknowablity of the cinematic images allows the viewing to develop new lines of thought and connection with the patterns on the screen.

Taking further this process of the unknowability, the ending of Denis's *Beau Travail* has been open to several different readings and considerations. The narrative, based on Herman Melville's *Billy Budd* (1924), examines the destructive and ultimately murderous desire that French Foreign Legion Officer Galoup develops for a young, popular, and charismatic recruit named Sentain. Set for the most part in deserts of Djibouti, the film shows Galoup descend into madness and eventually attempt to kill Sentain. Back in France, away from the heat of Djibouti, the camera focuses on Galoup's tattoo (which reads, "serve the good cause and die [*sers la bonne cause et meurs*]") and the throbbing vein in his arm that is holding his army service pistol as he lies prostrate and melancholic in his bed in Marseilles. From this ending, the film then returns to Galoup once again in the dance hall in Djibouti, and this time, unlike in the earlier section of the film when he dances with his men and the local women, he is alone. He then dances erratically to the music while facing a giant mirror. As the music concludes, he vanishes out of the door at the back of the club. Unsurprisingly, the ambiguity of the final scene is one that has raised many questions among critics. His final dance for some has been read as Galoup's regeneration/redemption,[33] and for others a final dance of death.[34] Galoup has literally decided to "serve the good cause and die." The main focus is on Galoup's body as he performs his disjointed and erratic dance routine, and on the tension between reality, truth, and fantasy. The whole film, but particularly the ending, is complicated by internal consistencies in

spatiotemporality of the aesthetic moment. In *Beau Travail*, we are unable to clarify and define the complex images of the ending. Janet Bergstrom comments that Denis's "conception on the 'unspoken' is not a silent language of images. It is linked to opacity."[35] This opacity serves not to alienate the viewers but serves to allow the filmmaker to "repudiate the widespread practices of closure which yield . . . only the false semblance of an honest explanation."[36] This rejection of a close-ended resolution is a call that is echoed in postcolonial studies, where the aim is to examine, debate, and discuss, in short a future-oriented process. Although the continual issue of the "writing back" and against the center has resulted in a disciplinary postcolonialism that for some has become closed and restrictive, the postcolonial "implies a critique and rejection of colonial forms of sociality; it also, however, gestures beyond critique and moves towards constructivism in so far as it properly emphasises a positive task barely begun: the conceptual creation of a 'new horizon.'"[37] Postcolonial aesthetics therefore is a mode of engagement with an article that involves "emotional, evaluative and intellectual appreciation."[38] As Michael Sullivan and John T. Lysaker note, the tension between subject and object may be the very key to emancipatory theory and practice.[39]

THE PAST, THE PRESENT, AND SMALL RUPTURES

In Denis's film *Chocolat* (1988), we see the colonial structures named via the characters (France, Protée and Aimée); interrogated (the unresolved passion that develops between Protée and Aimée, the clear hypocrisy of the colonial code examined via the illuminating and dubious proclamation of Luc); and questioned and challenged (via France's burnt hand, Protée's rejection of Aimée). Yet, there is no final resolution to the conflicts; in France and William J. Park's respective failed acts of return (to the land of her childhood and his heritage), we see a failed and incomplete process of homecoming. The film refuses to allow us to go back to the past, and we instead see "the struggle, if not the impossibility, of re-inscribing the self into that dislocated space and the impossibility of re-inventing a narrative and myth (of reclaiming a memory)."[40]

A similar notion of re-inscribing the self into a space that has changed beyond recognition is a struggle that Ozu's characters frequently face in the postwar moment. Noriko's traditional commitments to her widowed father in *Late Spring* results in him being forced to commit a hurtful deception to encourage her to marry and leave him. *Tokyo Twilight* (*Tokyo boshoku*, 1957) follows the traumas of a family in disharmony, unable to find peace within themselves or with each other. The parade of failed marriages and unwanted pregnancies that the film revolves around ultimately flags up the gradual disintegration of the family unit. Although the lead character Takako

decides to give her marriage another attempt, it is for the sake of her daughter rather than any real desire to repair the relationship. Take *Tokyo Story* (*Tokyo monogatari*, 1953). The tension between the rise of the modern moment and the prewar social structures shown results in the alienation of two generations of a family.

This narrative would be seen again in *An Autumn Afternoon* (*Sanma no aji*, 1962), and here the ending becomes even more pertinent. After he has managed to marry off his daughter, the elderly patriarch sits alone musing about the past and the gap that exists between the generations. In his traditional Western wedding suit, he goes into a bar and requests a neat whisky. As he sits, the bartender puts on for him the "Battle Hymn of the Republic," and the men in the bar begin to recite from memory the notification of defeat with a wry humor: "So we lost. Yes we did!" The camera then moves in a series of ellipses from the light in the bar, to Hirayama's tired face, to the sign outside the bar, to the corridor of his house, and finally to the table where his children are seated. As the camera moves back, the children leave, and Hirayama is left alone and drunkenly begins to sing the words of the battleship march. The sense of emptiness and dislocation that the camera provides in the vision of the empty house, from the viewpoint of various corridors and rooms, highlights the feelings of loss that the song and his daughter's marriage have provoked in Hirayama. In the final scene of Hirayama standing alone crying and pouring himself a drink, he is mourning the loss via marriage of his daughter—that much is clear—but the interplay of music and image express a much wider sense of this older generation's loss of their place in society. For Yoshida Kiju, the acting in this scene is "too nonsensical or silly to portray nostalgia for the war,"[41] yet, combined with the visual elements, it is hard not to read pathos into the interplay between the loss of a daughter and the loss of, if not empire per se, a previous sense of collectivity and togetherness. There remains an attachment to this imperial past that continues to impact the present.

Lauren Berlant's approach to affect is relevant here: she states that "cruel optimism is the condition of *maintaining* an attachment to a problematic object,"[42] and the cruel optimism of the postwar period is perhaps the inability to move beyond its structures in a truly meaningful way. The aesthetics of the cinematic movement is caught in the process. Throughout Denis's *Beau Travail*, we see the group of Foreign Legion soldiers enact their training on the landscape, unable to return to the past of the colonial glory of France, and yet unable to find a place in the postcolonial present. Optimism persists, even if cruel and unyielding, since the loss of the objects' promise carries the possibility of total destabilization.[43] The Foreign Legionnaires remain attached to their routines, their songs, their uniforms, and their camaraderie. This affective response is perhaps at the heart of a notion of a postcolonial aesthetic. Berlant points to a way out of this synchronous pattern in the ability to

recognize and be open to disruptive encounters. Although in Berlant's world this does not allow alternative schemes of attachment to develop and presents a way out of this cruel optimism, the moment of disruption is perhaps more powerful than she allows. Disruption is ultimately a way of generating knowledge as we can perhaps see "productive tensions arising from incommensurate differences rather than deceptive reconciliation."[44]

In a similar way, the disruptive moment of the act of prostitution in *Hen in the Wind* becomes the catalyst for a familial crisis that will eventually be resolved with both parties being forced to consider their actions and the social events that surround and constrain them. The closing scenes in the film, although offering a moment of narrative's reconciliation, also visually continue a narrative of disruption. We see the couple embrace in their home and the woman's hands tightly clasped in a prayer position behind her husband's back with her fingers intertwined. The film then cuts to the gas station with the levels raised to near full; as the camera moves away from this station, we cut to the children playing in the street, followed by another cut to people walking toward the gas station, which is empty this time (see figs. 12.1, 12.2 and 12.3).

This empty gas tank and the ending of the film, not focusing on main couple but on a desolate street where the citizens are only just visible beside the large empty structure, raises a sense of unease and confusion as the seemingly happy family reconciliation is undermined in the fractured and inconclusive ending.

The disruption presented at the ending of *Hen in the Wind* is constant throughout the films of both Ozu and Denis. Following Nietszche's Zarathustra, who points out that the greatest events are not always the noisiest but sometimes the quietest moments,[45] the work of Ozu focuses on the minutia of day-to-day life in expounding wider events. A process of aesthetic remembrance is formed via focusing on the minutia of daily life. In short, "it rests on the place for the sensate life on individual experience within the broad sweep of categories as the incommensurate and unknown that art yet seeks to imitate."[46] In *Tokyo Story*, the shrine of Shukichi and Tomi's deceased son, Shoji, is clearly prominent in the home of their daughter-in-law, Noriko, and this physical remembrance acts inside the film as a symbol for the loss that the family has undergone and has yet to endure. As Tomi comments when she goes to stay with Noriko, "I did not expect to sleep on the futon of my son," and this sentimental statement can perhaps be read as Tomi's own sense of mortality and imminent death. The framing of subsequent scenes further enhances this sentiment, such as the scene where Tomi sits underneath her son's portrait as Noriko hands her the small allowance. Tomi then moves to stare directly at her son's picture.

Memory continues to be a constant motif in Ozu's work, and of course it can be read in a variety of ways, and not just as related to the postcolonial. Yet, as it relates to aesthetics, the process of memory and more specifically memory as a

Figures 12.1, 12.2, 12.3.
The images offer a sense of fracture beyond the narrative reconciliation in *A Hen in the Wind*
(*Kaze no naka no mendori*, Ozu Yasujiro, 1948).

Figure 12.4.
Tomi stares at her deceased son's image in *Tokyo Story* (*Tokyo monogatari*, Ozu Yasujiro, 1953).

site of rupture and return is present in both the work of Denis and Ozu and can be seen as a marker of an engagement in the postcolonial moment (although not exclusively, since, as previously stated, the aim is not to engage in discussion of genre but rather of possibility). This constant process of return and rupture engaged the viewing in a process of affective response to the images on the screen. As Janet Wilson states in *Rerouting the Postcolonial*, affect signals the turning "from identity politics to subjectivity itself."[47] Affect is about placing the body at the center of discourse, since affect *proceeds* from the body and *in-betweenness* of bodily interaction.[48] Thus, in *Tokyo Story* we see the living memory of the dead husband/son as the affective linkage not only between Noriko and Tomi but also between the postwar and the imperial period (see fig. 12.4).

This *in-betweenness* of action is a key point of reference in two closely interlinked films: Ozu's *Late Spring* and Denis's homage to this film, *35 Shots of Rum* (*35 Rhums*, 2008). The narratives of the films are quite comparable: a close and loving father-daughter relationship (Professor Somiya/Noriko and Lionel/Josephine) is forever altered when the father realizes that he needs to allow his daughter to embark on a life of her own. By faking his own desire to remarry, he encourages her to take a husband. Where the films differ is that the sense of sadness that is clear at the end of *Late Spring* is given a more positive spin in *35 Shots of Rum*. The famous Noh theatre scene in *Late Spring*, where Noriko

realizes with muted but highly visible sadness that her father plans to remarry, is replaced by a similar exchange of slow looks and emotion crosscut between the two in *35 Shots of Rum* as the main characters retire to a late-night café after the car has broken down.[49] However, rather than the sorrow of Noriko, we have the sexuality of Josephine's developing feelings for the upstairs neighbor, Noe, shown alongside her familial love for her father, Lionel. When taken together with the very different stylistic elements, the films' endings also promote a very different emotional tone. While in *Late Spring* the father sits alone and unhappy as his daughter has entered into an unwilling marriage, in *35 Shots of Rum*, we see a potentially positive move toward change and development. The father's decision to down the titular thirty-five shots of rum is open to debate as an act of celebration or an act of sorrow, but the sense of movement is clear. As the guests dance behind him, rather than the lonely drinking of Professor Somiya accompanied only by Noriko's friend Aya, we see a social situation that allows him to gain comfort from those who support him. As he says, a "moment like this only happens once, so, thirty-five shots of rum." The rum becomes a symbol of the act of unknowing in a similar fashion to the rice cookers that are present throughout the film. At the opening, we see both father and daughter buy a new rice cooker, and once she realizes her father has bought one, the daughter hides hers. At the film's conclusion, we see Lionel unwrap the previously hidden rice cooker and place it side by side with the one already standing on the kitchen counter. The rum and the rice cooker remain floating symbols in that no specific meaning is assigned to them inside the film text but instead operates as an affective site of emotive significance. As Sedgwick comments, "[A]ffects can be, and are, attached to things, people, ideas, sensations, relations, activities, ambitions, institutions, and any number of other things, including other affects. Thus one can be excited by anger, disgusted by shame, or surprised by joy."[50]

Both films focus on the minutia of the father-daughter experience to grant an affective experience that creates a simultaneous sense of the imminent, the past, and the potentially disruptive. In *Late Spring*, the ending shot of Somiya, peeling an apple and bowing his head in sorrow as the camera switches to a sweeping shot of the dark sea, creates a sense of loss that is painful for the viewer to watch. Ozu's skill as a director, like Denis's, lies in the ability to allow the audience to develop an affective relationship to the images on the screen that goes beyond the narrative structures. This affective relationship allows for what Boehmer states is not only a "remapping but also a re-vision": it allows for the postcolonial to be found "not *in* language but rather *of* language."[51]

CONCLUSION

It would be reductive and impossible to posit an exact definition and illustration of a postcolonial aesthetic via the work of two filmmakers. Both aesthetic

and postcolonial are terms that require constant renegotiation and readjustment in their construction, approach, and application. However, seeing the postcolonial aesthetic as situated as an affective part of the film language allows for the debate to open up further in an examination of the interplay between the two terms and their cinematic rendering. In their cinemas of the ultimately unknowable, both Denis and Ozu move beyond dominant representational politics toward a new mode of understanding the colonial past. Whether this is a positive or a negative engagement, whether this is a desire to return to the colonial moment or a need to interrogate the postcolonial space, or simply a nostalgic examination of the past, the works of Denis and Ozu move beyond dominant representational politics toward a new mode of understanding the colonial past and the postcolonial present.

NOTES

1. Ramon H. Myers and Mark R. Peattie, *The Japanese Colonial Empire, 1895–1945* (Princeton NJ: Princeton University Press, 1987), 6.
2. See Robert Davis, "Interview: Claire Denis on *35 Shots of Rum*," *Daily Plastic*, March 10, 2009, accessed September 13, 2015. http://www.dailyplastic.com/2009/03/interview-claire-denis-on-35-shots-of-rum/. Although Denis has articulated how *35 Shots of Rum* was deeply inspired by *Late Spring*, the homage elements of the works are not the main focus of this essay. Therefore I have chosen to focus on films that articulate Denis's more specific engagement with the colonial and postcolonial moment, such as *White Materials* and *Beau Travail*.
3. Immanuel Kant, *The Critique of Judgement*, 2nd rev. ed., trans. J. H. Bernard (London: Macmillan, 1914): xix.
4. Emory Elliot, *Aesthetics in a Multicultural Age* (Oxford: Oxford University Press, 2002), 3.
5. Jerry Farber, "What Is Literature? What Is Art? Integrating Essence and History," *The Journal of Aesthetic Education* 39, no.3 (2005): 2.
6. Alan Goldman, "The Aesthetic," in *The Routledge Companion to Aesthetics*, ed. Berys Gaut and Dominic Mclver Lopes (London: Routledge, 2000), 200.
7. Theodor Adorno, "The Schema of Mass Culture," in *The Culture Industry*, ed. J. M. Bernstein (New York: Routledge, 2004), 63–64.
8. Elleke Boehmer, "A Postcolonial Aesthetic: Repeating upon the Present," in *Rerouting the Postcolonial: New Directions for the New Millennium*, ed. Janet Wilson, Cristina Şandru, and Sarah Lawson Welsh (London: Routledge, 2010), 172.
9. Kaja Silverman, *The Threshold of the Visible World* (London: Routledge, 1996), 37.
10. Silverman, *Threshold*, 4.
11. Silverman, *Threshold*, 186.
12. Inge. E. Boer, *After Orientalism: Critical Entanglements, Productive Looks* (Amsterdam: Rodopi, 2004), 12.
13. Alan Shapiro, *In Praise of the Impure Poetry and the Ethical Imagination: Essays, 1980–1991* (Evanston: Northwestern University Press, 1993), 11.
14. Geoffrey Galt Harpham, "Aesthetics and the Fundamentals of Modernity," in *Aesthetics and Ideology*, ed. George Levine (New Brunswick: Rutgers University Press, 1994), 135.

15. Alexandra Schultheis, *Regenerative Fictions: Postcolonialism, Psychoanalysis and the Nation as Family* (London: Palgrave Macmillian, 2004), 41.

16. Boehmer, *A Postcolonial Aesthetic*, 175.

17. Despite working with these notoriously indefinable terms, what is clear is that an engagement with the debate on the aesthetic and the postcolonial has been rather neglected in the cinema studies. The two recent edited collections examining the postcolonial and cinema both neglect aesthetics as a point worth serious discussion, and yet the film's visual content as opposed to pure narrative is never far from the points being made. See Sandra Ponzanesi and Marguerite Waller, eds., *Postcolonial Cinema Studies* (London: Routledge, 2012); and Rebecca Weaver-Hightower and Peter Hulme, eds., *Postcolonial Film: History, Empire, Resistance* (London: Routledge, 2014).

18. The Japanese Empire was both colonial and imperial in nature. For example, Manchuria was imperial rather than colonial when compared to territories such as Korea and Taiwan.

19. It is worth noting that Ozu's early films were all made under a state of potential censorship: first by Japanese wartime governmental controls and then later by American occupation edicts. The use of aesthetics in both time periods therefore becomes an important area of analysis in periods where narratives are more constrained by external forces.

20. Herbert Marcuse, *Counterrevolution and Revolt* (Boston: Beacon Press, 1972), 81; emphasis in original.

21. Barry M. Katz, "The Liberation of Art and the Art of Liberations: The Aesthetics of Hubert Marcuse," in *The Aesthetics of the Critical Theorists: Studies on Benjamin, Adorno, Marcuse and Habermas*, ed. Ronald Roblin (Lewistown: Edwin Mellen, 1990), 182.

22. Marcuse, *Counterrevolution*, xi, 6.

23. Laura McMahon, *Cinema and Contact: The Withdrawal of Touch in Nancy, Bresson, Duras and Denis* (Oxford: Legenda, 2012), 114.

24. Homi. K Bhabha, *The Location of Culture* (New York: Routledge, 1995), 1–2.

25. Paul Schrader, *Transcendental Style in Film: Ozu, Bresson, Dreyer* (1972; repr., New York: Da Capo Press, 1988); and Noël Burch, *To the Distant Observer: Form and Meaning in Japanese Cinema* (Berkeley: University of California Press, 1979).

26. Donald Richie quoted in Jonathan Rosenbaum, *Building from Ground Zero: A Hen in the Wind*, written for BFI DVD release of the film, accessed September 22, 2014. https://www.jonathanrosenbaum.net/2017/05/building-fron-ground-zero-a-hen-in-the-wind-tk/.

27. Hasumi Shigehiko, *Kantoku Ozu Yasujiro* [Director Ozu Yasujiro] (Tokyo: Chikuma shobo, 1983), 63.

28. Sato Tadao, *Ozu Yasujiro no geijutsu* [The art of Ozu Yasujiro] (Tokyo: Asahi shinbunsha, 1971), 107–113.

29. This is a direct case of mistranslation, as the Japanese title reads *Nagaya shinshi-roku* (perhaps best read as "who's who of the tenements"). However, this is main title the film now goes under in the global market, so I will continue to refer to the film as this.

30. Edward Fowler, "Piss and Run: Or How Ozu Does a Number on SCAP," in *Word and Image in Japanese Cinema*, ed. Carole Cavanaugh and Dennis Washburn (Cambridge: Cambridge University Press, 2001), 278.

31. Fowler, "Piss and Run," 278.

32. For a summary of all the various debates, see Markus Nornes, "The Riddle of the Vase: Ozu Yasujiro's *Late Spring* (1949)," in *Japanese Cinema: Texts and Contexts*, ed. Julian Stringer and Alastair Phillips (New York: Routledge, 2007), 78–89.

33. Martine Beugnet and Jane Sillars, "Beau Travail: Time, Space and Myths of Identity," *Studies in French Cinema* 1, no. 3 (2001): 166–173.

34. Susan Hayward, "Claire Denis's Films and the Post-Colonial Body—with Special Reference to *Beau Travail* (1999)," *Studies in French Cinema* 1, no. 3 (2001): 159–165.

35. Janet Bergstrom, "Opacity in the Films of Claire Denis," in *French Civilisation and Its Discontents*, ed. Tyler Stovall and Georges Van Den Abbeele (Maryland: Lexington Books, 2003), 71.

36. George M. Wilson, *Narrative in Light: Studies in Cinematic Point of View* (Baltimore: Johns Hopkins University Press, 1986), 54.

37. Simone Bignall, *Postcolonial Agency: Critique and Constructivism* (Edinburgh: Edinburgh University Press, 2010), 3.

38. Andrew Hock-soon Ng, *Interrogating Interstices: Gothic Aesthetics in Postcolonial Asian and Asian American Literature* (Oxford: Peter Land, 2007), 12.

39. Michael Sullivan and John T. Lysaker, "Between Impotence and Illusion: Adorno's Art of Theory and Practice," *New German Critique* 57 (Autumn 1992): 87–122.

40. Hayward, *Claire Denis's Films and the Postcolonial Body*, 161.

41. Yoshida Kiju, *Ozu's Anti-Cinema*, trans. Daisuke Miyao and Kyoko Hirano (Ann Arbor: The University of Michigan Press, 2003), 141.

42. Lauren Berlant, *Cruel Optimism* (Durham, NC: Duke University Press, 2008), 33.

43. Ibid.

44. Gulsum Baydar Nalbantoglue and Wong Chong Thai, eds., *Postcolonial Space(s)* (Princeton, NJ: Princeton Architectural Press, 1997), 8.

45. Friedrich Nietzsche, *Thus Spoke Zarathustra*, trans. Graham Parkes (Oxford: Oxford University Press, 2005), 169.

46. Deepika Bahri, *Native Intelligence: Aesthetics, Politics and Postcolonial Literature* (Minneapolis: University of Minnesota Press, 2003), 220.

47. Janet Wilson, Cristina Şandru, and Sarah Lawson Welsh, eds., *Rerouting the Postcolonial: New Directions for the New Millennium* (London: Routledge, 2010), 6.

48. Mike Featherstone, "Body Image and Affect in Consumer Culture," *Body and Society* 16, no. 1 (2010): 193–221.

49. The café sequence also highlights an additional element that is missing from *Late Spring*, the question of ethnicity. The ethnicity of Lionel/Josephine also points toward a postcolonial present founded on movement and flux and elements and the interplay between the minority communities of France (as represented by Lionel/Josephine and their wider group of friends, work colleagues, and acquaintances), and the wider French society is referenced throughout the film.

50. Eve Kosofsky Sedgwick, *Touching Feeling: Affect, Pedagogy, Performativity* (Durham, NC: Duke University Press, 2003), 19.

51. Boehmer, *A Postcolonial Aesthetic*, 170, 180.

CHAPTER 13

Wenders Travels with Ozu

MARK BETZ

It is not news that Wim Wenders is an admirer of the films of Ozu Yasujiro. He dedicated his 1987 film *Wings of Desire (Der Himmel über Berlin)* to three "angels"—two then recently passed, François Truffaut and Andrei Tarkovsky, and the other the long-dead Ozu. Four years earlier, in spring 1983, Wenders had made a pilgrimage to Tokyo to see if he could find Ozu there still: "No other city . . . has ever felt so familiar and so intimate to me, namely through the films of Ozu," he intones on the soundtrack of the by turns banal and meditative, quotidian and epiphanic feature-length documentary that resulted from this travel, *Tokyo-Ga* (1985). Halfway through the film, Wenders finds himself at night in Shinjuku, "a part of Tokyo that's wall-to-wall bars. In Ozu's films there are many such streets, where his lonely and abandoned fathers get drunk. I set up my camera and shot the way I used to; and then I did it again: the same street, from the same place, only using a different focal lens, a 50, which Ozu used for all his work. The result was a completely different scene, one that was no longer mine."[1] For Robert Phillip Kolker and Peter Beicken, Wenders's voice-over evokes a decidedly familial relation between the two filmmakers: the living one speaking here, "orphaned and without place, wanders through yet another culture to find paternal nourishment The son—by the act of changing a lens—becomes the father. Ozu is discovered and revived in an image. And lost again."[2] Just as the Oedipal dimensions of the male-male relationship are alluded to here, a frequent subject in many of Wenders's films—particularly those involving displacement, transit, the journey—so too is the seemingly total absence in these films of Ozu as a clearly identifiable influence.

This is the case not only formally but in practically every other comparative respect as well. Ozu's filmmaking career was limited to Japan and—for many commentators, mistakenly perhaps but also consistently—to one subject: the postwar Japanese family and its dissolution in the face of modernization, its material as well as social effects on the spaces of work, of home, and of those in between.[3] Born and raised in West Germany, Wenders completed film school and made his first shorts and feature films there before embarking on a career that can only be described as peripatetic, restless, and global. For Wenders, like his characters, "What's important is having the right 'attitude,' to be moving. That's their aim: to be on the road. I'm like that myself too; I prefer 'travelling' to 'arriving.'"[4] There is nothing one could point to that might qualify as a thematic or stylistic signature in Wenders's cinema, so wide-ranging are his subjects and his strategies—florid and sweeping camera movements here, classical decoupage there. By contrast, the stasis of style and of lifestyle, each carried by rhythms of filmic shooting and editing and of routinized existence that are quite strictly defined and adhered to, yields in the case of Ozu a life and an oeuvre often noted as singular in its uniformity. As far as their lives and careers, the style and subject matter of their films are concerned, the two seemingly could not be more incommensurate.

And yet Wenders has repeatedly, almost from the point in 1973 when he first saw Ozu's films, stated the importance Ozu holds for him—"The only influence. Or at least the only master" being one of his earliest such pronouncements.[5] Since this first encounter with Ozu and open acknowledgement of his dominion, Wenders critics and scholars have scoured his films for shared tendencies or correspondences, with slim as well as decidedly mixed results. In *Kings of the Road* (*Im Lauf der Zeit*, 1976), Kolker and Beicken consider a point-of-view shot from inside a truck at night to a train passing silently in the distance to be an "homage" to Ozu, whose "films are continually punctuated with shots of natural and man-made objects . . . that counter the lives of his characters with images of stasis and movement, comfort and yearning. They express an ultimate, or promised, or hoped-for tranquility and ongoingness that the characters within the narrative may themselves be unaware of."[6] The connection here is tenuous: the Wenders shot is not an insert or cutaway proper as it is in Ozu, though it does have some of the quality or spirit of an Ozu "pillow shot"—something I will return to later. Kathe Geist, who researched and published work on both directors in the 1980s, separately as well as together, maintains that

Wenders' kinship with Ozu rests on several levels. First they share an interest in representation instead of plot and in achieving realism and characterization through such devices as real time, non-narrative use of objects, and gesture. Second, they both struggle to create a personal cinema out of an essentially American film language. Finally, Wenders' sensitivity to aesthetic principles is very close to Zen-derived principles that inform Ozu's art.[7]

Without even taking on that final characteristic, which has been more famously proffered by others as concerns the director's "Japaneseness" (e.g., Paul Schrader), especially pertaining to Zen Buddhism and now quite thoroughly refuted (most comprehensively by Mitsuhiro Yoshimoto), and bearing in mind that I have just quoted Geist's concluding remarks and so omitted her examples, it must be said that these features can apply to countless filmmakers, so general are they in principle.[8] In a later work Geist notes the long sequence in *Tokyo-Ga* set in a wax food factory as showing "Wenders' interest in the quotidien [sic], not poeticized but just as it is," and this too "links him to Ozu."[9] This is not a complete accounting; but vague connections like these tend to be the rule of thumb on the Ozu-Wenders question.

To be fair, most of these putative echoes have been put forward by Wenders himself when pressed for details regarding the imprints Ozu has left on his own work. Another example, when asked why there are so many trains in his films: "Ozu has trains in almost all his films too."[10] One cannot really doubt Wenders's devotion, or his exegetes' either, as regards Ozu's presiding influence. But when put to the test, the links heretofore advanced must be regarded at best as slight, fleeting, occasional—all that is solid melts into air. Alexander Graf notes how even though Wenders made two film diaries in the 1980s researching life in Tokyo (*Notebook on Cities and Clothes*, released in 1989, is a similarly ruminative portrait of another Japanese male artist, in this case the fashion designer Yohji Yamamoto), "this culture does not seem to have influenced his work either formally or thematically to the same extent as American culture, which informs every film he has made."[11] The characterization of Wenders as in some manner a filmmaker indebted to Ozu is at the same time, then, neither new nor really proven yet in any satisfying sense.[12] Why bother, then? Because I think that debt *is* there, still outstanding—and it is time to make good on it.

In this chapter I take on the role of guarantor through recourse not to the documentaries above but instead through analyses of four feature films by both directors: two for Ozu, *Late Spring* (*Banshun*, 1949) and *Equinox Flower* (*Higanbana*, 1958); and two for Wenders, *Paris, Texas* (1984), and *Wings of Desire*. The formal correspondences among these four films may seem at first glance few and far between, but they are there. And they manifest themselves in a shared strategy of repeating, doubling, or twinning—of geographies or locales or spaces, of speeches and declarations and admonitions, and of character roles and responsibilities—which I think is significant insofar as it impacts the family at the center of the Ozu text. Indeed, one finds in certain of Wenders's films an appropriation and redistribution of a structuring familial tension, perhaps even a reversal of its terms, that highlights how human qualities and acts concerning self-actualization on the one hand and self-sacrifice on the other embeds itself in both filmmakers' work. Examining Wenders's borrowings and conversions can illuminate otherwise hidden corners for both

as well as a reflective form of cross-cultural analysis that extends to the levels of structure and dramaturgy—as repetition, recurrence—the kinds of formal codes and stylistic signatures that usually serve as the basis for determining generational influence and quotation.

TWO MONOLOGUES, TWO PATHS

Something Wenders stated in interview nearly forty years ago has been instructive for me:

Ozu has families. But he isn't dealing with anything else. And I could really accept these Ozu families, I've always accepted the way they worked. In a way, they are very traditional families. But I never had the feeling in an Ozu film that the structure of these families was repressive, or suppressive of the individuals [I]n Ozu's films, because they all deal with the disintegration of the family, everybody is able to breathe. It's all falling apart, and there's a feeling of responsibility, but nevertheless everybody is something in their own right.[13]

This flies against much of the criticism and interpretation of Ozu's representations of the postwar Japanese family underway at the time of Wenders's utterance here, and extending at least two decades hence, in its foregrounding of family members as part of a system that is traditional and as individuals in their own rights at the same time, particularly the generational problems and conflicts this engenders for postwar fathers and their unmarried daughters.

The most important repetition Wenders lifts from Ozu in this regard is from *Late Spring*, what might be called the double climactic monologue, in which a father and daughter express, in separate speeches at two different locations, their love and gratitude to each other before the daughter is to marry and depart permanently from the family home and her father's life. This double ending finds its way into the two Wenders films of the 1980s on which I will soon concentrate, though the daughter-father relation is reconfigured as a May-December romantic one—and, in the case of *Wings of Desire*, marks the beginning rather than ending of an intimate relationship. This reconfiguration is for me key to understanding how Wenders appropriates, at a structural and characterological level, father-daughter filial love as developed by Ozu in certain of his own films, prefigured in some respects in *Alice in the Cities* (*Alice in den Städten*, 1974), the screenplay for which Wenders was working on in 1973 when he first encountered the films of Ozu, but only reaching fruition a decade later in a phase of his career in which Ozu and "Japaneseness" were at the forefront of his thinking. The Wenders films under consideration here have been discussed as road movies and as Oedipal narratives by others.[14] But

a different consideration of these, of a conception of the father-daughter dyad so central to Ozu's postwar oeuvre, has gone unnoticed. And what this might mean for an understanding of a "traveling" film practice like that of Wenders, and in particular its taking of this structural feature of Ozu on the road in an era of international filmmaking, yields modest dividends as well.

Geist among others has noted a shift toward limitation and concentration of style, theme, and setting in Ozu's films that begins with *Late Spring*:

From 1949 on, Ozu's films were dominated by the style and narrative format with which he is most readily identified The quiescent camera and cutting technique is reflected by narratives in which Ozu avoided drama, whose stories generally involve marriage and/or death, and whose plots take over a fairly unified time period and in locales that are frequently predictable from film to film: the upper-middle-class house, the lower-middle-class apartment, the restaurant, the bar, the office, the train station, the temple, the scenic pilgrimage spot.[15]

The two main habitations in *Late Spring* comprise the upper-middle-class house in Kitakamakura on the outskirts of Tokyo occupied by the aging widower Somiya Shukichi and his only daughter, twenty-seven-year-old Noriko, and an inn in Kyoto in which they stay near the end of the film during one last holiday together, as she has agreed to an arranged marriage that is now imminent. There are other notable locations in the film as well, including several in Tokyo (where both father and daughter as well as friends work), a beachside bike ride early on, and a Noh play at midpoint, but the Kitakamakura house and the Kyoto inn are given greater weight, marked by the frequency of inclusion of the first and the narrative placement of the second. These two abodes feature in the double climactic monologue to which I now turn.

The length of Noriko and Shukichi's Kyoto sojourn is just two days, as three scenes depict them in their room at the inn, one in the morning after the overnight train ride there, and then two consecutive evenings. During the last of these, they both sit on the floor and pack for the trip home, chatting about the enjoyment they have derived from the trip. Shukichi brings up Noriko's coming married life and predicts a doting husband, then notices her silence and asks what is the matter. Noriko imparts how she wants them to stay as they are, how happy she is living with and taking care of him (it is in fact her "greatest happiness"), and asks, with characteristic though muted smiles and respectfulness undergirded by now tentative firmness and resolve, why they cannot stay just as they are. The admonishment delivered by Shukichi in response, which is two minutes and ten seconds long and comprises twenty-one shots (the majority of which are shot-reverse shots, direct address for him), takes in the new life she must embrace and build with her husband, the sadness that will give way to happiness as the work of their marriage will bear

fruit, how he will have no part in this next phase, and how "that's the order of human life and history." For two more minutes, there is some back and forth between daughter and father, with her begging forgiveness for being selfish and worrying him, his repeating (as if to convince them both) that she will be happy, that he is sure she will. Music in a minor key closes this climactic six-minute scene, replete with the finality of Noriko's agreement to marry and portent for their future as forever separate.

But there is a second climax still to come, two scenes and fewer than two minutes later. Shukichi and his sister Taguchi Masa, who like her brother is also on the side of tradition and an equal party in tricking Noriko into the arranged marriage via a ruse that he is going to remarry, join the bride in her upstairs chamber at the Somiya house as she makes the final adjustments to her livery and preparations for the wedding. Father and aunt sit on the floor, admiring a resplendent Noriko seated before her dressing table. A teary Masa asks Shukichi if he has anything more to say to his daughter; he replies no, she rises and adjusts the bridal kimono and then picks up two items of luggage and moves to go before noticing that Noriko has herself risen and taken a couple of steps before her now-standing father before kneeling in front of him, head bowing. As her father squats down, Noriko begins a short speech of thanks, the two-shot composition initially favoring her in the center and him to the right, then moving once more to shot-reverse shot:

NORIKO: Father [looks him in the eye]. For your loving care these many
 years . . . I thank you [deep bow].
SHUKICHI: Be happy, and be a good wife. [She nods.] Be happy. [Nod.]
 You'll be a good wife, won't you?
NORIKO: Yes [bows].
SHUKICHI: Now, shall we go?

This brief exchange, precipitated by Noriko's heartfelt acknowledgment of their loving relation, is only one minute long, but its impact is no less devastating than the one on their last night in Kyoto.

These two scenes, and the speeches at their cores, his in the first in their room at the Kyoto inn and hers in the second at the Shukichi residence in Kitakamakura, together constitute the emotional and narratival climaxes of the film, and they mark, in a tremendously forthright fashion, the end of the father-daughter relation properly speaking. Both characters are here making a sacrifice for the other, with uncertain consequences for Noriko (will she find love in her arranged marriage, one that might compare with the bond being severed here?) and a certain one for the widowed father—crushing loneliness, which the final two shots of the film emblematize in a way that will be repeated by Ozu and reworked by Wenders (as we will soon see).

Critics are divided on the meaning of Shukichi's and Noriko's motivations and decisions (if not their aftermaths). Robin Wood represents one faction when he writes that *Late Spring* "is about the sacrifice of Noriko's happiness in the interest of maintaining and continuing 'tradition,' but the sacrifice takes the form of her marriage, and everyone in the film—including the father and finally the defeated Noriko herself—is complicit in it."[16] Wood's reading of the film is that it "ends on a note of unqualified tragedy," owing to what he reads as its radical point: "that the institution of marriage itself, as traditionally practiced . . . functions as a means of subordinating and imprisoning the woman, her identity now socially inscribed as 'wife.' Freedom is a thing of the past."[17] Kristin Thompson takes an opposite view, understanding the main point as being that

the father, apparently so traditional in the eyes of Western viewers, actually represents the new notions of marriage and the family. He reinforces Noriko's ideal of love in marriage. Far from appealing to her sense of duty and telling her to go out and have children . . . he tells her to work at forming a good marriage so that eventually she will find happiness Thus her father has to push her into the new idea of marriage . . . and a move into a smaller, nuclear family.[18]

Geist plows a middle ground between these two positions. On the one hand she marks as "lamentable" the fact that Hattori Shoichi, Shukichi's assistant, is shown in several ways in the film to be the "right man" for Noriko, and that "he and Noriko miss each other because of the rigidity of Japanese marriage customs."[19] On the other she more generally notes how exclusive concern for Ozu in his late films is the marrying of young women, and that this narrative fixation exemplifies the director's view of marriage as part of the cycle of life: when they marry, women leave home and, "traditionally, are no longer part of the natal family. Consequently a daughter's marriage is far more disruptive to a family and demarcates more clearly the phases in the life cycle."[20] That said, she also asserts that *Late Spring*'s "central emotional tension arises from Noriko's oedipal feelings for her father. The purity of these characters precludes any suggestion of incest, but oedipal psychology is straightforwardly described by Sobiya [sic] at the end of the film when he tells Noriko she must transfer her love for him to a new man because that is how life goes on."[21]

Enter Wenders, albeit at no small remove both temporally and otherwise. For it would not be until the production and release of *Paris, Texas* in 1984, a year after his pilgrimage to Tokyo to see if he could still find Ozu there, that certain features of the Japanese director's work could be seen to have seeped into the German one's work, and at a critical point in his career following failure in Hollywood (*Hammett*, 1982) and a self-pitying and self-defeating metafilm (*The State of Things* [*Der Stand der Dinge*, 1982]) replete

with an existential despair not seen since some of the grimmer 1970s films. As in those films, the central character is a man, though a notably older one (no longer roughly the same age as the director): Travis Henderson opens the film a mute shell of a person who collapses while wandering the scrubland of the American Southeast and by degrees is drawn back into vocal being and the familial fold by his kind and patient brother Walt and his wife Anne, who have also been caring for Travis's young son Hunter, abandoned as a toddler on their Los Angeles doorstep some four years earlier by his mother, Travis's much younger wife Jane, who nonetheless sends money monthly by wire. As Stuart C. Aitken and Christopher Lee Lukinbeal see it,

Wenders's *Paris, Texas* revolves around the hopelessness of a middle-aged American nomad's search for self and family in a landscape of unreflexive icons. Paris is a "real" place in Texas toward which Travis journeys, but he never arrives. It is simultaneously a nostalgic search for his past, a forward-looking embodiment of reckless frontier spirit and a need for the security of his nuclear family Travis is searching for his Oedipal origins. Early on in the movie we learn that Paris is where Travis's parents met and where he was conceived. We learn also that, when he and his wife Jane were still together with their young child Hunter, Travis bought a "piece of dirt" in Paris that he hoped would eventually become their home. *Paris, Texas* is about the impossibility of the nuclear family and the sedentary male in place and taking responsibility.[22]

The first half of this passage rings true for me, but the second does not. The emphasis on the Oedipal dimensions of the film's story obfuscates other kinds of relations its unpromising scenario opens for the assumption of parental accountability taken on by degrees by Travis and the potential for a familial reconstitution it engenders. Whereas in Ozu the breakup of the family via the marriage of the daughter is the driving force of the narrative as well as its culmination, here in Wenders the breakup of the family precedes the events of the film's plot; it is backstory, and the family is actually reconstituted through the self-sacrifice of the father, not extended, perpetuated in an extrapolated and abstracted fashion as part of a "life cycle" into the next generation as Geist argues it is in Ozu. At least not until the end of the film.

The two main locations in *Paris, Texas* are Los Angeles and Houston, with much travel in between as Travis regains his self and his paternal role and embarks with Hunter on a road trip to find Jane. Casing the drive-through bank in Houston on the day of her monthly drop, they identify and follow her to her work place, a peep-booth hotel called the Keyhole Club. As Hunter remains in the car Travis enters the building, and after a false start with another young blonde woman finds himself before his estranged wife in a set-like hotel room through a two-way mirror. Travis is hidden from view and seated in a darkened booth with a telephone through which he can talk with her via the speakerphone on her side of the barrier. But on this first visit,

upon seeing Jane through the glass and her engaging him light-heartedly as a customer at first and then as a confidante ("Do you mind if I sit down? . . . Is there somethin', I don't know, is there something I can do for ya? . . . Is there something you want to tell me?"), he tears up and cannot bring himself to say much of anything apart from some loaded queries about her occupation delivered in a manner of agitated superiority. It is a seven and a half minute scene of failed communication, frustrating in its absolute nonconnection.

But that is not the end of it by any stretch. On the son's quietly firm instructions the next morning following a drunken evening at a roadside saloon, Travis returns the next day. It is here and now that the double climactic monologue as found in *Late Spring* is repeated but delivered in one long sitting as first Travis and then Jane relate the story of their courtship and marriage and the increasingly violent jealousy that grips him, destroying their union. Travis's speech (ten and a half minutes long) is an inversion of Shukichi's in that it narrates an unhappy marriage, one characterized by emotional immaturity and possessiveness rather than the kind of mutual understanding and work required to make a good and loving marriage that the Japanese father describes. Jane's monologue differs considerably from Noriko's as well, not least because of its length—though she is given by the film only a third as much time and space to develop her side of the story as he is—but also because it is something she must plead for, to be heard after being informed by Travis with some finality that Hunter is waiting for her at the Meridien Hotel, room 1520. But this obverse situation does precipitate a similar posture for her as for Noriko as she begins her speech, kneeling in front of the man, old enough to be her father, before her. Although there are other differences between these monologues and their staging and circumstances and those from *Late Spring*, the tonal similarities are palpable. What I would emphasize as key here is the outcome—the imminent and complete separation of the older man and the younger woman, refigured as May-December former husband and wife. In confessing, through his monologue, his own woefully inadequate, selfish, and irresponsible handling of his younger female charge, Travis here achieves a paternal status through a sacrifice toward which he has been working in the film's second half. In orchestrating a reunion between mother and son high up at night in a hotel room as he looks on alone from the empty parking lot below, Travis reconstitutes a previously dissolved male-female dyad with the son as the father's replacement; he, like Shukichi, is the now forever-excluded figure from the equation.

The Ozu-Wenders correspondences and reworkings do not begin and end with the climactic double monologue, though this is the most striking and generative. Geist notes how in Ozu many "of the later films include symmetrical bar scenes that recall those from other films The placement of the bar scenes in *Late Spring* near the beginning and end of the film points up another aspect of Ozu's use of repetition."[23] The bookending bar scenes

in *Late Spring*, ones in which older men discuss matters of love and marriage with younger women (who are not their daughters), are repeated and given even greater emphasis in *Equinox Flower*, the other postwar Ozu film in which the relation between father and daughter—and its necessary rupture through the marriage of the latter—is the central focus and center around which the various machinations and developments exfoliate. Like the climactic double monologue, this trope too undergoes revision by Wenders in *Paris, Texas*, compressed at the film's climax as the two visits Travis makes to the Keyhole Club, initially to confront and then to confess to Jane—for this space is not a true one of shelter or homely comfort but, like a bar, one of transient companionship.

The repeated bar scene finds its way even more notably into Wenders's next fictional feature, *Wings of Desire*, through two scenes (the latter the climactic one, complete with monologue) set in two West Berlin rock clubs featuring performances by the Australian bands Crime & the City Solution in the first instance and Nick Cave & the Bad Seeds in the second. Though they do not function as frames as they do in Ozu, these two scenes are separated temporally as they are in Ozu as well as dimensionally, given the Wenders film's unusual diegetic world constituted of two regimes of being, that of the angels witnessing and recording the travails and hopes of human life and that of the earthbound beings whose limitations for hearing and knowing another (in a direct way as the angels can) are countered by their physicality, which grounds them in a material existence unknowable to the immortals who stand invisible (though still sensate) beside them, listening while they are living.

The angels' existence is a wondrous detachment that one, Damiel, determines to break by taking the plunge into mortality, risk, sensation, and physical love, the forsaking of the sureties of a black and white world for the warp and woof of a color one. The twinning of key locales in *Late Spring* and *Paris, Texas* is here doubled: the close proximity of East Berlin and West Berlin, with their arbitrary but grimly impregnable dividing wall, a political barrier; and its counter, the fundamental gulf between sky and earth, *Der Himmel über Berlin*, a barrier of being. It is a young woman, a trapeze artist and circus performer named Marion (played by Solveig Dommartin, Wenders's new lover), and the possibility of physical love she presents, who provokes Damiel's leap into the void, his "taking the plunge." This decisive action is prefigured in the first rock club scene, four minutes in length and at the film's two-thirds mark, during which Marion responds to the pulsing rhythms of the music as a fully physical being and Damiel watches on, raptly, clutching his heart. And the plunge proves worth the gamble, as far as this particular love match is concerned, in the Esplanada, the second rock club that provides the setting for the film's climax. Damiel enters the space on his own, prompted by a wheat-pasted poster he comes across during one of his wanderings. Marion is already there, though they do not see one another at first; she moves again to the music but with less

abandon, seems distracted from the performers on the stage by the presence of another (the Noh play scene of *Late Spring* another teasing reference and recapitulation). Soon after the band has launched into a new number, Damiel makes his way from the main hall into the adjacent bar, hops onto a stool at the counter, and orders something from the bartender. Not long after, Marion (and the camera, from her point of view) moves into the same space and, spying the now embodied and middle-aged Damiel at the bar, makes her approach and stands to his right. He stands, faces her, and offers his goblet of white wine to her wordlessly and ceremoniously. She drinks, he puts the glass on the counter and leans forward, at which point she places her hand on his chest to signal that it is not quite time yet and then launches into a long monologue, again the first of two—his, half the length of hers, follows the next morning as inner speech, after their first evening together and his first experience of carnal intimacy and in the main hall of the Esplanade, she above practicing acrobatics and he below, steadying the rope for her.

Her speech is one that swings from the particular to the universal, from their individual story to the eternal cycle of human history, and as such it is a reinvention of Shukichi's in the Kyoto inn scene, the younger woman now delivering the encomium to the older man. For the first three minutes of this scene Damiel and Marion are in a two-shot, at which point it switches to a remarkable forty-five-second close-up of her in direct address and then a short three-second shot of him grinning sheepishly. The two-shot then resumes for a further minute and a half, culminating in her identification of him as her man and their kissing before a fade to black. The direct address of her (and his) looks in this scene short-circuit the diegetic armature that could rationalize its use in *Paris, Texas*, the two-way mirror of the Keyhole Club rooms allowing for the male speaker-viewer not to be seen by the working girl staring right at him. As iterated in *Wings of Desire*, it is Ozu point-glance staging and cutting at its most unmediated and direct—with the initiator now the young woman and not the older man, who is likewise marked in other ways in the film as in fact more a child figure than a paternal one (that role is arguably assumed by a predecessor fallen angel, now a film star, played by Peter Falk). *Wings of Desire* thus retains certain of Ozu's key doublings and transforms them into something more radically different than as reworked in *Paris, Texas*. The female-male relationship is now not only a fully fledged romantic one but also one at its beginning as opposed to its end.

JOURNEY'S END

Wings of Desire concludes with a bona fide happy ending. Yet there is sacrifice here, too, not on the part of a character but rather of the gravitas that proceeds from the recognition of the timeless passing of the baton from one

generation to another, regardless of the circumstances—of one's time now done, another's just starting. The bliss that is spoken by the male-female romantic couple figured at the end of *Wings of Desire* distinguishes it from the Ozu template, and in this regard *Paris, Texas* is for me the more complete of the Wenders reworkings, and not the least for its incorporation of the ending of *Equinox Flower* into its own. *Equinox Flower* features Ozu's most intransigent father, Hirayama Wataru, one bent on making his daughter Setsuko accede to the demands of tradition and accept an arranged marriage rather than the love match she has chosen for herself and is determined to see through. Given his initial position, this Ozu father has the most to lose, and he does, largely through the collusion of many women (including his own wife), clearly marked as being on the right side, behind the scenes to turn paternal refusal into favor. Another marriage plot, another intense father-daughter relation, another final-act wedding that takes place off-screen. Robin Wood succinctly notes how this "film's climax comes when Mrs. Hirayama, over the telephone, finally extracts from her husband . . . the promise to visit their daughter and the man she has married The film ends with Hirayama, on the train en route to visit Setsuko and her chosen husband, humming to himself the patriotic song of defeat" that one his contemporaries in a previous key scene had sung at a men-only "Old Boys Reunion" that celebrated the Emperor's birthday.[24] In the penultimate shot he wears a smile of defeated contentment as he sits and hums in the carriage, the final shot an exterior of the train carrying round a bend and disappearing into the distance on screen right. Two nearly identical shots end *Paris, Texas*, first of a moist-eyed Travis from behind and to the left as he drives into the night, his mission of reunion accomplished, then of an exterior of him in his car in the middle distance heading down the highway destination unknown, the strains of the plaintive Ry Cooder slide guitar filling the soundtrack—another father in transit, in this instance moving away from rather than toward those he loves, but no less contentedly.

I close with two final Wenders films, one just aft and the other considerably fore of the two consecutive fiction features from the middle 1980s that I have argued here reconfigure Ozu's exploration of the father-daughter relation in certain of his marriage films. The first is *Until the End of the World* (*Bis ans Ende der Welt*, 1991), a globe-trotting love story in which a male adventurer is motivated by the desire to find a way to restore the sight of his blind mother, a packed Oedipal scenario that veers distinctly and permanently away from his previous two (and Ozuesque) works yet contains his most explicit Ozu reference: the appropriation of the Shinjuku street shot from *Tokyo-Ga* as well as and more notably Ryu Chishu, a regular in the Japanese director's troupe of actors and the one who unforgettably plays the father in *Late Spring*, as Mr. Mori, a man with opthamological training who nonetheless concedes he can do nothing in this case. It is a tribute, a gesture, but nothing more—it leads nowhere that I can see. The second is *Alice in the Cities*, a film that centers on

a German man, Philip Winter, who in the film's opening scenes is revealed to be a magazine photographer and a lost soul in America. Alone in a foreign and empty landscape, Philip readies to leave for his homeland and is entrusted with a woman's daughter to take back to Europe and eventually to place her back into the family structure by finding her grandmother in Munich. Kolker and Beicken note how the "the ironies of the exiled man turned into maternal figure to a little girl, the persistent movement along the roads of the western part of Germany, diffuse the ordinariness of the narrative, as does the barely stated sexual tension between the young man and the little girl."[25] And John Sandford points out that the film, "like so much of Wenders' work, is the story of people on a quest, but here, for once, the quest has a clear ostensible goal in the shape of Alice's elusive grandmother. Nonetheless, it is clear that Philip Winter is at the same time another of those Wenders heroes whose life is made up of a much more indeterminate and much more fundamental quest, to put it in its most hackneyed formulation (and one that Wenders himself uses), for identity."[26]

The character of Alice functions in this film much the same way that Hunter does in *Paris, Texas*, as a means to giving the adult male "a story . . . a direction . . . a new role . . . a purpose" that relieves him of "his obsessive introspection," and so he is "in effect, put into a state of grace by the child, who offers him redemption."[27] Winter assumes the role of a substitute parent, and learns through Alice how to escape from the prison of the self through the primary care of another, a child. At the end of the film Alice and Winter are on a train heading for the now-found grandmother's house and familial reunion. Alice asks, "What will you do in Munich?" to which Winter replies, "Finish this story." The camera then "pulls back from the train, which is now passing through the Rhine Gorge, rises in exultant release high in the air, and pans across the open fields of the plateau above."[28] It would take another decade before this first incipient and inexact Ozu quotation, accomplished as it is in one shot rather than the two that close *Late Spring* and *Equinox Flower*, would blossom in a much more developed and organic way in Wenders's two most celebrated mid-career films, the ones that have been the focus of my analysis. But the sense of triumph through redemption and sacrifice that characterizes the ending of *Paris, Texas* especially is palpable here too, and it is that sense that may via this detour through Wenders find its way back to Ozu's endings too, a transformation of defeat into victory, loneliness into connectedness.

NOTES

1. Wim Wenders, *"Tokyo-Ga,"* in *The Logic of Images: Essays and Conversations*, trans. Michael Hofmann (London: Faber and Faber, 1991), 63.

2. Robert Phillip Kolker and Peter Beicken, *The Films of Wim Wenders: Cinema as Vision and Desire* (Cambridge: Cambridge University Press, 1993), 89.

3. Donald Richie set the terms for this line of interpretation in his book-length study of the director, *Ozu* (Berkeley: University of California Press, 1974).

4. Wim Wenders, "Film Thieves," in *The Logic of Images*, 36.

5. As quoted in an interview with Jan Dawson, in *Wim Wenders*, trans. Carla Wartenberg (New York: Zoetrope, 1976), 8.

6. Kolker and Beicken, *The Films of Wim Wenders*, 69.

7. Kathe Geist, "West Looks East: The Influence of Yasujiro Ozu on Wim Wenders and Peter Handke," *Art Journal* 43, no. 3 (Fall 1983): 237.

8. Paul Schrader, *Transcendental Style in Film: Ozu, Bresson, Dreyer* (Berkeley: University of California Press, 1972); Mitsuhiro Yoshimoto, "Japanese Cinema in Search of a Discipline," in *Kurosawa: Film Studies and Japanese Cinema* (Durham, NC: Duke University Press, 2000), 7–49. Other examples include Robert Boyers, "Secular Vision, Transcendental Style: The Art of Yasujiro Ozu," in *After the Avant-Garde: Essays on Art and Culture* (University Park: Pennsylvania State University Press, 1988); Kathe Geist, "Buddhism in *Tokyo Story*," in *Ozu's "Tokyo Story*," ed. David Desser (Cambridge: Cambridge University Press, 1997), 101–117.

9. Kathe Geist, *The Cinema of Wim Wenders: From Paris, France to Paris, Texas* (Ann Arbor: UMI Research Press, 1988), 109.

10. Wenders, "Film Thieves," 35.

11. Alexander Graf, *The Cinema of Wim Wenders: The Celluloid Highway* (London: Wallflower Press, 2002), 13.

12. Geist herself pretty much gives up the game when she admits that "although some direct influence is observable in *Alice in the Cities*, which Wenders was writing when he first saw Ozu's films . . . Ozu functioned for Wenders as the best teachers should: he encouraged his pupil's own vision." Geist, *The Cinema of Wim Wenders*, 28. That "direct influence" is clarified in an earlier publication as "a musical score [that] consists primarily of a pentatonic guitar motif that sounds like music from a Japanese *koto* or *samisen*." Geist, "West Looks East," 236.

13. As quoted in an interview with Jan Dawson, in *Wim Wenders*, 10.

14. See, for example, Mark Luprecht, "Freud at Paris, Texas: Penetrating the Oedipal Sub-Text," *Literature-Film Quarterly* 20, no. 2 (April 1992): 115–120; Gerd Gemünden, "The Oedi-Pal cinema of Wim Wenders," in *Framed Visions: Popular Culture, Americanization, and the Contemporary German and Austrian Imagination* (Ann Arbor: University of Michigan Press, 1998), 158–176.

15. Kathe Geist, "Narrative Strategies in Ozu's Late Films," in *Reframing Japanese Cinema: Authorship, Genre, History*, ed. Arthur Nolletti Jr. and David Desser (Bloomington: Indiana University Press, 1992), 100.

16. Robin Wood, "Resistance to Definition: Ozu's 'Noriko' Trilogy," in *Sexual Politics and Narrative Film: Hollywood and Beyond* (New York: Columbia, 1998), 116.

17. Wood, "Resistance to Definition: Ozu's 'Noriko' Trilogy," 122, 119.

18. Kristin Thompson, "*Late Spring* and Ozu's Unreasonable Style," in *Breaking the Glass Armour: Neoformalist Film Analysis* (Princeton, NJ: Princeton University Press, 1988), 321.

19. Geist, "Narrative Strategies in Ozu's Late Films," 101–102.

20. Kathe Geist, "The Role of Marriage in the Films of Yasujiro Ozu," *East-West Film Journal* 4, no. 1 (December 1989): 50.

21. Geist, "Narrative Strategies in Ozu's Late Films," 100.

22. Stuart C. Aitken and Christopher Lee Lukinbeal, "Disassociated Masculinities and Geographies of the Road," in *The Road Movie Book*, ed. Steven Cohan and Ina Rae Hark (New York: Routledge, 1997), 361.
23. Geist, "West Looks East," 235.
24. Wood, "Resistance to Definition: Ozu's 'Noriko' Trilogy," 138.
25. Kolker and Beicken, *The Films of Wim Wenders*, 51.
26. John Sandford, *The New German Cinema* (New York: Da Capo Press, 1980), 107.
27. Kolker and Beicken, *The Films of Wim Wenders*, 52.
28. Sandford, *The New German Cinema*, 107.

Look? Optical/Sound Situations and Interpretation

Ozu—(Deleuze)—Kiarostami

DAVID DEAMER

Sleep haunts *Five* (Abbas Kiarostami, 2003). I am pretty sure I have never seen the film through, in one go. Never in one go. I always seem to be ripe for a snooze, in the mid-afternoon, with the blinds semi-drawn. To fade out, to doze off, for some unforeseeable duration of the film, and then slowly awake, to fade back in. Is this insolence? Or. . . do we not encounter, with sleep, the soft underbelly of the cinema? Is not sleep the final verdict on the well-crafted film? Cinema demands attention! Every moment: look, look well, and even then, watch again. Yet Kiarostami says, in *The Making of Five* (Kiarostami, 2005), "I declare that you can nap during this film," that the audience can take "a pleasant nap, and I am not joking."[1] Take a nap. Kiarostami did. Of the central episode at the heart of the movie—"Dogs and Light"—Kiarostami recalls, "I switched the camera on and went to sleep."[2] In so doing, he (he?) created one of the most fascinating images of modern cinema. *Five* is haunted by sleep.

And yet . . . in almost the next breath Kiarostami proclaims alternative titles he considered: *Look; Look Well*; or *Watch Again*. Furthermore, in distinction to "Dogs and Light," the epic fifth and final episode—"Moon on Water, Serenade of Toads"—is purposefully envisioned, painstakingly executed, and heavily reworked. How can we resolve what must at first appear as contradictions: to watch and/or to sleep? To create through abandon and fate; or through intention and control? Such ambiguities permeate *Five*. Kiarostami

states, "I often have a problem giving my films a title. I look for a title that does not define the film."[3] Furthermore, he continues, with *Five* we should "not compare it with anything, especially with another film, because it is not comparable."[4] *Five* would thus seem to have the most open of titles, a numerical signifier signifying a movie consisting of five episodes. But wait . . . *Five* also has two subtitles (or perhaps better to say, one fore-title and one after-title), and this triadic naming schema is rendered onscreen in a vertical assemblage:

5 Long Takes
F I V E
Dedicated to Yasujiro Ozu

So it would seem—regardless of any trouble there may have been in choosing a name for the film—Kiarostami has expanded upon the elected title, twice. And in so doing, signaled a filmic process (the long take) and evoked an association with another filmmaker's films (Ozu Yasujiro). Expectations . . . the five episodes will each be composed of continuous shots of a sustained duration . . . and, accordingly, this procedure will somehow resonate with the movies of Ozu However, *Five* is not a composition of five long takes—the final episode, for instance, is a collage of many shots, "some 20 takes filmed over several months."[5] And Ozu's films are not even constituted by long takes, although (as David Bordwell has warned us) this seems to be "a common misconception about the director."[6] Ozu rather created his movies with character interactions filmed one-line, one-shot—interspacing such exchanges with still lifes and bookending sequences with the emptied spaces of landscapes, townscapes, street-scenes, and interiors. The meaning of this dedication of *Five* to Ozu is thus opaque—and, it seems to me, a cipher for all the discrepancies, contradictions, ambiguities, and disjunctions in and surrounding the movie.

Kiarostami may well appear to be the most unreliable of unreliable narrators, the most tricksy of commentators on their own work. Nevertheless, the objective of this chapter is to explore the resonances of *Five* with the cinema of Ozu, to theorize the nature of the dedication—and, in this way, it may be hoped, respond to some of the other obscurities that have been and will be exposed. To do so, I will approach such questions by way of the philosopher Gilles Deleuze. Deleuze wrote two books exploring film, *Cinema 1* and *Cinema 2*,[7] and while there is no evidence that Kiarostami's movie work or cine-thinking intentionally demonstrates the film philosophy of Deleuze, the *Cinema* books have, especially of late, provided a useful theoretical framework to discuss "cinema of the world." [8] More immediately, however, the movies of Ozu prove pivotal to Deleuze's theory of film. Ozu, for Deleuze, was among the first to create opsigns and sonsigns, "the first to develop pure optical and sound situations," to disrupt the traditional codes of classical cinema and open a way to a modern cinema; or rather, enact a collapse of the "movement-image"

(*Cinema 1*) and the creation of the "time-image" (*Cinema 2*).[9] To explore such disruption and creation, I will turn to one of Ozu's famous late films, *Floating Weeds* (*Ukigusa*, 1959). The focus will be three essential and interrelated procedures developed by the director over his years as a filmmaker, perhaps the most Ozuesque of Ozu's techniques: the structural organization of *sequences* within a film each bookended by *emptied spaces* and cohering around *still lifes*. Such emptied spaces and still lifes create sequences through the centrifugal and centripetal forces of these respective images. And such sequences become (as Deleuze puts it) "disconnected" and "de-chronologized" from each other;[10] yet immediately and as a consequence produce "a series of powers, always referring to each other and passing into one another."[11] Deleuze names this procedure the serial form (and also cinematic serialism).[12] After Ozu, concludes Deleuze, other filmmakers "came back to him," disrupting the coordinates of the movement-image, creating time-images.[13] Such filmmakers "did not imitate" Ozu—this is crucial—they had "their own methods."[14] Yet, in this way, Kiarostami's episodic "long takes"—(by way of Deleuze's cinematic serialism)—can be seen as resonating with Ozu's emptied spaces/still life sequences. And accordingly, I believe, we can affirm Kiarostami's dedication of *Five*.

OF CRISIS AND COLLAPSE

In *The Making of Five*, Kiarostami is reminded of a famous tale, taken from Persian poet Ferdowsi's tenth-century *The Book of Kings* (*Shahnameh*). There was once an ancient rivalry between two great rulers, the Maharajah of India and the Emperor of Persia. Seeking favor with his overlord, a philosopher in service to the Rajah created the game of chess as a simulation of the art of war. The Rajah, most impressed with his servant's inventiveness, delivered the game to the Persians as a demonstration of Indian ingenuity. The challenge being (as we might now say) to reverse-engineer the game: the distribution, value and movements of pieces, the rules of play, and the way to victory. The emperor of the Persians ordered his vizier, Bozorgmehr, to answer this seemingly impossible task. Bozorgmehr went one better. Not only did he figure everything out, but by way of reply, invented backgammon—an apparently far simpler game, but a game with dice, a game to illustrate that in war, as in all things, strategy and control are at the mercy of accident and chance. It is said—perhaps as a consequence of this being a story told by the Persians—that none of the Rajah's people were able to suss out the game. For Kiarostami, chess and backgammon are analogous to two different cinematic visions. The chess film is "the logical way, the way of cinema, the way of industry," a "well-crafted cinema" where "everything is ruled and controlled."[15] The backgammon film is "simpler, but also more complex . . . for this way of working you

need the earth, wind, and water to co-operate . . . as backgammon players say 'it's how the dice fall that counts.'"[16]

With this aside—and within the uncertain limits that should always be given to evocations of the analogous—Kiarostami captures the essential coordinates of Deleuze's film philosophy. Deleuze explores films to create a "cineosis," a semiosis of cinema: a taxonomy, or typology, of filmic images.[17] And this cineosis describes two regimes: movement-images and time-images—we might say the movement-image of the chess film and the time-image of the backgammon film. The movement-image is where everything is ruled and controlled through certain cinematic laws; and the time-image is where everything is both simpler and more complex. Kiarostami's *Five*—from the first moment onwards—is immediately identifiable as a time-image.

Fade in: the camera frames a small section of the seashore, where tide laps beach. A small hunk of driftwood, rotten and barnacle clad, is discovered on the sand, licked by the breaking waves of the Caspian Sea—the water apparently having relinquished the driftwood in its ebb. Troubled by the incoming tide, the chunk of dead branch rolls and spins on the grey, wet sand, is ensnared and released before inevitably being drawn into the flow once more, and carried with longshore drift. During all this, the camera has kept the driftwood in the center of the frame, but as it is buffeted by the breaking waves, it is broken into two, and the pieces float apart until one is carried out of frame. Or rather, the camera must choose which piece of wood will remain within the frame. Sometime later, however, the escaped chunk returns, much farther out to sea and drifting away: fade out. Such is episode 1, "Drift-Wood." This scene takes up the dice throw: one of which is the filmmakers chancing upon a lump of wood on the seashore, and in so doing, deciding to place it in the tide and to record what happens. Simultaneously, *Five* begins with the elimination of actors, of bodies, faces, characters. No characters to perceive the world, no characters who will feel something, think something, no characters to perform actions upon the world. Concomitantly, any immediate correlation between film-world and spectator is disrupted: we cannot perceive, feel, or think with the character, and we cannot subsume ourselves within the character's actions. This is a time-image, which has "a requirement," according to Deleuze, "to smash the whole system" of movement-images, "to cut perception off from its motor extension; action, from the thread which joined it to a situation; affection from the adherence or belonging to characters" and for "the mental image . . . to become 'difficult.'"[18] The movement-image function (with its cohesive distributions and judgments, its rules of play, and its resolutions) collapses.

The significance of such a collapse can perhaps only be fully appreciated in the wake of an exegesis of the coordinates of movement-image function. For Deleuze, movement-images are organizations of four cinematic domains: perception-images, affection-images, action-images, and

mental-images. The perception-image describes the composition of a solid center extracted from the world—most usually an individual human body.[19] Affection-images give emotions and feelings to this center—captured, for instance, in close-ups of the face (hate, fear, love, empathy): filmable external expressions of unfilmable internal intensive states.[20] The action-image (proceeding from the logic of the perception-image and affection-image that precede it) configures the environment as a determined situation in which the central character may perform acts.[21] The character senses (perception-image), feels (affection-image), and reacts (action-image)—a reciprocity where world grounds actions, and actions change the world. Such a trajectory is named the sensory-motor schema: determinations describing what may appear as simple, linear, cause and effect.[22] Yet, immediately, affects introduce and interweave conscious and unconscious complexity, alternatives and choices: mental images in mental spaces, recollections through flashbacks; dreams and nightmares; images of thought and thinking.[23] In this way, the determined human center becomes a center of indetermination.

The time-image is the disruption of these four cinematic domains—the creation of a new kind of image. In "Lucretius and the Simulacrum," Deleuze puts it very well: this new image "manifests neither contingency nor indetermination."[24] It "manifests something entirely different . . . the irreducible plurality of causes of causal series, and the impossibility of bringing causes together in a whole."[25] "The first things to be compromised," for Deleuze, are "the sensory-motor links which produced the action-image."[26] Here we encounter the crisis of the action-image.[27] And this crisis has "five apparent characteristics: *the dispersive situation, deliberately weak links, the voyage form, the consciousness of clichés, the condemnation of plot.*"[28] These five characteristics correspond exactly to what Deleuze has previously designated the five laws of action-image, laws which cohere movement-image narration.[29] First law (S→S′): the determining of an initial situation (S) that governs the requirements and restoration of the final situation (S′).[30] Second law (S→A): the situation devolves into forces, behaviors, and actions distributed to characters.[31] Third law (A): the action in-itself necessary to realize, by way of the duel, the final resolution.[32] Fourth law (A^n): the action is not simply the ultimate moment but is structural; duels permeate the film ($A^1 + A^2 + A^3 + \ldots$).[33] Fifth law (→): the whole flow of the plot, which carries situation to action and action to situation through the character in the world by way of the connection of spaces and in chronological, linear time.[34] The essential aspect is this: action-images—by way of the five laws—organize perception-images, affection-images, and mental-images into movement-image narration. Perception, affect, and mental states thus appear in the service of and are dominated by action. Accordingly, the crisis of the laws of the action-image simultaneously sets free perception, affect, and thought: there are no longer perception-images, affection-images, and mental-images. No longer is there a solid character at the center around which

all other images are organized; instead perception becomes gaseous and all images vary in respect to each other. No longer are affects recognizable and identifiable human facial expressions of internal intensities; affect becomes ahuman, produced through any-space-whatevers. And no longer are mental spaces assigned to characters as images of thought; the whole film is now an image of thought. The crisis of the action-image enacts the collapse of the movement-image function: the sensory-motor trajectory.

Five laws of the action-image, five characteristics of the crisis, five episodes to Kiarostami's *Five*. What are the chances? It is as if three dice have been cast, and each comes to rest presenting the same number of dots. It thus is tempting—very tempting indeed—to allow each of the five episodes of Kiarostami's film to correspond with each moment of crisis, and in so doing, explore the collapse of the movement-image and the creation of a time-image.

Episode 1, "Drift-Wood" embodies the first aspect of crisis. The first law of the action-image is S→S`, where an initial situation is determined in order to determine the final situation. With the crisis, however, the image "no longer refers to a situation which is globalising or synthetic, but rather one which is dispersive."[35] The globalizing situation is that which is distilled into a filmic milieu, while a synthetic situation is that which prescribes outcomes and restorations.[36] With the crisis, the milieu cannot be formed, and its outcomes are not foretold. And while it is true that in *Five* a center is cleaved from the world as a solid perception, such a perception describes an ahuman state and becomes gaseous, the driftwood dispersing in the amorphous background that is the any-space-whatever of the sea. Here we encounter open events, pure happenings, and nonessential accidents. Captured, battered, broken, separated, dispersed—a center overwhelmed by the forces that seize it, a world of chance from which no actions can be extracted. Of course, the first law and its crisis refer—as does each crisis of each law—to the entire film. Deleuze will write that any film undergoing the dispersive situation "is nevertheless not a series of sketches, a succession of short stories."[37] Accordingly, this first episode of *Five* resonates with the second, and so on—and all episodes become ensnared in the same logic of dispersal.[38]

Nevertheless, Kiarostami's procedure of fading in and fading out of these episodes means we immediately encounter a series of discontinuities that act as a weakening of links, the second characteristic of the crisis, the stymieing of the second law (S→A) where milieu devolves into actions: "the line or the fibre of the universe which prolonged events into one another, or brought about the connection of portions of space, has broken."[39] That being said, episode 2 of *Five* is in itself exemplary of such a weakening of links. "On the Promenade" uses a fixed camera to capture a scene. The setting is that of a stone promenade looking out to sea and set high above a beach (which cannot be seen). Sky, water, and stone form the three strata of the image; with the sea itself divided into three, cut through by the double railings of the esplanade.

Accompanying these horizontals are diagonals, a ramp and its barriers leading down to the invisible beach, and—angles corresponding exactly—shadows of two lampposts cast by a low sun behind the camera. It is through this perfect, precise framing that people will pass: joggers, dog walkers, surfers, strollers; at pace, dawdling; men and women, alone, in couples, in groups. This way, that way . . . sometimes leaving the frame empty. Eventually, four old men with walking sticks gather, chat for a while, then disperse. In accordance with the second characteristic of the crisis, the image describes chance, and the links and connections between the situation and the happenings are intentionally weakened. Who are all these people? Where are they all going? Who are the old men? Why must we wait so long for this moment to occur? What was this moment? What do they talk of?—(all we hear is the roar of the breaking waves). The image is composed of questions, not answers; composed of ellipses, not information. An any-space-whatever and an accidental meeting, caught by chance within the frame—although this chance is a creation. Kiarostami postpones the meeting of the old men through his selection of the shots (there is barely visible editing in this episode), and the gathering is or is made to appear fortuitous. This is the deliberate creation of weak links between a dispersive situation and the opaque behaviors of bodies.

The third characteristic of the crisis is where "the sensory-motor action or situation has been replaced by the stroll, the voyage . . . aimless movements."[40] No longer does behavior become embodied in a final, decisive action (A) in order to resolve the milieu. Such an undoing was, without doubt, a consequence in the first two episodes, but it is attained in the most exquisite way in "Dogs and Light," where Kiarostami explores "the role of having no role."[41] A thin line of beach, vast expanse of sea. Horizon and pallid blue sky. In the distance, the silhouettes of some dogs at the edge of the water, hanging out, napping (as is Kiarostami) in the morning sun. Then—almost imperceptibly through long duration—the sky becomes white, as does the sea and sand, the layers of the image bleeding into one another. The dogs are now black splodges of occasional movement, five blobs of darkness against a white background, disturbed by lines of color differentials, the waves, no longer waves but abstract lines rippling the whiteness, right to left, left to right. Such a change in light, bleaching out the screen, is pure serendipity (the camera not being adjusted as it records). Yet this does not disavow meaning—the image was still selected for the film. Everything will, for Kiarostami, "form one space" and "unify," but this unification is that of "non-existence" where "everything is completely annihilated before our eyes."[42] In this way, "Dogs and Light" demonstrates in extremis the third crisis: which is the purest of any-space-whatevers, denying the human coordinates of chronological time and comprehensive space, and in turn rejecting the logic of perception → affect → action. Actions as aimless movement.[43]

"In the fourth place," writes Deleuze, "we ask ourselves what maintains a set in this world The answer is simple . . . clichés, and nothing else.

Nothing but clichés, clichés everywhere."[44] What gives the appearance of a trajectory, of situations captured in actions, of actions restoring the coordinates of the world? Clichés. The fourth crisis concerns the cliché of action that appears to be the distinctive characteristic of each moment (A^n) and to permeate a whole, encompassing the whole. The question for Kiarostami is how to present the cliché in such a way that it appears as a cliché (and is not invisible, but becomes visible)? This is as much to ask, how to escape the cliché? Episode 4, "800 Ducks," is a mad chase scene: 800 ducks waddle past the camera left to right . . . the last duck pauses, quacks, turns, and pads right to left, as the other 799 ducks re-enter and zoom through the frame. Hilarious. "I do not know if they knew the scenario or not," comments Kiarostami wryly; "what is their motivation?"[45] This is a reification of the chase scene, exposing and overturning the cliché.

"Moon on Water, Serenade of Toads," the final and longest episode of the film, begins in something approaching sublime silence (all the previous sequences have been permeated by the white noise of the sea). A black screen, a silver circle in the center, softly undulating. It is, we realize, the full moon reflected upon water at night—the circular disc oscillating, fading in and out (sometimes we are left with a black screen). A slow crescendo: a chorus of toads and a storm becomes—in time—the roar of nature. Lightening, plops of raindrops hit the black water, mess with the reflection of the moon, make it fuzzy. The fifth and final moment of crisis is the condemnation of plot, which attacks the ordering of situation to action, and action to situation, of characters, their perceptions, emotions, thoughts and actions. "How can one not believe," asks Deleuze "in a powerful concerted organisation, a great and powerful plot . . . ?"[46] Yet this is what Kiarostami explores. With the reflected full moon, with its continual disappearances, its ephemeral presence. In the final episode of *Five*, Kiarostami collapses a solid center into a black screen of water, an any-space-whatever that disperses the image of which it is only a reflection, the pull and effect of the moon on the Earth, on its waters and animals, the contemplation of a great and powerful "plot."

Five episodes: five long takes? "Moon on Water, Serenade of Toads" appears as a long take, despite us knowing it is a collage of shots (captured—unnecessarily, perhaps—during one night each month). Yet as Deleuze comments, "Tarkovsky challenges the distinction between montage and shot when he defines cinema by the 'pressure of time' in the shot [W]e are plunged into time rather than crossing space."[47] Five episodes? If we have looked at each of the five scenes through each of the five characteristics of crisis, this was merely a tactical alliance. Each episode of *Five* enacts each moment of crisis, and each moment of crisis permeates each of the five episodes. Everything collapses: perception-images, affection-images, mental-images, action-images; even the so-called language of cinema—everything is undone—frame, shot, montage, sound, coloration: comprehensive space, chronological time, human

coordinates. *Five* is as much one "long take" (after Tarkovsky) of crisis and collapse.

OF TIME-IMAGES

One of the first directors to explore this crisis and collapse—according to Deleuze—was Ozu Yasujiro. Dispersive situations: "Ozu's spaces are raised to the state of any-spaces-whatevers, whether by disconnection, or vacuity."[48] Weak links: "everyday banality taken as family life in the Japanese house . . . allows only weak sensory-motor connections to survive."[49] The voyage form: "train journey, taxi ride, bus trip, a journey by bicycle or on foot: the grandparents' return journey from the provinces to Tokyo, the girl's last holiday with her mother, an old man's jaunt."[50] Consciousness of clichés: "the image constantly attempts to break through the cliché, to get out of the cliché . . . obsessive framings, empty, disconnected spaces, even still lifes."[51] And the condemnation of plot: the use of "'the one shot, one line' procedure borrowed from American cinema" where "Ozu modifies the meaning . . . which now shows the absence of plot."[52] Yet Ozu's cinema seems very different from Kiarostami's *Five*. *Five* appears very simple: a story of tides and fleeting events (the branch, the people, the dogs, the ducks, the frogs, the moon) divided into five distinct but resonating episodes of the crisis and collapse of the movement-image. Ozu's films—as we will see—have characters, and a film will follow these characters creating a story where complex relationships are explored and many diverse events unfold. Yet Kiarostami says, "I think *Five* . . . if it is not like Ozu's works, at least I can say that it is not in contrast with them or at least it is in contrast with the kind of cinema that Ozu avoided."[53] In other words, for Kiarostami, both he and Ozu enact crisis and collapse with respect to the movement-image function, and create opsigns and sonsigns to produce time-images.

William Brown, in "Complexity and Simplicity in *Inception* and *Five Dedicated to Ozu*" (2014), explores just such a contrast between movement-images and time-images—although without using this Deleuzian nomenclature—through two reciprocal neologistic concepts. For Brown, a movement-image (a movie of the classical cinema) such as *Inception* (Christopher Nolan, 2010) appears immediately complex; while a time-image (an arthouse movie) such as *Five* appears immediately simple. Yet—paradoxically—*Inception* has a surreptitious simplicity; and *Five* a hidden complexity. Brown takes inspiration for this formulation from scientist James Gleick, who states, "Simple systems give rise to complex behaviour. Complex systems give rise to simple behaviour."[54] Thus, the interrelationship of the complex and the simple, as Brown beautifully conceives it, is "something of a fractal."[55] *Inception* is composed of many baffling and puzzling moments across various levels of a world of real and

dream events, but its plot is rather straightforward: the secret implantation—or inception—of thoughts into characters so they believe them to be their own. *Five*, on the other hand, may have just five slow scenes, but it is incredibly difficult to read. Yet complexity and simplicity are not only relative but also perspectival. An event is not only complex in comparison to something else. Take a close-up of a face or a long-shot of the Earth: Is one simple and the other complex? Are both simple? Are both complex? Are they not both simultaneously simple and complex depending upon the perspective? The face is a simple moment of immediate recognition, yet—under a lover's gaze—an endlessly complex surface expressing and masking internal intensities. The Earth is a bluey-greeny ball amid a background of darkness, but composed of millions of years of geo-history inhabited by populations-individuals—people, peoples, nations, species, and so on. We encounter a reciprocity here, best captured by Jack Cohen and Ian Stewart (also in Brown): "Chaos theory tells us that simple laws can have very complicated—indeed, unpredictable—consequences. Simple causes can produce complex effects. Complexity theory tells us the opposite: Complex causes can produce simple effects."[56]

It can be said, in the wake of Brown, that *Five* as a film of complexity (the simple revealed as complex) is so as a consequence of crisis (with respect to action-images) and collapse (with respect to the movement-image). The movement-image (with its domains of perception-images, affection-images, mental-images, and action-images) and the action-image (with its laws of S→S', S→A, A in itself, A^n, and →) may appear complex but through its logical relations of space and time has a sensory-motor simplicity. We have, of course, seen this differentiation already with Kiarostami's backgammon film (of the time-image) and chess film (of the movement-image). Brown concludes that such revealed complexity and hidden simplicity are thus "interlinked in the physical universe in such a fashion that we might better use a term like *simplexity* or *complicity* to describe the intertwined relationship of the two."[57] This formulation is crucial: simplexity ↔ complicity are descriptions anchored in the "physical universe," both underpinned by the notions of cause and effect, and probability, reifying the sensory-motor system with its centers of indetermination; and subjecting the movement-image to crisis and collapse. Accordingly, while crisis and collapse are important for achieving time-images, this is so "only in the sense of preliminary conditions."[58] For Deleuze they make possible, but do not yet constitute, a new cinematic image: this crisis and collapse is "worthless by itself"; it is only "the negative condition of the upsurge of the new thinking image."[59] In short, this "complexity," for Henri Bergson, is merely "the material symbol of . . . the inner energy which allows the being to free itself from the rhythm of the flow of things."[60]

This difference between the movement-image and the time-image thus concerns the actual and the virtual. Such terminology arises from the philosophy of Bergson who can also be said to have given Deleuze the basic taxonomy

of the *Cinema* books.[61] In *Matter and Memory* (1896), Bergson describes a universe of images: image interacts with image, and centers coalesce, molecules here, a body there, here a planet, and so on—back and forth. The concept of the image, then, is a way of describing matter within spatiotemporal becomings. Images interpenetrate and collide: sound waves, particles of light, as well as bodies at any scale. Bergson sees these interpenetrations, collisions, and causes as perceptions (gaseous, liquid, and solid)—perceptions that effect a reaction. And in organic life, between such perceptions and such reactions, there is affect. This, for Bergson, is the basic trajectory of the sensory-motor schema: perception → affection → action. Life senses, feels, and reacts. Yet (as we saw echoed in Deleuze) affect is a center of indetermination. That is to say, the more complex the center (a fly, a pig, a philosopher, or a filmmaker, for example), the more possibilities there are for the emergence of different acts. Affect, coming between perception and action, selects from a range of potential reactions. And affect similarly selects perception. A body is bombarded by perceptions at every moment, yet affect tends to what interests the body. The mechanism for this intensive function of the sensory-motor schema is memory. With Bergsonian memory, however, we encounter a radical interplay of the habitual and the virtual. Habitual memory underpins the sensory-motor schema: intensive states select from a range of recognizable perceptions and recognized actions. This is memory inscribed within the image as an actual body in and with respect to movement. Pure or spontaneous memory, the virtual, is far more mysterious—Bergson will name it, among other things, "spirit."[62] Despite the provocation of such an esoteric naming, pure memory is for Bergson the virtual, duration, or pure time. Accordingly, the sensory-motor schema is spatial, or rather the reduction of pure temporality to spatial coordinates of the actual present: comprehensive space and chronological time (an interlinking of homogenous presents). Pure memory is duration, the temporalization of space.[63] Here—in memory—pasts, presents, and futures are heterogeneous, simultaneous, coexistent, fundamentally paradoxical, riven with disjunctions and forgettings, plagued with imagination and invention— the source of all creation.

All cinema is composed of actual on-screen images; and all cinema has virtual correlates. The difference is that the movement-image attempts an effacing of the virtual: actual image is joined to actual image in a logical and cohesive flow, cutting on movements, joining space to space and time to time. The time-image opens up to the virtual: spaces do not cohere and are not determined in cohesive temporal arrangements; there is disjunction in continuity; there are repetitions and caesuras. We have here two different images of thought: what Deleuze calls the "classical" and the "new."[64] The classical that sees solutions, be they only potential, to problems and is grounded upon cause and effect, upon probabilities; and the new that creates unsolvable problems and paradoxes evokes multiplicity, the ungiven, the unthought. Time-image cinema is

the production of the virtual, and it is from this perspective we can discover, with Deleuze and Kiarostami, the Ozuesque.

Pure optical and sound situations, opsigns and sonsigns, are affirmations that reorients the cinema from the actual to the virtual. In the upsurge of the time-image, these actual images are overwhelmed by virtual correlates (correlates expelled, elided, exorcised in the sensory-motor schema of the movement-image). And Deleuze sees three coordinates of the virtual arising from opsigns and sonsigns: (1) in the descriptions of the image in itself, (2) in the conjoining of images as narration, and (3) in the narrative or story—the encounter with narration by an audience.[65] Ozu developed any number of techniques to present the virtual through the image, narration and narrative, and we can explore these in general before giving a more grounded explication by way of *Floating Weeds*.

In the first instance, the actual opsign-sonsign in itself immediately evokes a virtual dimension. For instance, the resistance—especially in Ozu's post-war films—toward camera mobility and its replacement with the fixed shot; concomitantly, the purging of movement within the shot. In this way, the cinematographic image tends toward a photographic or pictorial image suspended in duration. The camera is positioned low, seizing the characters and the world in a perception that does not cohere to naturalized human vision. Bodies are captured in frontality with characters looking into the camera as they talk, feel, and think—a troubling of the fourth wall. Shots focus upon the same space, object, or character, each framed slightly differently, barely noticeable, but giving the uncanniness of difference in itself. Characters swap places from shot to shot. Eye-line matches do not match, but disparate objects graphic match; there is the use of 360 degrees, cinematic space consequently difficult to trace, the jarring of the flow of images. And dialogue of imprecise topics, repetitions, or silences. Ozu disrupts the image (of time, of space, of the frame, shot, and so on); a disruption that is, for Deleuze, "definitely not produced in the head or the mind, it is the objective characteristic of certain existing images which are by their nature double."[66] Double: actual images and their virtual correlates evoked though the indiscernibility of the image in itself.

We have already begun to discuss an accumulation of images; so, in the second instance, we encounter the virtual correlates of narration under—as Deleuze puts it—the "consequence of disconnected places and de-chronologized moments."[67] Pasts, presents, and futures have indeterminate relations; succession skips, jumps, stutters; instants are coexistent and divergent; homogenous spaces and times are decoupled, and heterogeneous times and spaces have false continuity. In other words, the connections between images are overwhelmed by the virtual. Ozu's cinema creates such virtual correlates by adopting the serial form: serialism. The film is structured through sequences in series. Each sequence will be prefigured by and concluded with

a number of emptied spaces (such functions necessarily overlapping for each sequence): landscapes, townscapes, street-scenes, or interiors—whatever-the-case, free of human bodies. Within these limits, the sequence will explore a particular moment in the lives of the characters, and there will be no distinct sense of time passing between each sequence. Each sequence is thus auton-omous and can be defined by a category or theme: the theme of rain, a visit to the beach (the rain-series and the beach-series, for instance, of *Floating Weeds*); and we could name each sequence against an emotion, a happen-ing, a concept, even a color. However, this does not mean a sequence in itself remains a homogenous space-time: the sequence brings together disparate spaces and times by false continuity. And such a sequence of shots often dwell on a still life, a moment within a sequence where an object or event (a vase, a clock, rain on a roof, falling blossoms, a table set for a meal—all images, again, from *Floating Weeds*) gives each its tenor. Finally, these sequences become the film as they enter into a series: where each sequence has a virtual connection with every other sequence. This is the basic formula, to which Ozu will apply endless variety.

Such a Deleuzian exploration of Ozu—it will be noted—follows in the wake of some of the most prominent writers on Japanese cinema. And the images that contour and define these sequences have been analyzed by Paul Schrader as "cases of stasis," Donald Richie as "still lifes," and by Noël Burch as "pil-low shots."[68] In "Burch's fine analysis," comments Deleuze for instance, we see functions of "suspension of human presence, passage to the inanimate, but also reverse passage, pivot, emblem, contribution to the flatness of the image, pictorial composition."[69] And both Richie and Schrader also see various func-tions to such images. What connects these writers—as Jinhee Choi beauti-fully teases out in her introductory essay to this book—is that they all believe in Japanese cinema as being a closed system within a traditional Japanese culture, but (at one and the same time) as being explicable through overtly theoretical frameworks such as Marxism (Burch) or relatively untheorized culturist assumptions of the irrevocable differences between the "East" and the "West" (Richie and Schrader).[70] Contemporary scholarship on East Asian cinema and Ozu has increasingly challenged such approaches as being essen-tialist or decontextualized, formalist or merely foregrounding surface qual-ities. Mitsuhiro Yoshimoto conducts a trenchant analysis of such concerns, calling for a "new study of Japanese cinema," a study that is "political" in the sense of being "beyond its specificity . . . conceived as a tactical intervention in the structures and practices of . . . established disciplines."[71] Yoshimoto's critique—it seems to me—is foreshadowed by that of Bordwell, who writes with respect to Ozu's "'empty' images" that the "search for sources, if car-ried out in the hope of finding simple correspondences" ends in "aporias."[72] As Bordwell explains, "For one Western critic, these are 'pillow shots,' like the pil-low words of classical verse. But Japanese critics have called the same images

'curtain shots.' Analogous to the break between acts in Western proscenium theatre."[73] Similarly, Bordwell decries Richie and Schrader for seeing still lifes as a "variant of 'false' POV" (point of view)—a "'decentering' of classical subjectivity"—instead of a "tactic" used "to enhance the ambivalence," introducing ambiguity into an image.[74]

Deleuze's explication of such emptied spaces and still lifes in this sense is Bordwellian. Tyler Parks is thus correct to maintain that for Deleuze there is thus a fundamental difference "between still lifes and shots of empty spaces."[75] Emptied spaces indicate "the absence of a possible content," while still lifes give "the presence and composition of objects wrapped up in themselves or become their own container."[76] For Deleuze, then, emptied spaces and still lifes are "two aspects of contemplation," of thought.[77] We could thus say that while emptied spaces are pure optical and sound situations, still lifes are what Deleuze calls a lectosign. And it is with the lectosign we encounter the third dimension of the virtual—the narrative, or story (which in its upsurge is an enfolding of the two previous dimensions of the virtual, the image and narration). If opsigns and sonsigns were the objective characteristic of the image, lectosigns happen in the head, where the brain becomes the screen: "lectosigns . . . force us to read so many symptoms of the image, that is, to treat the optical and sound image like something that is also readable."[78] The time-image must be interpreted.[79] Opsigns-sonsigns and lectosigns describe a reciprocity between the actual cinema-screen and the virtual brain-screen, film and thought—as image, narration, and narrative. The sequence in Ozu formed by the centrifugal forces of emptied spaces and the centripetal force of a still life allows opsigns and sonsigns to immediately become lectosigns. Indeed, "[t]here comes a moment," concludes Deleuze, "when one hesitates between the two, so completely can their functions overlap each other and so subtle are the transitions that can be made."[80] An example being "the marvellous composition with the bottle and the lighthouse" that opens *Floating Weeds*.[81] Deleuze mentions this image in passing, but it is worth exploring this becoming in the wake of the foregoing analysis.

The very first moment of *Floating Weeds* sees the camera capture its image in deep focus, an external mise en scène, a found image with an element of staging. A beautiful sunny summer's day, indigo sky and azure sea—and along a promontory, slightly to the right of the frame, a white lighthouse. In the foreground, on the edge of the stone harbor, and (from the position of the camera) to the right of the lighthouse, an empty black bottle. "I don't know it represents anything more than a sort of amusement," comments Roger Ebert, "at the fact that the bottle and the shape of the lighthouse are more-or-less the same."[82] For Ritchie, however, this moment marks a "passion for composition" in excess of narration.[83] Bordwell goes further—this conjunction of an emptied space and a still life is a case of what he calls "categorical-inclusion," a "non-causal and non-chronological" principle that alongside "adjacency

(perceptually contiguous shots)," "graphic resemblance," and "symmetry" act as a "conceptual link."[84] In Deleuzian terminology, this image is an opsign that becomes lectosign—an actual image with powerful virtual correlates. The form of the lighthouse and the form of the bottle are staged to echo each other; we have here something more profound than simply a wide establishing shot, the purpose of which would be to determine a milieu into which the characters are yet to be inserted. Indeed, the characters and their relations are already a virtual (non-)presence. This first shot is a mirror image of two actuals (the lighthouse and the bottle) with a virtual connection. And this connection is actualized as the story unfolds, the image of an actual of the virtual of the story in its becoming. Komajuro (Nakamura Ganjiro), with his troupe of itinerant players, returns to town to see his now-grown son Kiyoshi (Kawaguchi Hiroshi). Born of a liaison during the war to Oyoshi (Sugimura Haruko), Kiyoshi believes Komajuro to be his uncle. However, the woman in Komajuro's latest relationship—Sumiko (Kyo Machiko), one of the players in the troupe—discovers this secret and becomes jealous. She thus bribes a beautiful young actress, Kayo (Wakao Ayako), to seduce the son. When Sumiko's machinations are discovered by Komajuro, her belligerent response is "like father, like son"—a phrase Komajuro himself will repeat later in a moment of transitory self-revelation. Does not the opsign-lectosign of the lighthouse-bottle allow us to capture the Komajuro-Kiyoshi relationship? And, indeed, also that of Oyoshi-Kayo? Such an exchange between the father and fatherless-son, between the mother and the young actress is expressed in the next three shots that follow on from the first image. Ozu depicts the lighthouse, from varying spatial positionings, as a series at increased distance. In so doing, the lighthouse replaces, through its gradual reduction in size, the bottle. Here we discover the bottle becoming a virtual correlate of the actual lighthouse. Son becoming father, the temptress becoming lover: and both becomings playing out through the repetitions and differences of time-images.

DEDICATED TO OZU: SOMETHING OZUESQUE

Kiarostami's *Five*—it seems to me, in its dedication—echoes just such moments in Ozu: the conjunction of the empty and the full, of emptied spaces and still lifes, of the actual and the virtual, of opsigns-sonsigns and lectosigns. Yet we must immediately address an analysis from Bordwell. "Kiarostami didn't conceive his film as a tribute"; rather, it was "only after having premiered it at Cannes was he invited to attach it to the fall 2003 Ozu centenary. As a result, he changed the title."[85] Perhaps, however, it is only later, after the film is complete, that it will reveal an influence—to those other than the director, even to the director themselves. Toward the end of a conversation with French philosopher Jean-Luc Nancy, Kiarostami recites by rote the Qur'anic sura

of the earthquake. Nancy had referenced this sura in an extended essay on Kiarostami's cinema and in respect to *Life and Nothing More* (*Zendegi va digar hich*, 1991), a film exploring the aftermath of the devastating 1990 Iranian earthquake. "When I made the film," reflects Kiarostami—who has known the sura by heart since he was a child—"I didn't think of it."[86] Only after reading Nancy did Kiarostami discover the influence, the silent dedication. With *Five*, we could say we encounter the tremors of the earthquake of Ozu's cinema. Should we consider such an influence "formative" or "constitutive" (as Choi differentiates in the introduction to this book), as a priori or a posteriori? We could say the formative, for Bordwell, give us "citation, assimilation, or pastiche" of technique, while the constitutive allows for a more general correspondence.[87] And it is the latter a posteriori influence that Bordwell sees with Kiarostami: "Ozu becomes a model of a possible cinema—not through specific technical choices . . . but through an overall effect."[88] When Kiarostami claims that in Ozu the "long shots are everlasting" and that "interactions between people happen in the long shots," this would not be a mistaken belief that Ozu worked with long takes, but rather a conjuring of the Japanese director's serialism. As Deleuze observes, "[C]lassical reflection turns on this kind of alternative: montage *or* shot," but the time-image ungrounds such an opposition.[89] The shot is always already montage, and montage is already in the shot: "the identity of montage with the image itself can appear only in conditions of the direct time-image . . . there is no longer an alternative between montage and shot."[90] Ozu's sequences composed through emptied spaces and still lifes create a serialism that inspires the episodic (and some faux) "long takes" of *Five*.

Kiarostami calls *Five* an "open film" and—in a wonderful conceptual phrase—a "half-made film."[91] An accumulation of actual opsigns and sonsigns—but with virtual lectosigns: "I do not believe a film can exist without telling a story," says Kiarostami, but—as with Ozu—"it is the role of the audience to make the story."[92] Kiarostami's Ozuesque is a re-evaluation and reinvention of Ozu's method: a new way of creating the optical and sound situations, images that become lectosigns. Perhaps this is why Kiarostami rejected the titles *Look; Look Well;* and *Watch Again*. To look, to look well at cinema, to watch and watch again is not enough. The time-image requires something more, something other than looking, something beyond watching. It requires an effort of thought, it requires reading, it requires interpretation. And even, if you so wish, a nap.

NOTES

1. Abbas Kiarostami, *The Making of Five*, extra on *Five* DVD (Iran, 2005).
2. Ibid.
3. Ibid.

4. Ibid.
5. Geoff Andrew, *10* (London: British Film Institute, 2005), 23; also alluded to in Kiarostami, *Making of Five*.
6. David Bordwell, "Watch Again! Look Well! Look! (For Ozu)," *Observations on Film Art*, December 12, 2013, accessed February 13, 2015. http://www.davidbordwell.net/blog/2013/12/12/watch-again-look-well-look-for-ozu.
7. Gilles Deleuze, *Cinema 1: The Movement-Image*, trans. Hugh Tomlinson and Barbara Habberjam (London: The Athlone Press, 2002); *Cinema 2: The Time-Image*, trans. Hugh Tomlinson and Robert Galeta (Minneapolis: University of Minnesota Press, 2002).
8. See, for instance, David Martin-Jones, *Deleuze, Cinema and National Identity: Narrative Time in National Cinemas* (Edinburgh: Edinburgh University Press, 2006); *Deleuze and World Cinemas* (London: Continuum, 2011); Damian Sutton, "Philosophy, Politics and Homage in *Tears of the Black Tiger*," in *Deleuze and Film*, ed. D. Martin-Jones and W. Brown (Edinburgh: Edinburgh University Press, 2012), 37–53; Markos Hadjioannou, "In Search of Lost Reality: Waltzing with Bashir," in *Deleuze and Film*, ed. D. Martin-Jones and W. Brown (Edinburgh: Edinburgh University Press, 2012), 104–120; Seung-hoon Jeong, "The Surface of the Object: Quasi-Interfaces and Immanent Virtuality," in *Deleuze and Film*, ed. D. Martin-Jones and W. Brown (Edinburgh: Edinburgh University Press, 2012), 210–226; and David Deamer, *Deleuze, Japanese Cinema and the Atom Bomb: The Spectre of Impossibility* (London: Bloomsbury, 2014).

 Here, instead of "world cinema," I employ the term "cinema of the world": see Lúcia Nagib, "Towards a Positive Definition of World Cinema," in *Remapping World Cinema: Identity, Culture and Politics in Film*, ed. S. Dennison and S. H. Lim (London: Wallflower Press, 2006), 30–37.
9. Deleuze, *Cinema 2*, 13.
10. Ibid., 161
11. Ibid., 133
12. Ibid., 126, 133–137, 155.
13. Ibid., 126.
14. Ibid.
15. Kiarostami, *Making of Five*.
16. Ibid.
17. David Deamer, *Deleuze, Japanese Cinema and the Atom Bomb*, 2.
18. Deleuze, *Cinema 1*, 215; punctuation of translation slightly modified.
19. Perception image: see Deleuze, *Cinema 1*, 71–88; and David Deamer, *Deleuze's Cinema Books: The Introductions to the Taxonomy of Images* (Edinburgh: Edinburgh University Press, 2016), 77–81.
20. Affection-images: see Deleuze, *Cinema 1*, 89–140; and Deamer, *Deleuze's Cinema Books*, 82–86.
21. Action-images: see Deleuze, *Cinema 1*, 141–177; and Deamer, *Deleuze's Cinema Books*, 92–104.
22. Sensory-motor schema: see Deleuze, *Cinema 1*, 56–70; and Deamer, *Deleuze's Cinema Books*, 6–9.
23. Mental-images: see Deleuze, *Cinema 1*, 197–211; Deleuze, *Cinema 2*, 44–67; and Deamer, *Deleuze's Cinema Books*, 122–137.
24. Gilles Deleuze, "Lucretius and the Simulacrum," in *The Logic of Sense*, trans. Mark Lester with Charles Stivale (London: Continuum, 2004), 307.
25. Ibid.

26. Deleuze, *Cinema 1*, 206.
27. Ibid., 215.
28. Ibid., 210; translation slightly modified, emphasis in original.
29. Ibid., 155–159.
30. Ibid., 207.
31. Ibid.
32. Ibid., 208.
33. Ibid., 208–209.
34. Ibid., 209–210.
35. Ibid., 207.
36. Ibid., 205–206.
37. Ibid., 207.
38. Ibid.
39. Ibid.
40. Ibid., 208.
41. Kiarostami, *Making of Five*.
42. Ibid.
43. Deleuze, *Cinema 1*, 208.
44. Ibid.
45. Kiarostami, *Making of Five*.
46. Deleuze, *Cinema 1*, 209.
47. Deleuze, *Cinema 2*, xii.
48. Ibid., 15.
49. Ibid., 13, 15.
50. Ibid., 13.
51. Ibid., 21–22.
52. Ibid., 13.
53. Kiarostami, *Making of Five*.
54. James Gleick, *Chaos: Making a New Science* (London: Vintage, 1998), 304; in William Brown, "Complexity and Simplicity in *Inception* and *Five Dedicated to Ozu*," in *Hollywood Puzzle Films*, ed. Warren Buckland (London: Routledge, 2014), 130.
55. Brown, "Complexity and Simplicity," 130.
56. Jack Cohen and Ian Stewart, *The Collapse of Chaos: Discovering Simplicity in a Complex World* (London: Viking, 1994), 2; in Brown, "Complexity and Simplicity," 130.
57. Brown "Complexity and Simplicity," 131.
58. Deleuze, *Cinema 2*, 3.
59. Ibid.; *Cinema 1*, 215.
60. Henri Bergson, *Matter and Memory*, trans. Nancy Margaret Paul and W. Scott Palmer (New York: Zone Books, 2002), 222.
61. Deleuze, *Cinema 1*, 56–70; and Deamer, *Deleuze's Cinema Books*, 6–9.
62. Bergson, *Matter and Memory*, 9–11. See also Deamer, *Deleuze's Cinema Books*, 9–11.
63. Bergson, *Matter and Memory*, 217–219. See also Deamer, *Deleuze's Cinema Books*, 9–11.
64. Gilles Deleuze, *Difference and Repetition*, trans. Paul Patton (London: Continuum, 2004), x.
65. Deleuze, *Cinema 2*, 126–137.
66. Ibid., 69.
67. Ibid., 113.
68. Ibid., 16.
69. Deleuze, *Cinema 2*, 16; *Cinema 1*, 283–284.

70. Deamer, *Deleuze, Japanese Cinema and the Atom Bomb*, 10–20.
71. Mitsuhiro Yoshimoto, *Kurosawa: Film Studies and Japanese Cinema* (Durham, NC: Duke University Press, 2000), 49.
72. David Bordwell, *Ozu and the Poetics of Cinema* (Princeton, NJ: University of Princeton, 1988), 159.
73. Ibid.
74. Ibid., 117, 118, 136.
75. Tyler Parks, "Ozu, Deleuze, and the Visual Reserve of Events in their Appropriateness" (paper presented at the annual Film-Philosophy Conference, Glasgow, Scotland, July 2–4, 2014).
76. Deleuze, *Cinema 2*, 16.
77. Ibid., 16, 17.
78. Ibid., 24.
79. Ibid.
80. Ibid., 16.
81. Ibid. Deleuze is referring to *Floating Weeds* (*Ukigusa*, 1959) but names the film *A Story of Floating Weeds* (*Ukigusa monogatari*, 1934), the former being a remake of the latter.
82. Roger Ebert, commentary for *Floating Weeds* (Ozu Yasujiro, 1959), in *A Story of Floating Weeds / Floating Weeds*, The Criterion Collection.
83. Donald Richie, *Ozu: His Life and Films* (Berkeley: University of California Press, 1992), 127.
84. Bordwell, *Ozu and the Poetics of Cinema*, 122–123.
85. Bordwell, "Watch Again!"
86. Jean-Luc Nancy and Abbas Kiarostami, "In Conversation," in *The Evidence of Film: Abbas Kiarostami*, trans. Christine Irizarry and Verena Andermatt Conley (Bruxelles: Yves Gevaert Éditeur, 2001), 93–94.
87. Bordwell, "Watch Again!"
88. Bordwell, "Watch Again!"
89. Deleuze, *Cinema 2*, 36.
90. Ibid., 42.
91. Kiarostami, *Making of Five*.
92. Ibid.

CHAPTER 15

Sparse or Slow

Ozu and Joanna Hogg

WILLIAM BROWN

Ozu has not had such a direct influence. He is much less easy to assimilate. With few exceptions, his signature style has been far less imitated, and it has even been misunderstood. His effect on modern cinema, it seems to me, has been far more oblique, with directors paying him tribute in discreet, sometimes unexpected ways.
—David Bordwell, December 12, 2013[1]

Like many British filmmakers, Joanna Hogg started off working in television. Having in 1986 graduated from the National Film and Television School, during the 1990s Hogg directed episodes of *London Bridge* (1996) and *Casualty* (1997–1998), before in 2003 making an extended episode of *Eastenders* about long-running character Dot Cotton (June Brown). Since 2007, Hogg has directed three feature films: *Unrelated* (2007), *Archipelago* (2010), and *Exhibition* (2013). These latter films will be the focus of this chapter, which tries to account for the influence on Hogg of Ozu Yasujiro. The chapter will also explore some fundamental differences between Hogg and Ozu—especially the seeming development from a sparse humanism in Ozu's work toward a slow and more "posthumanist" aesthetic in Hogg's. We can start our analysis of Ozu's influence on Hogg, however, by looking at the issue of influence itself.

Hogg has explicitly stated that Ozu is an influence on her filmmaking, saying that "a film like (Ozu's) *Tokyo Story* [*Tokyo monogatari*, 1953] is extraordinary in its stillness and in its use of the space between things and not explaining plot-lines, so there's a lot there that I feel linked to. Although I should be so lucky to be compared to him and I think he was just an incredible master."[2] Meanwhile, in an interview with the British Film Institute, Hogg again describes *Tokyo Story* as a film that "encourages you to reflect on your life," saying that "as things speed up in our lives and we become more and more obsessed with our mobile phones, and not having so much direct communication with people, I think this kind of cinema that is like having a private conversation with somebody is going to be more and more important to experience."[3]

I shall return to the issue of "space between things" and "not explaining plot-lines" as a way of demonstrating Ozu's influence on Hogg shortly—and I shall latterly also discuss the way in which the contemporary world of the mobile phone that Hogg evokes means that certain aspects of her work differ from Ozu's films as a result of the industrial, cultural, and technological contexts in which they are made. But for the time being, I would like simply to point out that Ozu is a recognized influence on Hogg. We can see this both directly and indirectly. An example of direct influence—the equivalent of Hogg "quoting Ozu"—takes place toward the end of *Unrelated*, when Anna (Kathryn Worth), having left the holiday home of her old friend Verena (Mary Roscoe) and checked into a cheap hotel, looks out from her balcony. The ensuing point of view shot gives to us the Tuscan countryside, with certain signs of industry (a crane) and, in particular, a passing train, heading from left to right. The shot recalls various moments in *Tokyo Story* when Shukichi (Ryu Chishu) and Tomi (Higashiyama Chieko) also observe passing trains.

Although there do seem to be direct references to Ozu in Hogg's work, then, my main concern in this chapter is to show how Hogg's films are more obliquely "Ozuesque"—working positively with the obliqueness of the suffix "esque," as opposed to making any claims that Hogg is trying "to be" Ozu.[4] In short, the "esque" further allows us also to explore the important differences as well as similarities between the two directors—and one of the crucial differences is that Hogg is influenced not only by Ozu, but also by other filmmakers and artists. Indeed, when discussing the matter, Hogg states that

[o]ther art forms inspire me, not just cinema. So literature is incredibly influential: certain books—I was reading (Dostoyevsky's) *The Idiot* when I was writing *Archipelago* and with *Unrelated* I'd been reading *Death in Venice*. So all these influences filter in in their different ways, also painting is an influence. Also music, curiously, despite not

using any [or rather, not much] music in my films. And maybe the plays of Chekhov are inspiring and T. S. Eliot. There [are] all these other influences, which in a way are overriding some of my cinematic ones now.[5]

If literature is a clear influence on Hogg's work, cinematic influences other than Ozu are also notable. In the same interview, for example, Hogg discusses (at greater length than she does Ozu) the influence of Eric Rohmer on her films. Indeed, in telling the story of a woman who goes on holiday alone, *Unrelated* immediately bears some resemblance to Rohmer's *The Green Ray* (*Le rayon vert*, 1986), in which Delphine (Marie Rivière) also holidays alone—although Delphine heads off to various destinations while Anna is singularly in the area around Siena, Italy, and Delphine meets new people, while Anna predominantly stays with Verena and her family.

Furthermore, in *Unrelated*, the presence in Italy of a beautiful young man, Oakley (Tom Hiddleston), who seems somehow to lead astray everyone, including Anna, would suggest the influence not just of Rohmer, but also of Pier Paolo Pasolini, since this plot device—of the corrupting beautiful young man—is central to *Theorem* (*Teorema*, 1968)—as well as, in some respects, to *Death in Venice*, a novel that Hogg also mentions. The Pasolini influence also obliquely rears its head in the same film during a discussion of a sofa that used to belong to Benito Mussolini during the period of the Republic of Salò, about which, of course, Pasolini also made a film, namely *Salò, or the 120 Days of Sodom* (*Salò, o le 120 giornate di Sodoma*, 1975). Chantal Akerman also seems to be a great influence on Hogg, as made clear by the latter's curation of a full retrospective of Akerman's work through her film club, *À Nos Amours*, which itself is named after a film by Maurice Pialat. In other words, while Ozu is a clear influence on Hogg, she is a director who is working with numerous influences at the same time.

To have multiple influences is arguably itself "Ozuesque," since Ozu also had many influences—including Hollywood cinema and European and Japanese literary and artistic traditions—as David Bordwell has so cogently explained.[6] However, where Ozu is influenced by Hollywood—as well as by advertising—Hogg is not.[7] Instead, the large majority of her influences might broadly speaking be categorized as modernists (Dostoyevsky, Mann, Chekhov, Eliot), who, especially the filmmakers, make films in an art house tradition (Rohmer, Pasolini, Akerman, Pialat). Now, Ozu himself has also been characterized as a modernist, with Donald Richie comparing Ozu to Michelangelo Antonioni in 1964, and Kristin Thompson and David Bordwell also initially comparing Ozu to modernist filmmakers—before repudiating that position because they saw in Ozu's works an elaboration upon, rather than a rejection of, the Hollywood continuity editing system, as Markus Nornes has summarized.[8] Indeed, what distinguishes Ozu from these other filmmakers that influence Hogg is precisely the art house circuit in which they circulate: even if

Ozu shares with Antonioni and Akerman a concern for the fate of humanity in an increasingly technologized and alienating modernity, he was a studio film-maker, while those others were operating on a more art house/independent level. That Ozu has been *received* as an artist (rather than, say, as a commercial filmmaker who shows great artistry) is perhaps tied to the fact that Ozu began to be recognized in the West at around the same time as the likes of Antonioni, Akerman, Pasolini, Pialat, and Rohmer were emerging and/or consolidating their position as art house filmmakers, as the appearance of various studies of Ozu in the 1970s would testify.[9] In other words, the influence that Ozu shows on Hogg's work is inflected by the reception of Ozu in the West (he is considered alongside European modernist art house filmmakers), meaning that Hogg is as much influenced by that reception as by Ozu's cinema itself. In this way, Ozu's influence on Hogg can only be "oblique," and Hogg can only be "Ozuesque" rather than an Ozu imitator. I hope to show that this "inflected influence" is also manifest in the way that Ozu is "sparse" while Hogg is "slow," and in the way that Ozu is a "humanist" while Hogg demonstrates a more "posthumanist" philosophy. First, however, let us explore the contextual differences between the two filmmakers.

"OZUESQUE": THEMATIC CONCERNS

Ozu was a studio director for Shochiku, while Hogg works independently. In spite of these industrial differences, both can nonetheless lay claim to being auteurs for various reasons: their films contain autobiographical elements; they work repeatedly with the same cast and crew members; they deal repeatedly with the same themes, especially the concept of the family. In this section, I shall concentrate on the latter.

All of Hogg's films are about families: *Unrelated* shows two families on holiday in Tuscany, with Anna as something of an outsider guest; *Archipelago* is about a single family on holiday on Tresco in the Scilly Isles; and *Exhibition* is about a couple going through the process of selling their house in London. Although not all of Ozu's films deal with family, a good number do, with Bordwell observing that "Ozu's pre-1941 films use family relationships as one, usually privileged, arena of social conflict; and . . . after 1941, more often than not, character relationships (at work, in the neighborhood) are usually plotted with reference to family relationships."[10] Various tropes are also repeated (perhaps inevitably, given the breadth of Ozu's work) across the Japanese and British filmmakers' films. For example, Bordwell points out how sons criticize their fathers in *I Was Born, But . . .* (*Otona no miru ehon— Umarete wa mita keredo*, 1932), *Passing Fancy* (*Dekigokoro*, 1933), and *Story of Floating Weeds* (*Ukigusa monogatari*, 1934).[11] This intergenerational tension also exists in Hogg's films. In *Unrelated*, we see Oakley steal wine from his

father George (David Rintoul), and then (in a significant use of off-screen sound) we hear them row on account of Oakley's role in crashing the borrowed car of an Italian friend, Elisabetta (Elisabetta Fiorentini): George thinks Oakley irresponsible, while Oakley thinks George boring. In *Archipelago*, meanwhile, Edward (Tom Hiddleston) occasionally adopts a "posh" accent to mimic/mock his absent father, particularly on the subject of hunting/shooting, which apparently he holds dear ("bloody good shot"). Furthermore, the central husband and wife relationship of *Exhibition* is one examined by Ozu in, for example, *The Flavor of Green Tea over Rice* (*Ochazuke no aji*, 1952), also about a childless couple, Taeko (Kogure Michiyo) and Mokichi (Saburi Shin), who hit a troubled patch.

While Ozu examined characters from a variety of social backgrounds, from the urban proletariat in earlier films through to the middle classes in his postwar films, Hogg concentrates almost entirely on Britain's upper middle classes. With a lavish holiday home near Siena in *Unrelated*, a beautiful Tresco retreat in *Archipelago*, and an enormous (especially for London) home in *Exhibition*, her main characters clearly have, or at least have had, high levels of disposable income/significant assets. Unlike Ozu, we never get an insight into the workplaces of the main characters—except for D and H in *Exhibition*, who work from home. Nonetheless, we get both a sense that these characters work (meaning that they are not aristocratic), and that if they did not work, then their wealth might be threatened. In other words, Hogg's families are all (very) well-to-do, but a threat of downward social mobility lingers. This is made clear in *Unrelated*, for example, by the financial subtext to many comments and, indeed, the aforementioned arguments between Oakley and George. Oakley, who has been educated at Eton, seems profligate with (his father's) money; part of George's anger with him might stem, therefore, from Oakley's lack of appreciation of the value of money— although tension between the two perhaps also exists as a result of the lack of a mother figure in their family, an absence that is never explained. Furthermore, when at the end of the film Italian cleaners arrive to begin to tidy the house, the departing Britons repeatedly say how they will see them next year: the family does not own this property as a second (holiday) home, but seems to be renting it—and, indeed, possibly sharing the rent across both families, meaning that the lavish Tuscan lifestyle is more precarious than it seems for most of the film to be assured (they can only come once a year, not whenever they wish).

Ozu also explores the theme of downward mobility, for example in *Tokyo Chorus* (*Tokyo no korasu*, 1931), in which Okajima (Okada Tokihiko) is a middle-class office worker "reduced" to working in a restaurant, while his wife Sugako (Yaguma Emiko) looks after their two children. As befits a filmmaker who explores various classes in Japan, downward mobility is more real than threatened here, as Sugako has to sell her kimono in order to pay for her

daughter's medical bills. Ozu and Hogg explore similar themes, then, but in slightly different milieus.

This concern with downward mobility also manifests itself in the moments of social snobbery/class difference that crop up in each film, with class difference also being a common trope in Ozu's cinema. In *Archipelago*, even though hired chef Rose (Amy Lloyd) seems to be of an equally middle-class background to holidaymakers Patricia (Kate Fahy), Edward, and Cynthia (Lydia Leonard), Cynthia in particular seems determined to remind Rose that she is just hired help—and thus subservient to them; meanwhile, in *Exhibition* the (upper) middle-class H has an argument with a working-class builder (Mark McCabe) who has parked on the former's (small) front drive—the builder is not welcome on H's property. The assertion of "superior" class in both instances perhaps belies the characters' anxiety regarding the precarious nature of their own class position. Nonetheless, Hogg portrays upper-middle-class families whose fear of downward mobility manifests itself in snobbery.

To compare to Ozu, we can see such class awareness in *Tokyo Chorus*, when Okajima at first believes that handing out flyers to help promote the restaurant of his former teacher Omura (Saito Tatsuo) is beneath him—a sentiment echoed by Sugako when she discovers him doing it. Similarly, Shukichi and Tomi in *Tokyo Story* seem in part to be ignored by their eldest son and pediatrician Koichi (Yamamura So) as a result of their modest means. But where Ozu provides us with a happy ending in *Tokyo Chorus* as Okajima is offered a teaching job, and where in *Tokyo Story* Shukichi at least bonds with his daughter-in-law Noriko (Hara Setsuko) and his youngest daughter Kyoko (Kagawa Kyoko), if not with the rest of his family, Hogg offers no such consolation or sense of improvised (even cross-class) community. It is not that Hogg endorses the upper middle class and its concerns. Rather, Hogg quite detachedly observes the behavior of this particular milieu, lacking or refusing the warmth that we see in Ozu's work as a result of the characters' (minor) consolations (Okajima gets a job; Shukichi and Noriko bond). If Ozu and Hogg both return repeatedly to the themes of family and class, this evocation of the "observational" qualities of Hogg's work allows us now to discuss the formal elements of her films and how these are also in many respects "Ozuesque"—although I shall suggest that Hogg's work is "slow" while Ozu's is "sparse."

OZUESQUE AESTHETICS

No scholar has so exhaustively analyzed the formal properties of Ozu's films as has David Bordwell. He suggests that Ozu's narration is "not only pervasive and suppressive but highly self-conscious. It signals its awareness of presenting material for our eyes only Ozu's films certainly make visual style more

prominent than in classical cinema."[12] The same could be said of Hogg, as we shall see presently.

Bordwell has identified how, among other things, causality is not central to Ozu's cinema, meaning that there are numerous ellipses in his films—gaps in the story that the viewer is invited to fill in herself. For example, we are never told why Tomio (Tokkan Kozo) is wearing an eyepatch at the start of *Passing Fancy*.[13] Nor in *Late Spring* (*Banshun*, 1949) do we see the climactic wedding of Noriko (Hara Setsuko). We see Noriko, suitably attired, depart for the wedding, but the film then cuts to an encounter in a bar that takes place afterwards between her father, Shukichi (Ryu Chishu), and Noriko's friend, Aya (Tsukioka Yumeji). Similarly, causality is not Hogg's main point of interest, as is made clear in *Unrelated* when Anna, Oakley, and Oakley's friends Jack (Henry Lloyd-Hughes), Archie (Harry Kershaw), and Badge (Sarah Hiddleston) crash Elisabetta's car. We never see the car crash, nor how it happened—although we do discover latterly that Badge was driving and that Oakley should have been. Instead, we simply cut from a scene featuring Anna leaving George, Badge, and Verena's (second) husband Charlie (Michael Hadley) chatting in the garden over Negronis to a scene of the four youngsters and Anna standing next to the car as it lies at an awkward angle in a ditch as a tow truck tries to pull it out. Similarly, we are not told why Anna's partner, Alex, cannot make it to Italy. With both filmmakers, then, much is left to the audience's imagination through this use of elliptical storytelling.

Since causality is not central to the style of Ozu and Hogg, this means that other aspects of their films become more prominent, and as a result take on more meaning. In Ozu's films, there is much staging in depth, many symmetrical shots, and a lack of close-ups. *An Inn in Tokyo* (*Tokyo no yado*, 1935), for example, features many long shots of the main protagonist Kihachi (Sakamoto Takeshi) walking around the industrial wastelands that surround Tokyo with his two sons (Tokkan Kozo and Suematsu Takayuki) as he goes in search of work. Although Hogg has not yet explored the lives of the impoverished and homeless, as Ozu does with *An Inn in Tokyo*, she nonetheless also regularly stages her action in depth, as we see extreme long shots of Anna running across Tuscan countryside in *Unrelated*, Edward cycling across Tresco in *Archipelago*, and D and H walking down Kensington roads and across Hyde Park/Kensington Gardens in *Exhibition*. The result is that Ozu's and Hogg's films are imbued as much with a sense of setting and place as they are with a sense of story—as the titles of Ozu's *Tokyo Chorus*, *An Inn in Tokyo*, and *Tokyo Story* make clear. Indeed, both filmmakers seem to suggest that place and setting are as responsible for the story as the actions of their protagonists.

This shared emphasis on spatial depth is reinforced stylistically by the way in which both filmmakers seemingly prioritize visual style over story, with both regularly showing several planes of action, often in highly self-conscious

ways. For example, many of the interior shots in all three Hogg films involve several planes of action, often with a nearby wall taking up a portion of the frame with characters then carrying out actions in the middle and/or far distance. The prominent occluding walls and/or objects make Hogg's framing somewhat "arch," or "highly self-conscious," something we also find in Ozu, including in *An Inn in Tokyo*, where we see Kihachi and his children framed by pylons, or slightly out of focus in the background while grass blows gently in the breeze in the foreground.

Given how the self-conscious framing is in the work of both filmmakers, perhaps it is only logical that corridors also play a central role in both of their films. With Hogg, we regularly watch scenes that take place down corridors in and around *Unrelated*'s Tuscan villa, *Archipelago*'s Tresco guest house, and *Exhibition*'s London home. Meanwhile, when Kihachi's luck seems to change in *An Inn in Tokyo*, he and his boys are taken in by an old friend, Otsune (Iida Choko). We see long shots through Otsune's house, with her, Kihachi, and the boys in the middle ground, and then neighbors in their own homes in the background, seen typically through bead curtains. With both filmmakers, then, corridors take on depth while also being liminal, in-between spaces (corridors connect "main" rooms) that suggest the transitory nature of the characters in comparison to the more permanent nature of the places in which they find themselves and of space itself. *An Inn in Tokyo* makes this clear: Kihachi and the boys are guests, and the fact that we can see through into neighboring houses suggests the transience of life in relation to the permanence of space. Furthermore, in Hogg's films, the families are either on holiday (*Unrelated*, *Archipelago*) or selling their home (*Exhibition*): the space may be stable, but the residents are not.

That said, houses are very important to Ozu, as the discussion of *An Inn in Tokyo* makes clear, and to Hogg, with the house becoming so much of a character in *Archipelago* that Edward addresses it directly at the end of the film as if it were a character ("good bye, house"). Furthermore, D clearly feels aggrieved at leaving her home in *Exhibition*, such that she regularly is seen "hugging" parts of the house, and such that she and H make a cake in the house's image to eat at their house-leaving party. If humans are transient and space permanent, then this would justify the decision for both filmmakers to downplay causality via the elliptical structure of their stories: space shapes humans far more than humans shape (and act as causal agents in) space. In this way, the spaces become characters in their own right as much as the humans who feature within them.

Ozu and Hogg's shared emphasis on space can also be seen in their further stylistic similarities. Both often cut 90 degrees within a scene (instead of the usual, Hollywood-style 30 degrees), giving to the viewer greater coverage of the space in which the film is taking place. What is more, both Ozu and Hogg insert odd "transitions" between scenes—numerous shots of "still life"

objects, about which it was (and remains) difficult to determine whether they belong to the scene before the image or the scene after. These "transition" shots—of factory towers and power lines in *An Inn in Tokyo* and of sky, water, trees, and leaves blowing in the wind in Hogg's films—equally reaffirm our sense of space over our sense of human-driven action.

However, while both filmmakers have a shared concern to show space as much as, if not more than, action, there are differences between the two. If in Ozu's cinema the background often is filled with people—as per the neighbors going about their lives beyond Otsune's house in *An Inn in Tokyo*—in Hogg's cinema the spaces can often feel much more enclosed—hence her use of corridors, even when, as per D and H's house, there are many windows that look out on to the surrounding space. Indeed, in *Exhibition*, the windows often reflect, suggesting a sense of separation from rather than connection to the world outside. Kihachi and his children might be dwarfed by the factory chimneys as they wander Tokyo, but they are not imprisoned by their interiors; they are rarely so alienated as in Hogg's films.

The two directors' use of off-screen sound helps to further highlight this difference. Both directors use off-screen sound to convey information. I have already mentioned the tumultuous row between Oakley and George that takes place off-screen as Anna stands alone on the lawn between house and pool in *Unrelated*. Cynthia and Patricia have a similar off-screen argument in *Archipelago*—as we hold on Rose and then Edward in their respective bedrooms. Furthermore, in *Exhibition*, D and H's fear of having to leave their home is amplified by the constant sounds of traffic, shouting, car alarms, and sirens outside their home. We get a strong sense that the characters wish they were isolated from these sounds, which are distressing, threatening even, as they seep out or invade in. This forms a sharp contrast to the much more positive sense of connection that off-screen sound brings in Ozu's films. In *Good Morning* (*Ohayo*, 1959), for example, the continuous sounds of music in neighbors' houses suggests a Tokyo community, a sense of togetherness, rather than a desire for alienation and isolation.

OZUESQUE, NOT OZU, OR, FROM "SPARSE" TO "SLOW"

While space is of key importance to both filmmakers, Ozu's cinema suggests less alienated protagonists than Hogg's through the way in which space is depicted both visually and aurally: in Ozu, space connects, while in Hogg it isolates. We shall see how this relates to the humanism of the former and the "posthumanism" of the latter shortly. But first, let us look at the two directors' treatment not of space, but of time—and how Ozu is a "sparse" filmmaker, while Hogg is a "slow" one. Before making this distinction, we should bear in mind that various scholars have called Ozu a "slow" filmmaker. Indeed,

Tokyo Story is the first film to be mentioned in Ira Jaffe's monograph on "slow movies."[14] Furthermore, Song Hwee Lim similarly suggests that Ozu is a precursor to contemporary slow cinema. However, Lim also acknowledges that "the impression that Ozu's films are slow is perhaps mistaken."[15] Indeed, Lim makes reference at this point to Jonathan Rosenbaum, who points out that there is a range of speeds across Ozu's body of work, from the relatively fast *I Was Born, But . . .* , which has an average shot length (ASL) of 4 seconds, to the relatively slow *Tokyo Story*, the ASL of which is 10.2 seconds.[16] Rosenbaum is himself drawing on David Bordwell's quantitative analysis of Ozu, whose talkies typically had an ASL of 7–10 seconds, with *There Was a Father* (*Chichi ariki*, 1942) being his slowest sound film, with an ASL of 14.8 seconds.[17] In other words, Ozu is not too slow—especially when we compare him to Hogg.

Permitting some human error, and not including end credits in the running time (which would only increase the ASL), I counted 323 shots in *Unrelated* over the course of its 94-minute, 58-second duration, meaning it has an ASL of 17.6 seconds. This is by far Hogg's fastest film, for *Archipelago* involves 177 shots over the course of 108 minutes and 37 seconds, giving it an ASL of 36.8 seconds, and *Exhibition* has 193 shots during 101 minutes and 38 seconds, with an ASL of 31.6 seconds. In other words, if Hogg's fastest film is slower than Ozu's slowest, then Hogg emerges as clearly the "slower" filmmaker. Perhaps, then, it is sensible to say that Hogg is slow, while Ozu is, to adopt a term that Bordwell uses, "sparse."[18]

Bordwell characterizes Ozu as sparse on account not just of his rhythm of editing, but also as a result of the apparent stasis that seeps through in his films. And yet, there is more movement in Ozu's films, both in terms of within-scene editing and in terms of camera movement, than there is in Hogg's. Take the opening of *An Inn in Tokyo*: a shot of an empty industrial wire wheel is followed by a long shot of Kihachi and his sons walking away from us, framed by the wheel and a pylon. Cut to a low-angle tracking shot of the three from behind, then a low-angle medium tracking shot from in front of Kihachi as he consults a piece of paper. A low-angle medium tracking shot of the boys briefly follows, before we return to Kihachi. A static long shot, framed by pylons, sees Kihachi walk away from us as the boys enter frame right behind him. Kihachi stops, turns, and the boys approach him. An intertitle: "Wait here, the two of you." This brief sequence lasts 58 seconds and consists of seven shots (with an ASL of 8.3 seconds), four of which involve a moving camera.

Let us compare to Hogg, who, as mentioned, has a significantly slower cutting rate than Ozu, and for whom there is little camera movement, with within-scene editing reduced to only a few crucial cuts, if any, especially in *Archipelago* and *Exhibition*. Indeed, these latter two films regularly eschew in-scene editing in favor of single takes for entire scenes. Furthermore, the near-total stillness of Hogg's camera and the insistent use of long shots reinforce

the sense that her films feature "cold" observation, while Ozu is frequently praised for his humor and humanism.[19]

It is not that Hogg does not employ within-scene editing.[20] Furthermore, Hogg does on rare occasion move her camera. But when she does, even this can be seen as distinct from Ozu, since while Ozu's films do not feature a single dream sequence, Hogg often moves her camera precisely to signal them. For example, in *Exhibition*, D has a dream in which she talks about her art with H on a spot-lit stage at London's Institute for Contemporary Arts (ICA). During this dream sequence, we see the camera pan from left to right as D walks in slow motion across Trafalgar Square and to a man playing a fire-breathing trombone (with fire also being associated with the loss of D's house as a fire-breather entertains guests at their house-leaving party). We then have a tracking shot behind D and H as they walk through a cluttered, pipe-lined corridor in what seems to be the ICA. Meanwhile, in *Unrelated*, the tourists visit some hot springs near Siena, and as Anna walks from Verena to Oakley, the camera pans right to left with her. Minutes later, we see the characters all in the springs putting mud on each other, with Anna and Oakley also becoming more intimate. The camera constantly reframes during these moments, concentrating in particular on Oakley (indeed, Hogg seems most regularly to reframe in order to keep the beautiful Tom Hiddleston in focus throughout *Unrelated*). It is not that this is strictly a dream sequence, but the camera movement clearly adds meaning to the fact that Anna desires Oakley; Oakley is, as it were, a dream for Anna (and one that briefly turns into a nightmare when Oakley turns his attentions away from Anna and toward the younger Giovanna, played by Giovanna Mennell). In Hogg's films, then, camera movement is linked to the oneiric and to the revelation of the sub- or unconscious desires/fears of the protagonists (the camera also tilts up and down the spiral stairs that form the center of H and D's house in *Exhibition*—as if the tilts also bring to mind the notion of downward and upward social mobility).

Although camera movements connote dream or dreamlike states in Hogg's work, this in some sense only serves to reinforce the felt alienation of her characters' waking life, as rendered visually through her static camera and her long takes/her slowness. Not slow but sparse in terms of editing rhythm, and with camera movements far more regularly integrated into his films, Ozu offers to us a warmer cinema, which belies his humanism as opposed to Hogg's posthumanism, as we shall see in the next section.

HOGG AS POSTHUMANIST?

In Ozu's films, we often get a sense of the possibility of community. In *Good Morning*, the central family buys a television set at the film's end in order to support a neighbor who is a television salesman, while in *An Inn in Tokyo*

Otsune's generosity allows Kihachi to have a new chance in life. Even in films like *Tokyo Story*, where the selfishness of the younger, more "capitalist" generation is demonstrated (Shukichi's children ignore him), there is nonetheless hope that at least some people can form meaningful relationships (Noriko and Shukichi). In other words, Ozu might be mindful of the deterioration of human relationships in a world beset by the alienating effects of modernity and the pursuit of money over humanity, but he seems to counter this through his belief in community.

Hogg's films, meanwhile, seem to suggest a colder reality, in which it is almost too late for real relationships to develop.[21] Off-screen sound suggests that the outside world is a threat in *Exhibition*, where H and D try to separate themselves from others (embodying the British belief that "every Englishman's home is his castle"). The threat of downward mobility, manifested in moments of snobbery, adds to this: rather than any social(ist) sense of community emerging (H letting the builder park), we get a sense of an "every man for himself" ethos. Maybe this is also made clear by aspects of D and H's sexual relations: although they do have sex at several points in the film, D nonetheless masturbates in bed next to H—her desire/fantasies seemingly not being fulfilled by him, suggesting some sense of isolation.

Now, Hogg's work has been described as "realist,"[22] although the (possible) dream sequences described above would suggest that she engages not just in observational realism, but in some sort of representation of character psychology in her films (that is, the images cannot all be read as objectively real, but are instead expressive of characters' inner states, especially those of Anna, Edward, and D). The "psychological" aspects of these moments would suggest, then, that Hogg is a "humanist" filmmaker—concerned with the human condition, even if her filmmaking is "colder" than Ozu's. And yet, I wish by way of conclusion to argue that Hogg's "coldness" suggests not so much a "warm humanism," as per Ozu, but a more detached, "posthuman" perspective.

As mentioned, both Ozu and Hogg regularly put into their films cutaway shots, or "still lifes." However, where Ozu's cutaways/still lifes often feature human/manmade elements (water towers, trains, cityscapes), Hogg's more often than not feature nonhuman elements (water and clouds, especially in *Unrelated*, and, in all three of her films, numerous shots of trees, plants, and leaves dancing on the breeze). In other words, there is a distinction between the human/manmade elements of Ozu's films and what I am terming the "posthuman"/natural elements of Hogg's. Where Ozu seems insistently to refer back to the human dimension in his cutaways, Hogg seems to take us beyond (or "post") the human, and into the natural world. Hogg seems in a sense to remind us that all of our human concerns are somewhat petty and short-term when compared to the longer lifecycles of trees and nature more generally. Furthermore, nature is impassive to humanity (while humanity is

strongly shaped by space), while in Ozu's films we repeatedly see manmade objects that suggest humanity's capacity to shape nature (even if space also shapes humans). While both filmmakers explore the relationship between humanity and nature, Ozu's warmth reflects a belief in the importance of humanity in the universe, while Hogg's coldness reflects a "posthuman" reminder that humans are not important, but just another part of nature.[23]

The differences between Ozu's humanism and Hogg's "posthumanism" perhaps have at their root the different contexts in which they are working. Ozu's later warm comedies, for example, reflect a search for optimism in Japanese postwar society. If in *Good Morning* the advent of television functions as a means of uniting the family (however ironic this might be, since television typically keeps people at home, i.e., not socializing), in Hogg's films—made in the age of the mobile phone when, as Hogg herself has stated, human communication seems paradoxically to be on the wane—technology, including phones, and especially computers in *Exhibition*, seems to drive humans apart. The technologization of society that is intensified in the neoliberal era makes humans feel alienated from space, nature, and each other, even if nature continues impassively to surround and to shape humans. Hogg's slow cinema—surely in part a reaction to the way in which mainstream "cinemas of action" are themselves tied to the propagation of an individualistic neoliberal morality—is very different from Ozu's, even if it is Ozuesque. Hogg's films require like Ozu's a different way of looking, but one that stretches beyond the human and toward the world that surrounds and sustains humans—since it is from this world and from each other that humans are now alienated, rather than integrated as seems more to be the case in the work of the Japanese filmmaker.

As mentioned, Bordwell suggests that Ozu is less influenced by painting and more by advertising. Hogg, meanwhile, seems a much more painterly filmmaker, as the presence of painter Christopher (played by Christopher Baker in *Archipelago*), art dealer Jonathan (played by Jonathan Mennell in *Unrelated*), and artists D and H (*Exhibition*) make clear. In *Archipelago*, Christopher tells Patricia about how painting must draw upon "chaos"—something that Hogg also seems to do in her insistent cutaways to the chaotic, natural world. Christopher also discusses abstraction as being the distillation of information to the "important thing." If Hogg's work in some respects also does this, then it similarly suggests posthumanism in her work. For that to which her cinema is distilled is, as per her cutaways/still lifes, nature. Humans are a crucial ingredient in Hogg's cinema, but where Ozu keeps humans as his focus, Hogg asks us to look beyond the human, especially the human as individual in the mobile phone-riddled era of neoliberal capital. Instead, we must see how the human is part of a wider ecology, and how to abandon nature and to embrace technology seems not only to split humans from the natural world, but also

from each other. In the warmer work and world of Ozu, this alienation seems not (yet) to have taken place.

NOTES

1. David Bordwell, "Watch again! Look well! Look! (For Ozu)," *Observations on Film Art*, December 12, 2013, accessed October 6, 2014. http://www.davidbordwell. net/blog/2013/12/12/watch-again-look-well-look-for-ozu.
2. Matthew Turner, "Joanna Hogg Interview," *View London*, n.d., accessed October 6, 2014. http://www.viewlondon.co.uk/cinemas/joanna-hogg-interview-feature-interview-3934-1.html.
3. Joanna Hogg, "Joanna Hogg on *Tokyo Story*," *BFI Live*, British Film Institute. n.d., accessed October 6, 2014. http://www.bfi.org.uk/live/video/182.
4. As Aaron Gerow explains in his chapter in this collection, the term "Ozuesque" was coined by Japanese film scholar Hasumi Shigehiko in the 1980s to refer to Ozu's perceived aesthetics of little changes. For an updated edition, see Hasumi Shigehiko, *Kantoku Ozu Yasujiro* [Director Ozu Yasujiro] (Tokyo: Chikuma shobo, 2003).
5. Turner, "Joanna Hogg Interview."
6. David Bordwell, *Ozu and the Poetics of Cinema* (Princeton, NJ: Princeton University Press, 1988), 143–159.
7. Ibid., 150.
8. See Donald Richie, "Yasujiro: The Syntax of His Films," *Film Quarterly* 17, no. 2 (1964): 11–16; Kristin Thompson and David Bordwell, "Space and Narrative in the Films of Ozu," *Screen* 17, no. 2 (1976): 41–73; Markus Nornes, "The Riddle of the Vase: Ozu Yasujiro's *Late Spring* (1949)," in *Japanese Cinema: Texts and Contexts*, ed. Alastair Phillips and Julian Stringer (London: Routledge, 2007), 83–84.
9. See, for example, Donald Richie, *Japanese Cinema: Film Style and National Character* (New York: Doubleday, 1971); Paul Schrader, *Transcendental Style in Film: Ozu, Bresson, Dreyer* (Berkeley: University of California Press, 1972); Donald Richie, *Ozu: His Life and Films* (Berkeley: University of California Press, 1974); and Noël Burch, *To the Distant Observer: Form and Meaning in the Japanese Cinema* (Berkeley: University of California Press, 1979).
10. Bordwell, *Ozu*, 36. For a similar argument, see Catherine Russell, *Classical Japanese Cinema Revisited* (London: Continuum, 2011), 21.
11. Bordwell, *Ozu*, 37.
12. Ibid., 71–74.
13. Ibid., 54.
14. Ira Jaffe, *Slow Movies: Countering the Cinema of Action* (London: Wallflower, 2014), 1.
15. Song Hwee Lim, *Tsai Ming-Liang and a Cinema of Slowness* (Honolulu: Hawaii University Press, 2014), 9, 78, and 85.
16. Jonathan Rosenbaum, "Is Ozu Slow?," *Senses of Cinema* 4 (March 2000), accessed January 30, 2015. http://sensesofcinema.com/2000/feature-articles/ozu-2/.
17. Bordwell, *Ozu*, 377.
18. Ibid., ix.
19. Ibid., 20.

20. Indeed, one example of in-scene editing in *Exhibition* involves a typically Ozuesque palindromic sequence of shots in which we see: (1) D in long shot doing washing up from behind; cut 90 degrees to (2) a long shot of D walking away from the camera to a glass window frame right with blinds drawn; cut to (3) a high-angle point-of-view shot through the blinds of H downstairs smoking on a sofa. We then return to (2) the long shot of D at the window before, as she returns to the kitchen, seeing again (1) the long shot of D from behind doing the washing up. D and H have just had an argument of sorts (H: "did I do something?"), and so the scene clearly associates D with domestic chores, while H relaxes downstairs. The window and blinds suggest distance between the two characters, while the palindromic structure (a-b-c-b-a) suggesting some sort of "imprisonment" in domestic chores for D (perhaps a reference to Chantal Akerman's *Jeanne Dielman, 23 Quai du Commerce, 1080 Bruxelles*, 1976).

21. I do not have time fully to examine its role here, but music is also a key component in adding warmth to Ozu's films. Ozu's sound films are particularly characterized by swelling, upbeat scores, while Hogg barely uses any music in her films—unless as part of the diegetic soundscape (Oakley and others dance to music when drunk in *Unrelated*). This plays a key role in removing the sense of warmth from her films and making them more "cold"—since the music does not draw us in and guide us in terms of how we are to respond emotionally to what we see.

22. David Forrest, "The Films of Joanna Hogg: New British Realism and Class," *Studies in European Cinema* 11, no. 1 (2014): 64–75.

23. For a consideration of how "posthumanism" is an exploration of humanity's non-special place in the world, see Rosi Braidotti, *The Posthuman* (Cambridge: Polity Press, 2013).

BIBLIOGRAPHY

"15 nendo cnNihon eiga (geki) no satsuei gijutsu danmen" [A technological aspect of cinematography in 1940 Japanese (fiction) films]. *Eiga gijutsu* 1, no. 2 (February 1941): 88–90.

Adorno, Theodor. "The Schema of Mass Culture." In *The Culture Industry*, edited by J. M. Bernstein, 61–97. New York: Routledge, 2004.

Agamben, Giorgio. *Means without End*. Translated by Cesare Casarino and Vincenzo Binetti. Minneapolis: University of Minnesota Press, 2000.

Aitken, Ian. *European Film Theories: A Critical Introduction*. Bloomington: Indiana University Press, 2001.

Aitken, Stuart C., and Christopher Lee Lukinbeal. "Disassociated Masculinities and Geographies of the Road." In *The Road Movie Book*, edited by Steven Cohan and Ina Rae Hark, 349–370. New York: Routledge, 1997.

Anderson, J. L. "Spoken Silents in the Japanese Cinema; or, Talking to Pictures." In *Reframing Japanese Cinema: Authorship, Genre, History*, edited by Arthur Nolletti and David Desser, 259–311. Bloomington: Indiana University Press, 1992.

Ando, Sadao. "Kurasa ni tsuite: Itami Mansaku ni kansuru oboegaki" [About darkness: Notes on Itami Mansaku]. *Eiga* 1, no. 1 (May 1938): 19–20.

Andrew, Geoff. "Jim Jarmusch Interview." In *Jim Jarmusch: Interviews*, edited by Ludvig Hertzberg, 176–196. Jackson: University Press of Mississippi, 2001.

Andrew, Geoff. *10*. London: British Film Institute, 2005.

Anno, Hatsuo. "*Kamera wo motta otoko'* shikan" [My view on *Man with a Movie Camera*]. *Kinema junpo*, May 11, 1932, 46.

Aristotle. *Poetics*. Translated by Stephen Holliwell. Chapel Hill: University of North Carolina Press, 2006.

Atsuta, Yuharu, and Hasumi Shigehiko. *Ozu Yasujiro monogatari* [Ozu Yasujiro story]. Tokyo: Chikuma shobo, 1989.

Bahri, Deepika. *Native Intelligence: Aesthetics, Politics and Postcolonial literature*. Minneapolis: University of Minnesota Press, 2003.

Barbery, Muriel. *The Elegance of the Hedgehog*. Translated by Alison Anderson. New York: Europa editions, 2008.

Barrett, Gregory. "Comic Targets and Comic Styles: An Introduction to Japanese Film Comedy." In *Reframing Japanese Cinema: Authorship, Genre, History*, edited by Arthur Nolletti Jr. and David Desser, 210–228. Bloomington: Indiana University Press, 1992.

Baudelaire, Charles. *Selected Writing on Art and Artists*. Translated by P. E. Charvet. Cambridge: Cambridge University Press, 1981.

Baxter, Peter. "On the History and Ideology of Film Lighting." *Screen* 16, no. 3 (Autumn 1975): 83–106.

Benjamin, Walter, Michael William Jennings, Brigid Doherty, Thomas Y. Levin, and E. F. N. Jephcott. *The Work of Art in the Age of Its Technological Reproducibility, and Other Writings on Media.* Cambridge, MA: Belknap Press of Harvard University Press, 2008.

Bergson, Henri. *Laughter.* Translated by Cloudesley Brereton and Fred Rothwell. Rockville: ARC Manor, 2008.

Bergson, Henri. *Matter and Memory.* Translated by Nancy Margaret Paul and W. Scott Palmer. New York: Zone Books, 2002.

Bergstrom, Janet. "Opacity in the Films of Claire Denis." In *French Civilisation and Its Discontents,* edited by Tyler Stovall and Georges Van Den Abbeele, 69–102. Lanham, MD: Lexington Books, 2003.

Berlant, Lauren. *Cruel Optimism.* Durham, NC: Duke University Press, 2008.

Beugnet, Martine, and Jane Sillars. "Beau Travail: Time, Space and Myths of Identity." *Studies in French Cinema* 1, no. 3 (2001): 166–173.

Bhabha, Homi. K. *The Location of Culture.* New York: Routledge, 1995.

Bignall, Simone. *Postcolonial Agency: Critique and Constructivism.* Edinburgh: Edinburgh University Press, 2010.

Bingham, Adam. *Japanese Cinema since Hana-Bi.* Edinburgh: Edinburgh University Press, 2015.

Bingham, Adam. "The Spaces In-Between: The Cinema of Yasujiro Ozu." *Cineaction* 63 (2004): 49–50.

Bloom, Harold. *Anxiety of Influence.* Oxford: Oxford University Press, 1997.

Bock, Audie. "Ozu Reconsidered." *Film Criticism* 8, no. 1 (1983): 50–53.

Boehmer, Elleke. "A Postcolonial Aesthetic: Repeating upon the Present." In *Rerouting the Postcolonial: New Directions for the New Millennium,* edited by Janet Wilson, Cristina Șandru, and Sarah Lawson Welsh, 170–181. London: Routledge, 2010.

Boer, Inge E. *After Orientalism: Critical Entanglements, Productive Looks.* Amsterdam: Rodopi, 2004.

Booth, Wayne C. *The Rhetoric of Irony.* Chicago: The University of Chicago Press, 1974.

Bordwell, David. *Figures Traced in Light: On Cinematic Staging.* Berkeley: University of California Press, 2005.

Bordwell, David. "Hou Hsiao-hsien: Constraints, Traditions, and Trends." Vimeo video, 1:08:51. https://vimeo.com/129943635.

Bordwell, David. "A Modest Extravagance: Four Looks at Ozu." In *Ozu Yasujiro 100th Anniversary,* edited by Li Cheuk-to and H. C. Li, 16–17. Hong Kong: Hong Kong Arts Development Council, 2003.

Bordwell, David. *Narration in the Fiction Film.* London: Routledge, 1987.

Bordwell, David. *Ozu and the Poetics of Cinema.* Princeton, NJ: Princeton University Press, 1988.

Bordwell, David. "Watch again! Look Well! Look! (For Ozu)." *Observations on Film Art,* December 12, 2013. Accessed October 6, 2014. http://www.davidbordwell.net/blog/2013/12/12/watch-again-look-well-look-for-ozu/.

Bordwell, David, and Kristin Thompson. *Film Art.* New York: McGraw-Hill, 2004.

Boyers, Robert. "Secular Vision, Transcendental Style: The Art of Yasujiro Ozu." In *After the Avant-Garde: Essays on Art and Culture.* University Park: Pennsylvania State University Press, 1988.

Braidotti, Rosi. *The Posthuman.* Cambridge: Polity Press, 2013.

Brown, William. "Complexity and Simplicity in *Inception* and *Five Dedicated to Ozu*." In *Hollywood Puzzle Films*, edited by Warren Buckland, 125–139. London: Routledge, 2014.

Burch, Noël. *Life to Those Shadows*. Berkeley: University of California Press, 1990.

Burch, Noël. *To the Distant Observer: Form and Meaning in the Japanese Cinema*. Berkeley: University of California Press, 1979.

Buruma, Ian. "Humor in Japanese Cinema." *East-West Film Journal* 2, no. 1 (1987): 26–31.

Buruma, Ian. *Inventing Japan: From Empire to Economic Miracle 1853–1964*. London: Weidenfeld and Nicolson, 2003.

Calvino, Italo. *Calvino no bungaku kogi: Aratana sennenki no tame no muttsu no memo*. [Calvino's lectures on literature: Six memos for the new millennium]. Tokyo: Asahi shinbunsha, 1999.

"Camera, rokuon, sochi: Zadankai" [Camera, recording, and equipment: Group discussion]. *Shin eiga* 10, no. 7 (June 1940): 37–43.

Carroll, Noël. "The Power of Movies." In *Theorizing the Moving Image*, 78–93. Cambridge: Cambridge University Press, 1996.

Cartwright, Nancy. "What Makes a Capacity a Disposition?" In *Dispositions and Causal Powers*, edited by Max Kistler and Bruno Gnassounou, 195–205. Hamshire: Ashgate, 2007.

Cather, Kirsten. "Perverting Ozu: Suo Masayuki's *Abnormal Family*." *The Journal of Japanese and Korean Cinema* 2, no. 2 (2010): 131–145.

Chandler, James. *An Archaeology of Sympathy: The Sentimental Mode in Literature and Cinema*. Chicago: University of Chicago Press, 2013.

Chang, Hsiao-hung. "Fade-ins and Fade-outs of Body and City: Hou Hsiao-Hsien and *Café Lumière*." Lecture given at a Taiwanese Film Festival Symposium, Nagoya University, October 30–31, 2010.

Chang, Hsiao-hung. "Shintai-toshi no fade-in/fade-out: Hou Hsiao-hsien to Kohi jiko" [Bodies and the city in fade in/fade out: Hou Hsiao-hsien]. Translated by Hsu Shihchia. In *Taiwan eiga hyosho no ima: kashi to fukashi no aida*, edited by Hoshino Yukiyo, Hung Yuru, Hsueh Hua-yuan, and Huang Ying-che, 17–52. Nagoya: Arumu, 2011.

Chiba, Nobuo. *Ozu Yasujiro to nijusseiki* [Ozu Yasujiro and the twentieth century]. Tokyo: Kokusho kankokai, 2003.

Chion, Michel. *Film, a Sound Art*. New York: Columbia University Press, 2009.

Chow, Rey. *Ethics after Idealism: Theory, Culture, Ethnicity, Reading*. Bloomington: Indiana University Press, 1998.

Cohen, Jack, and Ian Stewart. *The Collapse of Chaos: Discovering Simplicity in a Complex World*. London: Viking, 1994.

Cook, Ryan. "An Impaired Eye: Hasumi Shigehkio on Cinema and Stupidity." *Review of Japanese Culture and Society* 22 (December 2010): 130–143.

Cousins, Mark. *The Story of Film*. London: BCA, 2004.

Crafton, Donald. "Pie and Chase: Gag, Spectacle and Narrative in Slapstick Comedy." In *Classical Hollywood Comedy*, edited by Kristine Brunovska and Henry Jenkins, 106–119. New York: Routledge, 1995.

Davies, Roger J., and Osamu Ikeno. *The Japanese Mind: Understanding Contemporary Japanese Culture*. Boston: Tuttle Publishing, 2002.

Davis, Darrell William. "Back to Japan: Militarism and Monumentalism in Prewar Japanese Cinema." *Wide Angle* 11, no. 3 (1989): 16–25.

Davis, Robert. "Interview: Claire Denis on *35 Shots of Rum.*" *Daily Plastic*, March 10, 2009. Accessed September 13, 2015. http://www.dailyplastic.com/2009/03/interview-claire-denis-on-35-shots-of-rum/.

Dawson, Jan. *Wim Wenders*. Translated by Carla Wartenberg. New York: Zoetrope, 1976.

Deamer, David. *Deleuze, Japanese Cinema and the Atom Bomb: The Spectre of Impossibility*. London: Bloomsbury, 2014.

Deamer, David. *Deleuze's Cinema Books: The Introductions to the Taxonomy of Images*. Edinburgh: Edinburgh University Press, 2016.

Deleuze, Gilles. *Cinema 1: The Movement-Image*. Translated by Hugh Tomlinson and Barbara Habberjam. London: The Athlone Press, 2002.

Deleuze, Gilles. *Cinema 2: The Time-Image*. Translated by Hugh Tomlinson and Robert Galeta. Minneapolis: University of Minnesota Press, 1989. Reprint, 2002.

Deleuze, Gilles. *Difference and Repetition*. Translated by Paul Patton. London: Continuum, 2004.

Deleuze, Gilles. "Lucretius and the Simulacrum." In *The Logic of Sense*, translated by Mark Lester with Charles Stivale, 303–320. London: Continuum, 2004.

Desser, David. "A Filmmaker for All Seasons." In *Asian Cinemas*, edited by Dimitris Eleftheriotis and Gary Needham, 17–26. Edinburgh: Edinburgh University Press, 2006.

Desser, David. "The Imagination of the Transcendent: Kore-eda Hirokazu's Maborosi (1995)." In *Japanese Cinema: Texts and Contexts*, edited by Alastair Philips and Julian Stringer, 273–283. New York: Routledge, 2007.

Dym, Jeffrey. *Benshi, Japanese Silent Film Narrators, and Their Forgotten Narrative Art of Setsumei: A History of Japanese Silent Film Narration*. Lewiston, NY: Edwin Mellen Press, 2003.

Ehrlich, Linda C. "Kore-eda's Ocean View." *Film Criticism* 35, nos. 2–3 (Winter–Spring 2011): 127–146.

Eisenstein, Sergei. "Methods of Montage." In *Film Form: Essays in Film Theory*, 72–83. San Diego: A Harvest Book, 1977.

Elena, Alberto. *The Cinema of Abbas Kiarostami*. Translated by Belinda Coombes. London: SAQI, 2005.

Elliot, Emory. *Aesthetics in a Multicultural Age*. Oxford: Oxford University Press, 2002.

Elsaesser, Thomas. *Weimar Cinema and After: Germany's Historical Imaginary*. London: Routledge, 2000.

Faison, Elyssa. "Tokyo Twilight: Alienation, Belonging, and the Fractured Family." In *Ozu Internaitonal: Essays on the Global Influences of a Japanese Auteur*, edited by Wayne Stein and Marc DiPaolo, 53–75. New York: Bloomsbury, 2015.

Farber, Jerry. "What Is Literature? What Is Art? Integrating Essence and History." *The Journal of Aesthetic Education* 39, no. 3 (2005): 1–21.

Farber, Manny. *Farber on Film: The Complete Film Writings of Manny Farber*. New York: Library of America, 2009.

Featherstone, Mike. "Body Image and Affect in Consumer Culture." *Body and Society* 16, no. 1 (2010): 193–221.

Film Art sha, ed. *Ozu Yasujiro o yomu* [Reading Ozu Yasujiro]. Tokyo: Film Art sha, 1982.

Forrest, David. "The Films of Joanna Hogg: New British Realism and Class." *Studies in European Cinema* 11, no. 1 (2014): 64–75.

Fowler, Edward. "Piss and Run: Or How Ozu Does a Number on SCAP." In *Word and Image in Japanese Cinema*, edited by Carole Cavanaugh and Dennis Washburn, 272–292. Cambridge: Cambridge University Press, 2001.

Fry, Roger. "Sensibility." In *Last Lectures*, 22–36. Cambridge: Cambridge University Press, 1939.

Fujiki, Hideaki. "Benshi as Stars: The Irony of the Popularity and Respectability of Voice Performers in Japanese Cinema." *Cinema Journal* 45, no. 2 (2006): 66–84.

Fujitani, Takashi. *Splendid Monarchy: Power and Pageantry in Modern Japan.* Berkeley: University of California Press, 1996.

Fukui, Keiichi. "Ozu Yasujiro to sono sakuhin" [Ozu Yasujiro and his works]. *Eiga hyoron* 9, no. 1 (July 1930): 26–30.

Furukawa, Takahisa. *Senjika no Nihon eiga: Hitobito wa kokusaku eiga o mitaka* [Wartime Japanese cinema: Did people watch national policy film?]. Tokyo: Yoshikawa kobunkan, 2003.

Garin, Manuel. *El gag visual. De Buster Keaton a Super Mario.* Madrid: Cátedra, 2014.

Geist, Kathe. "Buddhism in *Tokyo Story*." In *Ozu's "Tokyo Story,"* edited by David Desser, 101–117. Cambridge: Cambridge University Press, 1997.

Geist, Kathe. *The Cinema of Wim Wenders: From Paris, France to Paris, Texas.* Ann Arbor: UMI Research Press, 1988.

Geist, Kathe. "Narrative Strategies in Ozu's Late Films." In *Reframing Japanese Cinema: Authorship, Genre, History*, edited by Arthur Nolletti Jr. and David Desser, 91–111. Bloomington: Indiana University Press, 1992.

Geist, Kathe. "The Role of Marriage in the Films of Yasujiro Ozu." *East-West Film Journal* 4, no. 1 (December 1989): 44–52.

Geist, Kathe. "West Looks East: The Influence of Yasujiro Ozu on Wim Wenders and Peter Handke." *Art Journal* 43, no. 3 (Fall 1983): 234–239.

Gemünden, Gerd. "The Oedi-pal Cinema of Wim Wenders." In *Framed Visions: Popular Culture, Americanization, and the Contemporary German and Austrian Imagination*, 158–176. Ann Arbor: University of Michigan Press, 1998.

Gerow, Aaron. "Aoyama Shinji." In *Fifty Contemporary Film Directors*, edited by Yvonne Tasker, 27–38. London: Routledge, 2011.

Gerow, Aaron. "Consuming Asia, Consuming Japan: The New Neonationalist Revisionism in Japan." In *Censoring History: Citizenship and Memory in Japan, Germany, and the United States*, edited by Mark Selden and Laura Hein, 74–95. Armonk, NY: M. E. Sharpe, 2000.

Gerow, Aaron. "Critical Receptions: Historical Conceptions of Japanese Film Criticism." In *Oxford Handbook of Japanese Cinema*, edited by Daisuke Miyao, 61–78. Cambridge: Oxford University Press, 2014.

Gerow, Aaron. *Kitano Takeshi.* London: BFI, 2007.

Gerow, Aaron. *Visions of Japanese Modernity: Articulations of Cinema, Nation, and Spectatorship, 1895–1925* (Berkeley: University of California Press, 2010).

Gerow, Aaron, Abé Mark Nornes, eds. *In Praise of Film Studies: Essays in Honor of Makino Mamoru.* Victoria, BC: Trafford; Yokohama: Kinema Kurabu, 2001.

Ginoza, Naomi. "Koharu biyori no heiwa ni okeru hijoji" [Time of emergency during the interval of peace]. In *Nihon eiga to nashonarizumu: 1931–1945* [Japanese film and nationalism: 1931-1945], edited by Iwamoto Kenji, 29–61. Tokyo: Shinwasha, 2004.

Gleick, James. 1998. *Chaos: Making a New Science.* London: Vintage, 1998.

Goldman, Alan. "The Aesthetic." In *The Routledge Companion to Aesthetics*, edited by Berys Gaut and Dominic McIver Lopes, 181–192. London: Routledge, 2000.

Goodman, Nelson. *Languates of Art.* Indiannapolise: Hackett, 1976.

Graf, Alexander. *The Cinema of Wim Wenders: The Celluloid Highway*. London: Wallflower Press, 2002.

Gunning, Tom. "Crazy Machines in the Garden of Forking Paths: Mischief Gags and the Origins of American Film Comedy." In *Classical Hollywood Comedy*, edited by Kristine Brunovska and Henry Jenkins, 87–105. New York: Routledge, 1995.

Gunning, Tom. "Response to 'Pie and Chase.'" In *Classical Hollywood Comedy*, edited by Kristine Brunovska and Henry Jenkins, 120–122. New York: Routledge, 1995.

Hadjioannou, Markos. "In Search of Lost Reality: Waltzing with Bashir." In *Deleuze and Film*, edited by D. Martin-Jones and William Brown, 104–120. Edinburgh: Edinburgh University Press, 2012.

Hampshire, Stuart. *Freedom of Mind and Other Essays*. Oxford: Clarendon Press, 1972.

Hansen, Miriam Bratu. "Fallen Women, Rising Stars, New Horizons: Shanghai Silent Film as Vernacular Modernism." *Film Quarterly* 54, no. 1 (2000): 10–22.

Hansen, Miriam Bratu. "The Mass Production of the Senses: Classical Cinema as Vernacular Modernism." *Modernism/Modernity* 6, no. 2 (1999): 59–77.

Harpham, Geoffrey Galt. "Aesthetics and the Fundamentals of Modernity." In *Aesthetics and Ideology*, edited by George Levine, 124–149. New Brunswick, NJ: Rutgers University Press, 1994.

Hashiguchi, Konosuke. "Eiga *Kohi jiko* no nichijosei" [Everydayness in the film *Café Lumière*]. *Chugoku kingendai bunka kenkyu* 7 (2004): 48–51.

Hassan, Ihab H. "The Problem of Influence in Literary History: Notes towards a Definition." *The Journal of Aesthetics and Art Criticism* 14, no. 1 (September 1955): 66–76.

Hasumi, Shigehiko. *Eiga hokai zen'ya* [The eve before cinema's collapse]. Tokyo: Seidosha, 2008.

Hasumi, Shigehiko. *Eiga ni me ga kurande* [Dazzled by the cinema]. Tokyo: Chuo koronsha, 1991.

Hasumi, Shigehiko. *Eiga no shinwagaku* [The mythology of cinema]. Tokyo: Chikuma shobo, 1996.

Hasumi, Shigehiko. *Eigaron kogi* [Lectures on film theory]. Tokyo: University of Tokyo Press, 2008.

Hasumi, Shigehiko. *Eiga: Yuwaku no ekurichuru* [Cinema: The ecriture of temptation]. Tokyo: Chikuma shobo, 1990.

Hasumi, Shigehiko. *Hikari o megutte* [About light]. Tokyo: Chikuma shobo, 1991.

Hasumi, Shigehiko. "Kamokuna imaju no yubensa ni tsuite: Hou Hsiao-Hsien shi-ron" [On the eloquence of taciturn images: An essay on Hou Hsiao-Hsien]. *Bungakukai* 60, no. 3 (March 2006): 94–111.

Hasumi, Shigehiko. *Kamdok Ozeu Yasujiro* [*Director Ozu Yasujiro*], translated by Yun Yong-sun. Seoul: Hannarae, 2001.

Hasumi, Shigehiko. *Kantoku Ozu Yasujiro* [Director Ozu Yasujiro]. Tokyo: Chikuma shobo, 1983. Reprint, 1992.

Hasumi, Shigehiko. *Kantoku Ozu Yasujiro: Zoho ketteiban* [Director Ozu Yasujiro: Expanded and definitive edition]. Tokyo: Chikuma shobo, 2003.

Hasumi, Shigehiko. "Ozu's Angry Women," *Rouge*, 2004. Accessed April 19, 2015. http://www.rouge.com.au/4/ozu_women.html.

Hasumi, Shigehiko. "Sunny Skies." In *Ozu's Tokyo Story*, edited by David Desser and translated by Kathy Shigeta, 118–129. Cambridge: Cambridge University Press, 1997.

Hasumi, Shigehiko. "Who Can Put Out the Flame?: On Hou Hsiao-Hsien's *Flowers of Shanghai.*" In *Hou Hsiao-Hsien*, edited by Richard I. Suchenski, 106–117. Vienna: Österrreichisches Filmmuseum, 2014.

Hasumi, Shiguehiko. *Yasujiro Ozu*. Translated by Nakamura Ryoji, René de Ceccatty, and Hasumi Shigehiko. Paris: Éditions de l'Étoile, Cahiers du Cinéma, 1998.

Hasumi, Yamane Sadao, and Yoshida Kiju, eds. *Kokusai shinpojiumu, Ozu Yasujiro seitan 100 nen kinen 'Ozu 2003' no kiroku* [Record of 'Ozu 2003,' the international symposium celebrating the hundredth anniversary of the birth of Ozu Yasujiro]. Tokyo: Asahi shinbunsha, 2004.

Hayashi Koichi. "*Ukigusa monogatari kara*" [From *Story of Floating Weeds*]. *Kinema shuho* (December 14, 1934): 30.

Hayward, Susan. "Claire Denis' Films and the Post-Colonial Body—with Special Reference to *Beau Travail* (1999)." *Studies in French Cinema* 1, no. 3 (2001): 159–165.

Hazumi, Tsuneo. "Kare no shinkyo: Ozu Yasujiro tono ichimon ittou" [His thought: Interview with Ozu Yasujiro]. In Ozu Yasujiro, *Ozu Yasujiro zenhatsugen, 1933–1945* [Ozu Yasujiro: collected statements, 1933–1945], edited by Tanaka Masasumi, 31. Tokyo: Tairyu-sha, 1987.

Hazumi, Tsuneo. "Ozu Yasujiro no shoshimin-sei" [The shoshimin quality of Ozu Yasujiro]. *Eiga hyoron* 8, no. 7 (July 1930): 24–26.

High, Peter B. *The Imperial Screen: Japanese Film Culture in the Fifteen Years' War, 1931–1945*. Madison: University of Wisconsin Press, 2003.

Hirai, Teruaki. "Soko Nihon eiga satsuei shi 56" [Draft history of Japanese cinematography 56]. *Eiga Satsuei* 89 (July 1985): 67–76.

Hogg, Joanna. "Joanna Hogg on *Tokyo Story*." *BFI Live*, British Film Institute, n.d. Accessed October 6, 2014. http://www.bfi.org.uk/live/video/182.

Hou, Hsiao-hsien, and Watanabe Marina. "Shinshun tokubetsu taiwa Hou Hsiao-hsien versus Watanabe Marina" [A special New Year's conversation: Hou Hsiao-hsien versus Watanabe Marina]. *Kinema junpo* 1347, January 2002, 143–147.

Hou, Hsiao-hsien, and Yoshida Shuichi. "101nenme no 'Ozu Yasujiro' no tameni, Hou Hsiao-hsien versus Yoshida Shuichi, Tokyo no hikari, Taipei no kaze" [For the sake of 'Ozu Yasujiro' on the 101st anniversary of his birth: Hou Hsiao-hsien versus Yoshida Shuichi on the illumination of Tokyo and the air of Taipei]. *Shosetsu shincho* 58, no. 9 (September 2004): 258–265.

Hou, Hsiao-hsien, Iwamatsu Ryo, and Todoroki Yukio. "Taiwa Hou Hsiao-hsien kantoku versus Iwamatsu Ryo" [A dialogue between director Hou Hsiao-hsien and Iwamatsu Ryo, a special edition report on *Café Lumière*]. *Kinema junpo* 1412, September 2004, 50–54.

Husserl, Edmund. *Naiteki jikan ishiki no genshogaku* [On the phenomenology of the consciousness of internal time]. Translated by Tatematsu Hirotaka. Tokyo: Misuzu shobo, 1987.

Ichikawa Sai, ed. *Kokusai's Motion Pictures Year Book (Japan) 1934* (Tokyo: Kokusai eiga tsushinsha, 1934)

Iida, Shinbi. "*Tokyo no korasu*" [Tokyo chorus]. *Kinema junpo*, September 11, 1931, 78.

Iijima, Tadashi. "*Kore ga Roshia da*" [*This Is Russia*]. *Kinema junpo*, March 11, 1932, 31–32.

Ikeda, Yoshio. "Shoshimin eiga hihan" [Shoshimin film criticism]. *Eiga hyoron* 12, no. 4 (April 1932): 118–123.

Iwamoto, Kenji. *Jidaigeki densetsu: chanbara eiga no kagayaki* [The jidai-geki tradition: The brilliance of chanbara films]. Tokyo: Shinwa-sha, 2005.

Iwamoto, Kenji, ed. *Nihon eiga to nashonarizumu: 1931–1945* [Japanese film and nationalism: 1931–1945]. Tokyo: Shinwasha, 2004.

Iwamoto, Kenji. *Nihon eiga to modanizumu 1920–1930* [Japanese cinema and modernism 1920–1930]. Tokyo: Riburopoto, 1991.

Iwamoto, Kenji. "Nihon ni okeru montaju riron no shokai" [Study on the introduction of montage theory in Japan]. *Waseda daigaku hikaku bungaku nenpo* 10 (1974): 67–85.

Iwasaki, Akira. *Eiga geijutsu shi* [History of film art]. 1930. Reprint, Tokyo: Yumani shobo, 2004.

Iwasaki, Akira. *Eiga no geijutsu* [The art of film]. Tokyo: Kyowa Shoin, 1936.

Iwasaki, Akira. *Eiga-ron* [On cinema]. Tokyo: Mikasa Shobo, 1936.

Iwasaki, Akira. *Eiga to shihonshugi* [Cinema and capitalism]. Tokyo: Ouraisha, 1931.

Iwasaki, Akira. "Toukii-teki zuii" [My view on talkie cinema]. *Kinema junpo*, January 11, 1933, 52–53.

Jacobs, Lea. "Belasco, DeMille, and the Development of Lasky Lighting." *Film History* 5, no. 4 (1993): 405–418.

Jacoby, Alexander. "Why Nobody Knows—Family and Society in Modern Japan." *Film Criticism* 35, nos. 2–3 (Winter–Spring 2011): 66–83.

Jaffe, Ira. *Slow Movies: Countering the Cinema of Action*. London: Wallflower, 2014.

Jarmusch, Jim. "Two or Three Things about Yasujiro Ozu." *Art Forum* 42, October 2003. http://www.a2pcinema.com/ozu-san/ozu/influence/jarmusch.htm.

Jeong, Seung-hoon. "The Surface of the Object: Quasi-Interfaces and Immanent Virtuality." In *Deleuze and Film*, edited by D. Martin-Jones and W. Brown, 210–226. Edinburgh: Edinburgh University Press, 2012.

Kaffen, Philip James. "Image Romanticism and the Responsibility of Cinema: The Indexical Imagination in Japanese Film." PhD diss., New York University, 2011.

Kant, Immanuel. *The Critique of Judgment*. 2nd rev. ed. Translated by J. H. Bernard. London: Macmillan, 1914.

Kato, Atsuko. *Sodoin taisei to eiga* [The national mobilization policy and cinema]. Tokyo: Shinyo sha, 2003.

Katz, Barry M. "The Liberation of Art and the Art of Liberations: The Aesthetics of Hubert Marcuse." In *The Aesthetics of the Critical Theorists: Studies on Benjamin, Adorno, Marcuse and Habermas*, edited by Ronald Roblin, 52–187. Lewistown, NY: Edwin Mellen, 1990.

Kawakatsu, Masayuki. "Too Old to Rock'n Roll, Too Young to Die." *TV Bros* 18, no. 9 (2004): 112.

Kerr, Alex. *Dogs and Demons: The Fall of Modern Japan*. London: The Penguin Group, 2001.

Kiarostami, Abbas. "Around *Five*." Interview in the DVD release of *Five Dedicated to Ozu*. New York: KimStim video, 2007.

Kido, Shiro. "Kenzen naru ren'ai wa egaite ka" [Healthy love scenes can be displayed]. *Eiga junpo*, January 1, 1942, 31.

King, Rob. "Uproarious Inventions: The Keystone Film Company, Modernity and the Art of the Motor." In *Slapstick Comedy*, edited by Tom Paulus and Rob King, 114–136. New York: Routledge, 2010.

Kinoshita, Chika. "The Benshi Track: Mizoguchi Kenji's *The Downfall of Osen* and the Sound Transition." *Cinema Journal* 50, no. 3 (2011): 1–25.

Kinoshita, Chika. "From Twilight to Lumiere: Two Pregnancies." Paper presented at Relocating Ozu: The Question of an Asian Cinematic Vernacular, the University of California, Berkeley, February 19-20, 2010.

Kitada, Rie. "Tokii jidai no benshi: gaikoku eiga no Nihongo jimaku arui wa 'Nihonban' seisei o meguru kosatsu" [The Benshi in the talkie period: A consideration of 'Nihonban' or the Japanese subtitling of foreign films]. *Eiga kenkyu* 4 (2009): 4–21.

Klein, Christina. *Cold War Orientalism: Asia in the Middlebrow Imagination, 1945–1961*. Berkeley: University of California Press, 2003.

Kolker, Robert Phillip, and Peter Beicken. *The Films of Wim Wenders: Cinema as Vision and Desire*. Cambridge: Cambridge University Press, 1993.

Kotani, Henri. "Eiga ga dekiagaru made (1)" [Until a film is complete (1)]. *Kinema junpo*, June 11, 1922, 5.

Lavin, Mathias. "Prolonger Ozu, avec Kiarostami, Akerman, Hong Sang-soo." In *Ozu à present*, edited by Diane Arnaud and Mathias Lavin, 55–67. Paris: G3J Éditeur, 2013.

Lee, Laura. "Japan's Cinema of Tricks: Optical Effects and Classical Film Style." *Quarterly Review of Film and Video*, 32, no. 2 (2014): 141–161.

Lee, Mark Ping Bing. "Café Lumière." *Eiga satsuei* 163 (2004): 28–31.

Liepa, Torey. "Figures of Silent Speech: Silent Film Dialogue and the American Vernacular, 1909–1916." PhD diss., New York University, 2008.

Lim, Song Hwee. *Tsai Ming-Liang and a Cinema of Slowness*. Honolulu: University of Hawaii Press, 2014.

Lippit, Akira Mizuta. "Hong Sangsoo's Lines of Inquiry, Communication, Defense and Escape." *Film Quarterly* 57, no. 4 (Summer 2004): 22–30.

Luprecht, Mark. "Freud at Paris, Texas: Penetrating the Oedipal Sub-Text." *Literature-Film Quarterly* 20, no. 2 (April 1992): 115–120.

Mackie, Vera. *Feminism in Modern Japan: Citizenship, Embodiment and Sexuality*. Cambridge: Cambridge University Press, 2003.

Mamoru, Makino. "Rethinking the Emergence of the Proletarian Film League of Japan." In *In Praise of Film Studies: Essays in Honor to Makino Mamoru*, edited by Abé Mark Nornes and Aaron Gerow, 15–45. Victoria: Trafford / Kinema Club, 2001.

Marcuse, Herbert. *Counterrevolution and Revolt*. Boston: Beacon Press, 1972.

Margulies, Ivone. *Nothing Happens: Chantal Akerman's Hyperrealist Everyday*. Durham, NC: Duke University Press.

Mars, François. *Le gag*. Paris: Éditions du Cerf, 1964.

Martin-Jones, David. *Deleuze and World Cinemas*. London: Continuum, 2011.

Martin-Jones, David. *Deleuze, Cinema and National Identity: Narrative Time in National Cinemas*. Edinburgh: Edinburgh University Press, 2006.

Masahiro, Sonomura, and Nakamura Mariko. *Mystery of Yasujiro Ozu*. Big Spirit Comics Specials—Japanese Film Director Biographies. Tokyo: Shogagukan, 2001.

Mast, Gerald. *The Comic Mind: Comedy and the Movies*. Indianapolis: Bobbs-Merrill, 1973.

McMahon, Laura. *Cinema and Contact: The Withdrawal of Touch in Nancy, Bresson, Duras and Denis*. Oxford: Legenda, 2012.

Mellen, Joan. *The Waves at Genji's Door: Japan through Its Cinema*. New York: Pantheon, 1976.

Miyao, Daisuke. *The Aesthetics of Shadow: Lighting and Japanese Cinema*. Durham, NC: Duke University Press, 2013.

Miyao, Daisuke, and Kyoko Hirono. "Translator's Introduction." In *Ozu's Anti-Cinema*, ix–xx. Ann Arbor: University of Michigan Press, 2003.

Mori, Iwao. "Renga to hanataba (8)" [Brick and Bunch of Flowers (8)]. *Kinema shuho* (February 27, 1931): 18.

Mori Iwao, Kitamura Komatsu, Gosho Heinosuke, Tachibana Koshiro, Nagata Mikihiko, Horiuchi Keizo, Fushimi Akira, Noguchi Tsurukichi, Kawaguchi Matsutaro,

Kobayashi Kichijiro. "*Madamu to nyobo* o meguru Nihon tokii zadankai" [Round-table about *The Neighbor's Wife and Mine* and Japanese Talkies]. *Kinema shuho* (August 7, 1931): 8–10.

Mumford, Stephen. *Dispositions*. 1998. Reprint, Oxford: Oxford University Press, 2008.

Myers, Ramon H., and Mark R. Peattie. *The Japanese Colonial Empire, 1895–1945*. Princeton, NJ: Princeton University Press, 1987.

Nagib, Lúcia. "Towards a Positive Definition of World Cinema." In *Remapping World Cinema: Identity, Culture and Politics in Film*, edited by S. Dennison and Song Hwi Lim, 30–37. London: Wallflower Press, 2006.

Nakamura, Hideyuki. "Ozu, or on the Gesture." *Review of Japanese Culture and Society* 22 (December 2010): 144–160.

Nalbantoglue, Gulsum Baydar, and Wong Chong Thai. *Postcolonial Space(s)*. Princeton, NJ: Princeton Architectural Press, 1997.

Namiki, Shinsaku. *Purokino zenshi* [The history of prokino]. Tokyo: Godo Shuppan, 1986.

Nancy, Jean-Luc, and Abbas Kiarostami. "In Conversation." In *Abbas Kiarostami: The Evidence of Film*, translated by Christine Irizarry and Verena Andermatt Conley, 80–95. Bruxelles: Yves Gevaert Éditeur, 2001.

Neale, Steve, and Frank Krutnik. "The Case of Silent Slapstick." In *Hollywood Comedians: The Film Reader*, edited by Frank Krutnik, 57–73. London: Routledge, 2003.

Needham, Gary. "Ozu and the Colonial Encounter in Hou Hsiao-hsien." In *Asian Cinemas: A Reader and Guide*, edited by Dimitris Eleftheriotis and Gary Needham, 369–383. Edinburgh: Edinburgh University Press, 2006.

Ng, Andrew Hock-soon. *Interrogating Interstices: Gothic Aesthetics in Postcolonial Asian and Asian American Literature*. Oxford: Peter Land, 2007.

Nibuya, Takashi. *Tenno to tosaku: Gendai bungaku to kyodotai* [The emperor and perversion: Modern literature and the collective]. Tokyo: Seidosha, 1999.

Nietzsche, Friedrich. *Thus Spoke Zarathustra*. Translated by Graham Parkes. Oxford: Oxford University Press, 2005.

Niogret, Hubert. "Introducing: Yasujiro Ozu: ou pour la première fois à l'écran." *Positif* 203 (1978): 2–12.

Nishikawa, Etsuji. "Eiga gijutsu no saishuppatsu: Shin taisei kakuritsu dai 1 nen o mukaete" [Restart of film technology: In the first year of the new system]. *Eiga gijutsu* 3, no. 1 (January 1942): 42–43.

Nolletti, Arthur, Jr. "Introduction: Kore-eda Hirokazu, Director at a Crossroads." *Film Criticism* 35, nos. 2–3 (Winter 2011): 2–10.

Nornes, Abé Mark. *Japanese Documentary Film: The Meiji Era through Hiroshima*. Minneapolis: University of Minnesota Press, 2003.

Nornes, Abé Mark. "The Riddle of the Vase: Ozu Yasujiro's *Late Spring* (1949)." In *Japanese Cinema: Texts and Contexts*, edited by Julian Stringer and Alastair Phillips, 78–89. New York: Routledge, 2007.

Nornes, Abé Mark, and Yueh-ye Yeh. *Staging Memories: Hou Hsiao-hsien's* A City of Sadness (Ann Arbor: Michican Publishing, 2014). Accessed April 16, 2015. doi: http://dx.doi.org/10.3998/maize.13469763.0001.001.

Ohashi, Ryosuke. "Kiku koto to shite no rekishi: rekishi no kansei to sono kozo" [History as something heard: The structure and sensitivities of history]. Nagoya: University of Nagoya Press, 2005.

Okada, Hidenori. "Nihon no naitoreto firumu seizo shoki no jijo (ge)" [Nitrate film production in Japan: The conditions of early period (2)]. *NFC Newsletter* 31 (2000): 12–15.

Okamura, Akira. "*Kabocha*" [*Pumpkin*]. *Kinema junpo*, November 1, 1928, 102.

Okamura, Yasuo. "*Umarete ha mitakeredo*" [*I Was Born, But . . .*]. *Kinema junpo*, June 21, 1932, 50–51.

Osenlund, R. Kurt. "Still Walking." *Cineaste* 34, no. 3 (2011): 54–58.

Otsuka, Kyoichi. "Ozu Yasujiro ron" [On Ozu Yasujiro]. *Eiga hyoron* 8, no. 4 (April 1930): 40–45.

Otsuka, Kyoichi. "*Rakudai ha shitakeredo*" [*I Flunked, But . . .*]. *Eiga hyoron* 8, no. 7 (July 1930): 30–31.

Ozu, Yasujiro, Hazumi Tsuneo, Shigeno Tatsuhiko, Kishi Matsuo, Tomoda Junichiro, Kitagawa Fuyuhiko, and Iida Shinbi. "Ozu Yasujiro zadankai" [Discussion with Ozu Yasujiro]. *Kinema junpo*, April 1, 1935, 171–178.

Ozu, Yasujiro. *Antología de los diarios de Yasujiro Ozu*. Translated by Núria Pujol and Antonio Santamarina. Valencia: Filmoteca de la Generalitat, 2000.

Ozu, Yasujiro. *Ozu Yasujiro sengo goroku shusei: showa 21 nen (1946)–showa 38 nen (1963)* [A collection of Ozu Yasujiro's postwar statements, 1946–1963]. Edited by Tanaka Masasumi. Tokyo: Firumu Aato-sha, 1989.

Ozu, Yasujiro. *Ozu Yasujiro sakuhinshu* [The collected works of Ozu]. Edited by Inoue Kazuo. Tkyo: Rippu shobo, 1993.

Ozu, Yasujiro. *Ozu Yasujiro zenhatsugen: 1933–1945* [Ozu Yasujiro: collected statements, 1933–1945]. Edited by Tanaka Masasumi. Tokyo: Tairyusha, 1987.

Ozu Yasujiro, Yagi Yasutaro, and Yanai Takao, "*Chichi ariki* (dai ikko)" [*There Was a Father*: The first draft], in *Bungei bessatsu: Ozu Yasujiro* [Bungei extra: Ozu Yasujiro], edited by Nishiguchi Toru, 230–254. Tokyo: Kawade shobo shinsha, 2001.

Parks, Tyler. "Ozu, Deleuze, and the Visual Reserve of Events in their Appropriateness." Paper presented at the annual Film-Philosophy Conference, Glasgow, Scotland, July 2–4, 2014.

Philips, Alastair. "Pictures of the Past in the Present: Modernity, Femininity and Stardom in the Postwar Films of Ozu Yasujiro." In *Screening World Cinema*, edited by Catherine Grant and Annette Kuhn, 86–100. Oxon: Routledge, 2006.

Philips, Alastair. "Pictures of the Past in the Present: Modernity, Feminity and Stardom in the Postwar Films of Ozu Yasujiro." *Screen* 44, no. 2 (Summer 2003): 154–166.

Phillips, Alastair. "The Salaryman's Panic Time: Ozu Yasujiro's *I Was Born, But . . .* (1932)." In *Japanese Cinema: Texts and Contexts*, edited by Alastair Phillips and Julian Stringer, 25–36. New York: Routledge, 2007.

Ponzanesi, Sandra, and Marguerite Waller, eds. *Postcolonial Cinema Studies*. London: Routledge, 2012.

Raine, Michael. "Adaptation as 'Transcultural Mimesis' in Japanese Cinema." In *The Oxford Handbook of Japanese Cinema*, edited by Daisuke Miao, 101–123. Oxford: Oxford University Press, 2014.

Richie, Donald. "Buddhism and the Film." *Kyoto Journal*. Accessed July 27, 2014. http://www.kyotojournal.org/multimedia/buddhism-and-the-film/.

Richie, Donald. *A Hundred Years of Japanese Film*. New York: Kodansha International, 2001.

Richie, Donald. *Japanese Cinema: Film Style and National Character*. New York: Doubleday, 1971.

Richie, Donald. *Ozu: His Life and Films*, 1974. Reprint, Berkeley: University of California Press, 1977; 1992.

Richie, Donald. "Yasujiro Ozu: The Syntax of His Films." *Film Quarterly* 17, no. 2 (Winter 1963–1964): 11–16.

Rosenbaum, Jonathan. *Building from Ground Zero: A Hen in the Wind*, written for BFI DVD release of the film. http://www.jonathanrosenbaum.net/2017/05/building-fron-ground-zero-a-hen-in-the-wind-tk/.

Rosenbaum, Jonathan. "Is Ozu Slow?" *Senses of Cinema* 4 (March 2000). Accessed April 19, 2015. http://sensesofcinema.com/2000/feature-articles/ozu-2/.

Russell, Catherine. *Classical Japanese Cinema Revisited*. New York: Continuum, 2011.

Saiki, Tomonori, ed. *Eiga dokuhon Ito Daisuke: Hangyaku no passhon, jidaigeki no modanizumu* [Reader's guide to Ito Daisuke: Passion of resistance, jidaigeki modernism]. Tokyo: Film Art sha, 1996.

Sandford, John. *The New German Cinema*. New York: Da Capo Press, 1980.

Sasa, Genju. "Gangu/buki—satsueiki" [Camera—toy/weapon]. *Senki* 1, no. 2 (June 1928): 29–33.

Sato, Tadao. *Currents in Japanese Cinema*. Translated by Gregory Barrett. Tokyo: Kodansha, 1982.

Sato, Tadao. "From the Art of Yasujiro *Ozu*." *Wide Angle* 1, no. 4 (1977): 44–48.

Sato, Tadao. *Nihon eigashi* I: 1896–1940 [Japanese film history I: 1896–1940]. Tokyo: Iwanami shoten, 1995.

Sato, Tadao. *Ozu Yasujiro no geijustu* [The Art of Ozu Yasujiro], 1971. Reprint, Tokyo: Asahi shinbunsha, 2003.

Schiller, Friedrich. *Aesthetic Education of Man*. Translated by Reginald Snell. New Haven: Yale University Press,1954. Reprint, Mineola: Dover Publications, 2004.

Schilling, Mark. "Kore-eda Hirokazu Interview." *Film Criticism* 35, nos. 2–3 (Winter–Spring 2011): 11–20.

Schrader, Paul. *Transcendental Style in Film: Ozu, Bresson, Dreyer*. Berkeley: University of California Press, 1972. Reprint, New York: Da Capo Press, 1988.

Schultheis, Alexandra. *Regenerative Fictions: Postcolonialism, Psychoanalysis and the Nation as Family*. London: Palgrave Macmillian, 2004.

Sedgwick, Eve Kosofsky. *Touching Feeling: Affect, Pedagogy, Performativity*. Durham, NC: Duke University Press, 2003.

Sekino, Yoshio. "Shinkyo-mono no hasan to Ozu Yasujiro no zento" [The disruption of sentimental film and the future of Ozu Yasujiro]. *Eiga hyoron* 8, no. 7 (July 1930): 20–24.

Shapiro, Alan. *In Praise of the Impure Poetry and the Ethical Imagination: Essays, 1980–1991*. Evanston: Northwestern University Press, 1993.

Shapiro, Jane. "Stranger in Paradise. 1986." In *Jim Jarmusch: Interviews*, edited by Ludvig Hertzberg, 58–70. Jackson: University Press of Mississippi, 2001.

Silverman, Kaja. *The Threshold of the Visible World*. London: Routledge, 1996.

Sobchack, Vivian Carol. *The Address of the Eye: A Phenomenology of Film Experience*. Princeton, NJ: Princeton University Press, 1992.

Standish, Isolde. "Mediators of Modernity: 'Photo-interpreters' in Japanese Silent Cinema." *Oral Tradition* 20, no. 1 (2005): 93–110.

Suárez, Juan Antonio. *Jim Jarmusch*. Urbana: University of Illinois Press, 2007.

Sullivan, Michael, and John T. Lysaker. "Between Impotence and Illusion: Adorno's Art of Theory and Practice." *New German Critique* 57 (Autumn 1992): 87–122.

Sutton, Damian. "Philosophy, Politics and Homage in *Tears of the Black Tiger*." In *Deleuze and Film*, edited by David Martin-Jones and William Brown, 37–53. Edinburgh: Edinburgh University Press, 2012.

Tada, Michitaro. *Gestualidad japonesa*. Translated by Tomiko Sasagawa Stahl and Anna Kazumi Stahl. Buenos Aires: Adriana Hidalgo Editora, 2007.

Taketomi, Yoshio. "Ofuna eiga ryu no akarusa no shakumei" [Explanation on the brightness of the Ofuna films]. *Eiga gijutsu* 3, no. 4 (April 1942): 60–61.

Takinami, Yuki. "Reflecting Hollywood: Mobility and Lightness in the Early Silent Films of Ozu Yasujiro, 1927–1933." PhD diss., University of Chicago, 2012.

Tanaka, Hideo. *Ozu Yasujiro no ho e: Modanizumu eiga shiron* [Towards Ozu Yasujiro: A history of modernist cinema]. Tokyo: Misuzu shobo, 2002.

Tanaka Junichiro, Nakatani Giichiro, Tokugawa Musei, Mori Iwao, Suzuki Toshio, Takeyama Masanobu. "Hobun taitoru mondai zadankai sokki" [Notes on a Round-table on the Question of Japanese Language Titles]. *Kinema Shuho* (February 13, 1931): 28–32.

Tanaka, Masasumi. *Ozu ariki* [There was Ozu]. Tokyo: Seiryu shuppan, 2013.

Tanaka, Masasumi, ed. *Ozu Yasujiro sengo goroku shusei 1946–1963* [An anthology of Ozu Yasujiro's words after World War II: 1946–1963]. Tokyo: Film Art sha, 1989.

Tanaka, Masasumi. *Ozu Yasujiro to senso* [Ozu Yasujiro and war]. Tokyo: Misuzu shobo, 2005.

Tanaka, Toshio. "*Chichi ariki*" [*There Was a Father*]. *Eiga gijutsu* 3, no. 5 (May 1942): 74–75.

Tanaka, Toshio. "Eigateki na bi, shu, kegare" [Cinematic beauty, ugliness, and stain]. *Shin eiga* 10, no. 7 (June 1940): 44–45.

Tanaka, Toshio. "Satsuei" [Cinematography]. *Eiga junpo*, March 1, 1941, 33–35.

Tanaka, Toshio. "Sokoku no utsukushisa: Showa 16 nendo gijutsu kaiko" [The beauty of oppositions: Retrospective of technology in 1941]. *Eiga gijutsu* 3, no. 2 (February 1942): 56–59.

Tayama, Rikiya. *Nihon no eiga sakkatachi: Sosaku no himizu* [Japanese filmmakers: Secrets of creation]. Tokyo: Daviddosha, 1975.

Tezuka, Yoshiharu. *Japanese Cinema Goes Global*. Hong Kong: Hong Kong University Press, 2012.

Thompson, Kristin. *Breaking the Glass Armor: Neoformalist Film Analysis*. Princeton, NJ: Princeton University Press, 1988.

Thompson, Kristin. "*Late Spring* and Ozu's Unreasonable Style." In *Breaking the Glass Armour: Neoformalist Film Analysis*, 317–352. Princeton, NJ: Princeton University Press, 1988.

Thompson, Kristin, and David Bordwell. "Space and Narrative in the Films of Ozu." *Screen* 17, no. 2 (1976): 41–73.

Tsivian, Yuri, ed. *Lines of Resistance: Dziga Vertov and the Twenties*. Pordenone: Le Giornate del Cinema Muto, 2004.

Tsumura, Hideo. "Shochiku eiga ron" [A study of Shochiku film]. *Kinema junpo*, May 1, 1939, 10–12.

Turim, Maureen. *Oshima Nagisa: Images of a Japanese Iconoclast*. Berkeley: University of California Press, 1998.

Turner, Matthew. "Joanna Hogg Interview." *View London*, n.d. Accessed October 6, 2014. http://www.viewlondon.co.uk/cinemas/joanna-hogg-interview-feature-interview-3934-1.html.

Turvey, Malcolm. *Doubting Vision: Film and the Revelationist Tradition*. New York: Oxford University Press, 2008.

Uchida, Tokio. "*Zange no yaiba*" [*Sword of Penitence*]. *Kinema junpo*, November 21, 1927, 59.

Udden, James. *No Man an Island: The Cinema of Hou Hsiao-hsien*. Hong Kong: Hong Kong University Press, 2009.

Ueno, Ichiro. "1932 nen kaiko: Nihon eiga kaiko" [Looking back on 1932: Looking back on Japanese film]. *Eiga hyoron* 13, no. 6 (December 1932): 68–74.

Vertov, Dziga. "From Kino-Eye to Radio-Eye." In *Kino-Eye: The Writings of Dziga Vertov*, edited by Annete Michelson and translated by Kevin O'Brien, 85–92. San Diego: A Harvest Book, 1977.

Vertov, Dziga. "Man with a Movie Camera, Absolute Kinography, and Radio-Eye." In *Lines of Resistance: Dziga Vertov and the Twenties*, edited by Yuri Tsivian and translated by Julian Graffy, 318–319. Pordenone: Le Giornate del Cinema Muto, 2004.

Von Bagh, Peter. *Aki Kaurismäki*. Locarno: Cahiers du Cinéma, 2006.

Wada-Marciano, Mitsuyo. "A Dialogue Through Memories: *Still Walking*." *Film Criticism* 35, nos. 2–3 (Winter–Spring 2011): 110–126.

Wada-Marciano, Mitsuyo. *Nippon Modern: Japanese Cinema of the 1920s and 1930s*. Honolulu: University of Hawaii Press, 2008.

Weaver-Hightower, Rebecca, and Peter Hulme, eds. *Postcolonial Film: History, Empire, Resistance*. London: Routledge, 2014.

Wells, Marguerite A. "Satire and Constraint in Japanese Culture." In *Understanding Humor in Japan*, edited by Jessica Milner Davis, 193–217. Detroit: Wayne State University, 2006.

Wenders, Wim. "Film Thieves." In *The Logic of Images: Essays and Conversations*, translated by Michael Hofmann, 33–38. London: Faber and Faber, 1991.

Wenders, Wim. "*Tokyo-Ga*." In *The Logic of Images: Essays and Conversations*, translated by Michael Hofmann, 60–65. London: Faber and Faber, 1992.

White, Hayden. "The Value of Narrativity in the Representation of Reality." *Critical Inquiry* 7, no. 1 (Autumn 1980): 5–27.

Wilson, George M. *Narrative in Light: Studies in Cinematic Point of View*. Baltimore: Johns Hopkins University Press, 1986.

Wilson, Janet, Cristina Şandru, and Sarah Lawson Welsh, eds. *Rerouting the Postcolonial: New Directions for the New Millennium*. London: Routledge, 2010.

Wood, Robin. "Resistance to Definition: Ozu's 'Noriko' Trilogy." In *Sexual Politics and Narrative Film: Hollywood and Beyond*, 94–138. New York: Columbia, 1998.

Wood, Robin. *Sexual Politics and Narrative Film*. New York: Columbia University Press, 1998.

Worton, Michael, and Judith Still. *Intertextuality: Theories and Practices*. Manchester: Manchester University Press, 1990.

Yamamoto, Kikuo. *Nihon eiga ni okeru gaikoku eiga no eikyo* [The influence of foreign films on Japanese films]. Tokyo: Waseda daigaku shuppanbu, 1983.

Yip, June. *Envisioning Taiwan: Fiction, Cinema and the Nation in the Cultural Imaginary*. Durham, NC: Duke University Press, 2004.

Yomota, Inuhiko. *Ajia no naka no Nihon eiga* [Japanese cinema within Asia]. Tokyo: Iwanami shoten, 2001.

Yonaha, Jun. *Teikoku no zan'ei* [After-images of empire]. Tokyo: NTT shuppan, 2011.

Yoshida, Kenkichi. "Eiga bijutsu jihyo" [Review of film art]. *Nihon eiga* 7, no. 5 (May 1942): 28–32.

Yoshida, Kiju. *Ozu's Anti-Cinema*. Translated by Daisuke Miyao and Kyoko Hirano. Ann Arbor: University of Michigan Press, 2003.

Yoshida, Kiju. "Ozu Yasujiro ron saiko" [Rethinking the arguments on Ozu Yasujiro]. *Eureka: Poetry and Criticism* 636 (November 2013): 110–140.

Yoshimoto, Mitsuhiro. "Japanese Cinema in Search of a Discipline." In *Kurosawa: Film Studies and Japanese Cinema*, 7–49. Durham, NC: Duke University Press, 2000.

Yoshimoto, Mitsuhiro. *Kurosawa: Film Studies and Japanese Cinema*. Durham, NC: Duke University Press, 2000.

INDEX (Compiled by Kosuke Fujiki)

light comedy, 35–36, 151
silent comedy, 8, 38
slapstick, 12, 36, 105, 199–200, 211, 213n46
social comedy, 27
student comedy, 12, 37
See also gag; nonsense; *shoshimin*
commercialism, 11, 37–39, 109, 135, 151, 159, 161, 272
commodity fetishism, 90
common sense, 61, 74
See also Ohashi, Ryosuke
community, 24, 202–203, 218, 231n49, 274, 277, 279–280
complexity, 3, 9, 81, 83, 104, 133, 143, 178, 182, 186, 194, 199, 203, 223, 251–253, 257–259
See also simplicity
conservatism, 3, 11, 14, 33, 157, 171, 185–186
consistency, 35, 40, 80, 126, 218, 222
See also constancy
constancy, 13–14, 24, 80, 82, 94, 191, 193, 202, 225, 227, 277
See also consistency
continuity, 4, 7, 12, 39, 41, 93, 106, 143, 163, 198, 259–261
continuity editing. *See* editing
Hollywood continuity system. *See* Hollywood
narrative continuity, 52, 57n37
spatiotemporal, 35, 39
Cook, Ryan, 49–50, 83
cosmopolitanism, 156, 165
criticism, 2, 5, 8, 47, 50, 55, 57n39, 79, 122, 133, 137–139, 141, 145, 151–152, 169, 178, 193, 222, 236
auteur criticism, 119, 126
film criticism, 34, 46, 49–50, 55, 120, 139
impressionist criticism, 46
proletarian film criticism, 133, 139, 143
surface criticism (*hyoso hihyo*), 5, 50, 57n39, 83
See also Hasumi, Shigehiko
culturalism, 1, 6, 9, 11, 40, 156
See also essentialism
culture, 1–2, 5–11, 24, 34–35, 43n1, 46, 50, 53–54, 59–60, 62, 90, 113,

120, 129, 142, 169, 174n47, 181, 185–186, 201, 205, 207, 216–218, 233, 235, 270
American counterculture, 34, 42
bubble culture, 55
cross-cultural, 3, 5, 12, 14, 31, 34, 236
cultural clash, 205
cultural hybridity, 165
cultural identity, 10
cultural influence, 7, 9, 11, 14
cultural symbolism. *See* symbolism
film culture, 13, 21, 124, 165
Japanese culture, 6–7, 9–10, 22, 54, 123, 192, 261
kawaii (cute) culture. *See* kawaii (cute)
modern culture, 27, 133
popular culture, 27
Western (American) culture, 10, 235
See also mass culture
cutaway, 30, 85, 93–94, 193, 234, 280–281
See also pillow shot; shot; still life

Davis, Darrell W., 5, 13, 170, 173n37, 174n50
Days of Youth (Gakusei romansu: Wakaki hi), 12, 23, 82, 105, 133
deadpan, 178, 204–206, 211
découpage, 23, 105, 234
deformity. *See* form
Deleuze, Gilles, 4–5, 15, 249–262, 264
See also action-image; affect; any-space-whatever; lectosign; movement-image; opsign; perception; sensory-motor schema; serialism, cinematic; sonsign; time
Denis, Claire, 1, 12, 14, 177, 203, 215, 218–220, 222–225, 227–229, 229n2
density, 3–4, 83, 85, 88
See also texture
depth, 55, 62, 64, 83, 129, 276
psychological, 55
spatial, 64, 164, 275, 262
Desser, David, 78, 194
dialogism, 170, 177, 193–195
differences, just-noticeable, 29, 31
formal difference. *See* form
Dim Sum: A Little Bit of Heart, 12, 24–25
disparity, 2, 34, 36, 201

long, 30, 41, 58n46, 59, 112, 145, 149,
178, 189, 191, 258, 264,
275–276, 278, 283n20
low-angle, 39, 127–128, 189
point-of-view, 170, 182, 234,
270, 283n20
sequence shot, 39
shot/reverse shot (shot-reverse), 12,
35, 105, 107, 126–127, 151, 164,
219, 237–238
tracking shot, 112, 135, 191, 209,
278–279
transitional shot, 9, 81, 277
See also average shot length (ASL);
pillow shot; vase shot
signification, 171, 222
Silverman, Kaja, 216–217
See also look, productive
simplicity, 2, 10, 24, 40, 112, 188, 201,
251–253, 257–258, 261
See also complexity
slapstick. *See* comedy
slow cinema, 2, 4, 278, 281
Sobchack, Vivian, 170–171, 174n52
sojikei, 24, 206–208, 11
sonsign, 250, 257, 260, 262–264
See also Deleuze, Gilles
sound, 4, 31, 38, 66, 69, 86, 88–89,
103–104, 109–110, 114, 143,
165, 209, 218–219, 221, 250,
256, 259–260, 262, 264, 277
off-screen sound, 273, 277, 280
sound cinema, 104, 106–107, 109,
114, 115n20, 162, 278, 283n21
sound effect, 67, 102–103, 109–110,
117n43, 162
sound transition, 106, 113
sound version, 102, 108–111,
114, 117n43
soundscape, 67, 110, 283n21
space, 3, 12, 23–24, 27, 31, 50, 52,
64–66, 90, 93, 101–103, 105,
109, 143, 184, 189, 203, 205,
217–220, 223, 229, 234–235,
242–243, 253–257, 259–261,
263, 270, 276–277, 281
diegetic film space (dramatic space),
67, 102, 107
domestic space. *See* domesticity
emptied space. *See* emptiness

intermediate space, 36, 41, 184
liminal space, 180, 276
memory of, 71
mental space, 253–254
on- and off-screen space, 4
screen space, 164
shooting space, 35, 39, 81
spatial depth. *See* depth
spatial orientation, 65
time and space. *See* time
urban space (modern city space),
65, 183
See also 360-degree space
sparsity, 2, 104, 269
sparse *vs* slow, 272, 274, 277–279
spectator, 11, 14, 40, 77, 88, 91, 122,
161–162, 165, 167, 170, 173n33,
174n52, 209, 252
spectator's gaze. *See* gaze
speech, 36, 64, 102, 105, 107, 111, 155,
235–236, 238, 241, 243
inner, 243
visual, 101
spirituality, 6, 34, 36, 39
staging, 13, 24, 31, 82, 241, 243,
262, 275
stairs, 93, 162–163, 191, 219–220, 279
stardom, 3, 30, 71, 243
star system, 122
stasis, 2, 8, 32, 34, 36, 189, 191–192,
221, 234, 261, 278
See also stillness; transcendentalism
Sternberg, Josef von, 101, 106
still life, 4, 250–251, 257, 261–264, 276,
280–281
See also cutaway; shot; pillow shot
Still Walking (*Aruitemo aruitemo*), 23,
92–93, 195
stillness, 2, 4, 40, 270, 278
See also stasis
Story of Floating Weeds, A (*Ukikusa
monogatari*), 89, 108, 110–111,
117n43, 200, 206, 272
storytelling, 32, 38, 199–201
sparse (elliptical), 2, 275
Stranger Than Paradise, 24, 26, 203,
205–206, 213n32
style, 1–2, 7–14, 21–22, 27, 30, 35,
37–38, 41, 48, 53–55, 58n46,
77–79, 82, 91–94, 135, 169,